D0709747

FRIEZE ART FAIR

Yearbook
2003–4

Published in 2003 by frieze
5–9 Hatton Wall, London EC1N 8HX
Tel +44 20 7813 5555
Fax +44 20 7813 7779
Email admin@frieze.com
www.frieze.com

frieze is an imprint of Durian Publications Ltd.,
registered in England number 2609458

ISBN 0 9527414 4 X

A catalogue record of this book is available from the British Library.

Editor: Anna Starling
Commissioning Editors: Amanda Sharp and Polly Staple
Editorial Assistants: Megan O'Shea and Dan Biddulph
Subeditor: Matthew Taylor and Sam Roberts
Advertising Sales: Michael Benevento, Mareike Dittmer
Advertising Sales and Production: Joanna Brinton

Design: Graphic Thought Facility, London

Printed by: Butler and Tanner, Frome and London

Distributed by Thames and Hudson Ltd.
181A High Holborn, London WC1V 7QX
Tel +44 20 7845 5000
Fax +44 20 7845 5050
Email sales@thameshudson.co.uk
www.thameshudson.com

Contents

Participating Galleries

1301PE, Los Angeles
303 Gallery, New York
ACME., Los Angeles
Air de Paris, Paris
The Approach, London
Art:Concept, Paris
aspreyjacques, London
Blum & Poe, Los Angeles
Tanya Bonakdar Gallery, New York
BQ, Cologne
The Breeder Projects, Athens
Galerie Daniel Buchholz, Cologne
Cabinet, London
Luis Campaña Galerie, Cologne
Galerie Gisela Capitain, Cologne
carlier | gebauer, Berlin
China Art Objects Galleries,
Los Angeles
Sadie Coles HQ, London
Contemporary Fine Arts, Berlin
Corvi-Mora, London
Counter, London
CRG Gallery, New York
Galerie Chantal Crousel, Paris
doggerfisher, Edinburgh
Galerie EIGEN + ART, Berlin
Entwistle, London
Foksal Gallery Foundation, Warsaw
Galeria Fortes Vilaça, São Paulo
Marc Foxx, Los Angeles
Stephen Friedman Gallery, London
Frith Street Gallery, London
Gagosian Gallery, New York
GBE (Modern), New York
Galerie Gebr. Lehmann, Dresden
Gimpel Fils, London
Marian Goodman Gallery,
New York
Greene Naftali, New York
greengrassi, London
Galerie Karin Guenther, Hamburg

Hales Gallery, London
Galerie Hammelehle und Ahrens, Cologne
Jack Hanley Gallery, San Francisco
Haunch of Venison, London
Galerie Hauser & Wirth, Zurich
Galerie Ghislaine Hussenot, Paris
Taka Ishii Gallery, Tokyo
Jablonka Galerie Linn Lühn, Cologne
Galerie Martin Janda, Vienna
Galerie Rodolphe Janssen, Brussels
Annely Juda Fine Art, London
Georg Kargl, Vienna
galleria francesca kaufmann, Milan
Kerlin Gallery, Dublin
Klosterfelde, Berlin
Leo Koenig, Inc., New York
Michael Kohn Gallery, Los Angeles
Johann König, Berlin
Tomio Koyama Gallery, Tokyo
Andrew Kreps Gallery, New York
Galerie Krinzinger, Vienna
kurimanzutto, Mexico City
Galerie Yvon Lambert, Paris
Lisson Gallery, London
Luhring Augustine, New York
maccarone inc., New York
Kate MacGarry, London
Magnani, London
Mai 36 Galerie, Zurich
Giò Marconi, Milan
Matthew Marks Gallery, New York
Galerie Meyer Kainer, Vienna
Meyer Riegger Galerie, Karlsruhe
Milton Keynes Gallery, Bucks
Victoria Miro Gallery, London
Mizuma Art Gallery, Tokyo
Modern Art, London
The Modern Institute, Glasgow
Andrew Mummery Gallery, London
MW projects, London
Galerie Christian Nagel, Cologne
Galerie Michael Neff, Frankfurt

Galerie Neu, Berlin
neugerriemschneider, Berlin
Galleria Franco Noero, Turin
Galerie Nordenhake, Berlin
Galerie Giti Nourbakhsch, Berlin
Galerie Nathalie Obadia, Paris
Patrick Painter Inc., Santa Monica
Maureen Paley Interim Art, London
The Paragon Press, London
Parkett Editions, New York
Galerie Francesca Pia, Bern
Galerie Praz-Delavallade, Paris
Galerie Eva Presenhuber, Zurich
The Project, New York
Galerie Almine Rech, Paris
Anthony Reynolds Gallery, London
Ridinghouse, London
Galerie Thaddaeus Ropac, Salzburg
Galleria Sonia Rosso, Turin
Salon 94, New York
Galerie Aurel Scheibler, Cologne
Schipper & Krome, Berlin
Gallery Side 2, Tokyo
Brent Sikkema, New York
Sommer Contemporary Art, Tel Aviv
Sprovieri, London
Sprüth Magers Lee, London
Paul Stolper, London
Galerie Micheline Szwajcer, Antwerp
Timothy Taylor Gallery, London
Galerie Barbara Thumm, Berlin
Transmission Gallery, Glasgow
Emily Tsingou Gallery, London
Two Palms Press, New York
Vilma Gold, London
Waddington Galleries, London
Galleri Nicolai Wallner, Copenhagen
Galerie Barbara Weiss, Berlin
White Cube, London
Galerie Barbara Wien, Berlin
Wilkinson Gallery, London
The Wrong Gallery, New York
David Zwirner, New York

Art Fair Staff

Amanda Sharp, Director
Matthew Slotover, Director
Stephanie Dieckvoss, Fair Manager
Polly Staple, Curator
Nicole Bellamy, Marketing Director
Antony Green, Sponsorship Director
Daisy Shields, VIP Co-ordinator
Cristina Raviolo, VIP Co-ordinator (Italy/Spain)
Assistants: Jacob Jurgensen and Megan O'Shea

Selection committee for the Frieze Art Fair 2003

Gavin Brown, GBE (Modern), New York
Sadie Coles, Sadie Coles HQ, London
Jeanne Greenberg Rohatyn, Salon 94, New York
Martin Klosterfelde, Klosterfelde, Berlin
Maureen Paley, Interim Art, London
Eva Presenhuber, Galerie Eva Presenhuber, Zurich
Toby Webster, The Modern Institute, Glasgow

Introduction

We are delighted to introduce the inaugural Frieze Art Fair, the first international contemporary art fair held in London. Fairs can be great places to discover new art and to get an overview of what's being made at a particular point in time. Commercial galleries are often the first place one sees an artist's work, and we are very pleased to present so many of the world's most exciting galleries at the fair.

The vision for the fair is similar to our aims for *frieze* magazine, which we launched in 1991. We want to create something accessible but critical; serious but entertaining; and irreverent but respectful. Large events can be weighed down by their location and infrastructure – by holding the fair in a temporary structure in Regent's Park, we hope to allow the energy and excitement that emanates from all great art to shine through. By working with the architects at Adjaye Associates and graphic designers Graphic Thought Facility, we have sought to create the best environment for art works and visitors alike.

Alongside the gallery presentations, we invited curator Polly Staple to commission a number of artists to create site-specific, often spectacular projects, many of which are performance-based. The artists had to address the fair infrastructure, and have all approached the questions raised in well-considered and enjoyable ways. Polly is also responsible for an excellent talks and education programme, held in the fair auditorium. In addition, we are presenting an inventive three-night music programme compiled by *frieze*'s assistant editor Dan Fox and musician Steve Mackey. Held in a London club, these events will bring together artists and musicians who have a common interest in the edges of the culture of pop.

We are particularly pleased with this yearbook, and would like to thank all the galleries who provided information and images. Each gallery in the fair was invited to nominate up to three artists they would be exhibiting and *frieze* critics were then commissioned to write short texts on each artist. Published with an image, a selection of exhibitions, a brief bibliography and a list of galleries who represent the artist, the yearbook is intended to give a user-friendly guide to the fair as well as providing a lasting overview to today's art.

Matthew Slotover
Amanda Sharp

Frieze Art Fair wishes to acknowledge the generous support of the following companies and organisations:

THE
**ROYAL
PARKS**

Simmons & Simmons

Media partners

★THE INDEPENDENT THE INDEPENDENT
 ON SUNDAY

FRIEZE ART FAIR

TATE

The Frieze Art Fair Special Acquisitions Fund

We are delighted to announce the launch of the Frieze Art Fair Special Acquisitions Fund for presentation to the Tate Collection. The fund of £100,000 begins at this year's Frieze Art Fair.

We believe this is the first time an art fair and a museum have collaborated on a fund of this kind. The fund aims to bring a selection of the newest and most exciting contemporary art on display at the Frieze Art Fair to the Tate. Four internationally recognised curators will purchase artworks at the fair for presentation to the Tate Collection; the curators for this year's fund are:

Jan Debbaut, Director of Collections, Tate, London
Suzanne Ghez, Executive Director, Renaissance Society, Chicago
Massimiliano Gioni, Artistic Director, The Nicola Trussardi Foundation, Milan
Sean Rainbird, Senior Curator, Tate, London

The range of purchases will be decided by the curators, but the intention is to acquire a selection of major works by young British and international artists. The works chosen will be made public at 6pm on 16 October, the fair's preview day. All works will be selected from the art on display at the Frieze Art Fair, and will be presented to the Tate trustees in November.

The fund has been organised by London collector and Tate patron, Candida Gertler. Candida has raised the fund from a group of both established and new London-based collectors, keen to support Tate's acquisitions of international contemporary art and excited by the new activity the fair has brought to London. The fund will continue at next year's fair.

Sir Nicholas Serota, Director, Tate
Amanda Sharp, Director, Frieze Art Fair
Matthew Slotover, Director, Frieze Art Fair

FRIEZE
ART
FAIR Commissions

Frieze Art Fair Commissions 2003
Bring on the Clowns

'Oh so you would like us to be the clowns?'
gelatin said. So did Lawrence Weiner. Or rather
Lawrence's response to being invited to work on a
project for the Frieze Art Fair was, 'So you would
like me to do the social work?' In the United
Kingdom social workers represent the conscience
of the state; their work has worthy connotations
associated with non-profit do-gooding. At the
circus the clowns are the popular entertainers,
bought in to fool around between acts they disrupt
the monotonous accomplishments of the high-
flying aerialists with ribald humour. '50,000
people! In a tent! Ha ha, this is wonderful!'
laughed gelatin.

Lawrence and gelatin's brutal implication that
they would be employed at the Fair to meld things
together is true, if, as I would propose, being
critical or disruptive – albeit in an officially
sanctioned way – can offer a positive form of
social gelling. There is something insidious built
into the commissioning of 'artists projects' for an
art fair. Hinting as it does at ribbons and bells
being brought in to dress up an otherwise hard
faced commercial enterprise. An event packaged in
such a way as to perpetuate the promotion of art
as just another spectacularly banal extension of the
leisure industry. Such an argument is however way
too simple, presenting an entirely reductive and
naive response to the reality of cultural production
and the manufacture of meaning. To divide the
world into public good – private bad is not even
old fashioned it's just stupid, like you've
been starving in a garrat for the past 20 years or
still believe in divine inspiration. gelatin know
that, so does Lawrence hence their tart responses
and their canny interventions into the game.

All of the artists invited to work on commissions were interested precisely in the inherent contradictions of the art fair context and the peculiar dynamic of the event itself. The blatant rub up of art and economy is the most obvious factor. Competitive showmanship set within an accelerated time frame in a totally synthetic and temporary environment comes a close second. When you don't even have the luxury of solid walls to fall back on you have to think on your feet.

There is a very particular pace to an event of this kind, possessing as it does the semi-hysterical energy and spectacle of the circus subsumed beneath a beautifully designed exterior. In this artificial atmosphere every action is theatricalised and in turn scrutinized; codes of behavior, social hierarchies and rituals are so encoded as to become both ridiculous and unpleasant. But it's not so bad. In its own way, the fair with its curious mix of aesthetic energy and economic exchange is often closer to the heart of artistic production than the sanctified realm of the museum can ever get. The cut and thrust of the art fair brings into sharp focus all the strengths and weaknesses of human endeavour; under this harsh spotlight projected desires and imaginative fictions mingle with economic categorization and temporal reality; individual effort blends with collective appreciation in an immediacy that can be in turn ruthless and generous, disheartening and wonderfully playful.

I have just got off the phone from Jeremy Deller. We've been discussing which image is the most appropriate for his bag project. Jeremy has been photographing the characters who congregate at Speaker's Corner, a spot in London's Hyde Park where people assemble to lecture and rant informally to anyone who cares to listen. Historically a politically charged meeting point, Speaker's Corner has now become a Sunday afternoon tourist attraction. The informality and energy of the presentations still stands. Offering the

cheapest and most direct form of communication and social contact, the performers mingle with the gawkers. The speeches are in turn offensive, absurd and meaningful. Jeremy has two photographs of slighted battered English men wearing placards, one reads 'I have the secret to eternal youth', the other reads 'It can only get worse'. It could go either way. We are all consumers now; it is how you choose to invest your time and how you value the experience that is important here.

Polly Staple
Frieze Art Fair Curator 2003

Projects, talks & events supported by:

CiTYINN
contemporary hotels

Culture 2000

The artists projects and talks programme has been commissioned under the auspices of the Frieze Foundation with the support of Arts Council England and the Culture 2000 programme of the European Union, in association with NIFCA, Helsinki and Bürofriedrich, Berlin.

BüroFriedrich is a non-profit international venue for contemporary art in the centre of Berlin. Opened in Friedrichstraße in 1997, BüroFriedrich is now located among galleries in the S-Bahn arches near Jannowitz Bridge. The program presents art in the context of cultural exchange – both international and interdisciplinary – while promoting collaboration with other venues. Exhibitions, lectures, social gatherings and a project studio program aim to stimulate a dialogue between artists, curators and writers and the public. For more information please visit www.buerofriedrich.org

NIFCA – the Nordic Institute for Contemporary Art – creates opportunities for artists, audiences, curators and critics to enjoy and explore contemporary visual culture in the Nordic countries and internationally. NIFCA's activities range from the organisation of exhibitions and seminars to the production of new artistic works and publications. NIFCA also runs a wide range of residency programmes in the Nordic and Baltic countries and international exchange programmes to Asia and Russia. By connecting Nordic culture with its global context, NIFCA offers a productive environment for reflection on and analysis of contemporary issues. NIFCA is funded by the Nordic Council of Ministers, the body responsible for co-operation between the governments of Denmark, Finland, Iceland, Norway and Sweden, and is situated in Helsinki, Finland. For more information please visit: http://www.nifca.org

ARTS COUNCIL ENGLAND
LOTTERY FUNDED

A&B
Arts & Business
NEW PARTNERS

BüroFriedrich

nifca
NORDIC INSTITUTE FOR CONTEMPORARY ART

UNDERGROUND

Serpentine Gallery

austrian cultural forum[lon]

Participating Artists

gelatin
Paola Pivi
Pawel Ałthamer
The Mobile Cinema
Klaus Weber
Monica Bonvicini
Erik van Lieshout
Erwin Wurm
Johanna Billing
Jeremy Deller
Liam Gillick
Matthew Higgs
Lawrence Weiner

Manege frei!
2003
Poster
Courtesy Galerie Meyer Kainer,
Vienna, Leo Koenig Inc, New York

gelatin
Manege Frei!

'Roll up! Roll up!
The Greatest Show On Earth!
gelatin are coming to London's Frieze Art Fair!
gelatin will be making a lecture: *Manege Frei!*
in the Art Fair Auditorium.
Manege Frei is a German phrase used by
ringmasters to start a circus programme.
What gelatin will be talking about and how they
want our lives to be changed is not yet known.
Anyway, this is a show no one should miss and
will probably be one of the best things to see at
Frieze Art Fair.
Hold tight and bring your friends. They will
love it.'
gelatin, Vienna, August 2003

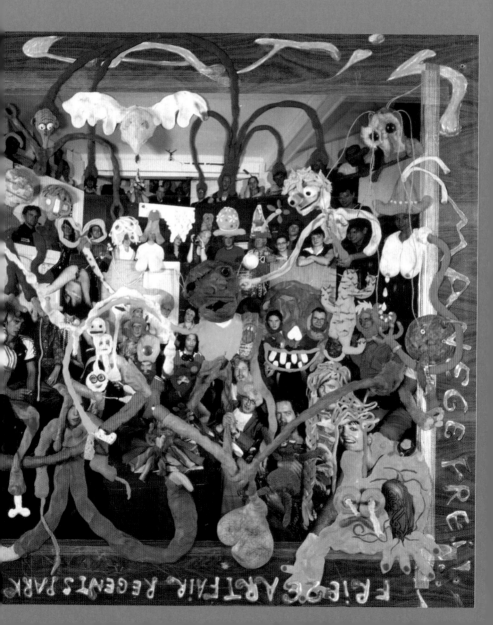

Untitled (Slope)
2003
Drawing
Courtesy the artist

Paola Pivi
Untitled (Slope)

Paola Pivi has been commissioned to make a site-specific interactive sculpture *Untitled (Slope)* (2003). A slope covered in grass turf 4×7×12 m will be built with a gradient sufficient and comfortable enough for Art Fair visitors to roll down at their leisure.

Untitled (Tent)
2003
Drawing
Courtesy the artist and Foksal
Gallery Foundation

Pawel Althamer
Untitled (Tent)

'Warsaw 23 February 2003

Dear Polly,

For the Frieze Art Fair I propose to attach my small, two person tent to the Fair jumbo tent. My tent should be sewn or otherwise attached to the side of the big tent, just round the corner from the entrance to the Fair. There should be an entrance (with a zipper) to the Fair area inside my tent. I will stay in and near the tent during the Fair, also overnight.

Please find enclosed the drawing and please let me know if you like the project and how we should proceed.

Best regards,

Pawel Althamer'

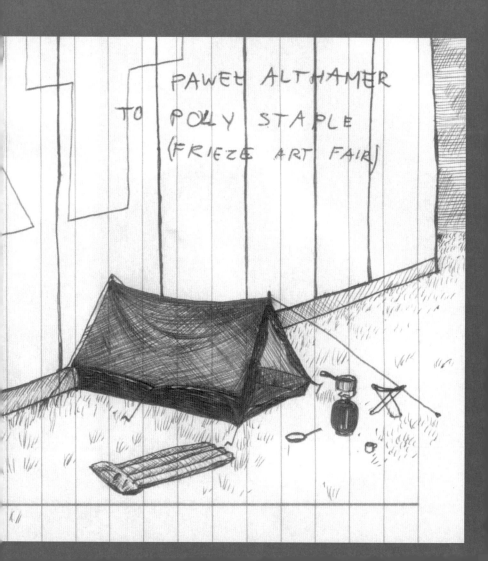

The Mobile Cinema

The 3×3×6m, 30 seat Mobile Cinema was designed and fabricated by the Glasgow based artists group JERKI for 'The Village Hall Roadshow' 2002, a programme of art and film organized by All Horizons Club which toured village halls across the North of England during summer 2002. The Mobile Cinema was subsequently donated to the Liverpool-based White Diamond Projects (www.whitediamond.org) for use as a roving venue for film screenings, slide shows and talks.

A programme of film and video – selected by curators, Dan Fox, Polly Staple, Ian White and White Diamond Projects – is to be screened in conjunction with the talks programme and artists projects.

Public Fountain LSD Hall
2003
Selection of working drawings and
found images
Courtesy the artist

Klaus Weber
Public Fountain LSD Hall

Public Fountain LSD Hall (2003) is a single room
installation consisting of drawings, architectural
sketches, models and documentation of Klaus
Weber's realised and yet to be realised public
sculptures. One of these public sculptures will
form the centrepiece of the installation: a fully
functioning three-tier glass fountain circulating
homœpathic, potentized LSD.

With thanks to Peter Fraser Director of the Institute
of Homœpathy, Dr Erik Kasten, Uli Götz, Julian
Goethe and Delfina, London.

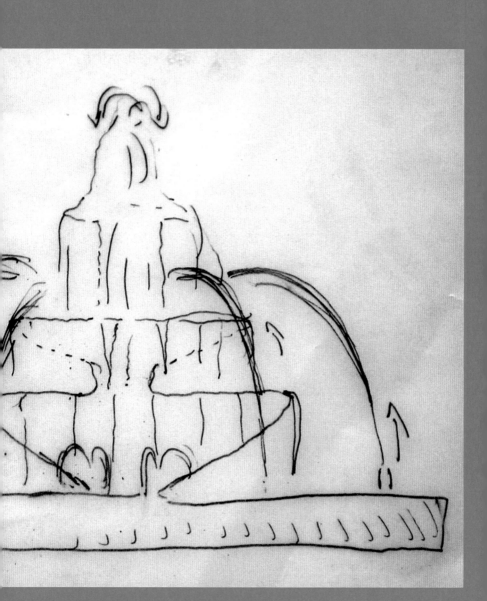

Top
Monica Bonvicini
Stone wall
2002
Galvanized iron, chain, safety glass
Courtesy the artist and Chouakri
Brahms, Berlin

Bottom
Erik van Lieshout
Heimerstein
2003
Installation view, caravan

Monica Bonvicini
Erik van Lieshout

What are the borders of architecture? The works
by Monica Bonvicini and Erik van Lieshout
explore the idea that architecture extends far
beyond a building's walls to demarcate a range
of human practices. Together, the two individual
works investigate how architecture's borders can
enforce notions of normality while separating
different groups of people. Distorting the norm, the
installation unsettles architecture's status as a
practical and aesthetic form of shelter within the
conventional world of commodities.

A BüroFriedrich project.
The work of Erik van Lieshout is produced
in collaboration with Bart van Lieshout.
Commissioners: Stichting de Opbouw,
The Netherlands and SKOR: Foundation for
Art and Public Space, The Netherlands

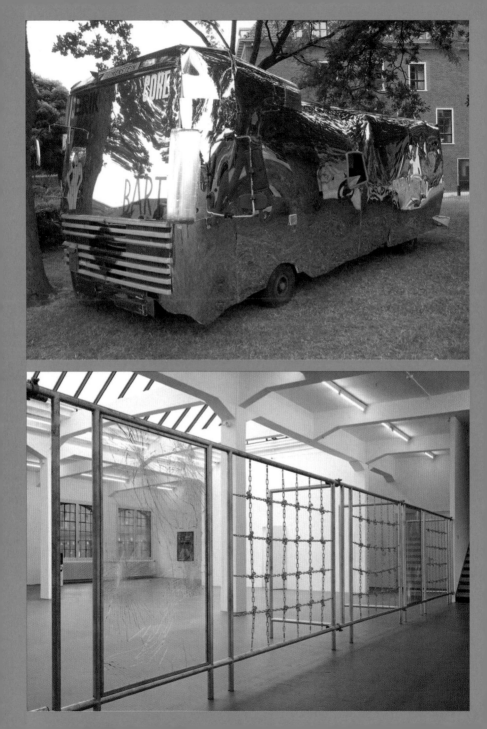

Erwin Wurm
one-minute-sculptures

'A pedestal approx 3×3m×30cm high
painted white.

On the pedestal there are some instruction-
drawings of *one-minute-sculptures* and some
objects which are related to the drawings.

The public is allowed to step on the pedestal and
to realize the sculptures by following the
instructions. While they are holding their position
I make a Polaroid of them. Then I would sign
the Polaroid (with themselves as a one-minute-
sculpture) and they would have an original
work of myself realized by themselves.'
Erwin Wurm, Vienna, July 2003

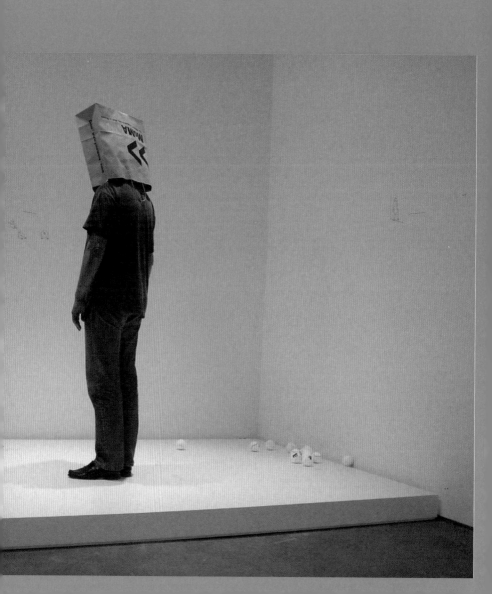

You Don't Love Me Yet
2002–3
Video production still
Courtesy the artist
Photograph: Emanuel Almborg

Johanna Billing
You Don't Love Me Yet

Frieze Art Fair will provide the London venue for
a series of live performances forming part of
Johanna Billing's touring film and live music
project, *You Don't Love Me Yet*. A series of bands will
perform live cover versions of Roky Erickson's 80s
pop song *You Don't Love Me Yet* in the Frieze Art Fair
Auditorium on Saturday 18 October 2003.

'The project commenced in October 2002 with live
performances at INDEX, including more than
twenty participating local bands. Roky Erickson's
song was covered again and again, repeated in a
wide variety of interpretations each reflecting the
participants' own personal style…' Mats
Stjernstedt, INDEX.

Produced in collaboration with INDEX the
Swedish Contemporary Art Foundation and
NIFCA the Nordic Institute for Contemporary Art.
With thanks to Lisa Panting, Milch, London.

Untitled
2003
Photograph
Courtesy the artist

Jeremy Deller
Untitled (Bag) 2003

'I was born, lucky me
In a land that I love
Though I am poor I am free
When I grow, I shall fight
For this land I shall die
Let her sun never set'
Ray Davies, extract from *Victoria* (1968)

Jeremy Deller has been commissioned to make a
limited edition bag to be distributed free to visitors
on the occasion of the Frieze Art Fair.

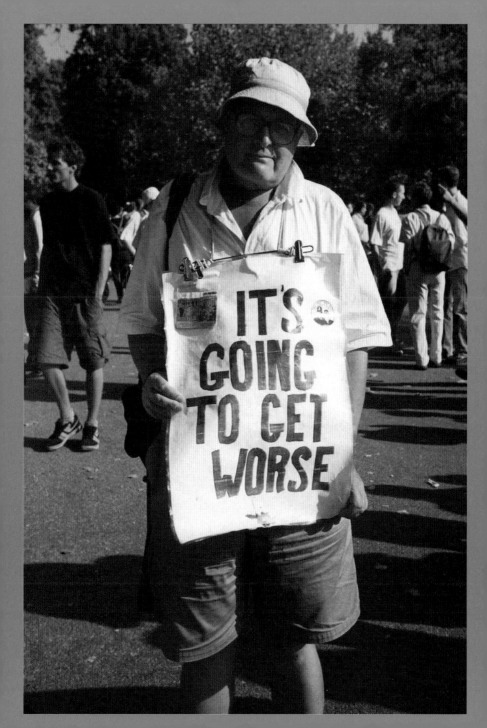

Headache/Phone Card/Soda/
Donuts/Stereo
2003
Five posters for London
Underground
Courtesy the artist and
Corvi-Mora, London

SODA

[Interior, day, a
library. People are
studying, it's pretty
quiet. A chair is
being slid back and
then we hear steps.]

[Man, now in front of
soda machine, has
realized he doesn't
have enough
change, turns around
hoping for help.]

Man
Somebody have
any...

Voice
Shhh!

Liam Gillick
Headache/Phone Card/
Soda/Donuts/Stereo

Liam Gillick has created a set of posters to be
displayed in unused spaces at Great Portland
Street Underground station (26 September
2003–9 January 2004). A project commissioned
in conjunction with London Underground
'Platform for Art'.

Gillick has established a reputation for his interest
in the grey areas where architecture, design and
art intersect. For Great Portland Street
Underground station Gillick has produced a series
of related posters featuring simple typography,
strong pattern and colours. The work makes use of
transcripts from non-specific television advertising –
placing the structure of one communication
medium into another. The structure of the message
overwhelms the product and we are left to reflect on
the potential of narrative and presentation.

Lawrence Weiner
Towards A Theatrical Engagement
Statement
2003
Courtesy of the artist

Matthew Higgs &
Lawrence Weiner
20 Questions

'The standard format of a one-to-one interview
invariably reveals as much about the subjectivity
of the interviewer as it does about the interviewee.
In an attempt to democratize – or dissolve – the
role of the interrogator, and to hopefully broaden
the interview's remit, I propose to invite 20
individuals who have had some kind of
relationship with Lawrence Weiner (or his work)
to each pose a single question, which will be used
as the basis for a conversation between myself and
Lawrence. The idea, ultimately, is to create – or
reveal – an informal community of inquiry around
Lawrence and his work.'
Matthew Higgs, San Francisco, 29 July 2003

TOWARDS A THEATRICAL ENGAGEMENT

ALL INTELLECTUALLY DETERMINED ACTIVITY IS THEATRICAL.
EACH ACTION MUST & DOES HAVE CONSEQUENCE.

IF & WHEN A PRESENTATIONAL SITUATION CANNOT ACCOMODATE BY
VIRTUE OF SELF PROTECTION (CONFLICT OF BASIC IDEOLOGIES) A NECESSITY
THE NECESSITY MUST THEN ERECT A STRUCTURE CAPABLE OF SUPPORTING ITSELF.
WHATSOEVER SUPPORT IS FOUND CAPABLE BECOMES IN EFFECT LEGITIMATIZED.
THE DIALECTIC CONCLUDES AS THE SYSTEM OF SUPPORT CHANGES.

WITH THE SETTING OF A STAGE FOR PRESENTATION IT & EVERY OTHER
MISE-EN-SCENE BY VIRTUE OF THE ASSEMBLED MASS CONSPIRE TO
CONSTRUCT AN AMBIANCE.
THE AMBIANCE IS IN FACT A MATERIAL REALITY
(MEANING)
WHICH IS THE POINT OF THE OPERATION.

LAWRENCE WEINER
NYC, 1960-2003

FRIEZE ART FAIR Artists

Franz **Ackermann**

Born 1963
Lives Berlin

Franz Ackermann's Mental Maps are like taking a peek inside the brain of someone trying to make sense of, and blend in with, foreign environments. Since 1992 he has been making these drawings while on his extensive journeys. They are like hungry whirls, spitting out conflicting representations of the world: streets look like nerves, sports stadiums like blood cells. In Ackermann's large-scale paintings the dense hum of the drawings becomes an irritating buzz: grey fragments of cityscapes sprout rainbow-coloured petals and ribbons. When the painterly work is integrated into his elaborate installations – as at the Kunsthalle Basel or Stedelijk Museum, Amsterdam – you think you are looking at the world through a microscope and binoculars at the same time. (JöH)

Represented by Galeria Fortes Vilaça F9, GBE (Modern) D5, Mai 36 Galerie D12, Giò Marconi C14, Meyer Riegger Galerie B7, neugerriemschneider C6, Parkett Editions H5, White Cube F6

Selected Bibliography

2003 *Away from Home*, Wexner Center for the Arts, Ohio State University, Columbus
Eine Nacht in den Tropen (A Night in the Tropics), Kunsthalle Basel

2002 'Travelling Light', Jörg Heiser, *frieze*, issue 66, April

2001 'Franz Ackermann', Marco Meneguzzo, *Artforum*, April
'Franz Ackermann', Tiziana Conti, *Tema Celeste*, 83, January–February
'Franz Ackermann', Raimar Strange, *Artist Kunstmagazin*, issue 4

Selected Exhibitions

2003 'Phantom der Lust' (Phantom of Desire), Neue Galerie am Landesmuseum Joanneum, Graz
Kunsthall, Bergen

2002 'Black Low', M.art.A, Herford, Bielefeld
'Interface to God', Kunsthalle zu Kiel
Galleria d'Arte Moderna, Bologna

2001 Galerie Krinzinger, Vienna

2000 Lyon Biennale
'Civil Disobedience', Sammlung Falckenberg, Kestner Gesellschaft, Hanover

1999 'Moon over Islam', Stedelijk Museum for Aktuelle Kunst, Ghent
'Umfeld, Umwelt' (Surrounding, environment), Palais des Beaux Arts, Brussels

1998 Manifesta 2, Luxembourg
São Paulo Biennale
'Soft Core Arkipelag TV', Historical Museum, Stockholm

Scenographer's Mind V
2002
2 colour prints, mounted, framed
as a set, with hand-coloured matte,
Edition of 10 + 2 AP
Frame: 118×180cm
Courtesy Parkett Editions

Selected Bibliography

2003 *Eija-Liisa Ahtila: Fantasized Persons and Taped Conversations*, Museum of Contemporary Art, Kiasma, Tate Modern, London

2002 *Documenta: Platform 5*, Daniel Birnbaum, Museum Fridericianum, Kassel

2001 *Women Artists in the 20th and 21st Century*, Taschen, Cologne

1999 'Realities – Eija-Liisa Ahtila's Human Dramas', Beatrix Ruff, *Parkett*, 55

1998 'Points of View, Daniel Birnbaum on Eija-Liisa Ahtila', *frieze*, 40, May

Selected Exhibitions

2003 De Appel, Amsterdam Museum of Contemporary Art, Dallas

2002 Dundee Contemporary Arts 'Fantasized Persons and Taped Conversations ' Kunsthalle, Zurich; Tate Modern, London and touring Klemens Gasser & Tanja Grunert, Inc., New York Documenta, Kassel

2000 Neue Nationalgalerie, Berlin

1999 Salzburger Kunstverein Kunst-Werke, Berlin Museum of Contemporary Art, Chicago

Eija-Liisa **Ahtila**

Born 1959
Lives Helsinki

There is an air of boreal enchantment to Eija-Liisa Ahtila's multi-channel video installations. Ahtila is fast becoming Finland's best-known contemporary artist, her renown built on a decade of work characterized by seemingly conventional cinematic melodramas that subvert causative logic and narrative continuity. In Ahtila's universe, everyday life is an unstable medium, suffering constant psychic slippages. Separate versions of reality vie for dominance, stumbling and overlapping in a circular, upside-down form of storytelling that is closer to the process by which we carefully burnish our faulty memories and unfulfilled wishes than 'straight' cinema ever aspires to be. (JT)

Represented by Marian Goodman Gallery C8, Parkett Editions H5, Anthony Reynolds Gallery D3

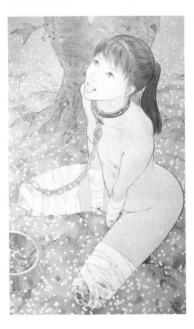

DOG *(Flower)*
2003
Japanese paper, mineral pigment,
acrylic on panel
100×69cm
Courtesy Mizuma Art Gallery

Selected Bibliography

2003 *7th Kitakyushu Biennale:Art For Sale*, Kitakyushu Municipal Museum of Art, Fukuoka

2002 *Misoji-La Trentaine de Makato Aida*, ABC Shuppan Co. Ltd

1999 *Lonely Planet*, Danvo. Co.Ltd
Mutant Hanako, Makato Aida, ABC Shuppan Co. Ltd

1996 *Adolescence and Perversion, Makato Aida*, ABC Shuppan Co. Ltd

Selected Exhibitions

2003 'American Effect, A Look at how America is Seen by Artists Around the World', Whitney Museum of American Art, New York

2002 'Edible Artificial Girls, Mi-Mi Chan', Murata&friends, Berlin
'BABEL2002,' National Museum of Contemporary Art, Seoul

2001 'Mega Wave-Toward a New Synthesis', International Triennale of Contemporary Art, Yokohama

2000 'Five Continents And One City', Museum of Mexico City

1999 'Ground Zero Japan', Contemporary Art Gallery, Art Tower Mito, Ibaraki

1999 'Doutei', Mitsubishi-Jisho Artium, Fukuoka

1998 'Paris, Tsudanuma', Mizuma Art Gallery, Tokyo

1996 'No Future', Mizuma Art Gallery, Tokyo

Makoto **Aida**

Born 1965
Lives Tokyo

In one of Makoto Aida's paintings Hokusai's famous print of an octopus pleasuring a fisherman's wife is dragged grotesquely into the Godzilla age. Post-orgasmic in a sci-fi helmet, a gigantic girl sprawls across a crushed city, tentacles snaking from her every aperture. Such profaning of canonical Japanese culture also occurs in Aida's pictures of teenage amputees, which employ the Nihonga painting technique as an instrument of dark eroticism. But if his painterly samplings drip with priapism, they also have a political dimension. Visiting perverse, Pop-cultural modernity on traditional forms, Aida's images have all the force and terrible beauty of a precision-guided bomb. (TM)

Represented by Mizuma Art Gallery C13

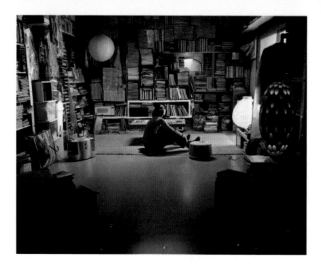

New Skin
2002
Video installation film still
Courtesy Victoria Miro Gallery

Selected Bibliography

2003 *Doug Aitken A–Z Book (Fractals)*, Hatje Cantz; Fabric Workshop and Museum, Philadelphia; Kunsthalle, Zurich

2002 *Doug Aitken, New Ocean*, Tokyo Opera City Cultural Foundation

2001 *Doug Aitken*, Phaidon, London
New Ocean, Serpentine Gallery, London

1999 'Doug Aitken, The "Stalker" of this Fin de Siècle', Christine van Assche, *Parkett*, 57

Selected Exhibitions

2003 'Doug Aitken', Kunsthalle, Zurich

2002–3 'Rise', Magasin, Centre d'Art Contemporain, Grenoble
'Interiors', Fabric Workshop and Museum, Philadelphia
'Rise', Louisiana Museum, Humlebaek

2001–3 'New Ocean', Serpentine Gallery, London; Tokyo Opera City Gallery; Fondazione Sandretto Re Rebaudengo, Turin; Kunsthaus Bregenz

'Metallic Sleep', Kunst Museum, Wolfsburg; Kunst-Werke, Berlin

2000 'Glass Horizon', Secession, Vienna

Doug **Aitken**

Born 1968
Lives Los Angeles

In Doug Aitken's work traditional concepts of landscape collapse like deckchairs. The relation between 'subject' and 'context', 'open' and 'confined' becomes inverted. Historically these oppositions have been reinforced or even created by views from the windows of coaches and aeroplanes, and through cameras; more recently, drugs, music and video games have radically warped them again. From *Electric Earth* (which won the International Prize at the Venice Biennale 1999) to his recent *Interiors* (featuring rapper André Benjamin from Outkast) Aitken's multi-screen architectural environments raise questions about how the perception of space interlocks with technology. (JöH)

Represented by 303 Gallery C12, Taka Ishii Gallery G9, Victoria Miro Gallery F4, Galerie Eva Presenhuber D7, Gallery Side 2 H10

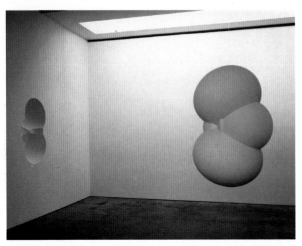

Selected Bibliography

2001 *Projects 74: Ricci Albenda*, Laura Hoptman, Museum of Modern Art, New York
the americans. new art, Booth-Clibborn Editions, London (text font designed by Ricci Albenda)
Casino 2001, Jeanne Greenberg Rohatyn, Lars Bang Larsen, Libby Lumpkin, Midori Matsui, Saul Anton and Andrea Scott, SMAK, Ghent

2000 *Glee*, Aldrich Museum of Contemporary Art, Ridgefield
Elysian Fields, Centre Georges Pompidou, Paris,

Ricci **Albenda**

Born 1966
Lives New York

Like Kurt Schwitters with his *Merzbau*, Brooklyn-born Ricci Albenda sees sculpture as a total environment. Not merely something adorning the wall, it is the wall. Satisfying many of the particular demands of architecture, sculpture and design, his svelte, whitewashed Minimalist surfaces dimple, blister and inflate in cupped swales like the subdividing interiors of soap bubbles blown from a soda straw. The wall reliefs or 'portals' – often paired with crisply painted text fragments rendered in acute perspective – owe something to tripped-out sci-fi fantasies involving geometrically mushrooming multiverses, and at times appear poised to suck text, gallery wall, and adjoining areas suddenly down a minute wormhole. At other times they suggest separated male and female counterparts which, were they ever to meet, would come to rest together as naturally as a walnut nests within its shell. (JT)

Represented by Andrew Kreps Gallery B10

Selected Exhibitions

2003 'The Moderns', Castello di Rivoli, Museo d'Arte Contemporanea, Turin

2002 'Out of Site', New Museum of Contemporary Art, New York

2001 'the americans. new art', Barbican Art Gallery, London
'Casino 2001', SMAK, Ghent
'Tesseract', Andrew Kreps Gallery, New York
'Projects 74: Ricci Albenda', Museum of Modern Art, New York

2000 'Ricci Albenda', Van Laere Contemporary Art, Antwerp

1999 'Spectral Paintings from COLOR-I-ME-TRY', Van Laere Contemporary Art, Antwerp

1999 'The Wave/Particle Project + Portals to Other Dimensions', Andrew Kreps Gallery, New York

1999 'Particles', Avalanche, New York

Playground Bródno-Warsaw
2003
Photo: Michał Woliński
Courtesy Foksal Gallery Foundation

Selected Bibliography

2002 'The Annotated Ałthamer',
Adam Szymczyk, 'Looking Back
without Being Able to See', Martin
Prinzhorn, *Afterall*, May
'Requiem for a dream', Francesco
Bonami, interview, *Flash Art*,
March–April

1997 *Spaceman*, Andrzej Przywara,
Pawel Ałthamer, Kunsthalle Basel
'A Seemingly Innocent Subversion
of Reality', Adam Szymczyk,
SIKSI, Summer

1996 *Air Conditioning*, Adam
Szymczyk, Andrzej Przywara
interview, Pawel Ałthamer, Foksal
Gallery Foundation, Warsaw

Selected Exhibitions

2003 The Wrong Gallery, New
York
neugerriemschneider, Berlin
Venice Biennale

2002 'Ausgeträumt...' (Dreams
Stopped), Secession, Vienna

2001 Foksal Gallery Foundation,
Warsaw
Museum of Contemporary Art,
Chicago

2000 Manifesta 3, Ljubljana
'Bródno 2000' (public project),
Warsaw

1997 Kunsthalle Basel
Documenta, Kassel

Pawel **Ałthamer**

Born 1967
Lives Warsaw

'People look strange when you're a stranger'
might be a chorus reverberating throughout Pawel
Ałthamer's work. He has perfected the art of
inserting into quotidian life alien elements that create
disturbing fissures. In his performance pieces he has
(among other things) instructed actors to perform
everyday activities in a busy public square, invited
everybody in the telephone book named Ałthamer to
join him for a formal reception, and asked homeless
people in Warsaw to wear badges of the *Observator*
newspaper and continue their job as silent observers
of ordinary events with an official mandate.
Ałthamer turns daily life into a play with one actor
too many on stage, whose presence is never
explained. (JV)

Represented by Foksal Gallery Foundation B2,
neugerriemschneider C6

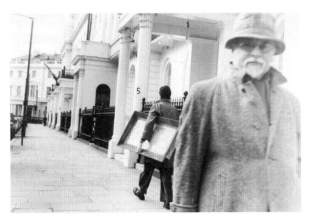

Walking a Painting
London, January 2000
Trial for LA, April 2002
Courtesy Lisson Gallery

```
- a painting* is hung on the museum ** wall.
- as the museum opens its doors, the carrier takes the
painting off the wall and walks the painting through
the city.
- as night and closing time approach, the carrier
brings the painting back to the museum, hangs it on the
wall and covers it with a veil for the painting to sleep.
- the same actions are repeated the following day.
```

Selected Bibliography

2003 *The Prophet and the Fly*, ed
Catherine Lampert, Centro
Nazionale per l'Arte
Contemporanea, Rome

2001 *Francis Alÿs, Cuauhtemoc
Medina, Thierry Davila and Carlos
Basualdo*, Musée Picasso, Antibes

1999 *Francis Alÿs – The Last Clown*,
David G. Torres, Cuauhtemoc
Medina and Mario Flecha,
Fundacio La Caixa, Barcelona

1998 *Le Temps du sommeil*, Kitty
Scott, Contemporary Art Gallery,
Vancouver

1997 *Walks/Paseos*, Francis Alÿs,
Ivo Mequita and Bruce Ferguson,
Museo de Arte Moderno, Mexico
City

Francis **Alÿs**

Born 1959
Lives Mexico City

Francis Alÿs lives in Mexico City and his multi-media work explores the ways in which the artist – and by association other people and animals – interact with an environment or idea, be it a city, the art world, or a piece of writing. Alÿs' point of departure is often one of his well-known 'walks'. These might include a stroll taken while unravelling a sweater; another accompanied by a leaking can of blue paint; a short promenade with a loaded gun, or pushing a melting block of ice through the steamy streets of Mexico City. These actions have been manifested in films, photographs and numerous paintings, many of which are peopled with various 'types' from the collector to the thief. (JH)

Represented by Galerie Yvon Lambert D16,
Lisson Gallery B4

Selected Exhibitions

2003 'Francis Alÿs, Obra Pictorica,
1992–2002', Centro Nazionale per
l'Arte Contemporanea, Rome;
touring to Kunsthaus Zurich; Reina
Sofia, Madrid
'When Faith Can Move Mountains',
project for Lima Biennale

2002 'The Modern Procession',
MoMA, Queens
'Francis Alÿs', Kunst-Werke, Berlin

2001 'Francis Alÿs', Musée Picasso,
Antibes
'The Ambassador', Venice Biennale

2000 'The Last Clown', Sala
Moncada, Fundacio La Caixa,
Barcelona; Lisson Gallery, London,
and touring

1998 'Le Temps du sommeil' (The
Time of Dreams), Contemporary
Art Gallery, Vancouver

1997 'The Liar, The Copy of the
Liar', Museo de Arte Moderno,
Mexico City

Orange Dormeux
(Orange Sleepers)
2002
Acrylic, gel medium and
embroidery on canvas
95×105cm
Courtesy Gagosian Gallery

Selected Bibliography

2002 *Ghada Amer*, Andrew Renton,
Gagosian Gallery, New York
Ghada Amer, Sahar Amer and Olu
Oguibe, De Appel, Amsterdam

2001 *Ghada Amer: Reading Between
the Threads*, Henie Onstad
Kunstsenter, Oslo

2000 *Ghada Amer: Intimate
Confessions*, Nehama Guralnik and
Mordecha Omer, Tel Aviv Museum
of Art

1998 *Ghada Amer: Critical Stands*,
Candice Breitz

Selected Exhibitions

2003 'Ghada Amer', De Appel,
Amsterdam

2002 'Ghada Amer', Gagosian
Gallery, London
'Works by Ghada Amer', San
Francisco Art Institute

2001 'Encyclopedia of Pleasure',
Deitch Projects, New York
'Ghada Amer: Pleasure',
Contemporary Arts Museum,
Houston
'Reading between the Threads',
Henie Onstad Kunstsenter, Oslo;
Kunst Palast, Dusseldorf;
Bildmuseet, Umeå

2000 'Intimate Confessions',
Tel Aviv Museum of Art

1999 'Ghada Amer', Centro
Andaluz de Arte Contemporáneo,
Seville

1996 Annina Nosei Gallery,
New York

1990 Villa Arson, Nice

Ghada **Amer**

Born 1963
Lives New York

Ghada Amer makes use of the exploitative visual
language that proliferates in pornography and
romantic fiction. She embroiders porn imagery and
texts by hand on to canvases in which profiles of
women in erotic poses are repeated like ornaments.
The result is an intricate maze of overlapping
coloured strings interwoven with a world of bodily
organs. In the process of working through the
material expropriated from the male-dominated sex
industry Amer invents her own erotic alphabet, in
which obscenity and intimacy exist side by side.
Amer's analysis of the patriachal order of sexual
representation seems driven by an ongoing
fascination with the object of her critique as she
probes it again and again with the tip of her needle.
(JV)

Represented by Gagosian Gallery F7

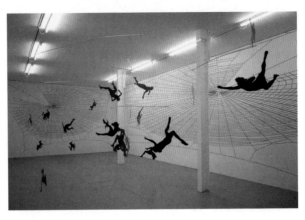

A Place for an Imaginary Friend
2003
3 mobiles and vinyl
Courtesy Yvon Lambert

Carlos **Amorales**

Born 1970
Lives Amsterdam/Mexico City

The work of Mexico-born, Amsterdam-based Carlos Amorales draws on two givens of contemporary Mexico: maquiladoras (sweatshops) and wrestling. Amorales has interlaced these in various performances since 1997, most famously *Amorales vs. Amorales* (1999), documenting staged fights between professional wrestlers wearing masks of the artist's features. Recent installations of ersatz maquiladoras have broadened the perspective by inviting viewers to piece together items such as a pair of boots, and thus temporarily exchange their identity for that of a factory worker – a trip to the bottom rung of a celebrity-obsessed economy that strips its subjects of their sense of self. (MH)

Represented by Galerie Yvon Lambert D16

Selected Bibliography

2002 *Mexico City: An Exhibition about the Exchange Rates of Bodies and Values*, Klaus Biesenbach, PS1, New York

2001 *... los Amorales,* Patricia Ellis, Cuauhtemoc Medina, Philippe Vergne, Rein Wolfs, Carlos Amorales, Stichting Artimo, Amsterdam
'The Fear of Returning and being Misunderstood', Michèle Faguet, *Parachute*, 104
Berlin Biennale 2, Oktagon, Cologne

2000 *Let's Entertain*, Walker Art Center, Minneapolis

Selected Exhibitions

2003 'The Bad Sleeps Well', Galerie Yvon Lambert, New York
Performance at the San Francisco Museum of Modern Art
'Amorales vs Amorales', Tate Modern, London
'Stage for an Imaginary Friend', Galerie Yvon Lambert, Paris
'Devil Dance', Boijmans van Beunigen, Rotterdam
'We Are the World', Dutch Pavilion, Venice Biennale
'M_ARS', Kunstverein, Graz

2002 'Mexico City: An Exhibition about the Exchange Rates of Bodies and Values', PS1, New York; Kunst-Werke, Berlin

2001 'Cabaret Amorales', Migros Museum für Gegenwartskunst, Zurich

2000 'Let's Entertain', Walker Art Center, Minneapolis and touring
'Au Delà du Spectacle', Centre Georges Pompidou, Paris

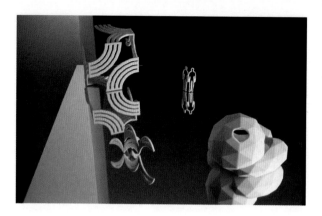

Neen World 02
2003
4 stereolithic 3D-prints, stand, mirror
122×50×50cm
Courtesy The Breeder Projects

Selected Bibliography

2003 'Under Construction', Carole Sabbas, *MIXT(E)*, June

2002 'La Maison Dehors-Dedans', Yi Zhou, *Blast*, August

2000 'Verkligheten blir abstract', N. Gunne, *Arkitekten*, May

1999 'One to Watch', Richard Pandiscio, *Interview*, August

1995 'Illegal Ideal', M. Manetas, V. Beecroft, *Purple Prose #9*, Summer

Selected Exhibitions

2003 The Breeder Projects, Athens

2002 'Inside Out', Analix, Geneva 'Outside-In', Forever Laser Institut, Geneva

2001 'Myself', Visionaire Gallery, New York

1994 'Second City', Magasin, Centre d'Art Contemporain, Grenoble

Andreas **Angelidakis**

Born 1968
Lives New York

A large amount of our time is spent in front of screens. Day-to-day activities, whether conducting business or emailing friends, are reliant on computer interfaces – those friendly icons and pictograms that enable us to steer our machines through their tasks. Andreas Angelidakis' architectural practice creates spaces and buildings that inhabit our material world in the way a screen object would. *TeleportDiner* (2003), for instance, involved the recreation of a Brooklyn diner – first in virtual form, with a physical replica of the online version then being rebuilt in Stockholm. Most recently he has developed a playground in Armenia based on the computer game Tetris. (DF)

Represented by The Breeder Projects H11

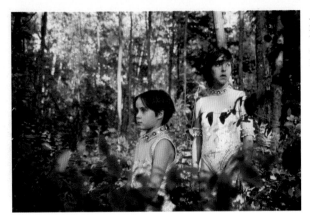

Angels Camp
2003
Video installation
Courtesy the artist and Galerie Eva
Presenhuber

Emmanuelle **Antille**

Born 1972
Lives Lausanne

Emmanuelle Antille notes that a trip to Death Valley inspired *Angels Camp*, premiered at the Swiss Pavilion of the 2003 Venice Biennale. Slow-motion rock by the band Honey for Petzi accompanied the multi-screen projection of scenes set in a swampy landscape: rituals of love and rejection, protagonists scuffling and tussling, barking like dogs. One is immediately reminded of the famous desert love scene in Antonioni's *Zabriskie Point* (1970); searching for the right soundtrack, the director had Pink Floyd, Jerry Garcia and John Fahey record hours of material, most of which was rejected. It's as if Antonioni's expensive failure had been transposed into the contemporary language of Antille's films: mysteriously coded, yet straightforwardly suggestive. (JöH)

Represented by Galerie Eva Presenhuber D7

Selected Bibliography

2003 *50th Venice Biennale, Angels Camp*, Amsterdam
Angels Camp, First Songs, Four short stories based on the Angels Camp screenplay, Amsterdam

2001 Kiss and Shoot–Tunes For Films And Dance, Emmanuelle Antille, Amsterdam (with audio CD)

2000 *Radiant Spirits. Les Ames Soeurs*, Migros Museum für Gegenwartskunst, Zurich
Pulsions, Attitudes/Centre Culturel Suisse, Paris, Geneva

Selected Exhibitions

2003 'Angels Camp', Swiss Pavilion, Venice Biennale
'Angels Camp', Renaissance Society, University of Chicago

2002 'As deep as our sleep, as fast as your heart', Contemporary Art Centre, Vilnius

2001 'As deep as our sleep, as fast as your heart', Galerie Hauser & Wirth & Presenhuber, Zurich
'Night for Day', Art Unlimited, Art Basel
'Wouldn't it be Nice', Extra Muros/Fri-Art, Fribourg

1999 Kunsthaus Glarus
'Change is Good', Museum Fridericianum, Kassel

1998 Attitudes, Geneva

1996 Low Bet, Geneva

Umbilical
2000
Sterling silver cast of family
silverware and negative impression
of artist's mouth and mother's hand
8×20×8cm
Courtesy Luhring Augustine

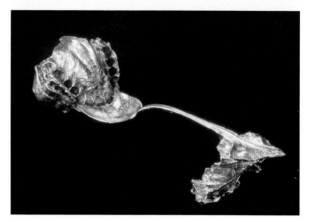

Selected Bibliography

2001 *The Girl Made of Butter*, Janine
Antoni, Aldrich Museum of
Contemporary Art, Ridgefield

2000 *Janine Antoni*, Ink Tree
Editions, Künstnacht

1999 *Art at the Turn of the Millenium*,
ed Burkhard Riemschneider and
Uta Gosenick, Taschen, Cologne
*Regarding Beauty: A View of the Late
Twentieth Century*, Hirshhorn
Museum and Sculpture Garden,
Washington DC; Haus der Kunst,
Munich

1998 *Cream – Contemporary Art in
Culture*, Phaidon, London

Selected Exhibitions

2002–3 'Taught Tether Teeter',
Site Santa Fe

2002 'Moving Pictures',
Guggenheim Museum, New York

2001 'Public Offerings', Museum of
Contemporary Art, Los Angeles
'The Girl Made of Butter', Aldrich
Museum of Contemporary Art,
Ridgefield

2000 'Open Ends: Minimalism and
After', Museum of Modern Art,
New York

1999 'Imbed', Luhring Augustine,
New York
'Swoon', Whitney Museum of
American Art, New York

1996 'Janine Antoni/Matrix 129',
Wadsworth Atheneum, Hartford

1996 The Hugo Boss Prize,
Guggenheim Museum Soho,
New York

1995 'Slip of the Tongue', Centre
for Contemporary Arts, Glasgow
and touring

Janine **Antoni**

Born 1964
Lives New York

Of her seminal 1992 work *Gnaw*, Janine Antoni
commented, '[I] decided that rather than describing
the body, I would use the body, my body, as a tool
for making art.' In the decade since, her body has
acted as a sculptural implement for probing weak
spots in previously unquestioned art-historical
narratives. Traces of Antoni's corporeal actions –
licking, scrubbing, biting, rubbing – don't always
fit the neat cubbyholes of gender or identity art, and
her fusion of Naumanesque Process art with feminist
theory and ritualized performance increasingly
focuses on personal familial relationships and
private compulsions. (JT)

Represented by Luhring Augustine D10

A Contented Skull
2003
Chromogenic print
138×286cm
Courtesy Blum & Poe and
Kaikai Kiki

Chiho **Aoshima**

Born 1974
Lives Tokyo

Chiho Aoshima's large-format digital illustrations
are populated by wide-eyed nymphets and curious,
hybrid vegetation, of a type familiar to consumers of
Japanese manga and anime. An assistant at Takashi
Murakami's Hiropon factory, Aoshima is well versed
in the candy-coloured, commercially savvy style
known as 'Superflat', but her work hints at a dark side
to all those winking eyes and happy mushrooms.
Aoshima's vulnerable waifs appear melancholy,
threatened and occasionally menacing, at odds with
the spectacular landscapes they inhabit. As written
in *frieze*, 'Aoshima's fantasies transcend oppressive
earthly conventions such as perspective and gravity,
creating an atmosphere of utter artificiality that
borders on the sublime.' (KR)

Represented by Blum & Poe D9

Selected Bibliography

2002 'Chiho Aoshima', Zoey
Mondt, *frieze*, 67, May
'Trouble Creeps into Paradise',
David Pagel, *Los Angeles Times*,
15 February 2002

2001 'Plumbing the Depth of
Superflatness', Michael Darling, *Art
Journal*, Spring
'Oops, I Dropped My Dumplings',
Susan Kendel, *Artext*, 73, May–July

2000 *Superflat*, Madra Publishing
and Takashi Murakami, Tokyo

Selected Exhibitions

2003 Berkeley Art Museum,
University of California
'For the Record: Drawing
Contemporary Life', Vancouver
Art Gallery
'SAM Collects: Contemporary Art
Project', Seattle Art Museum

2002 Liverpool Biennial,
Tate Liverpool
Blum & Poe, Santa Monica
'Coloriage', Fondation Cartier pour
l'Art Contemporain, Paris

2001 'Superflat', Museum of
Contemporary Art, Los Angeles,
touring to Walker Art Center,
Minneapolis; Henry Art Gallery,
Seattle

1999 'Tokyo Girls Bravo', Nadiff,
Tokyo and George's, Los Angeles

Memoirs of Hadrian #17
2002
Unique polaroid
86.5×56cm
Courtesy CRG Gallery

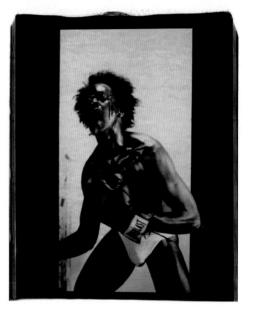

Selected Bibliography

2003 *Lyle Ashton Harris,* Anna
Deavere Smith, Gregory Miller &
Company and CRG Gallery,
New York
*The Squared Circle: Boxing in
Contemporary Art*, Walker Art
Center, Mineapolis

1999 'The Sublime, The
Grotesque, The Epic: Lyle Ashton
Harris interviews Cindy Sherman,'
Lyle Ashton Harris, *aRude*

1998 'Black Widow,' *The Passionate
Camera*, ed Deborah Bright,
Routledge, New York

1997 *Black Art and Culture in the 20th
Century*, Richard Powell,
Thames & Hudson Ltd, London

Selected Exhibitions

2003 CRG Gallery, New York
'The Squared Circle: Boxing in
Contemporary Art', Walker Art
Center, Mineapolis

2002 'New Work', Baldwin
Gallery, Aspen

1999 '20x24', Aldrich Museum of
Contemporary Art, Ridgefield
'Distillation', Galerie Analix
Forever, Geneva

1998 'Alchemy', in collaboration
with Thomas Allen Harris, New
Langton Arts, San Francisco
touring to Corcoran Gallery of Art,
Washington, DC

1997 'The White Face Series',
Thomas Erben Gallery, New York

1996 'The Watering Hole', Jack
Tilton Gallery, New York
'Select Photographs', Centro de
Arte Euroamericano, Caracas

1994 'The Good Life', Jack
Tilton Gallery, New York
'Redemption', Schmidt
Contemporary Art, St. Louis

Lyle **Ashton Harris**

Born 1965
Lives New York

Photographer and installation artist Lyle Ashton
Harris juggles multiple identity politics – striking
erotic poses before symbols of African history
spirituality, re-creating the scene of Jeffrey Dahmer's
cannibalism of young black men, wallpapering the
gallery with images of himself masturbating.
Featured in the Whitney's landmark 1995 group
show 'Black Male', Harris was a graduate of the
museum's respected Independent Study Program.
A self-styled 'redemptive narcissist', he takes a page
from Robert Mapplethorpe for his polished but in-
your-face portraiture. (KR)

Represented by CRG Gallery F8

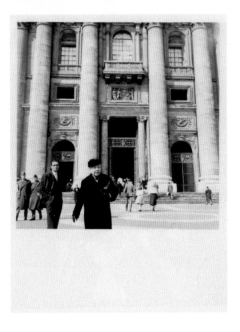

The **Atlas** Group/ Walid Raad

Born 1967
Lives New York

Walid Raad refers to his Atlas Group as an 'imaginary foundation' – a more or less fictional organization engaged in a fittingly Borgesian sort of archival research. The group – or Raad speaking in the voice of the group – chronicles the recent history of Lebanon: its brutal civil wars and the way these struggles have intersected with daily life and shaped modes of representation. In lectures, texts, videos and photographs invented characters offer testimony and present cryptic relics – surveillance videos redirected to sunsets, for example, or notebooks portraying every vehicle used as a car bomb in the 1980s. A provocative conceit, the Atlas Group adopts and deforms the voice of authority in order to speak of those moments that official history occludes. (SS)

Represented by Anthony Reynolds Gallery D3

Selected Bibliography

2003 'Mapping the Disaster', Deborah Root, *Prefix Photo*, May

'Missing in Action', Lee Smith, *Artforum*, February
'A Secret History', Saul Anton, *frieze*, 72 , January–February

2002 'Forging History, Performing Memory', Sarah Rogers, *Parachute*, October
'Walid Raad', Alan Gilbert, *Bomb*, Fall

Selected Exhibitions

2003 Anthony Reynolds Gallery, London
Venice Biennale
World Wide Video Festival, Amsterdam
'Witness', Barbican Centre, London

2002 Documenta, Kassel
Whitney Biennial, Whitney Museum of American Art, New York
Witte de With, Rotterdam
Fundacio Antoni Tapies, Barcelona
Migros Museum für Gegenwartskunst, Zurich

Untitled
2001
Oil on canvas
55×75cm
Courtesy Galerie Barbara Weiss

Selected Bibliography

2002 'Smoke Gets in your I.
Monika Baer in der Galerie
Barbara Weiss, Berlin', Clemens
Krümmel, *Texte zur Kunst*, 47,
September
'Monika Baer. Galerie Barbara
Weiss', Dominic Eichler, *frieze*, 69,
September

1998 *Damenwahl. Monika Baer,
Paul McCarthy*, ed Siemens
Kulturprogramm, Munich and
Portikus, Frankfurt
Monika Baer, Peter Mertes Stipendium,
Kunstverein, Bonn

1997 *Monika Baer*, ed Verein
Kunsthalle St. Gallen and Dorothea
Strauss, Kunsthalle St. Gallen

Selected Exhibitions

2003 'Monika Baer: Jäger',
Galerie Barbara Weiss, Berlin
deutschemalereizweitausenddrei'
(German Painting 2003),
Kunstverein, Frankfurt
'Falling Angels', Greene Naftali,
New York

2002 Galerie Barbara Weiss, Berlin

1998 Portikus, Frankfurt (with Paul
McCarthy)
Bonner Kunstverein (with J.
Wohnseiffer)
Galerie Luis Campaña, Cologne

1997 La Casa d'Arte, Milan
Kunsthalle St. Gallen

1995 Galerie Luis Campaña,
Cologne

Monika **Baer**

Born 1964
Lives Berlin

To learn to live inside yourself is a difficult task.
Monika Baer, it seems, knows her way around the
corners of her mind and the topography of her body.
Many of her paintings and drawings comprise
figurative visions of psychic states and dreamlike
scenarios rendered with a lucid precision and
hallucinatory intensity. Other works side-step the
world of painterly illusion as she transforms her
canvases into membranes with multiple orifices.
Painting becomes the gateway to a world in which
the split between inside and outside, private and
shared experience, is irreversibly broken down. Baer
opens her mind until it is as wide as a cinema screen.
The camera keeps rolling and the film never stops.
Sit back and watch. (JV)

Represented by Galerie Barbara Weiss F14

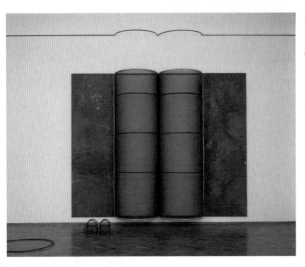

Miroslaw **Balka**

Born 1958
Lives Warsaw

Miroslaw Balka's sculptures and installations are grim yet compelling monuments to a life of scarcity and hardship, an art of unromanticized poverty rather than a resourceful Arte Povera. Balka's coffin-like boxes, rusted surfaces and empty spouts speak to the bleak history and economic climate of his native Poland, with a bodily inflection: felt, salt and ash, Balka's tribute to Joseph Beuys, stand in for living tissue. As formally indebted to Minimalism as it may seem, Balka's work comes from a place where the luxurious autonomy of Donald Judd's 'specific objects' is simply not possible. (KR)

Represented by Galerie Nordenhake D12, White Cube F6

Selected Bibliography

1997 *Revision 1986–1997*, IVAM, Valencia

1995 *Dawn*, Tate Gallery, London

1994 *Die Rampe* (The Ramp), Van Abbemuseum, Eindhoven

1992–93 *36,6*, Renaissance Society, University of Chicago

Selected Exhibitions

2002 'Nachtruhe' (Night Rest), Galerie Nordenhake, Berlin
Dundee Contemporary Art
Douglas Hyde Gallery, Dublin

2001 'Eclipse', Kröller-Müller Museum, Otterlo

1997 'Ordnung' (Order), Galerie Nordenhake, Stockholm
'Wounds', Moderna Museet, Stockholm
'Revision 1986–1997', IVAM Centre Julio Gonzalez, Valencia

1995 'Dawn', Tate Gallery, London
'Rites of Passage. Art For The End of the Century', Tate Gallery, London

1992 '36,6', Renaissance Society, University of Chicago

1990 'XXX', Galerie Nordenhake, Stockholm

Grosser Mann mit Weissem Hemd und Blauer Hose
(Tall Man with White Shirt and Blue Trousers)
2003
Carved and painted wood
270×85×43cm
Courtesy Galerie Thaddaeus Ropac

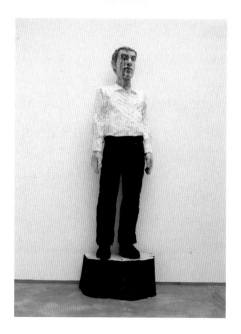

Selected Bibliography

1999 *Stephan Balkenhol*, Vittoria Coen, Galleria Civica di Arte Contemporanea, Trento

1996 *Sculptures and Drawings*, Noel Bebezra, Cantz Verlag, Ostfildern-Ruit

1988 *Stephan Balkenhol*, Jean-Christophe Ammann, Kunsthalle Basel

Selected Exhibitions

1999 'Stephan Balkenhol', Bawag Foundation, Vienna
'Stephan Balkenhol', Regen Projects, Los Angeles
'Stephan Balkenhol', Museum of Fine Arts, Montreal

1998 'People', Galleria Monica de Cardenas, Milan

1992 'Stephan Balkenhol', Kunsthalle, Hamburg
'Doubletake: Collective Memory and Current Art', Hayward Gallery, London

1989 'Das goldene Zimmer' (The golden Room), Kunstverein, Munich

1983 'Stephan Balkenhol', Art Cologne, Galerie Löhrl, Munich

Stephan **Balkenhol**

Born 1957
Lives Meisenthal

German sculptor Stephan Balkenhol carves people and animals from single blocks of wood, leaving them rooted to pedestals like classical icons. Although he came of age during the Minimalist and Conceptualist heyday of the 1970s, Balkenhol gravitated to the Pop and Photorealist figuration exemplified by Malcolm Morley, Richard Artschwager and Duane Hanson. His rough-hewn, resolutely ordinary characters are, as Adrian Searle has written in *frieze*, 'haunting and memorable'. They are indifferent to our gaze, and yet their condition as statuary makes them terribly vulnerable. (KR)

Represented by Stephen Friedman Gallery E6, Mai 36 Galerie D12, Galerie Thaddaeus Ropac B14

Concrete Poetry
2002
Plaster, polystyrene
Dimensions variable
Courtesy Frith Street Gallery

Fiona **Banner**

Born 1966
Lives London

Fiona Banner once described the full stop as 'a mark that alludes to nothing'. Leafing through her book *The Nam* (1997) – a breathless recounting of her memories of a number of Vietnam War movies – it's hard to imagine end-points trouble her too much. Like many of Banner's other textual landscapes (which record the artist's scene-by-scene recollections of action films, boxing matches and porno flicks), it's an endless, highly subjective entity that personalizes the mediated and menaces the idea of narrative 'truth'. Banner's recent sculptures of lumpen grammatical devices (which include, of course, full stops) do not signal an end to this activity. Rather, they are stones lapped by a lexical river, worn gradually away by so many words. (TM)

Represented by 1301PE B11, Frith Street Gallery C4, Galerie Barbara Thumm A4

Selected Bibliography

2002 *Banner*, Michael Archer, Patricia Ellis and Susanne Tietz, Revolver Publishing, Frankfurt

1997 *The Nam*, Frith Street Books, London

Selected Exhibitions

2002 'My Plinth is your Lap', Neuer Aachener Kunstverein, Aachen and Dundee Contemporary Arts
Turner Prize, Tate Britain, London

2001 Berlin Biennale

1999 'Stop', Frith Street Gallery, London
'Asterisk', Gesellschaft für Aktuelle Kunst, Bremen

o.T.
(Untitled)
2003
Mixed media
350×200cm
Courtesy Luis Campaña Galerie

Selected Bibliography

2002 *Beautiful Life?* Contemporary Art Center, Art Tower Mito, Tokyo, (with Kati Barath, Nobuaki Date, Hiroshi Fuji and others)

2001 *Heike Kati Barath Hast Du Lust?* (Would you like to?), Martin Stather, ed Kunstverein, Mannheim 'Heike Kati Barath, Galerie Luis Campaña, Cologne', Rainer Metzger, www.artmagazine.cc/ 'Heike Kati Barath. Lustvoll Ernsthaft' (Playful Serious), Thomas Hirsch, *Choices*, June

2000 'Heike Kati Barath – um ein Haar' (Nearly), Renate Puvogel, *Kunstforum*, October–December

Selected Exhibitions

2003 Kunstverein Lingen Cohan Leslie and Browne, New York Galerie Luis Campaña, Cologne 'Herbarium der Blicke' (Herbary of Gazes), Bundeskunsthalle Bonn

2002 'Beautiful Life', Contemporary Art Center, Art Tower Mito, Tokyo 'Kein Ort, nirgends' (No Place on Earth), Kunstverein Freiburg

2001 Galerie Cokkie Snoei, Rotterdam Galerie Luis Campaña, Cologne 'Hast Du Lust?' (Would you like to?), Kunstverein, Mannheim

2000 'Trendwende' (New Trend), Kunstverein, Dusseldorf

Kati **Barath**

Born 1966
Lives Cologne

If you thought the makers of Teletubbies were high on acid you will probably suspect Kati Barath to be popping even more exotic pills. Her overwhelmingly large paintings show cute bunnies, exceptionally hairy yetis and curly-haired girls in bathing suits. The friendly creatures are rendered in a faux naif style with little dots for eyes, smudgy mouth and big ears in colours boosted by some weird psychedelic chemistry. What makes the pictures really creepy, however, is the simple detail that every patch of hair (and there are lots of them) is painted with acrylic sealant – the bunnies look like they have the body hair of a gorilla. Their cuteness has a traumatic edge. If they ever get on children's TV, parental guidance is strongly recommended. (JV)

Represented by Luis Campaña Galerie E3

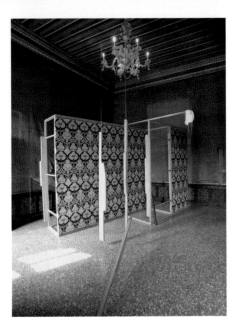

Claire **Barclay**

Born 1968
Lives Glasgow

Claire Barclay creates hybrid sculptural terrains out of disparate stuff: wood, clay, crystals, sail fabric and hunting and interior design magazines. Referencing Beuysian fetishism, the teasing poetry of Eva Hesse and sub-cultural spaces such as S&M clubs, Barclay's restrained handling of her materials generates a spitting Catherine wheel of associations. A number of her works resemble looms or gibbets, a-functional machines that she mucks up with mud or plugs with plastic, bringing pricked fingers, broken necks and flourishing microbes to mind. In Barclay's art textures speak of emotional states and abstract forms are unwittingly anthropomorphic, resulting in a constant testing and re-testing of what objects are and what, with a little thinking, they might become. (TM)

Represented by doggerfisher C21

Selected Bibliography

2002 *Early One Morning*, Iwona Blazwick and Andrea Tarsia, Whitechapel Art Gallery, London

2001 *Here + Now, Scottish Art 1990–2001*, Katrina M. Brown, John Calcutt and Rob Tufnell, Dundee Contemporary Arts

2000 *Homemaking*, Kirsty Ogg, Moderna Museet, Stockholm
Take to the Ground, The Showroom, London

1997 *Out of the Woods*, Francis McKee, Centre for Contemporary Art, Glasgow

Selected Exhibitions

2003 'Ideal Pursuits' Dundee Contemporary Arts
'Zenomap', Venice Biennale

2002 'Early One Morning', Whitechapel Art Gallery, London
'Some Reddish Work Done at Night', doggerfisher, Edinburgh
'Any Where', Center for Curatorial Studies, Bard College, Annandale-on-Hudson
'EU2', Stephen Friedman Gallery, London

2001 'Here + Now, Scottish Art 1990–2001', Dundee Contemporary Arts

2000 'Homemaking', Project Space, Moderna Museet, Stockholm
'Take to the Ground', The Showroom, London

1997 'Out of the Woods', Centre for Contemporary Art, Glasgow

My Brother's Gardens
2002–3
Video still
36 minute film
Courtesy Hales Gallery

Selected Bibliography

2003 'My Brother's Gardens',
Art Review

2001 'Situation (1)', review on
installation at Hales Gallery, Jane
Griffiths, *Flux Magazine*,
February–March
*Hans Op de Beeck A Selection of Works
1996–2001*, interview with Marie-
Pascale Gildemyn, Dorothee De
Pauw Gallery and Cera
Foundation, Brussels

Selected Exhibitions

2003 'My Brother's Gardens',
Hales Gallery, London
and Xavier Hufkens, Brussels
'Hans Op de Beeck – Drawings',
CIAP, Hasselt
'City Mouse/Country Mouse',
Space 101, New York

2002–3 PS1 Studio Program,
New York

2002 Critique is Not Enough,
Zurich
Victoria Miro Gallery, London
'La Nuova Agora',
Cittadellarte/Fondazione
Pistoletto, Biella

2001 Stichting Villa De Bank,
Enschede

Hans Op de **Beeck**

Born 1969
Lives Brussels

From the video *Determination* (1998) – featuring a
family staggering forwards upon a digitally erased
treadmill – to his ongoing series of intricate models of
desolate buildings, Belgian artist Hans Op De Beeck
unhesitatingly uses artifice to nail the loneliness and
pointlessness that underlie the human condition. If
the snatched footage in *Coffee* (1999) of an ageing,
silent, mutually antagonistic couple is a naturalistic
exception to this tendency, the 35mm *My Brother's
Gardens* (2003) – which employs a New York acting
troupe, multiple voiceovers, swelling choral music,
live action and animated drawings to tell a severe
but redemptive story of three misfortunate brothers –
is its recent apex. (MH)

Represented by Hales Gallery A8

Untitled
2003
Mixed media on paper
157.5×169cm
Courtesy BQ

Selected Bibliography

2003 *Dirk Bell*, BQ, Cologne

2001 *Dirk Bell – Darling*, BQ, Cologne
Darling (version 2001 by MO), 7 inch record, Dirk Bell/BQ, Cologne

1998 *Dirk Bell/Friedrich Kunath – Why Are My Friends Such Finks*, BQ, Cologne

Selected Exhibitions

2003 'deutschemalereiz – weitausenddrei' (German Painting 2003), Kunstverein, Frankfurt
'Painting on the Roof', Museum Abteiberg, Mönchengladbach
The Modern Institute, Glasgow
BQ, Cologne

2002 Gavin Brown's enterprise, New York

2001 BQ, Cologne

2000 'Malerei IV', Monika Sprüth Galerie, Cologne
'Make My Paper Sound', Studiogalerie Kunstverein Braunschweig

1998 'Why Are My Friends Such Finks', BQ, Cologne (with F. Kunath)

1995 'Malerei III', Monika Sprüth Galerie, Cologne

Dirk **Bell**

Born 1969
Lives Berlin

Dirk Bell's paintings and drawings evoke a fleeting, fragile place; more a state of mind than somewhere specific, full of appealing shadows, barnacles of light, melancholy songs and sad girls. Deeply romantic, and apparently without irony, his images are soporific and dreamlike; as if the artist is murmuring his reveries to a confidante at twilight. His paint application is thin and washy, his palette sombre and often lush. His pictures recall the hallucinogenic worlds of Symbolists such as Odilon Redon and Jean Delville. Borders, both imaginary and actual, appear to be dissolving – but if the centre cannot hold, its dissolution is a seductive one. (JH)

Represented by BQ B6, GBE (Modern) D5, The Modern Institute G8

By Night III
2003
Acrylic on canvas
215×310cm
Courtesy Galerie Nathalie Obadia

Selected Bibliography

2002 *Vitamin P: New Perspectives in Painting*, ed Valérie Breuvart, Phaidon, London
Dear Painter, Paint Me, ed Alison M. Gingeras, Centre Georges Pompidou, Paris; Kunsthalle Vienna; Schirn Kunsthalle, Frankfurt

1999 *Carole Benzaken*, CAPC Musée d'Art Contemporain de Bordeaux

1994 *L'oeil et l'esprit: Exposition d'art contemporain français* (The eye and the spirit: approaches to contemporary art in France) Alfred Pacquement, The National Museum of Contemporary Art, Seoul

Selected Exhibitions

2003 'Made in Paris', Anne Faggionato Gallery, London

2002 Galerie Nathalie Obadia, Paris
'Dear Painter, Paint Me', Centre Georges Pompidou, Paris; Schirn Kunsthalle, Frankfurt; Kunsthalle, Vienna

2001 Annina Nosei Gallery, New York

2000 INMO Gallery, Los Angeles
'Summer Invitational', Annina Nosei Gallery, New York

1999 'Primitive Passion', Palais des Papes, Avignon
CAPC Musée d'Art Contemporain, Bordeaux

1994 Fondation Cartier pour l'Art Contemporain, Paris

Carole **Benzaken**

Born 1964
Lives Paris/Los Angeles

Carole Benzaken's painting is a channel-surfing trawl through personal and public imagery. With sources ranging from private photographs to found images from print and broadcast media, the surfaces of her canvases oscillate between points of individual and collective memory. Begun in 1989, and exhibited in the recent survey exhibition 'Dear Painter' (Centre Georges Pompidou, 2002), her ongoing 'Rouleau à Peintures' (1989–) – a long coiled strip of small paintings resembling a reel of film – constitutes a kind of personal diary charting the evolution of her ideas and interests. Resident in Los Angeles since 1998, her work has focused on the residents of the local African-American and Hispanic communities. The generic quality of Benzaken's imagery floats her paintings freely between her personal experience and a collective familiarity. (DF)

Represented by Galerie Nathalie Obadia F2

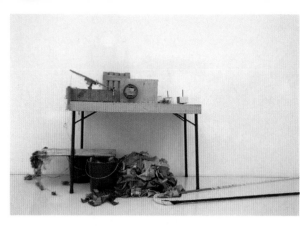

Lolita (Seaside-Sailor 'Lolita')
2003
Construction to tie
wood, rope, iron ribbon, pillows,
nails
435×180×250cm
Pasteboard
folding table wood, cloth, tape rolls,
paper tubes, paste, sponge, bucket
95×60×115cm
Roller carriage with candles, tape
dispenser and cable ties
20×40×40cm
Sticks
Iron ribbon, cloth, paste
Dimensions and number variable
Courtesy Galerie Michael Neff

Michael **Beutler**

Born 1976
Lives Berlin/Frankfurt

Young Frankfurt-based artist Michael Beutler's makeshift installations and machines put metal, chipboard, cloth and glass into stunningly consistent ad hoc constellations. Yet the work 'is not just about process and materials', as Ronald Jones put it in *frieze*, but 'assembles meaning on the back of a lo-fi economy of production', exposing the Dadaistic element in seemingly utilitarian techniques of building and tearing. Sculpture and vernacular construction are given leading roles in a madcap comedy with a happy ending – one of rigged and jagged beauty. (JöH)

Represented by Galerie Michael Neff C20, Galerie Barbara Wien G2

Selected Bibliography

2003 'Under Construction' Ronald Jones, *frieze*, 75, May
Michael Beutler, Secession, Vienna

Selected Exhibitions

2004 Kunstverein, Oldenburg

2003 'Strandsegler Lolita' (Sailing Boat Lolita), Galerie Michael Neff, Frankfurt
Galerie Barbara Wien, Berlin

2002 Secession, Vienna

2001 Dontmiss, Frankfurt
'Sour Cherry Soup (Meggyleves)', Mafuji Gallery, London
'Interim', Mackintosh Gallery, Glasgow School of Art
'Haiku Installation', Unit 2, London/Podium Gallery, Glasgow School of Art

2000 'Membershow', Transmission Gallery, Glasgow

Inseguendo la mano destra
(Following the right hand)
Anita Ekberg in *La Dolce Vita*
2003
Drawing on Perspex
57×79cm
Courtesy Galleria Sonia Rosso

Selected Bibliography

2003 'Signed Anonymous Message
Addressed to People I Don't Know',
Tema Celeste, 97, May–June

1999 Catalogue CCC
Tours/FRAC Languedoc
Roussillon/ Tramway Glasgow
End, MC Publication, London
Pierre Bismuth, Michael Newman,
Lisson Gallery, London
Pierre Bismuth, Galerie Yvon
Lambert, Paris

Selected Exhibitions

2003 'I Agree – Cloning Humans
is Disgusting', Galerie Jan Mot,
Brussels
Galleria Sonia Rosso, Turin
Lisson Gallery, London

2001 CAC, collaboration with
Jonathan Monk, Vilnius
'Pierre Bismuth', Centre d'Art
Contemporain de Brétigny
Dvir Gallery, Tel Aviv
'Closed', Diana Stigter Gallery,
Amsterdam
'Bonjour chex vous', Centre
d'Art Contemporain de Brétigny
'Plateau of Humankind',
Venice Biennale
'Pierre Bismuth: Alternance',
Kunsthalle, Basel

Pierre **Bismuth**

Born 1963
Lives London/Brussels

An artwork trying to compete with the lure of
Disney's 1967 classic *Junglebook* would inevitably be
turned, like Mowgli in the grip of Khan, into a
helpless bundle. Or so you would think. But Pierre
Bismuth did the trick, producing the highlight of
Manifesta 4 in Frankfurt, 2002. The French artist
got hold of every available dubbed version: suddenly
Mowgli speaks Spanish, Balou the bear Hebrew, and
Bagheera the panther Arabic, producing a strangely
touching Babel utopia. Bismuth is a master of simple
conceptual manipulations: newspaper clips altered by
Warholesque repetition of the image on the same
page, for example. He regroups found footage with
the deftness of a trickster dealing a deck of cards.
(JöH)

Represented by Lisson Gallery B4, Galleria Sonia
Rosso C2

No Mirror
2001
Digital c-type print
104×263.5cm
Courtesy Ghislaine Hussenot

Jeremy **Blake**

Born 1971
Lives Los Angeles

If there is a school of Gothic psychedelia, then
Jeremy Blake is its leading practitioner. Referencing
Victorian spiritualism, pre-cinematic 'magic lantern'
entertainments, paranoiac acid-head visions and
1960s-era kaleidoscopic nightclub projections,
his slowly unfolding DVD loops feature
phantasmagorical patterns and forms that morph
like ghostly ectoplasmic discharges. Resembling
sinisterly mesmerizing Colour Field paintings with
a mind of their own, Blake's bleeding and mutating
Rorschach stains of colour are the primordial stew
from which periodically emerge curious
representational fragments – usually derived from
sombre historical photographs – that briefly come
into focus before being once again subsumed by
a wilful abstracting process. (JT)

Represented by Galerie Ghislaine Hussenot F15

Selected Bibliography

2001 'Blake's Process – Digitale
Video-Gemälde', Christian Schoen,
in *Offensive Malerei*, Lothringer13
/halle, Munich
'Jeremy Blake: Politics and Fashion
in Buccinan', Reena Janna, *Flash
Art,* May–June

1999 'Jeremy Blake: Project With
Theresa Duncan', *Artext.*
November–January
'Jeremy Blake: Bungalow 8',
Andrew Perchuck, *Artforum,*
Summer
'Mr. Fascination' Lia Gangitan,
Trans>Art and Culture, Summer

Selected Exhibitions

2003 Reina Sofia, Madrid

2002 Blaffer Gallery, University
of Houston
Ghislaine Hussenot Gallery, Paris

2001 'Mod Lang', Feigen
Contemporary, New York
'Disappearing Floor', Dorothée
DePauw Gallery, Brussels
'bitstreams', Whitney Museum
of American Art, New York

2000 'Greater New York', Museum
of Modern Art/PS1, New York
'Jeremy Blake: Bungalow 8',
The CAC, Cincinnati
'Jeremy Blake: Digital Projections',
Pennsylvania Academy of the Fine
Arts, Philadelphia
Art Statements, Art Basel

1999 'Sucking in the Seventies',
Recent Works/Jacob Fabricius,
Copenhagen

1997 Whitney Biennial, Whitney
Museum of American Art, New
York

Ratatac
1997–2003
Oil on hardboard
94×69cm
Courtesy Waddington Galleries

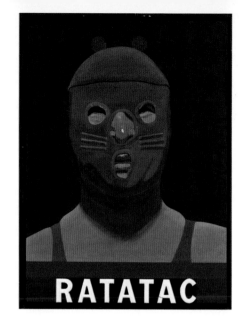

Selected Bibliography

2003 *Peter Blake*, Natalie Rudd, Tate Publishing, London

2000 *Peter Blake:About Collage*, Dawn Ades, Peter Blake and Natalie Rudd, Tate Publishing, London

1996 *Now We Are 64: Peter Blake at the National Gallery*, Marco Livingstone and Colin Wiggins, intro. Peter Blake, National Gallery Publications, London

1986 *Peter Blake*, Marina Vaizey, The Royal Academy – Painters and Sculptors, Weidenfeld and Nicolson, London

1983 *Peter Blake*, Michael Compton, Nicholas Usherwood, Robert Melville, Tate Publishing, London

Selected Exhibitions

2003 'Peter Blake', Artiscope, Brussels

2002 'Sir Peter Blake/And Now We Are 70', Paul Morris Gallery, New York

2000–01 'Peter Blake: About Collage', Tate Liverpool

1996–7 'Now We Are 64: Peter Blake at the National Gallery', National Gallery, London

1995 'Peter Blake: Peintures et aquarelles', Galerie Claude Bernard, Paris

1988 'Peter Blake', Nishimura Gallery, Tokyo

1983 'Peter Blake', Tate Gallery, London

1973–4 'Peter Blake', Stedelijk Museum, Amsterdam and touring

1969 'Peter Blake', City Art Gallery, Bristol

1965 'Peter Blake: Paintings', Robert Fraser Gallery, London

Peter **Blake**

Born 1932
Lives London

Along with his contemporaries Richard Hamilton, Sir Eduardo Paolozzi and David Hockney, Peter Blake is undoubtedly one of the most significant elder statesmen of British art. Emerging in the 1950s as one of the pioneers of British Pop, his paintings and assemblages used a meticulous realism with which he deftly and playfully explored the signs and syntax of burgeoning postwar Pop culture. Perhaps best known for his seminal cover design for The Beatles' *Sergeant Pepper's Lonely Hearts Club Band* (1967), Blake's interest in vernacular imagery also extended, via membership of the Brotherhood of Ruralists in the mid-1970s, to a passionate advocacy of the importance of British folk crafts. His iconic and striking graphic sensibility has remained as steadfast an influence on British art as the swinging era from which his unique voice emerged. (DF)

Represented by Waddington Galleries G3

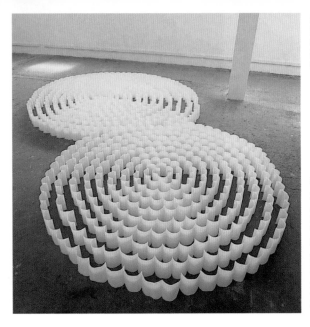

Selected Bibliography

2003 *Michel Blazy*, co-edition
Art:Concept, Paris; Cimaise et
Portique, Albi; Les Abattoirs,
Toulouse; CCAC Wattis, Institute,
San Francisco

2002 *Michel Blazy*, Editions
Kunsthaus Baselland, Basel

2000 *Les Animaux*, Michel Blazy,
Edition Centre d'art de l'espace Jules
Verne, Brétigny-sur-Orge

1999 'Michel Blazy', Passage: New
French Art, exposition itinerante
1999–2000, Japan, The Association
of Art Museums
Plantes Vertes, Michel Blazy, Edition
Centre d'art de l'espace Jules Verne,
Brétigny-sur-Orge

Selected Exhibitions

2003 Württembergischer
Kunstverein, Stuttgart
'Les Succulentes', Art:Concept, Paris
'Our Mutual Friend', Bloomberg
Space, London

2002 'Michel Blazy', Kunsthaus
Basel
CCAC Wattis Institute for
Contemporary Art, San Francisco

2001 'Do It', Museo de Arte
Carrillo Gil, Col San Angel,
Mexico City

2000 'The Greenhouse Effect',
Serpentine Gallery, London
'Jour de fête', Centre Georges
Pompidou, Paris

1998 'The life of things',
Correct Contemporary Exhibitions,
New York

1997 'La vie de choses' (The life
of things), Musée d'Art Moderne
de la ville de Paris

Michel **Blazy**

Born 1966
Lives Paris

Putrid, rotting, mouldy and foul-smelling, Michel
Blazy's aesthetic is surprisingly beautiful. Using
materials ranging from paper tissue to cat biscuits
and puréed carrot, Blazy's delicate constructions have
as much in common with the alchemy of gardening
and cookery as they do with contemporary art.
Drawing from such diverse practices as Land art,
ornamental garden design and Colour Field painting,
his semi-organic forms exist for only short periods of
time, making a virtue of their instability, growing
and changing in the throes of their own decay. (DF)

Represented by Art:Concept G7

MEECHbuilding
2000
Barrel, wood, cardboard, hay,
metallic wire
165×90cm
Courtesy Giò Marconi

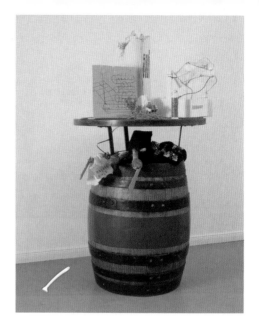

Selected Bibliography

2003 Jens Hoffmann, Daniel Birnbaum, Jan Avgikos, *Parkett*, 67

2002 'Nonstop Nonsens', Ilka Becker, *Texte zur Kunst*, 47, September

2000 'Bettina Funcke's conversation with John Bock', *Trans>Art and Culture*, 8 *RE_public*, Kunstverein, Graz

1999 'Openings: John Bock', Ronald Jones, *Artforum*, Summer

Selected Exhibitions

2003 CCA Kitakyushu
Museum Boijmans van Beuningen, Rotterdam

2002 'Sprawl', CAC, Cincinnati
Documenta, Kassel

2001 'A Little Bit of History Repeated', Kunst-Werke Berlin
'Im AtomeiterzinsKonflikt mit einer EierstockCapitalSaint', Magasin 3, Stockholm Konsthall
'Hypermental: Wahnhafte Wirklichkeit 1950–2000.
Von Salvador Dalí bis Jeff Koons' (Hypermental: Rampant Reality) Kunsthaus, Zurich and Kunsthalle, Hamburg

2000 'Four Lectures', MoMA, New York

1999 Art Statements, Art Basel

1998 'MienGribbohmWien', Secession, Vienna

John **Bock**

Born 1965
Lives Berlin

John Bock doesn't just give you art, he gives you a whole world. The art discourse of the 1990s saw a resurgence of interest in how individuals organize their lives and make meaning for themselves. Bock's work was at the centre of this process. His labyrinthine installations function as stage sets for his performances in which he gives scientific lectures on nuclear physics, art and all sorts of other subjects, mixing rural folk theatre with sublime slapstick. Step by step you are introduced to a personal universe with its own laws, histories and philosophies. The evolution of this world is a never-ending process, as Bock continues to expand his domain in a process of infinite bricolage. (JV)

Represented by Sadie Coles HQ B8, Klosterfelde B9, Galerie Meyer Kainer F1, Giò Marconi C14, Galerie Michael Neff C20

4/104 Unique
2002
C-type print mounted using dyasec process
100×104cm
Courtesy Emily Tsingou Gallery

Selected Bibliography

2002 *What Gets You through the Day*, La Vie Publishing, London

1999 *Point and Shoot*, Hatje Cantz, Ostildern-Ruit
La Vie Quotidienne, Editions 20.21, Essen

1998 *The Cult of the Street*, Emily Tsingou Gallery, London

Selected Exhibitions

2003 Le Consortium, Dijon

2001 'Century City', Tate Modern, London
'Instant City', Centro Luigi Peggi per Arte Contemporanea, Prato

2000 Kunsthalle zu Kiel
Centre de la Photographie, Geneva

1999 Fotomuseum, Winterthur

1998 'Fast-Forward', Kunstverein Hamburg

1997 'Jonctions', Palais des Beaux Arts, Brussels

1996 'Traffic', CAPC Musée d'Art Contemporain, Bordeaux

1993 'Aperto', Venice Biennale

Henry **Bond**

Born 1966
Lives London

Henry Bond photographs London's youth and street cultures, targeting his elusive subjects throughout the city with a variety of cameras, from the most technically elaborate to the flimsiest disposable. Part amateur photojournalist, part fashion photographer, he has filled two substantial books with shots of urban nooks and crannies, teenagers prowling the shops and occasional celebrity sightings – all of which look as though they could be the product of London's extensive surveillance network. (KR)

Represented by Galerie Almine Rech H7, Emily Tsingou Gallery A6

Our Love is Like the Flowers, the Rain, the Sea and the Hours
2002
Mixed media
Installation view at Tramway Gallery, Glasgow
Courtesy The Modern Institute

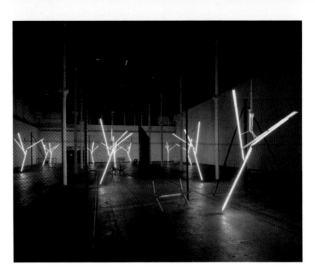

Selected Bibliography

2003 *Undead Dreams*, Will Bradley, RomaRomaRoma, Rome

2002 Catrin Lorch, *Kunst-Bulletin*, December
For 1959 Capital Avenue, Michael Archer, Museum für Moderne Kunst, Frankfurt

2001 *Zero Gravity*, Will Bradley, Kunstverein für die Rheinlandes und Westfalen, Dusseldorf

2000 *Martin Boyce*, Tom Gidley, Fruitmarket Gallery, Edinburgh

Selected Exhibitions

2004 The Modern Institute, Glasgow
Adolf Luther Prize, Krefeld Museum

2003 Biennale d'Art Contemporain de Lyon 'Undead Dreams', RomaRomaRoma, Rome
'Our Love is Like the Earth, the Sun the Trees and the Birth', Contemporary Art Gallery, Vancouver

2002 'Our Love is Like the Flowers, the Rain, the Sea and the Hours', Tramway, Glasgow
'For 1959 Capital Avenue', Museum für Moderne Kunst, Frankfurt
'My Head is on Fire but my Heart is Full of Love', Charlottenborg Exhibition Hall, Copenhagen

2001 'Zero Gravity', Kunstverein für die Rheinlandes und Westfalen, Dusseldorf

2000 'Fear View', Johnen & Schöttle, Cologne

1999 'When Now is Night', Fruitmarket Gallery, Edinburgh

Martin **Boyce**

Born 1967
Lives Glasgow

Mining classics of Modernist design for a subtext altogether darker than the egalitarian ideals that first inspired them, Martin Boyce assigns these objects of desire new functions or contexts in order to create unsettling atmospheres drawn from their very heart. Fascinated with the failures of 20th-century utopian Modernism, Boyce recently turned his attention from interiors to exteriors with the park-like environment *Our Love is Like the Flowers, the Rain, the Sea and the Hours* (2003). Like the result of an uneasy collaboration between Charles and Ray Eames and Brett Easton Ellis, the carefully milled surfaces of these objects and installation are inflected with fear and paranoia. (DF)

Represented by Art:Concept G7, The Modern Institute G8, Galerie Eva Presenhuber D7

Me, Myself, I
2001
Triple-channel DVD installation
Dimensions variable
Courtesy galleria francesca
kaufmann

Candice **Breitz**

Born 1972
Lives Berlin

Candice Breitz dives beneath the surface of pop
culture to explore its dark undertow of narcissism.
For the series 'Four Duets', for example, Breitz edited
promotional video clips of pop divas such as Olivia
Newton-John, Whitney Houston, Annie Lennox
and Karen Carpenter to leave only the words 'I'
and 'you'. Played back simultaneously on two
separate monitors, each singer serenaded their
double, creating a feedback loop of schizophrenic
desire and self-love. In *Diorama* (2002), characters
from the US soap opera *Dallas* were edited to repeat
the same lines endlessly – empty banalities used to
amplify television's – and by extension our own –
idea of normality. (DF)

Represented by aspreyjacques D14,
galleria francesca kaufmann H3

Selected Bibliography

2002 *ART NOW: 137 Artists at the
Rise of the New Millennium*, Uta
Grosenick and Burkhard
Riemschneider, Taschen, Cologne
'Istanbul Biennial,' Jennifer Higgie,
frieze, 50, January–February

2001 'Killing Me Softly... An
Interview with Candice Breitz',
Rosanne Altstatt, *Kunst-Bulletin*,
June
Candice Breitz: Cuttings, Martin
Sturm and Renate Plochl, O.K.
Centrum für Gegenwartskunst, Linz

2000 'Candice Breitz: Fighting
Words', David Hunt, *Flash Art*, 211,
March–April

Selected Exhibitions

2003 'Candice Breitz/Jim Lambie',
Museum of Modern Art, Oxford
Galerie Max Hetzler, Berlin

2002 ArtPace Foundation, San
Antonio
Künstlerhaus Bethanien, Berlin

2001 'Candice Breitz/Thomas
Demand', De Appel Foundation,
Amsterdam
O.K. Centrum für Gegenwartskunst,
Linz
Kunstverein, St. Gallen
galleria francesca kaufmann, Milan

2000 Centre d'Art Contemporain,
Geneva
New Museum of Contemporary Art,
New York

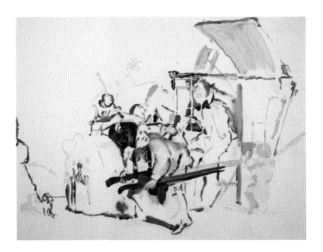

Untitled
2003
Monotype
51×61cm
Courtesy Two Palms Press

Cecily **Brown**

Born 1969
Lives New York

Swirling strokes of near-abstract imagery; a chaotic palette of hallucinogenic flesh beneath flambé skies; a restless anatomy fuelled by self-doubt and paint. Tangled bodies, fevered intentions and echoes of Pollock and De Kooning – restraint has no place in the paintings and works on paper of Cecily Brown. Reason disappears in the space between abstraction and figuration. Nothing is distilled – layers, limbs and colour pile up until the whole thing collapses, is scraped away and rebuilt anew. Brown is interested in what happens to your mind when it tries to make up for what is missing. Her stated aim is to make pictures that are tender, grasping and indescribable. (JH)

Represented by Contemporary Fine Arts D4, Gagosian Gallery F7, Two Palms Press A7

Selected Bibliography

2003 *Cecily Brown*, Jan Tumlir, Gagosian Gallery, Beverley Hills

2001 *Cecily Brown,* CFA, Berlin

Selected Exhibitions

2003 'Cecily Brown', Museo di Arte Contemporanea, Rome
'Cecily Brown', Gagosian Gallery, Beverley Hills

2002 'Directions – Cecily Brown', Hirshhorn Museum and Sculpture Garden, Washington DC

The Holy Virgin
2003
Oil on panel
114×76.5cm
Courtesy Patrick Painter, Inc

Selected Bibliography

2002 *Dear Painter, Paint Me,* ed
Alison M. Gingeras, Centre
Georges Pompidou, Paris;
Kunsthalle, Vienna; Schirn
Kunsthalle, Frankfurt
Melodrama, Doreet Levitte Harten,
Artium, Centro-Museo Vasco de
Arte Contemporaneo, Vitoria-
Gasteiz; Palacio de los Condes de
Gabia, Granada; Museo de Arte
Contemporanea, Vigo

2000 *Glenn Brown,* Paul Frederic,
Domaine de Kerguehennec, Centre
d'Art Contemporain, Bignan
*Hypermental.Wahnhafte Wirklichkeit
Rampant Reality 1950–2000. Von
Salvador Dalí bis Jeff Koons,* Kunsthaus
Zurich; Kunsthalle Hamburg; Hatje
Cantz Verlag, Ostfildern-Ruit

1996 *Glenn Brown,* Phil King,
Queen's Hall Arts Centre, Hexham
and Karsten Schubert, London

Selected Exhibitions

2003 'Delays and Revolutions',
Venice Biennale

2002 'Dear Painter, Paint Me',
Centre Georges Pompidou, Paris;
Kunsthalle, Vienna; Schirn
Kunsthalle, Frankfurt

São Paulo Biennale
'(The World May Be) Fantastic',
Sydney Biennale
Galerie Max Hetzler, Berlin

2001 Patrick Painter, Inc, Santa
Monica

2000 Turner Prize, Tate Gallery,
London
'Glenn Brown', Domaine de
Kerguehennec, Centre d'Art
Contemporain, Bignan

1997 'Sensation: Young British
Artists from the Saatchi Collection',
Royal Academy of Art, London
and touring

1996 'Glenn Brown', Queen's Hall
Arts Centre, Hexham

Glenn **Brown**

Born 1966
Lives London

Glenn Brown's trademark is the flattened painterly
gesture – Auerbach without the impastoed anguish,
Rembrandt without the biographical gloom,
Fragonard without the frivolity. Although his
virtuoso handling of paint links the look of his
paintings – hyperreal 'copies', or variations on a
theme or detail of another painting – each one is
different from the one that precedes it. Brown's
technique, like all trademarks, only hints at the
complexity of the finished product. These paintings
are about the cyclical dreams of art history; the
architecture of paint; the slippery relationship
between time and the possibilities of representing it.
There's no right way to look at or remember a
painting, they seem to be saying. And they're right.
(JH)

Represented by Patrick Painter, Inc B1

Untitled (Tablet of Portraits)
2003
Rubbed-out newspaper cuttings
85×60cm
Courtesy Kate MacGarry

Matt **Bryans**

Born 1977
Lives London

Taped to the gallery wall like queasy, animal-hide quilts, Matt Bryans' collages of newspaper photographs have a strange, phantom appeal. Having selected them from an ongoing collection, Bryans takes an eraser to each image, rubbing out the background and the contours of each face, leaving only the eyes, the mouths and smudgy marks that hang on the page like polluted mist. There is something democratic about the result (the celebrity and the crime victim, after all, are equal under Bryans' ministrations) but also something essentialist, as though each human face hides the same weepy-eyed, wide-mouthed ghostly visage. (TM)

Represented by Kate MacGarry C19

Selected Exhibitions

2003 'Matt Bryans', Kate MacGarry, London

2002 'May It Return in Spades', Bart Wells Institute, London
'If the Wind Changes You'll Stay Like That', Mafuji Gallery, London

Thomas Muir Help Desk
2003
Banner
Dimensions variable
Courtesy Galerie Praz-Delavallade

Roderick **Buchanan**

Born 1965
Lives Glasgow

Glasgow-based Roderick Buchanan produces deadpan sociological investigations into the rituals and allegiances that we use to define ourselves. For avowedly frustrated footballer Buchanan, chief among these is sport: the video *Chasing 1,000* (1992) featured him and a friend in America, heading a basketball soccer-style; the photographic series *Yankees* (1996) pictured non-Americans wearing US baseball caps. Yet his Beck's Futures 2000-winning video *Gobstopper* (1999) featured children holding their breath while being driven under a tunnel, and a recent project revolved around Thomas Muir, a 19th-century lawyer prosecuted for promoting ideas of social equality. With such works – which tease out his theme's prosaic and political overtones – Buchanan dummies effectively around his audience's expectations. (MH)

Represented by Lisson Gallery B4, Galerie Praz-Delavallade B18

Selected Bibliography

2001 'Club 18–40', Andrew Smith, *Scotland on Sunday*, The Art Issue *Players*, Roderick Buchanan (artists book), Dundee Contemporary Arts

2000 'Roderick Buchanan, l'effet travelling', Jean-Marc Huitorel, *Art Press*, 253,

1999 Venice Biennale Catalogue

1997 *Yankees*, artists book with Art Metropole, Toronto

Selected Exhibitions

2003 'Thomas Muir – Help Desk', Galerie Praz-Delavallade, Paris 'Squared Circle', Walker Art Center, Minneapolis

2002 'New', recent acquisitions of contemporary British art, Scottish National Gallery of Modern Art, Edinburgh

2001 5th Biennial on Media and Architecture, Graz Kunsthalle, Nuremberg 'Roderick Buchanan, Inside Out', Lisson Gallery, London

2000 Dundee Contemporary Arts 'Let's Entertain', Walker Arts Center, Minneapolis and touring

1998 'Turnaround', Hayward Gallery, London Galerie Praz-Delavallade, Paris

Minus
2002
Mixed media installation
(Public Affairs, Kunsthaus Zurich)
Courtesy O.K. Centrum für
Gegenwartskunst, Kunsthaus,
Zurich

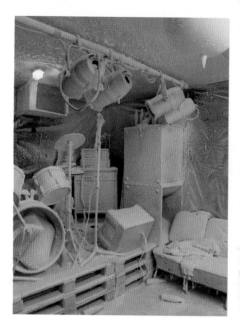

Selected Bibliography

2002 'Christoph Büchel', Meghan
Dailey, *Artforum*, March
'Ein echt Schweizer Afgahne'
(A real Swiss Afgahne), Jörg Bader,
Frankfurter Allgemeine Zeitung, 18
March 2002

2001 'Christoph Büchel', Roberta
Smith, *New York Times*, 21 December
2001
'Christoph Büchel', Frantiska &
Tim Gilman-Sevcik, *Flash Art*,
November–December

2000 'Vom Verschwinden im
Raum'(About Disapparence in
Space), Susanne Meyer-Buser,
Aller Anfang ist Merz (All Beginning
is Merz), Hanover

Selected Exhibitions

2003 Museum am Abteiberg,
Mönchengladbach

2002 'Shelter', Haus der Kunst,
Munich
'Shelter II', O.K. Centrum für
Gegenwartskunst, Linz
'House of Friction', Sammlung
Hauser & Wirth, Lokremise St.
Gallen
'Minus', Public Affairs, Kunsthaus
Zurich

2001 'Fiat' (with B. Gramsma),
Tirana Biennale

2000 'Zur Ausstellung erscheint ein
Katalog (Joy of the Institution)',
Kunstmuseum, St. Gallen
'HB XAO', Powersources, Fri Art
Centre d'Art Contemporain,
Fribourg

1999 'Alles wird gut' (Everything
will be all Right), Ausstellungsraum
Offenbach
Kunsthalle, St. Gallen

Christoph **Büchel**

Born 1966
Lives Basel

Christoph Büchel's work oscillates wildly between
Yves Klein's 1958 *Le Vide* (The Void) – the empty
gallery space as exhibit – and Arman's 1960 *Le Plein*
(The Full) – turning it into a container filled with
waste, the vestiges of modern life. The Basel-based
artist takes each of these poles to a new extreme.
He hides, for example, a suitcase full of money –
the exhibition budget – behind the plaster walls of
an empty gallery space, inviting visitors to turn into
greedy vandals; or alternatively he transforms the
space into the crammed home of someone who can
never finish anything, complete with a half-repaired
car motor on a living-room table. Büchel is a
magician of the white cube: he makes it both
appear and vanish at the same time. (JöH)

Represented by maccarone inc. H2

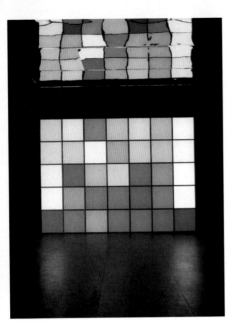

Macro World: One Hour3 and Canned
2002
35 DMX-modules, 1 black box
253×355×51cm
Installation view
Courtesy Schipper & Krome

Selected Bibliography

2002 *Material_o1. Angela Bulloch*,
Institute of Visual Culture,
Cambridge

2001 *Angela Bulloch: Pixel Book,*
ed Beatrix Ruf, Kunsthaus Glarus

2000 *Rule Book*, Angela Bulloch,
ed Stefan Kalmár, Book Works,
London

1998 *Satellite*, ed Stefan Kalmár
and Angela Bulloch, Museum für
Gegenwartskunst, Zurich and
Le Consortium, Dijon

1994 *Angela Bulloch*, FRAC,
Languedoc Roussillon; Kunstverein,
Hamburg

Angela **Bulloch**

Born 1966
Lives London/Berlin/Vienna

Angela Bulloch has employed materials as diverse
as bean bags, nail varnish, plasticine, tables, pressure
sensors and telephones to explore the limits of a
Conceptual vernacular. Many of her works are
activated by the viewer – they might, for example,
speak back or offer rest. Interested in reductive systems
that in the act of paring back may expand meaning,
Bulloch has recently turned to cinema. Her 'Pixel
Cubes' (lightboxes echoing the basic forms of classic
Minimalist sculpture), push scenes from films – such as
2001:A Space Odyssey, and footage Bulloch shot at the
site of a scene from Antonioni's *Zabriskie Point* – to the
point of pixellated abstraction. (JH)

Represented by 1301PE B11, Magnani F11,
Galerie Eva Presenhuber D7, Schipper & Krome E8,
Galerie Micheline Szwajcer E5

Selected Exhibitions

2002 'Frequenzen (Hz)',
Audiovisuelle Räume, Schirn
Kunsthalle, Frankfurt
'Claude Monet... bis zum digitalen
Impressionismus' (Claude Monet...
to Digital Impressionism),
Fondation Beyeler, Basel
'Remix', Tate Liverpool
'Macro World: One Hour_, and
Canned', Schipper & Krome, Berlin
'Horizontal Technicolor', Institute of
Visual Culture, Cambridge

2001 'Connivence', Lyon Biennale
'Z Point', Kunsthaus Glarus

2000 'Prototypes', Galerie Hauser
& Wirth & Presenhuber, Zurich
'Sonic Boom – The Art of Sound',
Hayward Gallery, London
'EIN/räumen. Arbeiten im
Museum' (Putting Away, Works in
the Museum), Kunsthalle, Hamburg

1998 'Superstructures', Museum für
Gegenwartskunst, Zurich

Bobby Bohnen und seine Hunde
(Bobby Bohnen and his Dogs)
2001
Oil on canvas
210×155cm
Courtesy Galerie Hammelehle
und Ahrens

Selected Bibliography

2003 *TODALL!*, Galerie
Hammelehle und Ahrens, Cologne
Malerei und Gesundheit (Painting and
health), Thomas Groetz, André
Butzer – *Chips und Pepsi und
Medizin*, Galerie Max Hetzler,
Berlin
deutschemalereizweitausenddrei
(German painting 2003),
Kunstverein, Frankfurt

2002 *Offene Haare, Offene Pferde –
Amerikanische Kunst 1933–45*,
Thomas Groetz, Kölnischer
Kunstverein, Cologne
'How to accuse a society of its best
and worst in order to cause its
death', Thomas Groetz, *Texte zur
Kunst*, June

Selected Exhibitions

2003 'TODALL!', Galerie
Hammelehle und Ahrens, Cologne
'deutschemalereizweitausenddrei'
(German painting 2003),
Kunstverein, Frankfurt
Galerie Max Hetzler, Berlin

2002 'Bitches of all Genders They
Come and Go', Galerie
Hammelehle und Ahrens, Cologne
'Offene Haare, Offene Pferde –
Amerikanische Kunst 1933–45',
Kölnischer Kunstverein

2001 Tirana Biennale
Galerie Hammelehle und Ahrens,
Stuttgart

2000 'HOSSA – German Art of
the Year 2000', Centro Cultural
Andratx, Palma de Mallorca
'Wanderung nach Annaheim',
Galerie Guido W. Baudach, Berlin

1997 'Akademie Isotrop',
Künstlerhaus, Stuttgart

André **Butzer**

Born 1973
Lives Berlin

André Butzer's ferociously coloured canvases look
like the vivid aftermath of a fight between Asger Jorn
and Edvard Munch. These works articulate a
painterly world in which spatial and figurative
elements are collapsed into a neo-Expressionist soufflé
of intense chromatics and gestural brushmarks. With
their elastic limbs and huge eyes, his anamorphic
figures look like friendly cartoon characters, yet
spend time with them and they begin to appear
diseased, panic-stricken and frightened by their
plagued existence. The limbo they inhabit – between
figuration and abstraction – reflects these physically
wracked figures' psychological suffering. (DF)

Represented by Galerie Hammelehle und
Ahrens E13

New Morning
2003
Acrylic on canvas
150×243cm
Courtesy Marc Foxx

Brian **Calvin**

Born 1969
Lives Los Angeles

Brian Calvin's resolutely sallow, blasé but cartoonishly attractive figures always seem on the cusp of finally taking some long-postponed action. Described in crisply flattened and economically simplified scenes that are nearly cinematic, they recall Alex Katz' unflappably urbane social portraits of friends and family of the '60s. But something a little less wholesome is going on here – perhaps it's the Philip Guston-esque obsession with inertia and totemic cigarettes, or the spectre of Bernard Buffet worked into the grimy crease of a knuckle, or just the plain indeterminacy of what they are up to. Not much seems to be happening – people smoke distractedly, or pause shin-deep in some summer lake or slouch at dinner looking like they haven't got much of an appetite. Caught in the gulf between thought and act, they seem just barely holding on. (JT)

Represented by Corvi-Mora F10, Marc Foxx G12, Gallery Side 2 H10

Selected Bibliography

2003 'The Unmemorable now Unforgettable: Brian Calvin at Marc Foxx', David Pagel, *Los Angeles Times*, 9 May 2003

2001 'Brian Calvin at Corvi-Mora', Jennifer Higgie, *frieze*, 61, September
'Openings: Brian Calvin', Bruce Hainley, *Artforum*, February

2000 'Subversion du kitsch: Conjectures on Conceptual Uses of Figurative Realism', Alison Gingeras, *Art Press*, 263, December
'Paintings Look at Our Cartoonish Nature: Brian Calvin at Marc Foxx', Christopher Knight, *Los Angeles Times*, 15 December 2000

Selected Exhibitions

2003 Corvi-Mora, London
Marc Foxx, Los Angeles
'Baja to Vancouver: The West Coast in Contemporary Art', Seattle Art Museum, Seattle; Museum of Contemporary Art, San Diego; Vancouver Art Gallery; CCAC Wattis Institute, Oakland
'The Fourth Sex: Adolescent Extremes', Stazione Leopolda, Florence
'Painting Pictures, Painting and Media in the Digital Age', Kunstmuseum Wolfsburg

2002 'Dear Painter, Paint Me', Centre Georges Pompidou, Paris; Kunsthalle, Vienna; Schirn Kunsthalle, Frankfurt
Corvi-Mora, London
Gallery Side 2, Tokyo

2001 'the americans. new art', Barbican Art Gallery, London

2000 Marc Foxx, Los Angeles

Untitled
2003
Oil on canvas
200×200cm
Courtesy Sprovieri

Selected Bibliography

2001 Giorgio Verzotti, *Artforum*, May
Maurizio Cannavacciuolo, Cardi Gallery, Milan

1999 Marco Meneguzzo, *Artforum*, May
New York Contemporary Art Report, May

1998 *Ho detto tutto!* (I said everything), Marco Colapietro, No Code Gallery, Bologna

Selected Exhibitions

2003 Sprovieri, London

2002 Museu da Republica, Galeria do Catete, Rio de Janeiro

2001 Franco Noero, Turin

1999 aspreyjacques, London

1997 Fundacio Ludwig de Cuba, Havana

1996 Sperone Westwater, New York

1993 Gian Enzo Sperone, Rome Studio Guenzani, Milan

1989 Museum Puri Lukisan, Ubud, Bali

1983 Lucio Amelio, Naples

Maurizio **Cannavacciuolo**

Born 1954
Lives Rome

Maurizio Cannavacciuolo's paintings and large-scale drawings are predicated on a tense counterbalance. Superficially concerned with formal design – constructed from numerous layers of overlapping outlines, they've been compared to Persian rugs – on close viewing these miasmic masses fragment into a teeming image-world of small figures engaged in copulation and killing, often accessorized with obscene Italian slang. The arc of the Neapolitan artist's career has been to push this incongruity to breaking point. In recent years he has covered gallery walls with impossibly dense palimpsests that, on occasion, have to be viewed using a ladder – dreamlike reflections of a world where endless violence bursts from beneath a placid surface, only to be turned into one sign among many and neutralized into meaninglessness. (MH)

Represented by Sprovieri D15

The Cow with the Crystal Claw
2001
Oil on canvas
195×195cm
Photo: Simon Vogel
Courtesy Galerie Christian Nagel

Merlin **Carpenter**

Born 1967
Lives London

Merlin Carpenter recently made a painting entitled *What It's Like To Be Hated* (2003). Four sinister figures – one of whom has a head that looks like something made by Barbara Hepworth – lurk in a landscape littered with abstract sculptures and a pair of red, disembodied lips. Like all of Carpenter's paintings, the messy paint application and clumsy drawing evoke an approach popular in the 1980s. His titles mix alienation with humour – they include *My Father, the Castaway* (2001) and *The Eternal Battle between Land Rovers and Centaurs* (2002). Carpenter's approach is, however, far from naive – not 'about seeking or finding a universal language […] but about insisting that what is done in painting is entirely legible and non-mysterious on a formal level'. (JH)

Represented by Galerie Christian Nagel E4

Selected Bibliography

2002 'An der langen Leine' (On a long leash), Michael Krebber, *Texte zur Kunst*, 46, June
Militant, Galerie Christian Nagel, Cologne

2000 *As a Painter I Call Myself the Estate of*, Merlin Carpenter, Secession, Vienna

1996 Isabelle Graw, *Texte zur Kunst*, 23, August

1993 *Meet You by the Strange Twisted Old Oak Tree on the Secluded Knoll at Dawn in Your Swimming Trunks and I'll Tell You Something Secret*, MC and Nils Norman for fictional exhibition at Galerie Z, Göttingen

Selected Exhibitions

2003 'Children of the Projects', American Fine Arts at PHAG Inc., New York

2002 'Militant', Galerie Christian Nagel, Cologne

2000 'When You Drain a Pool, You Don't Consult the Frogs First', Magnani, London
'As a Painter I Call Myself the Estate of', Secession, Vienna

1999 'Survivors', Galerie Christian Nagel, Cologne

1998 'Chant No 1', Galerie Max Hetzler, Berlin

1996 Friedrich Petzel Gallery, New York

1994 Metro Pictures, New York

1992 'Meadow/Wiese', Galerie Max Hetzler, Cologne

1991 'To the extreme', Fettstrasse 7A (Birgit Küng), Zurich

Wildschwein
(Wild Boar)
2002
Fibreglass, wine
Life-size
Courtesy Galerie Francesca Pia

Selected Bibliography

2002 'Les vertiges de la rétine'
(vertigo of the retina), Gauthier
Huber, *Kunstbulletin*, April

2001 *Accross/Art/Suisse 1975–2000*,
Lionel Bovier, Skira Milan, Geneva
'Valentin Carron, CAN,
Neuchâtel', *frieze*, 60, July–August

Selected Exhibitions

2003 'Freelander', Alimention
Générale, Luxembourg
'Musollaici', Centre Culturel Suisse,
Paris
'Fink Forward', Kunsthaus Glarus
Prague Biennale

2002 'The Golden Week',
Kodoma, Osaka
'After the Hunting Rush',
Circuit, Lausanne
'Jeep, Heep, Heep', Galerie
Francesca Pia, Bern
'Sweet Revolution', Fri-Art,
Fribourg

2001 'Rock, Paper, Scissors',
Galerie Francesca Pia, Bern

Valentin **Carron**

Born 1977
Lives Martigny

The young Swiss artist Valentin Carron works
with an Alpine aesthetic of the sort seen lately in
*Wallpaper** – faux-bois surfaces, obsolete snow
bicycles from the 1970s known as 'ski-bobs', piles of
ersatz snow made from cast resin. Carron achieves
the 'finish fetish' surfaces of his projects with the help
of local artisans, giving his work an aspect of
regional pride. Carron has also shown performance-
based pieces such as a gallery splattered floor to
ceiling with red wine, a nod to Abstract Expressionist
alcoholism. (KR)

Represented by Galerie Francesca Pia C3

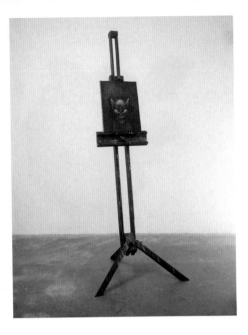

Jake, Sunday Morning
2003
Painted bronze
212×81×73cm
Photo: Stephen White
Courtesy White Cube

Jake & Dinos **Chapman**

Born 1965/1962
Live London

Since they burst noisily on to the British art scene in the mid-1990s with life-size mannequins of children whose faces and bodies bristled with sexual organs, Jake & Dinos Chapman have been remarkably consistent in encouraging viewers to gawk at the unpalatable and, ideally, to analyse their scopophiliac tendencies. Their subject matter, however, has changed regularly: from remakes of Goya's 'Disasters of War' (1810–14) etchings through an intricately modelled, Hieronymus Bosch-like vision of a concentration camp, to their recent cod-ethnological conflations of tribal art and McDonalds. That the Chapmans rarely seem short of a new nasty focus for their attention says as much about the compounded horror of our present and recent past as it does about their own fecundity. (MH)

Represented by Counter B13, White Cube F6

Selected Bibliography

2002 *Works from the Chapman Family Collection*, Suhail Malik, Jay Jopling/White Cube

2001 *Francisco Goya and Jake and Dinos Chapman: The Disasters of War*, Stéphane Aquin, Musée des Beaux-Arts de Montréal, Québec

1997 *Sensation. Young British Artists from the Saatchi Collection*, Brooks Adams et al. Royal Academy of Arts, Thames & Hudson, London
Unholy Libel, Jake Chapman, Interview with Robert Rosenblum, Gagosian Gallery, New York
Chapmanworld, Nick Lande, ICA, London

Selected Exhibitions

2003 White Cube, London
Museum Kunst Palast, Dusseldorf
Modern Art, Oxford

2001 'A Baroque Party' Kunsthalle Vienna

2000 'Apocalypse', Royal Academy of Arts, London

1999 White Cube, London
Gagosian Gallery, New York

1997 'Sensation: Young British Artists from the Saatchi Collection', Royal Academy of Arts, London and touring

Sinisa's Broken Nose 2002
2002
Lambda print mounted on dibond
Edition of 4
61×76.5cm
Courtesy Kerlin Gallery

Selected Bibliography

2002 'Real Society', Project and
interview with Michele Maccarone,
Sherman, Winter
'Merry Christmas Mr. Collins',
project with essay by Sinisa
Mitrovic, *artext*, Fall
'Becoming More Like Us' and
'Bad Infinity', review by Caomhin
MacGiolla Leith, *Artforum*, Summer
Interview with Maurizio Cattelan,
Purple 11, Spring
'Phil Collins: Face Value',
interview with Michele Robecchi
and Massimiliano Gioni, *Flash Art*
January–February

Selected Exhibitions

2003 'Phil Collins: Real Society',
Ormeau Baths, Belfast
'Baghdad Screen Tests', Meeting
House Square, Dublin

2002 'Sinisa and Sanja', The
Wrong Gallery, New York
'Bad Infinity 2', Locust Projects,
Miami
'Becoming More Like Us',
Artopia, Milan
'Bad Infinity', Kerlin Gallery,
Dublin
'Hi(story)', Salzburger Kunstverein,
Salzburg

2001 'Uniform: Order and
Disorder', PS1, New York
'Pandaemonium', The Lux,
London

2000 Manifesta 3, Moderna
Gallery, Ljubljana

Phil **Collins**

Born 1970
Lives Brighton/Belfast

Describing his camera in a recent interview,
Phil Collins commented that it 'could be said to steal
your soul, or document accurately, or all the other
fictions put about about this small plastic box and
its magic film'. This awareness of the frailty of his
chosen media (Collins also works in video) inflects his
work, which characteristically focuses on individuals
dealing with the hangovers of war, violence and loss.
Collins approaches his subjects – who range from
members of the Orange order to citizens of Ba'ath
Party-era Iraq – with purposeful intimacy, hoping
to circumvent the cold, controlling eye of the
documentary mode. (TM)

Represented by Kerlin Gallery F16, maccarone inc.
H2

Untitled, January 21, 2002
2002
Pen and ink on Strathmore
Bristol paper
23×23cm
Courtesy Michael Kohn Gallery

Selected Bibliography

2002 *2002 BC: The Bruce Conner Story Part II*, Peter Boswell et al. Walker Art Center, Minneapolis
2002 BC (eight 16mm films by Bruce Conner on DVD), Michael Kohn Gallery, Los Angeles

2000 *Bruce Conner, Twenty-Two Inkblot Drawings, 1991–1999*, Kohn Turner Gallery, Los Angeles

1999 *Bruce Conner Drawings Vol. I, 1960–1968*, Kohn Turner Gallery, Los Angeles

1997 *Bruce Conner, Inkblot Drawings, Engravings, Collages*, Kohn Turner Gallery, Los Angeles

Selected Exhibitions

2003 'The Dennis Hopper One Man Show Vol. II', Susan Inglett, New York

2002–3 'Ce Qui Arrive', Fondation Cartier pour l'Art Contemporain, Paris

2002 'Ferus', Gagosian Gallery, New York
'A new digital transfer of Bruce Conner 16mm films', Michael Kohn Gallery, Los Angeles
'Anonymous, ANON, Anonymouse, Anon', Michael Kohn Gallery, Los Angeles
'Self-Medicated', Michael Kohn Gallery, Los Angeles

1999 '2000 BC, The Bruce Conner Story, Part II', Walker Art Center, Minneapolis and touring

1997 Whitney Biennial, Whitney Museum of American Art, New York

1996 'Hall of Mirrors: Art and Film since 1945', Museum of Contemporary Art, Los Angeles

1995 'Beat Culture and the New America: 1950–1965', Whitney Museum of American Art, New York and touring

Bruce **Conner**

Born 1933
Lives San Francisco

For an artist concerned with the condition of anonymity, Bruce Conner's influence and reputation stretches far and wide. Closely allied with the 1950s generation of Beats in San Francisco, he first came to attention with a series of assemblages exploring the social turbulence and Cold War paranoia of that era. In a career that embraced a wide range of media and strategies Conner's savagely satirical short films such as *A Movie* (1958) and *Report* (1963–7), meticulously edited from newsreel and B-movie footage, have become landmarks of experimental filmmaking. His approach, however, has also been consistently to undermine the art world cult of celebrity: 'I've joined Artists Anonymous. It's a 12-step programme […] I won't allow my work to be attributed to me. I won't acknowledge it. My art history has been completed.' (DF)

Represented by Michael Kohn Gallery E12

Almost Always is Nearly Enough
2002–3
Oil on canvas
152×213cm
Courtesy Modern Art

Selected Bibliography

2002 *Nigel Cooke*, Jake Chapman,
Modern Art, London
Still Life, Ann Gallagher, British
Council, London
Melodrama, Musée de Arte
Contemporanea, Vigo

1998 *New Contemporaries 98*,
published by New Contemporaries

Selected Exhibitions

2004 Art Now, Tate Britain,
London

2003 Andrea Rosen Gallery,
New York
'Dirty Pictures', The Approach,
London
'I see a Darkness', Blum & Poe,
Santa Monica
'Exploring Landscape: Eight Views
from Britain', Andrea Rosen
Gallery, New York

2002 'Still Life', British Council
touring show
'Melodrama', ARTIUM, Centro-
Museo Vasco de Arte
Contemporanea Vitoria-Gasteiz;
touring to Centro Jose
Guerrero/Palacio de los Condes
de Gabia, Granada
Modern Art, London
'Nigel Cooke', Chapman Fine Arts,
London

Nigel **Cooke**

Born 1973
Lives London

If God is in the detail, then the deity that rules
Nigel Cooke's painstakingly rendered apocalyptic
scenarios is indeed a cruel one. The work of this
emerging London-based painter depicts a dark world
where Old Testament vengeance is meted out amid
the fetid remains of a contemporary social order.
Extremes of scale and obsessive detailing create a
tongue-in-cheek Gothic land of theatrical Heavy
Metal imagery and terrifying visions, where smug
fashionistas are tortured by malevolent monkeys
under the sinister hex of omnipotent celestial eyes.
(DF)

Represented by Blum & Poe D9, Modern Art A1

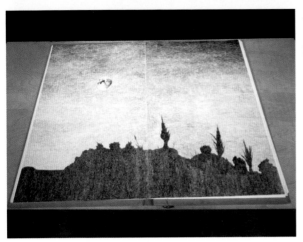

Atlas of Lunar Drawings
1996
Ink on paper and linen cover
Dimensions variable
Courtesy CRG Gallery

Russell **Crotty**

Born 1956
Lives Malibu

Russell Crotty spends his nights stargazing. Observing the sky from a home-made observatory, he fills notebook after notebook with precise astronomical sketches. These studies are elaborated into meticulously detailed ballpoint drawings, sometimes suspended in Lucite spheres or assembled into enormous, almost sculptural books. The darkly glowing images – curiously pitched between scientific objectivity and crackpot amateur passion – bespeak an extraordinary patience. Crotty first attracted attention in the early 1990s with his gridded drawings of surfers – works that borrowed Minimalist structure to depict a particularly Californian take on the Sublime. While his subject has shifted, his concerns remain the same: location, repetition and 'the poetics of space'. (SS)

Represented by CRG Gallery F8

Selected Bibliography

2003 *Perspectives #138: Russell Crotty*, Lynn Herbert, Contemporary Arts Museum, Houston
Bigger Than Us, Russell Crotty and Kelly McLane, Michael Duncan, Phoenix Art Museum
Russell Crotty: Globe Drawings, Kemper Museum of Contemporary Art, Kansas City

2002 *Drawing Now: Eight Propositions*, Laura Hoptman, The Museum of Modern Art at Queens, New York

2001 *The Universe: A Convergence of Art, Music, and Science*, Armory Center for the Arts, Pasadena

Selected Exhibitions

2003 'Perspectives #138: Russell Crotty', Contemporary Arts Museum, Houston
'Globe Drawings', Kemper Museum of Contemporary Art, Kansas City
'Bigger Than Us, Russell Crotty and Kelly McLane', Phoenix Art Museum

2002 'Drawing Now: Eight Propositions', Museum of Modern Art at Queens, New York
CRG Gallery, New York
Hosfeldt Gallery, San Francisco

2001 'The Universe from My Back Yard', Art Center College of Design, Pasadena

2000 CRG Gallery, New York
Shoshana Wayne Gallery, Santa Monica
'Western Skies', Sabine Wachters Fine Art, Brussels

1998 'Hiding out on Solstice Peak', Dan Bernier Gallery, Los Angeles,

1997 'Atlases', Transmission Gallery, Glasgow

Aereopuerto Alterno
2002
Knives and wood
Dimensions variable
Courtesy kurimanzutto

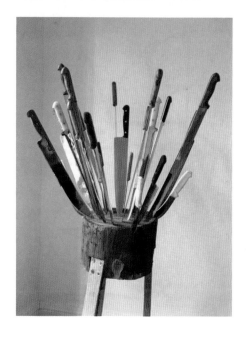

Selected Bibliography

2002 'Eduardo Abaroa, Jedediah
Caesar and Abraham Cruzvillegas',
Holland Cotter, *New York Times*, 2
August 2002

1999 *Taller General: Abraham
Cruzvillegas, Gabriel Kuri, Gabriel
Orozco, Damian Ortega*, Museo
Barbier-Muller d'Art
Precolombino, Barcelona

1994 'Limited arts funding sparks
a new kind of creativity', Elisabeth
Malkin, *Culture Club*, 6 February
1994

Selected Exhibitions

2003 'Abraham Cruzvillegas',
Jack Tilton, New York
'Abraham Cruzvillegas'
Contemporary Arts Museum,
Houston
'Il Quotidiano Alterato', Venice
Biennale
'The Squared Circle: Boxing in
Contemporary Art', Walker Art
Center, Minneapolis

2002 Inter.Play, Miami
'New Sculpture', Roberts and
Titon, Los Angeles
'Cruzvillegas, Caesar, Abaroa',
Jack Tilton, Anna Kustera Gallery,
New York
Saõ Paulo Biennale

2001 'Abraham Cruzvillegas',
MUCA, Mexico City
'El Curriculum Oculto', La
Esmeralda, Mexico City
'Escultura Mexicana. De la
Academia a la Instalacion', Palacio
de Bellas Artes, Mexico City

Abraham **Cruzvillegas**

Born 1968
Lives Mexico City

The unorthodox marriage of materials to be found
in the work of Abraham Cruzvillegas constitutes a
somewhat poetic form of genetics. Man-made
devices are grafted on to natural objects, tough
hardwearing surfaces can be found sprouting delicate
plumages, and animal hides present themselves as
malleable architectural materials. In *Warm Architecture
for Babies* (2002) for example, a dozen gardening
poles are splayed across seven lambskins, inviting,
as the title suggests, reconfiguration as an infant
shelter. *The Invincible* (2001) on the other hand,
appears aggressive by comparison. A rock used to
indicate a street address sports coloured feathers –
less an invitation to visit somewhere than a totemistic
warning to steer clear. Cruzvillegas' sculptures
deploy Arte Povera strategies to seemingly
ambiguously functional ends. (DF)

Represented by kurimanzutto B2

Double Bluff
2003
Acrylic on linen
195×162cm
Courtesy Kate MacGarry

Stuart **Cumberland**

Born 1970
Lives London

A disembodied, schematic arm seems to haunt Stuart
Cumberland's paintings. It hangs among robust,
rather macho abstract forms or stands perkily alone
against a monochrome background, as though some
Boys' Own modern master had torn it from his
shoulder in a fit of pique and decided to use it as a
brush. Although they're steeped in the work of his art-
historical forebears (Pablo Picasso, Fernand Léger
and Philip Guston spring immediately to mind),
Cumberland's witty, textural canvases have the odd
freshness of a familiar thing that you were not – right
now – expecting. (TM)

Represented by Kate MacGarry C19

Selected Bibliography

1996 *East International*, Norwich Art
Gallery

Selected Exhibitions

2003 'Stuart Cumberland', Kate
MacGarry, London

2002 '5 New Paintings', Tablet at
the Tabernacle, London

2001 'New Paintings', Royal
College of Art, London

2000 'Heart & Soul', Sandroni Rey,
Venice, California

1999 'Heart & Soul', 60 Long Lane,
London

1998 'Home & Away', Gavin
Brown's enterprise, New York

1997 'Gonzo', Bethnal Green Police
Station, London
'Still Things', The Approach,
London

1996 'East International', Norwich
Art Gallery

1993–4 'BT New Contemporaries',
National Touring Exhibition

Untitled
2003
Pencil, crayon on paper
78.5×62.5cm
Couresty Galerie Martin Janda

Selected Bibliography

2002 'Adriana Czernin', Sabine B. Vogel, *Artforum*, December
'Adriana Czernin', Friedrich Tietjen, *Flash Art*, November-December
Uncommon Denominator: New Art from Vienna, MASS MoCA, North Adams

2001 L'art de la chute' (The art of the fall), Elisabeth Wetterwald, *Parachute*, 101, January

Selected Exhibitions

2003 ATA-Center for Contemporary Art, Sofia
'Ausser Atem/Fokus österreichische Malerei', Nassauischer Kunstverein Wiesbaden
'Video Screening 04', Galerie der Stadt Schwaz
'Mimosen, Rosen, Herbstzeitlosen', Kunsthalle Krems

2002 'Uncommon Denominator/ New Art From Vienna', MASS MoCA, North Adams
Galerie Martin Janda, Vienna

2001 Galerie Martin Janda
Raum aktueller Kunst, Vienna
Galerie Almut Gerber, Cologne

2000 Wider Bild Gegen Wart, NICC Antwerp

1998 Galerie Esther Freund, Vienna

Adriana **Czernin**

Born 1969
Lives Vienna

To drown in a sea of flowers might be a pleasurable experience; the protagonists in Adriana Czernin's drawings, however, resist any such temptation. The pictures show young women struggling to avoid being immersed in fields of floral ornaments. Their bodies are on the verge of disappearing, but just manage to remain visible. Czernin's video works present metaphors for a similar conflict – the artist is shown trying to free herself from a headscarf printed with roses, or performing a warped dance routine in an open field with one foot tied to a post. It takes a persistent struggle, Czernin's works seem to suggest, to undo the link between femininity, nature and decorative beauty enforced by the traditional regime of patriarchal culture. (JV)

Represented by Galerie Martin Janda F14

Dinkelsbühl
2002
Watercolour on paper
114×161cm
Courtesy Galerie Barbara Thumm

Selected Bibliography

2003 'War in Watercolours –
Martin Dammann surprises with
aquarells/watercolours' Martin
Conrads, *Zitty*, May
'From the Galleries – Galerie
Barbara Thumm', Karl Heinrich,
Die Welt, 21 February 2003
Ulrich Clewing, *Tagesspiegel*, 22
February 2003

2001 'Ziel und Spur von Bildern –
Zur "Eagle"-Serie von Martin
Dammann' (Goal and Trail of
Images – Remarks on the 'Eagle'
Series by Martin Dammann), *IBM-
Kunstpreis Neue Medien*, Christian
Janecke, Kunstsammlung Gera

2001 *Einsiedler – Vorübergehend*
(Eremit – passing), Martin
Dammann, Museum Folkwang
Essen

Martin **Dammann**

Born 1965
Lives Berlin

Martin Dammann is an avid analyst of visual culture.
He appropriates imagery from television, military or
photographic archives to rework them in video
montages, collages and watercolours. In the collages
film sequences are broken down into cubist
compositions. In his recent watercolours Dammann
paints from photographs with an unclear origin and
history: there are images of a German small town
street or a local carnival parade but also scary scenes
like a GI in a fist fight with an adolescent or two
suspicious types on a park bench in a conspirative
meeting. Dammann's pictures give you a sense of the
subliminal crisis that has haunted petty bourgeois
normality in Germany from the 50s throughout the
cold war until today. (JV)

Represented by Galerie Barbara Thumm A4

Selected Exhibitions

2003 'New Works', Galerie
Barbara Thumm, Berlin

2002 Konrad-Adenauer-Stiftung,
Berlin

2001 'Einsiedler –
Vorübergehend'(Eremit – passing),
Museum Folkwang, Essen
'Pandaemonium', The Lux, London

2000 'Experimental Projects', PS1,
New York

1999 'Video Exhibition', Kunst-
Werke, Berlin

1998 'Between', Jacksonville
Museum of Contemporay Art,
Florida

1997 'Medienpaket' (Media
package), ZKM Karlsruhe; Goethe
Institute
'Hybrid Work Space' Documenta,
Kassel

1996 Video Award of ZKM
Karlsruhe

Tania Colouring her Hair
1995
C-type print
40×60cm
Courtesy Gimpel Fils

Selected Bibliography

2002 *Unseen Vogue*, Robin Derrick and Robin Muir, Design Museum, London

2001 *The Fantastic Recurrence of Certain Situations: Recent British Art and Photography*, Sala de Exposiciones del Canal de Isabel II, Conserjeria de Cultura, Madrid

2000 *Diary*, Corinne Day, Kruse Verlag, Hamburg
Imperfect Beauty: The Making of Contemporary Fashion Photography, Charlotte Cotton, Victoria and Albert Museum, London

1999 *Trade Secrets: Young British Talents Talk Business*, ed Cynthia Rose, Thames & Hudson, Hong Kong

Selected Exhibitions

2002 'Unseen Vogue: The Secret History of Fashion Photography', Design Museum, London
'Fashion Photographs, Nude/Action/Body', Tate Modern, London
'Chic Clicks', Institute of Contemporary Art, Boston and touring

2001 'No Attitude Allowed', InsideSpace, London
'The Fantastic Recurrence of Certain Situations: Recent British Art and Photography', Sala de Exposiciones del Canal de Isabel II, Conserjeria de Cultura, Madrid

2000-1 'Imperfect Beauty: The Making of Contemporary Fashion Photography', Victoria and Albert Museum, London

2000 'Corinne Day: Tara', Gimpel Fils, London
'Corinne Day: Diary', The Photographers' Gallery, London

1994 'A Positive View', Saatchi Gallery, London

Corinne **Day**

Born 1965
Lives London

Corinne Day's photographs are filled with ebullience, brutality and tense, dull fears. Her early fashion shots of Kate Moss beaming in *The Face*, or skinny and scowling in baggy knickers in a heroin-chic *Vogue* spread, prefigure the formal and emotional range of her later work. Day's recent, more documentary photographs have focused on the pleasures and pains of her Stoke Newington social circle. Here a fraught continuum of drug use, hazy sex and parental responsibility is presented with an honesty and warmth that recall the work of Nan Goldin and Richard Billingham. (TM)

Represented by Gimpel Fils D1

Section Cinema
2002
16mm film, colour with optical
sound
13 minutes
Courtesy Frith Street Gallery

Tacita **Dean**

Born 1965
Lives Berlin

Tacita Dean's evocative 16mm films and drawings
meditate on history and the passage of time, be it the
revolving restaurant high up in Berlin's Fernsehturm,
bathers in Budapest's steam baths or the tale of
Donald Crowhurst, the British solo yachtsman who
went missing at sea. Like the oceanic planet that is a
residuum of memory in Stanislav Lem's *Solaris* (1972),
the sea is central to Dean's work, in which celluloid
records tales of loss and adventure on the high seas.
(DF)

Represented by Frith Street Gallery C4, Marian
Goodman Gallery C8

Selected Bibliography

2003 *Tacita Dean*, ARC Musée d'Art
Moderne de la Ville de Paris and
Steidl Verlag, Göttingen

2001 *Tacita Dean – Recent Films and
Other Works*, Clarrie Wallis et al,
Tate Publishing, London
Tacita Dean, Roland Groenenboom
and Tacita Dean, Museu d'Art
Contemporani de Barcelona

2000 *Tacita Dean*, Museum für
Gegenwartskunst, Basel

1999 *Teignmouth Electron*, Tacita
Dean, Book Works and National
Maritime Museum, London

Selected Exhibitions

2003 ARC Musée d'Art Moderne
de la Ville de Paris
Kunstverein für die Rheinlandes und
Westfalen, Dusseldorf

2001 'Tacita Dean', Tate Britain,
London
Museu d'Art Contemporani de
Barcelona

1998 'Tacita Dean', Institute of
Contemporary Art, Philadelphia

Untitled
2002
C-type print
55.5×41cm
Courtesy Art:Concept

Selected Bibliography

2002 *After the Gold Rush*, Editions CCAC, San Francisco

2001 *The English Civil War Part II, Personal Accounts of the 1984–85 Miners' Strike*, Jeremy Deller, Artangel, London

2000 *Life is to Blame for Everything*, Salon 3, Arts Council of England, London

Selected Exhibitions

2003 'Ill Communication', Dundee Contemporary Arts
'Utopia Station', Venice Biennale

2002 Art:Concept, Paris
'Rock my World', Californian College of Arts and Crafts, San Francisco

2001 'City Racing (A Partial History)', ICA, London
'The Battle of Orgreave', Orgreave, South Yorkshire, Artangel

2000 'Republic', Kunstverein, Graz
'Presumés Innocents', CAPC Musée d'Art Contemporain, Bordeaux
Tate Britain, London

Jeremy **Deller**

Born 1966
Lives London

Jeremy Deller's work explores vernacular culture and episodes from recent history. His collaborations with often overlooked individuals have resulted in works such as *The Uses of Literacy* (1997), an exhibition of sophisticated, heart-breaking art and poetry by Manic Street Preachers fans, and *The Battle of Orgreave* (2001), a project in which the ex-picket residents of a Yorkshire pit village restaged one of the bloodiest clashes of the miners' strike. More recently Deller has attempted to map America's cultural topography. A book-cum-treasure-trail, *After the Goldrush* (2002) is a work in which X marks the spot of nameless, sad-eyed dreams. This is art that weakens history's hold and offers – for a moment at least – fresh freedoms to the disenfranchised and the forgotten. (TM)

Represented by Art:Concept G7, The Modern Institute G8

Lichtung
(Clearing)
2003
Offset print on affiche paper
330×925cm
Courtesy 303 Gallery and Victoria
Miro Gallery

Selected Bibliography

2003 Jörg Heiser, *frieze*, 73 March
Thomas Demand, Susanne
Gaensheimer, Collier Schorr,
Neville Wakefield and Jeffrey
Eugenides, Lenbachhaus Munich;
Louisiana Museum of Modern Art,
Humlebaek

2001 *Thomas Demand*, Holger Liebs,
Yilmaz Dwiezior, and Ulrike
Schneider, Sprengel Museum,
Hanover
'Doubt the Day', Adrian Searle,
Parkett, 62
'Memoryscapes', Ruby Andreas,
Parkett, 62

Thomas **Demand**

Born 1964
Lives Berlin

In his Berlin studio Thomas Demand builds precise
life-size paper replicas of environments, based on
existing images of real incidents – and then throws
them away after he has photographed or filmed
them. Some may still, years later, recognize that
Tunnel (1999) – a tracking shot from a driver's
perspective through an empty tunnel lined by
concrete pillars – is modelled on the Paris underpass
where Princess Diana died, but the reference is never
spelt out. Generally, Demand's work is not about
illusionist effect. The confusion over the story 'behind'
the scene is a welcome part of the work's reception:
it produces gaps through which we can glimpse,
with surprised eyes, the stripped-down designs of the
modern world. (JöH)

Represented by 303 Gallery C12, Taka Ishii Gallery
G9, Victoria Miro Gallery F4, Schipper & Krome E8

Selected Exhibitions

2003 Louisiana Museum of
Modern Art, Humlebaek
'Interludes', Venice Biennale

2002 Castello di Rivoli, Museo
d'Arte Contemporanea, Turin
Lenbachhaus, Munich

2001 De Appel, Amsterdam
Sprengel Museum Hanover

2000 Fondation Cartier pour l'Art
Contemporain, Paris

1999 'Art Now 17', Tate Gallery,
London
'Great Illusions- Demand, Gursky,
Ruscha', The Museum of
Contemporary Art, North Miami

1998 Kunsthalle Zurich

Above the City
2001
Lambdachrome
180×223cm
Courtesy Entwistle

Sarah **Dobai**

Born 1965
Lives London

A photographer and filmmaker often compared to an adept novelist, Sarah Dobai uses actors, props, establishing shots and digital tweaking as narrative aids. Yet her art of the past decade is not predominantly an analysis of photographic 'truth' but a meditation on human struggle. The woman in *Into the Desert* (2001) has reached the end of her tether, slumped over a freezer cabinet; the couple in *Red Room* (2001) are having sex that feels like a transaction. What is truly unnerving about Dobai's work, however, is its doubled effect: her perfected technique alternately convinces us of her world's reality and highlights its artifice. We feel the characters' pain and the actors' hard-won concentration, and each exertion reinforces the other. (MH)

Represented by Entwistle E2

Selected Bibliography

2003 *Two on a Party*, ArtLab

2000 *Sarah Dobai, Patio de Escuelas*, Imago 2000, Salamanca University

Selected Exhibitions

2003 'Sodium Dreams', Bard College, New York

2002 'Sarah Dobai', Artists' Space, New York

2000 'Patio de escuelas', Imago 2000, Centre of Photography, Salamanca; Museum of Contemporary Art, Santiago di Compostela

1999 'Turnaround Project', Hayward Gallery, London
'Another Girl, Another Planet', Greenberg van Doren, New York

1998 'Sightings: New Photographic Art', ICA, London

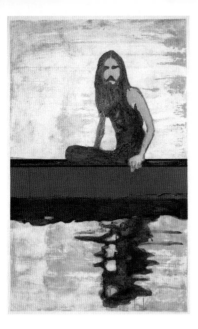

100 Years Ago
2002
Etching
166×111.5cm
Courtesy The Paragon Press

Peter **Doig**

Born 1959
Lives London

Peter Doig has commented, 'I don't think I'm a realist.' Although his paintings and works on paper are often inspired by photographs, they tend to evoke altered states of mind. Roads, oceans and rivers dominate, but the journeys they hint at are usually solitary ones. Surfaces are uneven, animated and occasionally tired. Doig is equally in thrall to 19th-century painting and 1970s bands, the sky and skin. These are narratives that have no story to tell except the ones you tell yourself. They draw you in as effectively as a camp fire – images of exile that make you feel less alone. (JH)

Represented by Contemporary Fine Arts D4, GBE (Modern) D5, Galerie Ghislaine Hussenot F15, Victoria Miro Gallery F4, The Paragon Press A5, Ridinghouse G15

Selected Bibliography

2002 *100 Years Ago*, Victoria Miro Gallery, London

2000 *Almost Grown, Paintings by Peter Doig*, Douglas Hyde Gallery, Dublin and Victoria Miro Gallery, London

1998 *Peter Doig: Blizzard Seventy-seven*, Terry R. Myers et al, Kunsthalle zu Kiel, Kunsthalle Nuremberg; Trustees of the Whitechapel Gallery, London
Peter Doig/Udomsak Krisanamis, Arnolfini, Bristol; Fruitmarket Gallery, Edinburgh

1995 *Peter Doig: Blotter*, Contemporary Fine Arts, Berlin; Victoria Miro Gallery, London

Selected Exhibitions

2002 '100 Years Ago', Victoria Miro Gallery, London

2001 National Gallery of Canada, Ottawa

2000 'Echo Lake', Matrix, University of California, Berkeley touring to Museum of Contemporary Art, Miami; Saint Louis Art Museum
'Almost Grown', Douglas Hyde Gallery, Dublin

1999 'Version', Kunsthaus Glarus

1998 Kunsthalle, Nuremberg
Whitechapel Art Gallery, London

1996 Gesellschaft für Aktuelle Kunst, Bremen

1994 Turner Prize, Tate Gallery, London

1993 '1st Prize Exhibition 18', John Moores Prize, Liverpool

between the morning and the handbag
2002
35mm film on DVD
4 minutes 13 seconds
Courtesy carlier | gebauer and
Wilkinson Gallery

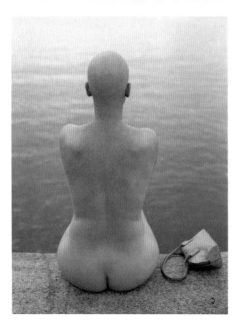

Selected Bibliography

2001 *It could happen to you*, Film &
Video Umbrella, text Steven
Bode/interview Elle Carpenter,
NGCA Sunderland and South
London Gallery, London
Anne Katrine Dolven, Kunsthalle
Bern; Kunsthalle Nuremberg

Selected Exhibitions

2004 Mead Gallery, University of
Warwick

2003 'The Meal: A K Dolven',
Anthony Wilkinson, London

2002 'Galleries Show', Royal
Academy/Anthony Wilkinson
Gallery, London
'Stairs: A K Dolven', Staatliches
Museum, Schwerin
'2:57: A K Dolven',
carlier | gebauer, Berlin
'A K Dolven', Henie Onstad
Kunstsenter, Oslo

2001 'A K Dolven', South London
Gallery
'A K Dolven', Kunsthalle Bern
Kunsthalle Nuremberg

2000 'The Other side of Zero',
Tate Liverpool

A K **Dolven**

Born 1953
Lives London

Oslo-born Anne-Katrine Dolven makes videos and
photographs of individuals and couples in intense
states of absorption. She trained as a painter, and it
shows: her video portraits, while updated by burbling
techno and drum 'n' bass soundtracks, often make
reference to well-known paintings and their
compositions are invariably almost static. As a result
we become hypersensitive to depicted body language
– that of the couple entwined on the bed in *It Could
Happen To You* (2001), for instance, or of the
headphones-sporting nude girl in Dolven's update
of Edvard Munch's *The Kiss* (2000). And, although
narrative is denied, the sense that we have had a
real-time encounter with a vulnerable, seemingly
present other is palpable. (MH)

Represented by carlier | gebauer H9,
Wilkinson Gallery E1

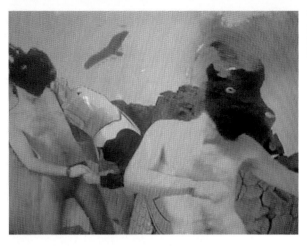

Peter **Donaldson**

Born 1977
Lives Tokyo

The relationship between King Nebuchadnezzar II and the production of contemporary video art is not one often explored. Currently living and working in Japan, emerging Scottish artist Peter Donaldson, like an eccentric contemporary Orientalist, revisits myths of old via cult Japanese television and early 1980s pop videos. Using simple props and the language of obsolete video special effects, Donaldson's recent work *The Fall of Babylon* (2002) reworks the tale of the arrogant Nebuchadnezzar's hubris and subsequent divine punishment. Delusions of grandeur are reflected in the tacky glamour of the music promo, and the pathos of the ancient morality tale is punctured by the bathos of Donaldson's modest lo-fi sensibility. (DF)

Represented by Transmission Gallery B17

Selected Bibliography

2003 'Best in Show', Neil Mulholland, *The Scotsman*, February

Selected Exhibitions

2003 'The Haunted Swing', Collective Gallery, Edinburgh
'Design Festa Arts Festival', Tokyo
'Peter Donaldson, Kalin Lindena, Tobias Putrih', Transmission Gallery, Glasgow

2002 'The Dirt of Love', Transmission Gallery, Glasgow
'Degree Show', Edinburgh College of Art

Suspiria: Camera 1 and 2
2002
C–type print mounted on
gatorboard
145×122cm
Courtesy David Zwirner

Selected Bibliography

2003 *Stan Douglas: Film Installationen,* Kestner Gesellschaft, Hanover

2002 *Documenta 11 Platform 5: Exhibition*, Museum Fridericianum, Kassel

2001 *Stan Douglas*, Kunsthalle Basel

2000 *Double Vision, Stan Douglas and Douglas Gordon*, Dia Center for the Arts, New York

1999 *Stan Douglas*, Daina Augaitis, George Wagner and William Wood, Vancouver Art Gallery

Selected Exhibitions

2003 'Stan Douglas: Film Installations and Photographs', Kestner Gesellschaft, Hanover
'Suspiria', David Zwirner, New York

2002 'Stan Douglas', Serpentine Gallery, London
Documenta, Kassel

2001 'Stan Douglas: Le Detroit', Kunsthalle Basel; Hamburger Bahnhof, Berlin

2000 'Le Detroit', Art Institute of Chicago

1999 'Stan Douglas', Vancouver Art Gallery, and touring
'Double Vision, Stan Douglas and Douglas Gordon', Dia Center for the Arts, New York
'Stan Douglas: Pursuit, Fear, Catastrophe: Ruskin B.C.', Fondation Cartier pour l'Art Contemporain, Paris

1998 'Stan Douglas' Kunstverein, Salzburg

Stan **Douglas**

Born 1960
Lives Vancouver

Like a movie camera rotating around its subject, Stan Douglas's film and video work circles around meaning to create multiple shifts in perspective. Time slips and slides – scenes are replayed (often across a number of screens) in endless loops, dialogue moves in and out of sync with action, and restaged scenes from literary and cinematic history are collapsed together to form scenarios heavy with interpretative possibilities. Often referencing canonical novels and Hollywood classics, Douglas turns the grammar and syntax of the moving image upside-down to render transparent the mechanisms that keep their orthodox narratives ticking. (DF)

Represented by David Zwirner F5

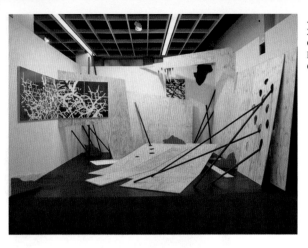

Symptom & Folie
2002
Cardboard, paper, wood
Dimensions variable
Courtesy Galerie Gebr. Lehmann

Selected Bibliography

2002 *Dorothea von Stetten-Kunstpreis*, Harald Kunde, Kunstmuseum Bonn
Markus Draper, Mauerblümchen – Wallflower, Jan Avgikos, Philip Morris Kunstförderung

2001 *Markus Draper*, Friedrich Meschede, Marion Ermer Prize
Success – Junge Kunst aus Dresden (Young Art from Dresden), Torsten Birne, Kunsthaus Dresden

2000 *Bildwechsel* (Image swap), Henrik Winkler, Kunstsammlung, Gera

Markus **Draper**

Born 1969
Lives Berlin

In Markus Draper's installation pieces thick black liquid seems to ooze from the gaps between wooden panels or from underneath stud partitions. His paintings show brick walls with smudges of colour, alien graffiti or bullet holes dripping with blood. For Draper horror is as much a style as it is a psychic reality. Unidentifiable substances become fetishes of fear, yet, artificial as they obviously are, the special effects still make your hairs stand on end. After all, at the cinema you scream even though you know the blood is all fake. And when you scream, Draper's works seems to suggest, you do so not from fear of reality, but to express joy at the endless fascination of the visually repulsive. (JV)

Represented by Galerie Gebr. Lehmann C18

Selected Exhibitions

2002 'Symptom & Folie', Galerie Gebr. Lehmann, Dresden
'Förderkoje', Art Cologne
'Five Years', Galerie Jennifer Flay, Paris
'Dorothea von Stetten-Kunstpreis', Kunstmuseum Bonn
Galerie Michael Neff featuring Galerie Gebr. Lehmann, Frankfurt
'Split Points', Narodni Galerie, Prague

2001 'Schock Sensor', AR/GE Kunst Galerie Museum, Bozen
'Young Art from Europe', Fondazione Ado Furlan, Pordenone
'Modèles/Models', Art Workshop 01, Casino Luxembourg

2000 'Nächtelang' (Throughout the night), Galerie Gebr. Lehmann, Dresden

Your Spiral View
2002
Stainless steel
Installation view: Fondation Beyeler
Riehen/Basel, 2002
320×800cm
Courtesy neugerriemschneider and
Tanya Bonakdar Gallery

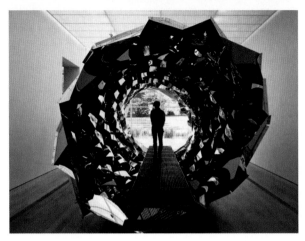

Selected Bibliography

2002 *Olafur Eliasson*, Phaidon,
London
*To the habitants in space in general and
the spatial inhabitants in particular*,
Einar Thorsteinn/ Olafur Eliasson,
Bawag Foundation Edition
*Olafur Eliasson: Chaque matin je me
sens différent, chaque soir je me sens le
même* (Each morning I feel different,
each evening I feel the same),
Musée d'Art Moderne de la Ville
de Paris
Surroundings surrounded; ed. Peter
Weibel, MIT Press, Cambridge

2001 *Olafur Eliasson: your only real
thing is time*, Institute of
Contemporary Art, Boston
Parkett, 64

Selected Exhibitions

2003 Tate Modern, London
Danish Pavilion, Venice Biennale
'Funcionamiento silencioso',
Reina Sofia, Madrid

2002 'Chaque matin je me sens
différent, chaque soir je me sens le
même' (Each morning I feel
different, each evening I feel the
same), Musée d'Art Moderne de
la Ville de Paris

2001 'Aperto', Venice Biennale

2000 'Surroundings Surrounded,'
Neue Galerie, Graz

1998 The Very Large Ice-Floor,
Saõ Paulo Biennale
'Seeing yourself Sensing', MoMA,
New York
'The Mediated Motion', Kunsthaus
Bregenz
Galerie für Zeitgenössische Kunst,
Leipzig

1997 'The Curious Garden',
Kunsthalle Basel

Olafur **Eliasson**

Born 1967
Lives Berlin

' "Hi there landscape!" I say, and look before me …
"Hi Olafur!" I decide the landscape answers',
states Olafur Eliasson, a Romantic landscape artist
of the technological age. His elegant, ingenious
installations deftly put nature, science and
technology at the service of each other. Waterfalls
flow backwards, mists shroud gallery interiors,
rivers run bright green and museum walls grow moss.
His practice is a personal meteorology observing the
pressure systems and shifting patterns that are
affected by humanity and nature. (DF)

Represented by Tanya Bonakdar Gallery E7,
Marc Foxx G12, neugerriemschneider C6

Laurence **Elliott**

Born 1979
Lives Glasgow

Hysterical heads and collapsing buildings peer from clusters of various-sized paintings and drawings; Laurence Elliott's pictures are like warning signals for something unspecified and malevolent. But if they are more comic than tragic, it's because Elliott's intentions are as enigmatic as his paint application is intentionally 'bad'. To help clarify matters he produces fanzines, which he thinks of as instruction manuals for his paintings. 'Drawing', he has commented 'is the most efficient tool I have at my disposal, intended to make conceptual jabs that cause sinners to feel itchy.' Elliott also writes soundtracks for his pictures with his band, Chorus of Gastornis. (JH)

Represented by Transmission Gallery B17

Selected Bibliography

2003 'Hampstead Achieved', Neil Mulholland and Alex Pollard, *Untitled* 29, Winter-Spring

Selected Exhibitions

2003 'New Contemporaries', Cornerhouse, Manchester and touring
'A Few Foughts for a New Year', Bognor Pier, Bognor Regis

2002 'There's the Trouble with a Lot of Things, Actually', Vic Gallery, Glasgow School of Art
'Alleslinkserum', X-Garten, Ostkervez, Kreuzberg, Berlin
'Hampstead Achieved', K Jacksons, Edinburgh
'Rob Churm, Laurence Elliott, Iain Hetherington, Massimo Franco, John Mullen', Transmission Gallery, Glasgow

2001 'Creative Use of Vagueness', Glasgow School of Art
'Another Nail through me Wrists, another Feather in me Hat' Assembly Gallery, Glasgow School of Art

Landslide
2002
Dustbin, rubbish sacks, trash bag,
various items
305×120×300cm
Courtesy Klosterfelde

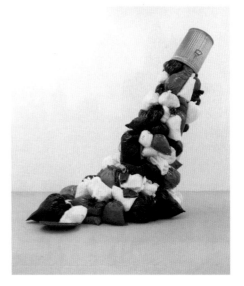

Selected Bibliography

2003 *Spaced Out*, Portikus,
Frankfurt

2002 *Michael Elmgreen & Ingar
Dragset:Taking Place*, ed Beatrix Ruf,
Kunsthalle Zurich; Hatje Cantz
'White on White. The Art of
Michael Elmgreen & Ingar
Dragset', Daniel Birnbaum,
Artforum, April

2000 *Zwischen anderen Ereignissen*,
Galerie für Zeitgenössische Kunst,
Leipzig
'White Out', Lars Bang Larsen,
frieze, 53, June–August

Selected Exhibitions

2003 'Utopia Station', Venice
Biennale
'Spaced Out', Portikus, Frankfurt
Fondazione Trussardi, Milan

2002 'How Are You Today?',
Galleria Massimo de Carlo, Milan
Saõ Paulo Biennale

2001 'Taking Place', Kunsthalle
Zurich
'Linienstr. 160', Klosterfelde, Berlin
'Powerless Structures, Fig. 111',
Portikus, Frankfurt

2000 'Zwischen anderen
Ereignissen' (Between other Events),
Galerie für Zeitgenössische Kunst,
Leipzig

Michael **Elmgreen** & Ingar **Dragset**

Born 1961/1969
Live Berlin

Bomb the white cube! Or better still, let it die a slow, lingering death. In their installation works Elmgreen & Dragset have subjected the white-walled exhibition space, the modern symbol of neutrality and purity, to all kinds of manipulation, carried out in a spirit of playful investigation and gleeful sadism. They have buried a gallery space in a field, installed another white cube as a pavilion in a cruising area in a park, and drilled glory holes into gallery walls, then spent weeks painting them white over and over again. Many of these works Elmgreen & Dragset call 'powerless structures,' a term to indicate that, while it may be an element that art cannot do without, the white cube itself is a plastic material to be used or be abused at will. (JV)

Represented by
Tanya Bonakdar Gallery E7, Taka Ishii Gallery G9, Klosterfelde B9, Galleri Nicolai Wallner B12

10th St. Bridge, Atlanta
2003
C-tpe print
84×104cm
Courtesy greengrassi

Roe **Ethridge**

Born 1969
Lives New York

Behind the hyper-clarity and glowing surfaces of Roe Ethridge's photographs something odd is going on. It's never spelt out exactly; the subjects of his genre-hopping work range from the banal to the bucolic – UPS labels, pine trees, fashion models, stop-motion close-ups of pigeons in flight – all depicted with cool reserve and flawless technical mastery. Yet it's hard to arrive at a clear and stable reading for these disparate images: some arcane web of connections seems to link one to another. While the beauty of Ethridge's photography is self-evident, its power comes from resonant gaps in the viewer's understanding. (SS)

Represented by greengrassi A3, Andrew Kreps Gallery B10

Selected Bibliography

2002 'Reviews, Roe Ethridge', Martha Schwendener, *Artforum*, October
'Roe Ethridge', Tim Griffin, *Time Out New York*, 30 May 2002
'Roe Etheridge', Gus Powell, *The New Yorker*, 27 May 2002

2001 *the americans. new art*, Mark Sladen, Barbican Art Gallery, Booth-Clibborn Editions, London

2000 *Roe Ethridge, Bennett Simpson, Greater New York*, Museum of Modern Art/PS1, New York

Selected Exhibitions

2003 'Roe Ethridge', greengrassi, London
'Answered Prayers', Cameraworks, Berlin

2002 'Bystander', Andrea Rosen Gallery, New York
'The Bow', Cheekwood Museum of Art, Nashville; Andrew Kreps Gallery, New York
'Hello my name is...', Carnegie Museum of Art, Pittsburgh

2001 'the americans. new art', Barbican Art Gallery, London
'Rocks and Trees', Photographic Resource Center, Boston

2000 'Young Pines, Model Portraits, UPS Drivers, Ambulance Accident', Andrew Kreps Gallery, New York
'Greater New York', PS1, New York

Diagram of Love
2002
Mixed media on paper
30.5×48cm
Courtesy Jack Hanley Gallery

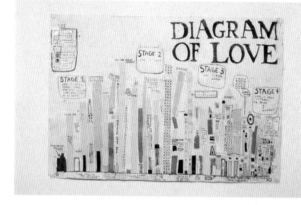

Simon **Evans**

Born 1972
Lives San Francisco

Charts, lists and plans map out Simon Evans'
humorously misanthropic take on the world.
Decidedly handmade and lo-fi, lists such as *All That's
Wrong with Sex* (2002) and *100 Reasons Why I Hate the
Irish* (2002) are decidedly unhinged bullet point
polemics, observing that sex is 'like fighting but
wetter' or that Ireland is 'not a place for the spiteful'.
His map of the universe (*The Universe*, 2003) notes
previously undiscovered constellations including 'the
hand that takes' and 'the star of much longing',
while his *Traveller's Map of Heaven* (2003) depicts the
hereafter as an ornamental garden replete with
lakes of bottled water and an antique toilet.
These meticulously detailed stoner cartographics
and whimsical diagrams offer an acute take on
a whacked-out world. (DF)

Represented by Jack Hanley Gallery G4

Selected Exhibitions

2003 Jack Hanley Gallery, San
Francisco
'The Dropout Show', China Art
Objects Galleries, Los Angeles

The Charisma Police, still from the performance *A Rite of Passage (from T-shirts into Shirts)*
2003
Courtesy Anthony Reynolds Gallery

A war machine that does not assume war as its object. Charisma police, a free-forming posse that commits to assault in the name of the fraternal, and not for the equal. A murderous, pitiless line of flight that knows no strategy, only the absolute war of chance, vagary, and seduction.

Keith **Farquhar**

Born 1969
Lives Edinburgh

Scottish artist Keith Farquhar's work is about dragging the stuff that surrounds you into a place that you find beautiful. Making use of the bland, mostly tourist-targeted stuff of 'official' Caledonian culture (Pringle golf pullovers, Charles Rennie Mackintosh-style typefaces, Edinburgh's firework displays) and more intimate items such as his grandmother's musquash coat, the artist makes objects that hum with political and personal associations. A three-way negotiation between national stereotypes, his family background and knowing, art-school cool, Farquhar's works insist – like the most compelling people – on their own awkward, individual loveliness. (TM)

Represented by doggerfisher C21, Galerie Neu E10, Anthony Reynolds Gallery D3

Selected Bibliography

2002 'Herkunftsmuster' (Patterns of Heritage), Emily Pethick, *Texte zur Kunst*, June
The Best Book about Pessimism I Ever Read, Kunstverein Braunschweig
Tom Morton, *frieze*, 65, March 2002
'Show Jumper', Niru Ratnam, *The Face*, January

Selected Exhibitions

2003 'A Rites of Passage (from T-shirts into Shirts)', Galleria Laura Pecci, Milan
'Nation', Kunstverein, Frankfurt

2002 'The Best Book about Pessimism I Ever Read', Kunstverein Braunschweig
'BlindCraft', Galerie Neu, Berlin
doggerfisher, Edinburgh

2001 'Mintview', Anthony Reynolds Gallery, London
'The Soft Parade' (with Craig Gibson), Window Gallery, Prague
'Phoenix Specific' (with Stefan Thater), Kunsthaus Hamburg

2000 'It may be a Year of Thirteen Moons but it's Still the Year of Culture', Transmission Gallery, Glasgow
'Nouveau Riche' (with Gary Webb), The Approach, London

Space Cowboys
2001
Painting under mirror
185×330cm
Courtesy Art:Concept

Selected Bibliography

2003 *Daniel Schlier*, Editions Musée d'Art Moderne et Contemporain, Strasbourg

2002 Richard Fauguet, *Cahiers du musée de l'Abbaye Sainte-Croix*, 97

1997 *Daniel Schlier: Les jours maigres, les jours gras* (The lean days and the fat days), Calais, Le Channel, Galerie de l'Ancienne Poste/Noisel

1996 *Richard Fauguet*, Éspace Jules Vernes, Centre d'art de Bretigny-sur-Orge

1995 *50 têtes regardant à gauche et à droite* (50 heads looking to left and right), Editions Sainte-Opportune, Bruxelles, J.F. Dumont, Bordeaux

Selected Exhibitions

2003 Armory Show, New York
'Colocataires' (Co-tenants) Centre d'Art Contemporain, Castres

2002 'Double Messieurs' (Double Gentlemen), Centre Régional d'Art Contemporain, Montbéliard
Musée de l'Abbaye Sainte-Croix, Les Sables d'Olonne

2001 Galerie Thomas Taubert, Dusseldorf

2000 FIAC, Paris

Richard **Fauguet** & Daniel **Schlier**

Born 1963/1960
Live Chateauroux/Strasbourg

When Richard Fauguet and Daniel Schlier collaborate on paintings, they are linked not only by the diverse use in their solo practises of materials such as lasagne, candles, dust, eggshells, urine and sweat but by their shared interest in the creation of unexpected associations between physical and abstract languages. Whereas Fauguet's installations often refer to 20th-century artists – he has titled pieces *Voyam Duchampsinus* and *Beuyus Divinare* – Schlier is a painter whose primary concern would appear to be the deferral and reanimation of meaning. Together they create paintings that might include myriad references to film, early photography, ping pong, the history of painting and dreams. (JH)

Represented by Art:Concept G7

Interview
2003
9-minute video with Lou Castel
Courtesy Galerie Karin Guenther

Jeanne **Faust**

Born 1968
Lives Hamburg

Jeanne Faust's photos and videos look as if they're extracts from non-existent films, loaded as they are with a blend of cinematic clichés and new sentiments. An admitted fan of Fassbinder, the Hamburg-based artist pushes the cinéaste's 'double vision' to the limit: quite willing to empathize with the scenario he presents, and yet completely aware of the cinematic conventions that produced it. In the context of artistic takes on cinema – Cindy Sherman, James Coleman, Sharon Lockhart, to name but a few – Faust clearly carves out her own approach. While her protagonists are locked in irritated gazes and muted interactions, the way cinema establishes a connection with the viewer – through shot and counter-shot, for example – becomes abstracted and juxtaposed with Baldessarian wit. (JöH)

Represented by Galerie Karin Guenther G10

Selected Bibliography

2003 *Jeanne Faust*, Tom Holert, Kunsthalle, Dusseldorf; Kunstverein, Heilbronn
Fabula, National Museum of Film, Photography and Television, Bradford

2002 *Manifesta 4*, Frankfurt

2000 'Jeanne Faust', Raimar Stange, *Flash Art*, January– February

Selected Exhibitions

2003 Kunstverein, Heilbronn
Galerie Karin Guenther, Hamburg
Kunsthalle, Dusseldorf
National Museum of Film, Photography and Television, Bradford

2002 Artist in Residence, Kunstmuseum, Vaduz, Liechtenstein
Manifesta, Frankfurt

2001 'New Heimat', Kunstverein, Frankfurt

2000 Galerie Karin Guenther, Hamburg

1999 Galerie Karin Guenther, Hamburg

1998 'Fast Forward III – Bodycheck', Kunstverein, Hamburg

Monda alla Rovescia
(World in Reverse)
2002
C-type print
180×240cm framed
Courtesy Galleria Franco Noero

Selected Bibliography

2003 '...cercare mezzodì alle quattordici', Chiara Bertola, 'intervista con Lara Favaretto', Giorgio Verzotti, *Eldorado*, Galleria d'Arte Moderna e Contemporanea, Bergamo
Gyonata Bonvicini, GAMEC, *Flash Art*, 238, February-March

2002 'Self Portrait', Lara Favaretto, *Tema Celeste*, May-June

2001 'Lara Favaretto', M. Smarelli, *Tema Celeste*, March-April

Selected Exhibitions

2003 Galleria Franco Noero
Studio Program 2002-3, PS1, New York
Art Statements, Art Basel, Galleria Franco Noero

2002 Eldorado, Galleria d'Arte Moderna e Contemporanea, Bergamo
'Nuovo Spazio Italiano', Palazzo delle Albere, Trento
'Toward uncertainty', Bell Gallery, Brown University, Providence

2001 'Magic and Loss', Contemporary Art Centre, Vilnius; Museo d'Arte, Nuoro
'Premio Querini Stampalia – furla per l'arte', Prima selezionata, Fondazione Querini Stampalia, Venice

2000 'Shy As a Fox', Galleria S.A.L.E.S., Roma
'Fai da te', Sparwasser HQ, Berlin

Lara **Favaretto**

Born 1973
Lives Turin/New York

Lara Favaretto wants her work to be seen as 'potential, and not a definitive or finished act'. Her videos and photographs are like souvenirs left over from time spent collaborating with others – professionals, craftsmen, acquaintances, dilettantes – to whom she relinquishes authorial control, diminishing her central role as an artist. Favaretto likes the unforeseen consequences that arise when committed dabblers try to get something done, especially if it's something nobody ever thought worth doing. Such was the case when she brought a group of friends together with an unsuspecting donkey in the countryside and had them consider the popular Italian proverb 'You can lift it but you can't make it fly'. Sometimes a common turn of phrase can be more like a sophomoric dare or an open call to action. (JT)

Represented by Galleria Franco Noero G13

Untitled
2003
Steel, wood and primer
150×43×104cm
Courtesy Galerie Martin Janda

Selected Bibliography

2002 'Werner Feiersinger', Jörg Heiser, *frieze*, 66, April
Unter freiem Himmel (In open Air), Florian Steininger and Doris von Drathen, Schloß Ambras, Innsbruck

1996 *Werner Feiersinger*, Gottfried Hundsbichler, De Appel, Amsterdam

1994 *100 Umkleidekabinen. Ein ambulantes Kunstprojekt* (100 changing rooms, A mobile art project), Bad zur Sonne Graz, steirischer Herbst '94, Paolo Bianchi and Martin Janda, Graz

1991 *Werner Feiersinger.Werkauswahl 1987-90*, (Selected works 1987–90), Robert Fleck, ed Martin Janda, Vienna

Werner **Feiersinger**

Born 1966
Lives Vienna

For all their industrial precision and machine-tooled regularity, the boxes of Donald Judd could never have been confused for actual mass-produced functional objects. Austrian artist Werner Feiersinger's sculptures, however, have the scale, the formal specificity and just enough detailing to make the viewer puzzle over just how these things are meant to be used. Oscillating between Minimalist abstraction and industrial readymade – one object could be a tiny metal cot if not for the smooth steam pipe-like cylinders fitted from headboard to footboard – they look like nameless things you might stumble across in some defunct factory, artefacts whose meaning remains unfixed in the mind of the viewer as a succession of possible uses are considered and rejected. If Feiersinger's objects ever had a purpose, it is lost to us. They now just offer themselves to the world as is. (JT)

Represented by Galerie Martin Janda F14

Selected Exhibitions

2003 'Transfer Wien', contemporary art from Vienna at the collection Falkenberg/Phönix Art, Hamburg
'Discussing Sculpture', Galerie Martin Janda, Vienna

2001 'Unter freiem Himmel' (In the Open Air), Schloß Ambras, Innsbruck
Galerie Martin Janda, Vienna

1999 Raum Aktueller Kunst Martin Janda, Vienna
'Freespace', NICC, Antwerp

1998 Galerie Jos Jamar, Antwerp

1997 'Sculptures', Büchsenhausen Ausstellungsraum, Innsbruck

1996 De Appel, Amsterdam

1992 Galerie Paul Andriesse, Amsterdam (with Willem Oorebeek, Henri Jacobs, Gottfried Hundsbichler, René Daniels)

H
2002
Fabric, resin, foam, wood and paint
102×185×80cm
Courtesy Corvi-Mora

Selected Bibliography

2003 'Rachel Feinstein', Adrian Dannatt, *Flash Art*, May-June 2003
'Rachel Feinstein', James Hall, *Artforum*, February

2002 'Ugo Rondinone & Rachel Feinstein', Gilda Williams, *Art Monthly*, October

2001 'Material Girl', Jennifer Higgie, *frieze*, 58, April
'Rachel Feinstein', Alanna Heiss, *Connaissance des Arts*, January

Selected Exhibitions

2003 '3-D', Friedrich Petzel Gallery, New York

2002 Corvi-Mora, London

2001 Marianne Boesky Gallery, New York
'the americans. new art', Barbican Art Gallery, London

2000 'Pastoral Pop', Whitney Museum of American Art, New York
'Greater New York', PS1, New York

1999 White Room, White Columns, New York
Robert Prime, London

1998 'How will we behave?', Robert Prime, London

1994 'Let the artist live', Exit Art, New York

Rachel **Feinstein**

Born 1971
Lives New York

Feinstein makes many things – some sculptural and others which loosely fit into the category of painting. Most have funny, enigmatic titles such as *Peaquod in Denim and Diamonds* (1999), reference songs or plays, and recall lifestyles varnished with the patina of old magazines. Happily mingling Rococo flourishes with Pop approximations of hallucinations, Feinstein's work looks as if she has plundered the contents of her bedroom and emptied a hardware store. The materials she uses include wood, plaster, denim, mirrors, velvet, rope, paint and rhinestones. (JH)

Represented by Corvi-Mora F10

Hans-Peter **Feldmann**

Born 1941
Lives Dusseldorf

In the early 1980s Hans-Peter Feldmann decided to withdraw from the art world. Since coming out of exile a few years ago he has exhibited series of handmade books combined with photographs of the view from his window, placed tiny erotic pictures between the pages of a novel, and shown a collection of 'unbuyable books'. Feldman never signs his work and insists that his editions are limitless. He also appropriates amateur photographs, which he often displays alongside his own work. Dominic Eichler, writing in *frieze*, described Feldmann's approach as 'a refusal to equate mass with trash, the inexpensive with the valueless or the fleeting with the insignificant'. (JH)

Represented by 303 Gallery C12, Galerie Francesca Pia C3, Galerie Barbara Wien G2

Selected Bibliography

2003 'Hans-Peter Feldmann', Catrin Lorch, *frieze*, 76, Summer
Georg Imdahl, *Frankfurter Allgemeine Zeitung*, 6 March 2003

2002 *Graz*, Hans-Peter Feldmann, Graz
272 Pages, Fundacio Antoni Tapies, Barcelona

1999 *Hans-Peter Feldmann: All the Clothes of a Woman*, Art Metropole, Toronto; VG Bild Kunst, Bonn

Selected Exhibitions

2003 'Utopia Station', Venice Biennale
Galerie Johnen & Schöttle, Cologne

2002 Galerie Chouakri Brahms, Berlin
Galerie Barbara Wien, Berlin
303 Gallery, New York

2001–2003 'Hans-Peter Feldmann', Fundacio Antoni Tapies, Barcelona, touring to Centre National de la Photographie, Paris; Fotomuseum Winterthur; Museum Ludwig, Cologne

1998 Galerie Barbara Wien, Berlin

1993 Guggenheim Museum, New York

1972 Documenta, Kassel

Presenting Snowdrop Lane
2003
Oil on canvas
152.5×183cm
Courtesy Corvi-Mora

Selected Bibliography

2003 'Exploring Landscape',
Roberta Smith, *New York Times*, 14
February 2003
'Critics Picks', Martha
Schwendener, www.artforum.com,
February
'Exploring Landscape: Eight Views
from Britain', *Art Monthly*, March

2002 *100 Reviews*, ed Arnatt,
Bickers, Charlesworth, Collings,
Gillick, Walther König
Publications, Cologne
'Art Graduate', *ArtReview*, LIII,
June
'Home is where the heart is',
Stephanie King, *Time Out*, 29
May 2002

Selected Exhibitions

2003 'I want! I want!', Northern
Gallery of Contemporary Art,
Sunderland
'The Peripheries Become the
Centre', Prague Biennale
'The Progressive Future', Platform,
London
'Natural/Nature', Galleria d'Arte
Moderna Ricci Oddi, Piacenza
Anthony Wilkinson, London
'Dirty Pictures', The Approach,
London
'Exploring Landscape: Eight Views
from Britain', Andrea Rosen
Gallery, New York

2002 'Paint', FA Projects, London
'The Show 2002', Royal College
of Art, London

2000 'Story', Hemma Hos Julia,
Stockholm

Dee **Ferris**

Born 1973
Lives London

The intense light that emanates from Dee Ferris'
landscapes is almost celestial. Her forest glades and
country gardens, occasionally inhabited by carefree
children and adolescents, seem almost prelapsarian.
These paintings could be depictions of a lost golden
age, or visions of a future Never-Never Land, an
Edenic state of grace untroubled by war or poverty.
Pale, washed-out colours push through the ethereal
haze, describing glitter-dappled woodland glades.
Like accounts of a serene acid trip, or the sublime
welcoming light described in near-death experiences,
Ferris' images are intensely personal testimonials
dreaming up a utopian future for us all. (DF)

Represented by Corvi-Mora F10

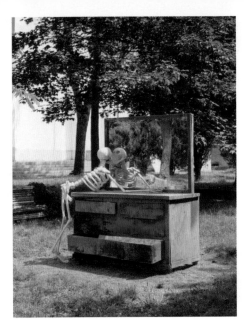

Skinny Afternoon
2003
Aluminium sand cast, screws, mirror
Installation view, Venice Biennale
200×120×160cm
Courtesy the artist, Galerie Eva
Presenhuber

Selected Bibliography

2003 'Openings, Urs Fischer',
Alison Gingeras, *Artforum*, May

2000 *Urs Fischer. Time Waste. Radio-
Cookie und kaum Zeit, kaum Rat*
(Time – waste. Radio-Cookie and
barely no time, no advice), ed
Beatriz Ruf, Edition Unikate, Glarus
Manifesta 3, Hans-Ulrich Obrist,
Cultural and Congress Centre,
Ljubljana

1999 'Fundamentgefummel.
(Stormy weather) von Urs Fischer'
Anna Helwing, *Kunst-Bulletin, 3*,
March

1998 *Ironisch/ironic*, ed Rein Wolfs,
Migros Museum für
Gegenwartskunst, Zurich

Selected Exhibitions

2003 'Dreams and Conflicts',
Venice Biennale
'Portrait of a Single Raindrop',
Gavin Brown's enterprise,
New York
'Need No Chair when Walking',
Sadie Coles HQ, London

2002 'What Should an Owl Do
with a Fork', Santa Monica
Museum of Art
'Mystique Mistake', Modern
Institute, Glasgow
'Bing Crosby', Contemporary Fine
Arts, Berlin

2001 'Mastering the Complaint',
Galerie Hauser & Wirth &
Presenhuber, Zurich

2000 'Capillon – Urs just does it for
the girls' (with Amy Adler), Delfina,
London
'Tagessuppen/Soups of the Days'
and 'Domestic Pairs Project' (with
Keith Tyson), Kunsthaus Glarus
'The Membrane – Why I don't
mind bad-mooded People', Stedelijk
Museum Bureau, Amsterdam

2000 'Without a Fist – Like a Bird',
ICA, London

Urs **Fischer**

Born 1973
Lives Los Angeles/Zurich

The twisted agility with which Urs Fischer divides his
time between Los Angeles, Berlin and his hometown,
Zurich, is topped only by the confidence with which
he navigates the Bermuda triangle of rough-edged
sculpture: from Bruce Nauman to Dieter Roth to
Franz West – from Conceptual edge to accumulative
sensibility to slapstick virtuosity. Yet Fischer is not just
a traditionalist. With spotlit goose eggs dangling from
the ceiling or a polystyrene chair that comes with its
shadow painted on the floor, Fischer constantly
breaks new ground with his precarious confrontations
of the seriously silly and the happily sublime. (JöH)

Represented by Sadie Coles HQ B8, Contemporary
Fine Arts D4, GBE (Modern) D5, The Modern
Institute G8, Galerie Eva Presenhuber D7

Visible World
2000
Approx. 2000 slides, 12 tables
Dimensions variable
Courtesy Sprüth Magers Lee

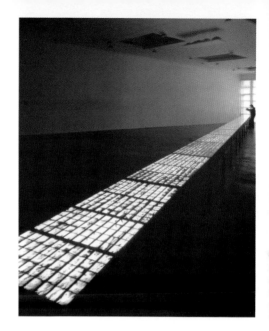

Selected Bibliography

2002 *Findet mich das Glück?* (Is happiness going to find me?), Walther König, Cologne *Peter Fischli/David Weiss*, Kaspar König, Marjorie Joengbloed, Boris Groys et al, Museum Ludwig, Cologne

2000 *Mike Kelley: Peter Fischli/David Weiss*, ed Ingvild Goetz and Rainald Schumacher, Kunstverlag Ingvild Goetz GmbH

1997 *Peter Fischli/David Weiss*, Centre Georges Pompidou, Paris

1990 *Airports*, Patrick Frey, Zurich/IVAM, Valencia

Selected Exhibitions

2002 AC-Raum Museum Ludwig, Cologne

2001 'Airports', Monika Sprüth/Philomene Magers, Munich

2000 Sammlung Goetz, Munich (with Mike Kelley)

1999 ARC Musée d'Art Moderne de la Ville de Paris

1998 'Arbeiten im Dunkeln' (Working in the Dark), Kunstmuseum Wolfsburg

1996 'In a Restless World', Walker Art Center, Minneapolis and touring

1995 Swiss Pavilion, Venice Biennale

1992 Musée National d'Art Moderne, Centre Georges Pompidou, Paris

1988 Museum of Contemporary Art, Los Angeles

1987 Dallas Museum of Art, University Art Museum, Berkeley 'Resources', PS1, New York and touring

1985 'Stiller Nachmittag' (Quiet Afternoon), Monika Sprüth Gallery, Cologne

Peter **Fischli** & David **Weiss**

Born 1952/1946
Live Zurich

Great sense of humour paired with a great sense of form: with their installation *Untitled (Questions)* (1996–2003) – a hilariously spooky slide projection of worried questions in a dark space – Peter Fischli and David Weiss won the prize for the best artwork at the Venice Biennale 2003. The Swiss artists explore the way leisure pursuits – pottery, armchair psychology, amateur photography – hover between stupidity and playfulness. Yet they neither snigger at dilettantism nor pretend to break down distinctions between High and Low, as their 1981 clay sculpture *Popular Oppositions: High and Low* makes clear: the difference comes down to that between a dachshund begging on its hind legs (high) or walking on all fours (low). (JöH)

Represented by Matthew Marks Gallery C7 Galerie Eva Presenhuber D7, Sprüth Magers Lee B3

Six Foot Leaping Hare on Empire State
2002
Bronze
Edition of 8
216.5×191×79cm
Courtesy Waddington Galleries

Selected Bibliography

2002 *Barry Flanagan: Sculpture and Drawing*, Kunsthalle Recklinghausen and Musée d'Art Moderne et d'Art Contemporain, Nice

1993 *Barry Flanagan*, Fundacio la Caixa, Madrid and Musée des Beaux-Arts de Nantes

1983 *Barry Flanagan: Sculptures*, Centre Georges Pompidou, Paris

1982 *Barry Flanagan: Sculpture*, Venice Biennale

1977 *Barry Flanagan: Sculpture 1966–76*, Van Abbemuseum, Eindhoven

Selected Exhibitions

2002–3 'Barry Flanagan: Sculpture and Drawing', Kunsthalle Recklinghausen

1996 'Barry Flanagan: Sculpture in Grant Park', Chicago

1995–6 'Barry Flanagan on Park Avenue', New York

1993–94 'Barry Flanagan' Fundació la Caixa, Madrid

1992 'The Names of the Hare: Large Bronzes by Barry Flanagan: 1983-1990', Yorkshire Sculpture Park, Wakefield

1987–8 'Barry Flanagan – A Visual Invitation, Sculpture 1967–1987', Laing Art Gallery, Newcastle

1983 'Barry Flanagan: Sculptures', Musée d'Art Moderne, Centre Georges Pompidou, Paris

1982 'Barry Flanagan, Stone & Bronze sculptures' British Pavilion, Venice Biennale

1981–2 'Sixties and Seventies: Prints and Drawings by Barry Flanagan', Mostyn Art Gallery, Llandudno

1977–9 'Barry Flanagan: Sculpture 1966–1976', Van Abbemuseum, Eindhoven

Barry **Flanagan**

Born 1941
Lives Dublin

Born in North Wales in 1941, Barry Flanagan had his first solo exhibition in 1966. His early abstract collages – fabricated from torn swatches of intensely chromatic paper – explored pictorial space with verve and vertiginous humour. Now largely in bronze, Flanagan's sculptures are dominated by the figure of the hare. In folklore the emissary of the moon, here the hare is a lithe, floppy-eared gad-about, happy to body-pop in public spaces or squat – like a digital descendant of Auguste Rodin's *Thinker* (1880–81) – on top of a computer hard drive, its back paw distractedly tapping the keyboard. Characterized by fluid lines and a gentleness that borders on whimsy, Flanagan's is an art that knows – and is happy with – what it is. (TM)

Represented by Waddington Galleries G3

The Last Minister
2002
Oil on linen
65×55cm
Courtesy doggerfisher and Arts
Council of England Collection

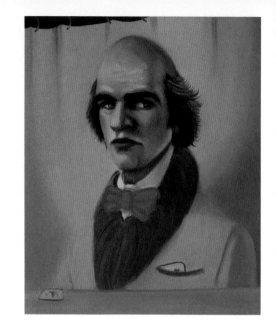

Selected Bibliography

2002 *New Recent Acquisitions of Contemporary British Art*, Alice Dewey, Scottish National Gallery of Modern Art, Edinburgh

2001 *Here + Now, Scottish Art 1990–2001*, Katrina M. Brown, John Calcutt, Rob Tufnell, Dundee Contemporary Arts
Open Country – Scotland: Contemporary Scottish Artists, Caroline Nicod, Francis McKee, Rob Tufnell, Musée Cantonal des Beaux-Arts de Lausanne
Locale, Keith Hartley, City Art Centre, Edinburgh

1996 *Moyna Flannigan*, Angela Kingston, CCA, Glasgow

Selected Exhibitions

2003 'Rendered', Sara Meltzer Gallery, New York
'Paulina Olowska, Elke Krystufek, Moyna Flannigan, Chantal Joffe', Galerie Akinci, Amsterdam
'The Company We Keep', Inman Gallery, Houston
'Knucklehead', Sara Meltzer Gallery, New York

2002 'I'm a stranger here myself', doggerfisher, Edinburgh
'New, Recent Acquisitions of Contemporary British Art', Scottish National Gallery of Modern Art, Edinburgh
'I think about it almost all the time', Sara Meltzer Gallery, New York

2001 'I could be happy with you', Galerie Akinci, Amsterdam
'Here + Now, Scottish Art 1990–2001', Dundee Contemporary Arts
'Open Country – Scotland: Contemporary Scottish Artists', Musée Cantonal des Beaux-Arts de Lausanne

Moyna **Flannigan**

Born 1963
Lives Edinburgh

Moyna Flannigan makes painterly golems: until she puts them on canvas, her subjects exist only in her imagination; afterwards they seem irrefutable. From the fish-eyed father and son in *Just Like Daddy* (1998) to the baleful drag queen in *I'm A Stranger Here Myself* (2002) and the shady fop in *The First Time* (2002), all force a response to their confessional gaze. An increasingly rich Old Masterly palette, inspired by time spent recently on a British Arts Council scholarship in Rome, contrasts with the underlying psychological discord of her images; while, as she says, 'exploring their other self', these phantasms also encourage us to explore our own. (MH)

Represented by doggerfisher C21

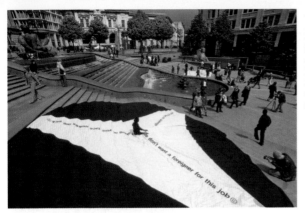

*Anti_dog: Unwanted Sentences,
Birmingham 2003*
2003
Single-channel video projection,
sound, colour,
Edition of 3 + 2 AP
3 minutes in loop
Courtesy Galerie Micheline
Szwajcer

Alicia **Framis**

Born 1967
Lives Barcelona/Amsterdam

A blood bank merged with a fish restaurant; an escort
bureau of identical twins for lonely travellers; an area
for children to explore their creativity without adults;
a public space for women to find emotional and
sexual satisfaction – these are some of the projects
initiated by Spanish artist Alicia Framis. Her work,
which could be described as social sculpture, develops
the tradition of performance art that developed in the
1970s, in particular the belief that an artist can
communicate best through direct contact with an
audience. Framis feels that the potential of art objects
to fulfil people's needs is limited, preferring instead to
provide city-dwellers with the emotional sustenance
their lives might be lacking – intimacy, interaction
and poetry. (JH)

Represented by Galerie Micheline Szwajcer E5

Selected Bibliography

2003 *Alicia Framis:Works
1995–2003*, Artimo, Amsterdam
'Tegen angst en eenzaamheid. De
anti-dogtournee van Alicia Framis'.
Barbara van Erp, *Vrij Nederland*, 24,
14 June 2003

Selected Exhibitions

2002–3 'We Are the World', Dutch
Pavilion, Venice Biennale
'Salon', Palais de Tokyo, Paris
'anti_dog', Ikon Gallery,
Birmingham; De Dunkers
Kunsthalle, Helsinborg; Reina Sofia,
Madrid; Palais de Tokyo, Paris

2001 'Aussendienst' (External duty),
Cultural Board of the City of
Hamburg and the Art Society,
Hamburg

2000 'Soledad Enlaciudad', Museu
d'Art Contemporani, Barcelona;
Museum Abreiberg
CBK, Dordrecht; Kiasma, Helsinki
'Remix Buildings', Migros Museum
für Gegenwartskunst, Zurich

1999 'Loneliness in the City',
Dordrecht, Mönchengladbach

Volumes
2002
Acrylic and resin on canvas
162×130cm
Courtesy Galerie Micheline
Szwajcer

Selected Bibliography

2003 *Aplat, Bernard Frize*, Editions
Paris Museés

2002 *Bernard Frize,* Jan Hoet,
Wim van Krimpen, Ulrike Schick,
Jan Thorn-Prikker, Eva Wittoc,
Exhibitions International

1999 *Size Matters*, Bernard Frize,
Actes Sud, Arles

Selected Exhibitions

2003 'Aplat', Musée d'Art
Moderne de la Ville de Paris
'Hands ON', Ikon Gallery,
Birmingham
Studio A Ottendorf, Cuxhaven

2002 Stedelijk Museum Actuele
Kunst, Ghent
Gemeentemuseum, The Hague

2000 Westfälisches Landesmuseum,
Munster

1999 'Carré d'art', Musée d'Art
Contemporain, Nîmes
Museum Moderner Kunst, Stiftung
Ludwig, Vienna
Kunstmuseum St. Gallen

1998 De Pont Stichting, Tilburg

Bernard **Frize**

Born 1954
Lives Paris

For the past 20 years or so Bernard Frize has
experimented with the materials of painting.
The artist pours, strips back or applies various,
often incompatible, types of paint and resin with
different-sized brushes and rollers in an attempt to
de-personalize the creative act. In the process he has
managed to create a body of often exuberant images
that David Barrett in *frieze* has described as 'Op art
meets spaced-out techno graphics'. In some respects
Frize's Minimal and Abstract endeavour echoes that of
Robert Ryman, who famously described his practice
as 'painting the paint'. However, whereas Ryman
restricted himself to a monochrome palette, Frize has,
at one time or another, explored the entire spectrum.
(JH)

Represented by Frith Street Gallery C4, Patrick
Painter, Inc B1, Galerie Micheline Szwajcer E5

Jun **Fujita**

Born 1971
Lives Tokyo

Jun Fujita's paintings have been likened to Techno music, in which discrete beeps rise above the beat like birds soaring free of some grotty bit of architecture. Overlaying muted Op art grounds with ever so slightly 'off' geometrical forms, Fujita paints his images on to MDF board, canvases and snares (he is also a drummer). With their calm tones and casual beauty they're like Bridget Riley paintings re-imagined by a room full of post-club stoners – pictures to look at but also, in a strange way, to hear. (TM)

Represented by Gallery Side 2 H10

Selected Bibliography

2003 'Artist of the Month', *Dazed & Confused Japan*, March
'Painting Reincarnation', *Bijutsu Techo*, March
'Cool and Emotional', *Chie Sumiyoshi, Ryuko Tsushin*, 478 June

2001 'A Pursuit of Innocence in the 21st Century Art', Hideki Kawahara, *Bijutsu Techo*, February

2000 'Japanese Innovators', Midori Matsui, *Flash Art*, January–February

Selected Exhibitions

2003 Gallery Side 2, Tokyo
'SK8 on the Wall', Rocket, Tokyo

2002 'Jun Fujita, Yuko Murata, Kiyomichi Shibuya, Shinako Sato', Gallery Side 2, Tokyo

2000 'Jay-Way', Lydmar Hotel, Stockholm
Logos Gallery, Parco, Tokyo
Saison Art Program Gallery, Tokyo

Lazy Fellow
2002
Acrylic on canvas
117×117cm
Courtesy Tomio Koyama Gallery

Selected Bibliography

2003 *VOCA 2003*, *Kazuhiko Shibusawa*, Ueno Royal Museum, Tokyo

2002 'Transforming Scenes of Everyday Life', Yayoi Kojima, *Pacific Friends*, November
'Focus Painting Part One', *Flash Art*, October

Selected Exhibitions

2003 Gallerie Michael Zink, Munich
'VOCA 2003 – The Vision of Contemporary Art', Ueno Royal Museum, Tokyo
'Opening Exhibition', Tomio Koyama Gallery, Tokyo

2002 'View from Artist', Gallery TAF, Kyoto
'Bedroom Paintings', Tomio Koyama Gallery, Tokyo

2001 'Morning Glory', Tomio Koyama Gallery, Tokyo

1986 Museum of Fine Arts, Gifu

Atsushi **Fukui**

Born 1966
Lives Tokyo

The imagination is a great boon in moments of boredom. Freely associative journeys are described in Atsushi Fukui's careful depictions of banal domestic surroundings. Scraps of white paper littering a watery green carpet become sea serpents rising from the ocean depths. The multicoloured stripes of a rug in *Transport* (2001) zoom around the perimeter of a room like some kind of futuristic speedway. Fukui's paintings capture the interstitial moments of inactivity that punctuate daily routines, those points where the eye settles on an object, the mind begins to drift and the subliminal imagination breaks the surface. (DF)

Represented by Tomio Koyama Gallery C5

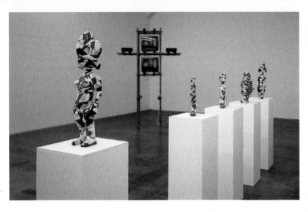

'Twilight of the Idols' Series
2002
Chevron-wrapped African works
of art
Courtesy Luis Campaña Galerie

Selected Bibliography

2002 *My Tongue in Your Cheek*,
Les Presses du Réel, Réunion des
Musées Nationaux, Paris-Dijon-
Bruxelles
'Kendell Geers', Jerome Sans, *Tema
Celeste*, 92, July–August
'Kendell Geers: What is Art Today;
Qu'est-ce que l'art aujourd'hui',
Beaux Arts Special Edition, Paris

2000 'The Art of the Phoenix',
Christine Macel, Interview with
Kendell Geers, *Art Press*, 257, May

1995 *Argot*, Kendell Geers,
Chalkham Hill Press, Johannesburg

Kendell **Geers**

Born 1968
Lives Brussels

Less concerned with conflict resolution than with
picking at open sores, Kendell Geers is a provocative
and at times divisive voice in the South African art
world and beyond. With works such as *Title Withheld
(Score)* (1995–6), a Conceptual accounting of the
various minority groups comprising an exhibition of
South African art, Geers has refused to conform to
international expectations for a white Afrikaner artist
in the sensitive post-apartheid climate. Geers' barbed
gestures and writings have found favour with
respected cultural arbiters such as Okwui Enwezor,
who view him as a much-needed enfant terrible in a
country still suffering from historical paralysis. (KR)

Represented by Luis Campaña Galerie E3,
Stephen Friedman Gallery E6, Marian Goodman
Gallery C8, Salon 94 D6

Selected Exhibitions

2003 'TerroRealismus', Migros
Museum für Gegenwartskunst,
Zurich
'MARS – Art and War', Neue
Galerie am Landesmuseum
Joanneum, Graz
'HardCore, Vers un Nouvel
Activisme' (Towards a New
Activism), Palais de Tokyo, Paris

2002 Documenta, Kassel
'Sympathy for the Devil',
Palais de Tokyo, Paris

2001–2 'The Short Century',
Museum Villa Stuck, Munich,
touring to Haus der Kulturen der
Welt, Berlin; PS1, New York;
Museum of Contemporary Art,
Chicago

2001 'Casino 2001', SMAK, Ghent
'Televisionaires', Württembergischer
Kunstverein and Schloss Solitude,
Stuttgart

2000 'Timbuktu', MAK, Vienna
'!Ya Basta!', Le Consortium, Dijon

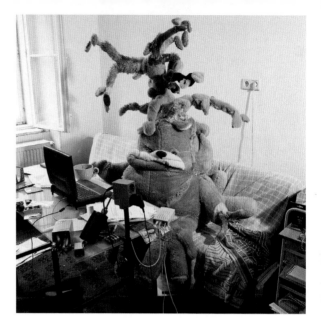

Rénéé
2002
Mixed media
180×70×70cm
Courtesy Galerie Meyer Kainer

gelatin

Born 1970/1970/1970/1968
Live Vienna

The boys from gelatin love taking a walk on the wild side. As a collective the four Viennese artists travelled the desert, lived like chickens, built a balcony for the World Trade Center and crammed galleries with labyrinths made from scrap furniture. They have constructed devices to make viewers experience primary sensations, such as the *Hugbox* (1999), a machine that presses you into a mattress to give you a suffocatingly intense feeling of intimacy, or *Weltwunder* (2000), a 10-foot-deep pool with a tunnel to an underwater cave that viewers can discover if they dare to take the plunge. If Hunter S. Thompson ever planned to stage the sequel to *Fear and Loathing in Las Vegas* (1971) in Vienna he'd be well advised to have a word with gelatin first. (JV)

Represented by Leo Koenig, Inc G16, Galerie Meyer Kainer F1

Selected Bibliography

2002 *grand marquis*, gelatin, DVD, Walther König, Cologne

2001 *nellanutella*, gelatin, Walther König, Cologne
The B-Thing, gelatin, Walther König, Cologne

Selected Exhibitions

2002 'flaschomat', Kunsthalle, St. Gallen
'grand marquis', Galerie Ars Futura, Zurich
Liverpool Biennial
Shanghai Biennale 2002
Exposition collective, Palais de Tokyo, Paris

2001 'gelatin is getting it all wrong again', Leo Koenig, Inc, New York
'Sonsbeek 9', Locus/Focus, Arnhem
Austrian Pavilion, Venice Biennale

2000 'Boutique transporter', Galerie Meyer Dainer, Vienna

1998 'Percutaneos Delight (Sexy summer evenings)', PS1, New York

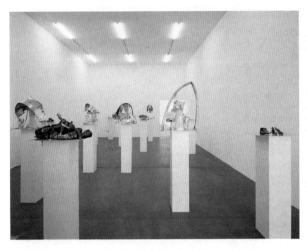

Empire/Vampire, who kills death
2003
22 parts, mixed media
Courtesy Galerie Daniel Buchholz

Selected Bibliography

2003 *Isa Genzken*, Diedrich Diederichsen et al, Museum Abteiberg Mönchengladbach; Kunsthalle Zurich; Walther König, Cologne

2001 *AC: Isa Genzken/Wolfgang Tillmans,* Kasper König and Michael Krajewski, AC-Saal, Museum Ludwig, Cologne; Walther König, Cologne

2000 *Isa Genzken. Urlaub* (holiday), Vanessa Joan Müller, Kunstverein, Frankfurt; Lukas & Sternberg, New York

1996 *Isa Genzken. MetLife,* ed Sabine Breitwieser, Generali Foundation, Vienna

1992 *Isa Genzken. Everybody needs at least one window,* Benjamin H.D. Buchloh and Paul Groot, Renaissance Society, University of Chicago; Portikus, Frankfurt

Isa **Genzken**

Born 1948
Lives Berlin

Isa Genzken puts the Modernist principles of abstraction and constructivism to the test in the phenomenological space of sculpture and lived experience. The wooden bodies of her ellipsoid and hyperboloid sculptures from the mid-1970s look as if geometric forms out of El Lissitzky paintings had entered real space to resist the forces of gravity. The weight of sculptural bodies is dramatized in the architectural theatre of Genzken's later works, where concrete blocks are propped on slender steel legs. Recent sculptures shaped like columns rise up with the ease of skyscrapers. Their surfaces are coated with mirrors, coloured film or collages taken from pages of newsprint. Genzken puts funk and soul into the cool façades of Modernism without ever betraying its promise of transparency. (JV)

Represented by Galerie Daniel Buchholz A2, Magnani F11, neugerriemschneider C6

Selected Exhibitions

2003 Kunsthalle Zurich

2002 Museum Abteiberg, Mönchengladbach
Wolfgang-Hahn-Preis, Museum Ludwig, Cologne

2001 Galerie Daniel Buchholz, Cologne
'Science Fiction/To Be Content here and Now', AC-Saal (with Wolfgang Tillmans), Museum Ludwig, Cologne

2000 'Holiday', Kunstverein, Frankfurt
'Sie sind mein Glück' (You are my luck), Kunstverein Braunschweig, Brunswick

1996 'Met Life', EA-Generali Foundation, Vienna

1992–3 Galerie Daniel Buchholz, Cologne
'Everybody needs at least one window', Renaissance Society, University of Chicago

1989 Museum Boijmans van Beuningen, Rotterdam

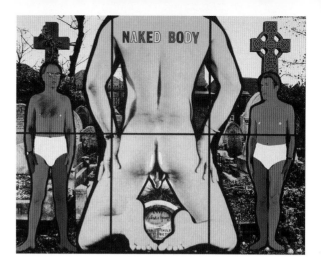

Naked Body
1991
Six-part panel piece
169×213cm
Photo: Prudence Cuming
Courtesy White Cube

Selected Bibliography

2002 *The Dirty Words Pictures*,
Michael Bracewell and Lisa G.
Corrin, Serpentine Gallery, London

2001 *The World of Gilbert & George*,
Marco Livingstone, Enitharmon
Press, London

1999 *Gilbert & George. A Portrait*,
HarperCollins, London

1995 *The Naked Shit Pictures*,
South London Gallery

Selected Exhibitions

2002 'The Dirty Words Pictures',
Serpentine Gallery, London
'Gilbert & George. Nine Dark
Pictures', Portikus, Frankfurt
'Gilbert & George', Centro Cultural
de Bélem, Lisbon

2001 'Gilbert & George', School
of Art, Athens
'Gilbert & George', Château
d'Arenthon Fondation pour l'Art
Contemporain, Alex

2000 'Enclosed and Enchanted',
Museum of Modern Art, Oxford

1999 'Gilbert & George 1970-1988'
Astrup Fearnley Museum of
Modern Art, Oslo
'The Rudimentary Pictures',
Milton Keynes Gallery

1998 'New Testament Pictures',
Museo di Capodimonte, Naples

1995 'The Naked Shit Pictures',
South London Gallery

Gilbert & George

Born 1943/1942
Live London

Gilbert & George have been living and working together since 1967 as what they call 'living sculptures'. Humorous, iconic and controversial, their performances, films and large-scale photographic works have made a lasting and deep impression on the contemporary art landscape. From the early 'Magazine Sculptures' (photographs of the young artists captioned 'GEORGE THE CUNT' and 'GILBERT THE SHIT' (1969)), through performances and videos such as *Singing Sculpture* (1969-71) and the seminal *World of Gilbert and George* (1981) up to the high impact graphics of the recent *New Horny Pictures* (2001) series, the duo have striven to create an inclusive 'art for all' – a unique aesthetic leavened with a dry wit that reaches far beyond the rarefied mores of art into a gritty world of ambiguous social commentary. (DF)

Represented by Gagosian Gallery F7,
Galerie Thaddaeus Ropac B14, White Cube F6

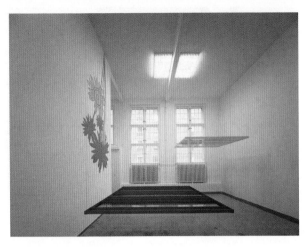

Liam **Gillick**

Born 1964
Lives New York/London

Viewed naively, Liam Gillick's *What if? Scenario* (1996) and *Discussion Island* (1997) installations – complemented by his playful writing about social and economic shifts – appear as quasi-utopian sites for the enactment of the Habermasian notion of communication without constraints. Yet, constructed from the materials favoured by the suburban office, health club and shopping area (aluminium, friendly-coloured Perspex, pine panels), they only become actual islands for discussion if you take them as absurd sitcom sets: stand here, shake hands, discuss the subject. Gillick turns the easy opposition between the 'Conceptual' and the 'Retinal' into a schizoid joy-ride. (JöH)

Represented by Air de Paris B16, Corvi-Mora F10, Galerie Meyer Kainer F1, Galerie Eva Presenhuber D7, Schipper & Krome E8, Galerie Micheline Szwajcer E5

Selected Bibliography

2002 *Literally No Place. Communes, Bars and Greenrooms*, Liam Gillick, Book Works, London
The Wood Way, Liam Gillick, Whitechapel Art Gallery, London

2000 *The Book of the 3rd of June*, Liam Gillick, CCA Kitakyushu
Liam Gillick, ed Susanne Gaensheimer and Nicolaus Schaffhausen, Cologne

1998 *Discussion Island/Big Conference Center*, Liam Gillick, Kunstverein, Ludwigsburg and Orchard Gallery, Derry

Selected Exhibitions

2003 '… punctuated everydays', Galerie Max Hetzler, Holzmarktstrasse, Berlin
'Hills and trays and …', Schipper & Krome, Berlin
'Utopia Station', Venice Biennale

2002 'The Wood Way', Whitechapel Art Gallery, London
Turner Prize, Tate Gallery, London

2001 'Annlee You Proposes', Tate Britain, London
Lyons Biennale, Musée d'art contemporain

2000 'Renovation Filter: Recent Past and Near Future', Arnolfini, Bristol
'What If. Art on the Verge of Architecture and Design', Moderna Museet, Stockholm

1999 'Liam Gillick', Kunsthaus, Glarus
'Laboratorium', Provincial Museum voor Fotografie and elsewhere in Antwerp

Page 4
1978–2000
Silver gelatin print
Edition of 10
51×75cm
Courtesy Matthew Marks Gallery

Selected Bibliography

2003 *Robert Gober Displacements*, Astrup Fearnley Museum of Modern Art, Oslo

2001 *Robert Gober, The United States Pavilion*, Venice Biennale

1999 *Robert Gober: Sculpture + Drawing*, Walker Art Center, Minneapolis

1997 *Robert Gober*, Museum of Contemporary Art, Los Angeles, and Scalo Publishers, New York

1992–3 *Robert Gober*, Dia Center for the Arts, New York

Selected Exhibitions

2003 'Robert Gober Displacements', Astrup Fearnley Museum of Modern Art, Oslo

2001 The United States Pavilion, Venice Biennale

1999 'Robert Gober: Sculpture + Drawing', Walker Art Center, Minneapolis and touring

1997 'Robert Gober', The Geffen Contemporary, Museum of Contemporary Art, Los Angeles

1995 'Robert Gober', Museum für Gegenwartskunst, Basel

1993 'Robert Gober', Serpentine Gallery, London; Tate Liverpool

1992 'Robert Gober', Dia Center for the Arts, New York

1991 'Robert Gober', Galerie Nationale du Jeu de Paume, Paris; Reina Sofia, Madrid

1990 'Robert Gober', Museum Boijmans van Beuningen, Rotterdam; Kunsthalle Bern

1988 'Robert Gober', Art Institute of Chicago

1984 'Slides of a Changing Painting', Paula Cooper Gallery, New York

Robert **Gober**

Born 1954
Lives New York

For the past 20 years Robert Gober's mysterious, loss-haunted sculptures and installations have repeatedly provoked and fascinated, earning critical acclaim and, on more than one occasion, attention from the local police. Carefully handcrafted objects – uncanny domestic furnishings, phantom drains and culverts, tapless sinks and truncated limbs – totter between the erotic and the elegiac, sometimes coolly metaphorical, sometimes shockingly literal. Gober has developed a singular, constantly mutating iconography of amputations, penetrations and flow: the permeability of the human body is never far away, whether represented or invoked. A deeply affecting physical vulnerability runs through his work like an endless rush of water. (SS)

Represented by Matthew Marks Gallery C7

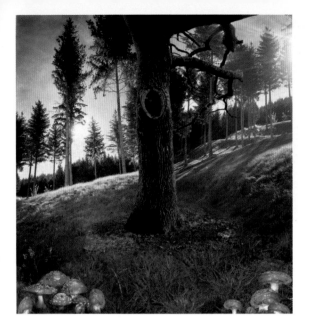

Mushroom Hill
2002
Black and white C-type print
Edition of 9
96.5×91.5cm
Courtesy Galerie Aurel Scheibler

Selected Bibliography

2002 'A Cut above the Rest',
Edward Lucie-Smith, *Art Review*,
Critic's Diary, December–January
Libération, Culture, 26 October 2002

2001 'Six of the Best Young Artists',
Raf Simons, *I-D Magazine*, 206,
February
'Portrait of the Artist as a Young
Boy', Jennifer Dalton, *Anthony
Goicolea*, RareArt Properties, Inc.,
New York

2000 'Look At Me: Self-Portrait
Photography After Cindy Sherman',
Jennifer Dalton, *PAJ:A Journal of
Performance and Art*, 66, September

Anthony **Goicolea**

Born 1971
Lives New York

Me, myself and I: these are the main protagonists
of Anthony Goicolea's digitally manipulated
photographic psychodramas, which feature scenes
of youthful indiscretion, pool parties and episodes of
adolescent hazing peopled exclusively by the artist's
own self-replicating image. Like a hyperactive
Narcissus dissatisfied with merely one reflection,
Goicolea seems curious and a bit repulsed to know
what it would be like to live in a world populated by
endless variants of oneself. Influenced by American
landscape painting, his new photographs of remote
forests and landscapes include leftover remnants of
human activity but hint at a magical world of fairy-
tales and fables. (JT)

Represented by Galerie Aurel Scheibler D13

Selected Exhibitions

2003 'Landschaften – Neue
Fotografien und Filme' (Landscapes
– New Photographs and Films),
Galerie Aurel Scheibler, Cologne
'Snowscape', Art Unlimited, Basel

2002 'Neue Photographien und
Zeichnungen' (New Photographs
and Drawings), Galerie Aurel
Scheibler, Cologne
Art Space, Auckland
Museum of Contemporary
Photography, Chicago
'Water', Sandroni-Rey, Los Angeles

2001 'Detention', RARE, New
York
Corcoran College of Art and
Design, Corcoran Gallery of Art,
Washington DC

2000 'Solo', Vedanta, Chicago

1999 'You and What Army',
RARE, New York

Valerie floating in the sea, Mayreaux
2001
Cibachrome
Edition of 15
76×102cm
Courtesy Matthew Marks Gallery

Selected Bibliography

2003 *Nan Goldin, Devil's Playground*, Phaidon, New York

1996 *Nan Goldin, I'll Be Your Mirror*, Whitney Museum of American Art and Scalo, New York

1994 *A Double Life*, Nan Goldin with David Armstrong, Scalo, New York

1993 *Nan Goldin, The Other Side*, Scalo, New York

1986 *Nan Goldin, The Ballad of Sexual Dependency*, Aperture Foundation, New York

Selected Exhibitions

2002 'Moving Pictures', Guggenheim Museum, New York

2001 'Le Feu Follet', Centre Georges Pompidou, Paris and touring

1997 'A Rose is a Rose is a Rose: Gender Performance in Photography', Guggenheim Museum, New York

1996 'Nan Goldin: I'll Be Your Mirror', Whitney Museum of American Art, New York

1995 'Public Information: Desire, Disaster, Document', San Francisco Museum of Modern Art and touring

1994 'Nan Goldin', Die Neue Nationalgalerie, Berlin

1993 'Nan Goldin', Fundacio la Caixa, Barcelona

1993 Whitney Biennial, Whitney Museum of American Art, New York and touring

1991 'Pleasures and Terrors of Domestic Comfort', Museum of Modern Art, New York and touring

1986 'Nan Goldin, The Ballad of Sexual Dependency', Aperture Foundation, New York

1985 Whitney Biennial, Whitney Museum of American Art, New York

Nan **Goldin**

Born 1953
Lives New York/Paris

Alex Farquharson has observed in *frieze* that Nan Goldin's images 'are all about love (especially when they are also about death). They aspire to, and sometimes attain, a perfectly crafted pop song's measure of directness and insight.' Shooting the New York world she inhabits – populated by friends, lovers, drug addicts and transsexuals – Goldin's photographs and slide shows provide an intimate, largely un-voyeuristic portrait of her subjects' social and sexual selves. Balanced between dirtied-up diaristic photography and the chiaroscuro drama of the Italian Baroque, her much-celebrated work seems to counter the policing of identity by pushing it unapologetically into the spotlight's glare. (TM)

Represented by Galerie Yvon Lambert D16, Matthew Marks Gallery C7

Above–Below
2003
2-screen DVD installation with sound-track
Dimensions variable
Courtesy Stephen Friedman Gallery

Selected Bibliography

2003 *Dryden Goodwin Minigraph*, Film and Video Umbrella, London

2002 *Reality Check – Recent Developments in British Photography and Video*, The Photographers' Gallery and British Council, London

2001 *The Fantastic Recurrence of Certain Situations*, The Photographers' Gallery and British Council, London

2000 *Video Positive – The Otherside of Zero*, FACT/Tate Liverpool

1999 *Dryden Goodwin – Recent Video Work*, published in association with Mid-Pennine Arts, Burnley

Selected Exhibitions

2003 Venice Biennale
'Above–Below', Baltic, Gateshead
'Reveal', Lacock Abbey Cloisters, Lacock, Picture This Moving Image and South West Screen Commission
'Dilate' Manchester City Art Gallery, Film & Video Umbrella commission

2002 'Closer' (Three screen video installation), Art Now commission, Tate Britain, London
'Light structures', TranzTech2001, Toronto; Tate Britain, London; National Museum of Photography, Film and Television, Bradford; Arnolfini, Bristol; Moderna Galeria, Ljubljana
'Reality Check – Recent Developments in British Photography and Video', British Council/The Photographers' Gallery and touring

2001 'The Fantastic Recurrence of Certain Situations: Recent British Art and Photography', Canal de Isabel II, Madrid

2000 'Wait, Drawn to Know', Stephen Friedman Gallery, London

1999 'Video Cult/ures', ZKM, Karlsruhe

Dryden **Goodwin**

Born 1971
Lives London

Can pictures get to grips with the real? Dryden Goodwin tests their ability to do so. In his earlier films he recorded aeroplanes, passing cars or strangers' faces one by one, shooting a single frame at a time. Reality is captured in a still image, yet, when the film starts, the individual frame is washed away with the movement of the images. For the recent video work *Closer* (2002) Goodwin took pictures of lone businessmen visible in illuminated office windows at night. Zooming in on them, he traced their features with the red dot of a laser pen. For a brief moment the film touches the world of the person whose image is taken, but at the same time the image erects an impenetrable barrier behind which reality recedes. (JV)

Represented by Stephen Friedman Gallery E6

Yin / Yang Pavilion
Architectural model: two-way
mirror, acrylic, wood, lead
32×107×107cm
Photo: Jon and Anne Abbott
Courtesy Marian Goodman Gallery

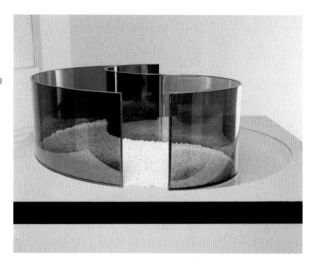

Selected Bibliography

2001 *Dan Graham Works 1995–2000,* Richter Verlag, Dusseldorf

1999 *Two Way Mirror Power,* MIT Press, Cambridge

1998 *Dan Graham,* ed Gloria Moure, Ediciones Poligrafia, Barcelona

1997 *Dan Graham Interviews,* ed Hans Dieter Huber, Cantz Verlag, Ostfildern-Ruit

1995 *Dan Graham. Collected Writings,* ed Ulrich Wilmes, Stuttgart

Selected Exhibitions

2003 Venice Biennale

2001–2 'Dan Graham Works 1965–2000', Museu Serralves, Porto and touring

2001 'Into the Light', Whitney Museum of American Art, New York

1999 'Dan Graham, Architekturmodelle', Kunst-Werke, Berlin

1997 Centro Galego d'Arte Contemporánea, Santiago de Compostela
'Architecture 1', Camden Arts Centre, London
'Architecture 2', School of Architecture, Architectural Association, London

1992–4 'Walker Evans/Dan Graham', Witte de With Centre for Art, Rotterdam; Musée Cantini, Marseilles; Westfälisches Landesmuseum, Munster; Whitney Museum of American Art, New York

1988 'Pavilions', Kunstverein, Munich

1987 ARC Musée d'Art Moderne de la Ville de Paris

Dan **Graham**

Born 1942
Lives New York

Emerging in the mid-1960s alongside a generation including Dan Flavin and Sol LeWitt, Dan Graham remains one of the most influential artists working today. Operating outside the gallery walls in order to critique the art world's structural apparatus, his particular brand of socially conscious Conceptual work began with text- and image-based works published in popular magazines. His ideas moved through video and performance during the 1970s to his acclaimed architectural works, rigorously investigating art's utilitarian potential, and the threshold between public and private space. Also central to Graham's practice has been his writing, perhaps most famously *Rock My Religion's* (1993) comparative study of rock music and American religious communities. Utopian in inspiration, realistic in practice, the social relevance of Graham's practice today is undeniable. (DF)

Represented by Marian Goodman Gallery C8, Galerie Hauser & Wirth B5, Lisson Gallery B4, Parkett Editions H5, Galerie Micheline Szwajcer E5

The Photokinetoscope
2001
16mm film installation
Courtesy 303 Gallery

Rodney **Graham**

Born 1949
Lives Vancouver

In 20 years of droll and digressive work Rodney Graham has played many roles – earnest Freudian scholar, costumed slapstick buffoon, guitar-toting troubadour. His own persona seems part mad scientist, part intellectual dandy – pursuing logical systems to the point of absurdity, Graham follows speculations wherever they lead. In the process he has produced an astonishingly diverse range of artefacts: photographs, optical devices, books, videos, films, sound installations and quite a few catchy pop songs. Seriously fooling with the forms and history of art, psychoanalysis, music and cinema, he creates devices that revel in their own loops, spirals and recursions, enacting the endless movement of reference twisting back on itself. (SS)

Represented by 303 Gallery C12, Galerie Hauser & Wirth B5, Lisson Gallery B4, Galerie Micheline Szwajcer E5

Selected Bibliography

2002 'I'm Wondering Who Could be Writing this Song', Matthew Hale, 'A Tale of a Hat', Lynne Cooke, *Parkett*, 64
'River Deep, Mountain High', Steven Stern, *frieze*, 71, November-December

1994 *Rodney Graham, Works from 1976 to 1994*, Jeff Wall, Matthew Titelbaum, Boris Groys, D. Tuen, Art Gallery of York University, Ontario; Yves Gevaert, Brussels; Renaissance Society, University of Chicago

1989 *Rodney Graham*, Jan Debbaut and Frank Lubbers, Stedelijk Van Abbemuseum, Eindhoven

1988 *Rodney Graham*, Jeff Wall, Art Gallery, Vancouver

Selected Exhibitions

2002 'Rodney Graham' Whitechapel Art Gallery, London, Kunstsammlung Nordrhein-Westfalen, Dusseldorf; Galeries Contemporaines des Musées de Marseille

2000 'The Nearest Faraway Places' (with Bruce Nauman), Dia Center for the Arts, New York

1999 'Vexation Island', Museum of Contemporary Art, Miami National Gallery of Canada, Ottawa

1998 Wexner Center for the Arts, Columbus

1997 Canadian Pavilion, Venice Biennale

1989 Stedelijk Van Abbemuseum, Eindhoven

1987 'The System of Landor's Cottage', Art Gallery of Ontario, Toronto

Van, Red Hook, NY
2003
Silver gelatin print
Edition of 6
50×40cm
Courtesy Salon 94 in association
with Artemis Greenberg van Doren

Selected Bibliography

2002 'Variety Photoplays', Phyllis
Tuchman, *Art in America*, June

2001 'A Poignant Intersection of
Fantasy and Reality', David Pagel,
Los Angeles Times, 29 May 2001
'Alice in Levittown', Steven
Vincent, *Art & Auction*, February
'Katy Grannan', Holly Myers,
Art Issues, January-February
'Katy Grannan: Dream America',
Ana Honigman, *Contemporary Visual
Arts*, November

Selected Exhibitions

2003 'New Work', Artemis
Greenberg Van Doren, New York
'New Work', Salon 94, New York
'Imperfect Innocence',
Contemporary Museum, Baltimore

2001 'Katy Grannan: Dream
America', 51 Fine Art, Antwerp
'Legitimate Theater', Los Angeles
County Museum of Art

2000 'Dream America',
Lawrence Rubin Greenberg
Van Doren, New York
'Dream America', Kohn Turner,
Los Angeles

1999 'Another Girl, Another
Planet', Greenberg Van Doren,
New York

Katy **Grannan**

Born 1969
Lives New York

While August Sander managed to coax Germans
from all classes and occupations to let him photograph
them in their 'natural habitat', he never got them to
take their clothes off. Not that all of Grannan's
subjects disrobe for her. But the fact that some do is
an indication of how complete strangers come to trust
this young woman with a camera, inviting her into
their suburban homes and momentarily revealing a
side of themselves that perhaps not even their next-door
neighbours have ever seen. Her subjects are
encountered in the living-rooms and bedrooms of
upstate New York, surrounded but not over-defined by
the stuff they have accumulated. Awkward at times but
definitely at home in their very real bodies, they
frankly return the intimate gaze of someone they will
probably never see again. (JT)

Represented by Michael Kohn Gallery E12,
Salon 94 D6

Untitled
2002
Trap, wood, camera
19×20×36cm
Courtesy Johann König

Tue **Greenfort**

Born 1973
Lives Frankfurt

Tue Greenfort works with animals, but it's always a fair deal. In return for photographs taken with an automatic camera, some foxes on the outskirts of Frankfurt got the sausage that released the shutter, and birds in Berlin got a moment of rest on a branch provided by the artist. At the Istanbul Biennale in 2001 Greenfort lured ants – with a honey-soaked piece of string – into taking a detour through an exhibition space. Yet he is not a romanticist of lost idylls. Just like humans, animals are the inhabitants of the contemporary cityscape, and it is this that Greenfort explores with conceptual precision – and, if necessary, with some help from his little friends. (JöH)

Represented by Johann König B15

Selected Bibliography

2004 *Tue Greenfort*, Lukas & Sternberg, New York and Berlin

2002 In *dieser Stadt sind wir zu Hause*, (In this City we are at Home), Ilona Czerny , Akademie Stuttgart, Rottenburg, Stuttgart

Selected Exhibitions

2003 Schnittraum, Cologne 'The State of the Upper Floor: Panorama/total motiviert', Kunstverein, Munich

2002 'Fresh and Upcoming', Kunstverein, Frankfurt 'Out of Site', Johann König, Berlin

2001 'Vasistas', Teknik University, Istanbul

Member No. 6
2001
60×50cm
Courtesy Vilma Gold

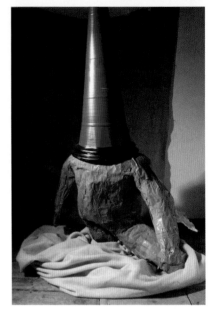

Selected Bibliography

2001 'When Few Were Charmed',
Tom Morton, *frieze*, 61, September
'These Epic Islands', Gilda
Williams, *Art Monthly*, 234
Beck's Futures, John Slyce, Sally
O'Reilly, ICA, London

2000 'Brian Griffiths', Jonathan
Jones, *The Guardian*, March
'Urban Spaceman, Brian Griffiths',
Duncan McLaren, *The Independent*

Selected Exhibitions

2003 'Brian Griffiths', Vilma Gold,
London
'The Lost Collection of an Invisible
Man', The Laing Art Gallery,
Newcastle
'Strange Messengers', The Breeder
Projects, Athens

2002 Galeria Luisa Strina, Saõ
Paulo
MC Magma, Milan

2001 'Open Plan P3',
The Marathon, Alphadelta
Gallery-Artio Gallery, Athens
'Beck's Futures 2', ICA, London;
Fruitmarket Gallery, Edinburgh;
Sothebys, New York
'City Racing, (A Partial History)',
ICA, London

2000 'Brian Griffiths and Kenji
Yanobe', Barbican Centre, London

1999 'Neurotic Realism (Part 1)',
Saatchi Gallery, London

Brian **Griffiths**

Born 1968
Lives London

The British approach to make-believe and fantasy
is one of getting by and making do. Whether it's
Dr Who's alchemical transformation of a kitchen
sink plunger into a deadly ray gun, or *The Prisoner*'s
re-imagining of a sleepy Italianate village in Wales
as a secret government penitentiary, British visions
of the future are not shiny, hi-tech chrome surfaces
but DIY assemblages culled from the here and now.
Brian Griffiths' cardboard supercomputers and
waste-paper horsemen of the Apocalypse concern
themselves with the surface of these home-made
fantasies, the point at which the imagination wrestles
ordinary objects from their mundane origins and
sends them spinning into orbit around distant worlds.
(DF)

Represented by Vilma Gold G5

Untitled (White Butterfly Blue MG)
2001
Oil on linen
180×65cm
Courtesy Blum & Poe

Selected Bibliography

2002 'Working Variables, Switching Games: Mark Grotjahn', Christopher Miles, *artext*, Fall

2001 'Group Show at Gorney, Bravin & Lee', *The New Yorker*, 5 February 2001

1998 'Trying to Fit In', David Pagel, *Los Angeles Times*, 20 November 1998

Selected Exhibitions

2003 Anton Kern Gallery, New York

2002 'L.A. On My Mind: Recent Acquisitions from MOCA's Collection', Museum of Contemporary Art, Los Angeles

2001 'Superman in Bed: Kunst der Gegenwart und Fotografie Sammlung Schurmann' (Contemporary Art and Photography from the Schurmann Collection), Museum am Ostwall, Dortmund
'David Brody, Mark Grotjahn, Wade Guyton, Siobhan Liddell', Gorney Bravin & Lee, New York

2000 Blum & Poe, Santa Monica
'00', Barbara Gladstone Gallery, New York

1999 'After the Gold Rush', Thread Waxing Space, New York

1998 'Entropy at Home', Neuer Aachener Kunstverein, Aachen
'Winter Selections 1998', Drawing Center, New York

1997 'Helmut Federle, Gunter Umberg, Mark Grotjahn, Ingo Muller', Anthony Meier Fine Arts, San Francisco

Mark **Grotjahn**

Born 1968
Lives Los Angeles

An avid poker player, Mark Grotjahn makes paintings the way some people deal cards: working his way around the surface with a practised generosity, enjoying the feel of the process without forgetting the shifting odds or revealing his hand. Grotjahn's skewed fans of eye-popping colour don't quite add up the way you expect them to, each obeying an obscure set of algorithms. Just when you wonder if the glistening confectioner's surfaces are some latter-day Op art refinement, one detail – such as the artist's initials excised from a corner to expose a layer of expressionistic underpainting – hints that the canvases are as poker-faced as the artist. (JT)

Represented by Blum & Poe D9

After Forever (Ever All)
1998
Various green plants, drip system,
fog-humidifier, HPS/milights,
pump, controller, construction
poles, wood
Dimensions variable
Courtesy Galleria Franco Noero

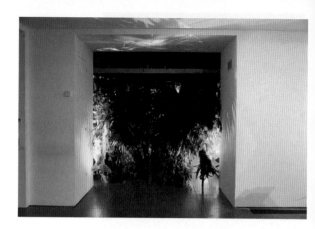

Selected Bibliography

2001 'Henrik Håkansson', Heidi
Fichtner, *Flash Art*, October
*Trans Plant. Living Vegetation in
Contemporary Art*, Hatje Cantz
Publishers, Ostildern-Ruit

2000 'A bug's life', Andrew
Gellatly, *frieze*, 54, September-
October

1999 'Henrik Håkansson,
Tomorrow and Tonight', Caroline
Corbetta, *Nu:The Nordic Art Review*

1997 'The Return of Doctor
Doolittle', Joshua Decter, *Siksi*,
Summer

Selected Exhibitions

2003 De Appel, Amsterdam
Moderna Museet, Stockholm
Kunstverein, Bonn
Ars Viva 02-03 Landschaft, Neue
Galerie im Höhmann-Haus,
Kunstsammlungen Augsburg;
Kunstverein, Hamburg;
Kunstammlungen der Städtischen
Museen Zwickau

2002 Galleria Franco Noero,
Turin
Secession, Vienna

2001 'The Blackbird-Song for a
New Breed', Künstlerhaus
Bethanien, Berlin

2000 'Sweet Leaf', Galerie für
Zeitgenössische Kunst, Leipzig

1999 'Tomorrow and Tonight',
Kunsthalle Basel

1997 Nordic Pavilion, Venice
Biennale

Henrik **Håkansson**

Born 1968
Lives Varberg/Berlin

Henrik Håkansson is not a scientist, but he plays
one in the gallery. Or rather, he borrows selectively
and strategically from the domain of science.
His installations involve deadpan video recordings
of far-flung expeditions in jungles and caves, and
often feature actual wildlife – crickets, beetles, frogs,
butterflies – set in artificial habitats. Taking on the
role of amateur biologist, Håkansson leaves out,
and leaves open, the foundational truth claims of
genuine scientific research. He has commented:
'It always seems too difficult for scientists to just sit
there, they have to change something.' Re-presenting
nature as pure spectacle, these displays give us
scientific effects without scientific knowledge, and in
their resolute purposelessness, put the act of looking
itself under the microscope. (SS)

Represented by The Modern Institute G8,
Galleria Franco Noero G13

Ey Däd-e Bidäd
2002
Inkjet print
188.5×83cm
Courtesy Galerie Karin Guenther

Michael **Hakimi**

Born 1968
Lives Hamburg

Can ornaments tell stories? Michael Hakimi plays with possible answers to this question. The computer graphics he presents on glossy posters are products of a process of visual jamming. Designs reminiscent of early 1980s record covers and stock poster images are combined in intricate formalist compositions. Yet the ornaments resonate with memories and emotions. They take you back to the world of the New Romantics, where cool artificiality framed an unashamed yearning for love and beauty. In the installation *Nawar-e Shad* (2002) two rows of tar-paper led up to an ornamental ribbon while newspapers glued to the adjacent wall formed a huge triangle. What looked like a piece of rigid Minimalism turned out to be an evocative imaging of a car journey into the Iranian mountains. On the flat surface of ornaments narratives thrive. (JV)

Represented by Galerie Karin Guenther G10

Selected Bibliography

2003 'Ein grosser Berg mit kleinen Zacken' (A Big Mountain with Little Teeth), Thomas Gahn in *Zusammenhänge herstellen* (Making connections), Kunstverein, Hamburg

2002 *Michael Hakimi*, Department for Culture, Hamburg
Anna-Catharina Gebbers, *Artist Kunstmagazin,* 3

Selected Exhibitions

2003 'Am Zaun' (At the Fence) Galerie Borgmann-Nathusius, Cologne

2002 'Zusammenhänge herstellen'(Making connections), Kunstverein, Hamburg
'Landschaft 300 qm', Hohenzollernstr.113, Munich
'metropolitan', Galerie Jürgen Becker, Galerie Karin Guenther, Hamburg
Galerie Nomadenoase, Golden Pudel Club, Hamburg

2001 Galerie Karin Guenther, Hamburg
Jahresgaben, Kunstverein, Hamburg

1999 'Revolution, Evolution, Exekution', Akademie Isotrop

Blue Prison
2001–2
Acrylic and pearlescent acrylic and
Roll-a-tex on canvas
119.5×119cm
Courtesy Waddington Galleries

Selected Bibliography

2002 *Peter Halley: Contamination*, Tim Griffin, Alberico Cetti Serbelloni Editore, Milan

2000 *Peter Halley: Maintain Speed*, ed Cory Reynolds, D.A.P./Distributed Art Publishers, New York

1998 *Peter Halley: Utopia's Diagrams*, Arturo Schwarz, Tema Celeste Editions, Milan

1997 *Peter Halley: Recent Essays 1990–1996*, ed Richard Milazzo, Edgewise Press, New York

1988 *Peter Halley: Collected Essays 1981–87*, Galerie Bruno Bischofberger, Zurich

Selected Exhibitions

2003 'Peter Halley', Galleria Cardi & Co., Milan

1999 'Peter Halley', Waddington Galleries, London

1998 'Peter Halley, Paintings of the 1990s', Museum Folkwang Essen 'Peter Halley, Painting as Sociogram 1981–1997', Kitakyushu Municipal Museum of Art

1997 'New Concepts in Printmaking 1: Peter Halley', Museum of Modern Art, New York

1995 'Encounters 6', Dallas Museum of Art

1992 'Peter Halley: Paintings 1989–1992', Des Moines Art Center

1991–2 'Peter Halley: Oeuvres de 1982 à 1991', CAPC Musée d'Art Contemporain, Bordeaux

1989 'Peter Halley: Recent Paintings', Krefelder Kunstmuseen, Museum Haus Esters, Krefeld

1980 P.S. 122, New York

Peter **Halley**

Born 1953
Lives New York

Peter Halley, who is also a writer, and publisher of *Index* magazine, has been making hard-edged paintings since 1993, many of which are wall-paintings and installations. Although Halley's images may recall Mondrian and Albers, his investigation lies less with abstraction than with the idea of geometry as a metaphor for society. That said, the artist also acknowledges the function of intuition in his painting and many of his titles reference film and music. Russell Haswell, writing in *frieze*, commented that 'the self-restraint … in Halley's work is a nod to heavy minimalism – Ryman and Serra spring to mind'. Conduits and cell units – as in prison cells, telephones, computers or bacteria – function for the artist as diagrams of the urban landscape. (JH)

Represented by Galerie Thaddaeus Ropac B14, Waddington Galleries G3

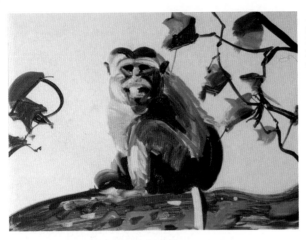

Fear Grin
2003
Monoprint
26×38cm
Courtesy Paul Stolper

Susie **Hamilton**

Born 1950
Lives London

The figures that emerge from the gauzy, layered, shifting surfaces of Susie Hamilton's paintings feel increasingly like ghosts. Previously she painted fringe figures, such as mafia men, who had vanished from the social scene for one reason or another, but in recent years her paintings of horse riders and skeletal white figures in darkness have constructed a floating, dissolving, penumbral world that feels mutedly apocalyptic. It's not surprising, then, that a recent series – images of riders savaged by stinging light – was made in response to the work of 17th-century metaphysical bard Andrew Marvell; his unstable poetics and proposal of a problematically transfiguring union with nature chime perfectly with Hamilton's own. (MH)

Represented by Paul Stolper H13

Selected Bibliography

2002 'Fantastical Mutations', Charlotte Mullins, *Financial Times*, 14 December 2002
'Free Association', Charlotte Edwards, Artist's Profile, *Art Review*, November

2001 'Mutilates', St. Giles' Church, Cripplegate, The Barbican, London, Martin Coomer, *Time Out*, 31 October 2001

2000 *Art Works: British & German Contemporary Art: 1960–2000*, Deutsche Bank, Alistair Hicks, Merrell Publishing, London
'Consumed by Light', Charlotte Mullins, *Art Review*, September

Selected Exhibitions

2002–3 'Paradise Alone', Ferens Art Gallery, Kingston upon Hull

2002 'Postmodernism and Spirituality', University of Central Lancashire, Preston
'Cab Gallery Retrospective', essor gallery project space, London

2001 'Mutilates', St. Giles' Church, Cripplegate, The Barbican, London

2000 Ikon Gallery, Birmingham and touring

1999 'White Light', Paul Stolper, A22 Projects, London

Surface
2002
Lightjet print with matte laminate
and frame
164×109cm
Courtesy ACME.

Selected Bibliography

2003 *Venice Biennale*

1998 *L.A. Times*, Patricia
Sandretto, Fondazione Sandretto
Re Rebaudengo, Turin
Delta, Musée d'Art Moderne de la
Ville de Paris

1997 *L.A.: Particles and Waves*,
Timothy Martin & Diedrich
Diedrichsen, Studio 246 Exhibitions
Künstlerhaus Bethanien, Berlin
Kevin Hanley: Sentiment and Vagrancy,
Frances Stark. 1–20 Gallery, New
York

Selected Exhibitions

2003 'Threesixty', ACME.,
Los Angeles
'Dreams & Conflicts: The Viewer's
Dictatorship', Venice Biennale

2002 'For Instance Tomorrow',
Taka Ishii Gallery, Tokyo

2001 'Passing and Resemblance',
ACME., Los Angeles
'One Wall', Orange County
Museum of Art, Newport

2000 'Provincial Occupations',
Rocket Gallery, London

1998 'Routine and Missing',
1–20, New York

1996 'A Touch of Class', Galerie
Christian Nagel, Cologne
'Dresden Pre-occupation (at Studio
246)', Künstlerhaus Bethanien,
Berlin

Kevin **Hanley**

Born 1969
Lives Los Angeles

Kevin Hanley's photographs and videos randomly
note the passing scene, recording how things look
while wandering aimlessly from place to place.
While there is a long tradition of street photography,
Hanley's work is defined by what Jan Tumlir calls a
'hyper-refined sort of languor ... a deliberate laxity
which at times is reminiscent of the Situationists and
their anti-productive ethos'. This lack of a goal,
a focus, a thematic concern, is what sets Hanley
apart from a Winogrand or an Atget, whose flânerie
was marked by a degree of purposeful discernment.
Hanley's recent video drifts, in contrast, seem
organized according to a set of criteria unavailable
to the viewer. Why this place? Why this picture –
of a skateboarder, a rear-view mirror, a Los Angeles
boulevard – and not some other or none at all? (JT)

Represented by ACME. C16

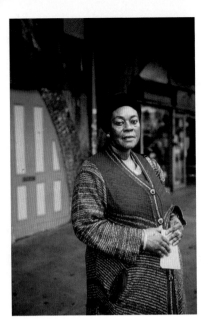

Untitled
2002
C-type print
Edition of 8 + 2 AP
25×38cm
Courtesy Klemens Gasser &
Tanja Grunert, Inc

Selected Bibliography

2000 *Jitka Hanzlová: Female*,
Schirmer & Mosel, Munich and
Hamburg
*The Citibank Private Bank Photography
Prize 2000*, The Photographers'
Gallery, London

1999 *Vielsalm, Jitka Hanzlová*,
Sunparks Art Project, Rekem

1997 *Rokytník, Jitka Hanzlová*,
Museum Schloss Hardenberg,
Velbert

1996 *Bewohner* (Inhabitants),
Kunstverein Frankfurt, Richter
Verlag, Dusseldorf

Jitka **Hanzlová**

Born 1958
Lives Essen

In 1990 Czech-born photographer Jitka Hanzlová
returned to her native village, where she shot a
series of luminous photographs entitled 'Rokytník'.
Recalling both tourist snaps and 19th-century Social
Realist paintings, these dignified images of animals,
hunters, farmers and families in rural idylls are as
serene and strangely surreal as their composition is
straightforward. More recently Hanzlová has
photographed people in various locations across
Europe, North Africa and America; she has also
been documenting landscapes. Although Hanzlová's
subjects are often pictured conventionally gazing
directly at the camera, her images resist archetypes,
revealing personality in the cut of a coat, the look in
an eye or the understanding that can exist between
a person and an animal. (JH)

Selected Exhibitions

2003 Citibank Photography Prize,
The Photographers' Gallery,
London and touring

2001 Stedelijk Museum, Amsterdam
Fotomuseum, Winterthur

2000 Deichtorhallen, Hamburg

1998 Goethe Institut, Budapest

1997 'Rokytník', Museum Schloss
Hardenberg, Velbert

1996 Kunstverein, Frankfurt
Manifesta, Museum Chabot,
Rotterdam

1995 La Maison de la
Photographie, Lectoure
'European Photography Award
1995', Englische Kirche, Bad
Homburg

Change
2002
Fibreglass, American maple,
electric light
133×184×192cm
Courtesy Kerlin Gallery

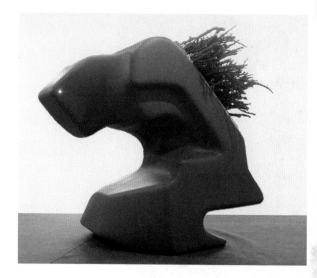

Selected Bibliography

2002 'Second Skin', Mark Gisbourne, *Contemporary,* April

2000 *Siobhán Hapaska/Charles Long/ Ernesto Neto*, Magasin 3, Stockholm Konsthall

1999 *Siobhán Hapaska*, Saison Art Programme, Tokyo

1998 *IMMA/Glen Dimplex Artists Award*, Irish Museum of Modern Art, Dublin

1997 *Siobhán Hapaska*, Oriel Gallery, Llandudno; ICA, London 'Out There', Jennifer Higgie, *frieze,* 37, November-December

Selected Exhibitions

2002 Tanya Bonakdar Gallery, New York
Kiasma Museum of Contemporary Art, Helsinki

2001 Kerlin Gallery, Dublin

2001 Irish Pavilion, Venice Biennale

2000 Magasin 3, Stockholm Konsthall

1999 Sezon Museum of Art, Tokyo

1998 'IMMA/Glen Dimplex Artists Award', Irish Museum of Modern Art, Dublin
'Speed', Whitechapel Art Gallery, London

1997 Documenta, Kassel

1995–6 'Saint Christopher's Legless', Institute of Contemporary Arts, London

Siobhán **Hapaska**

Born 1963
Lives London

Described by critic Caoimhím Mac Giolla Léith as 'retromodern nostalgia for a bygone vision of a lost future', the art of Belfast-born Siobhán Hapaska collides organic and futuristic elements. Genuine tumbleweeds move stiffly along motorized tracks; a video shows a couple aroused by an alien visitation in a natural landscape; St Christopher is figured as a legless sculpture; and a streamlined, silvery fibreglass form – all blurred edges, as if based on a snapshot of a moving motor cycle – might have been beamed in from another galaxy. What connects them, as Hapaska has noted, is their air of being lost: a mood that poetically figures our contemporary interregnum between cybernetic futurity and natural past – and our fearful yearning for both. (MH)

Represented by Tanya Bonakdar Gallery E7, Kerlin Gallery F16

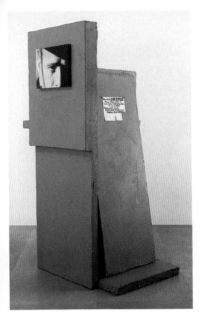

The Honey Collection
Mixed media sculpture
2002
82.5×85×125cm
Courtesy Greene Naftali

Rachel **Harrison**

Born 1966
Lives New York

Confronting Rachel Harrison's hybrid sculptures for the first time can be something of a challenge. They are perplexing, often ungainly, things – conglomerations of home-improvement materials and blobby painted masses, scattered with seemingly random found objects and photographs. Spend enough time with them, though, and the disparate parts begin to communicate. They speak in the language of recent art history, setting the formalist against the formless, Minimalist objecthood against ready-made appropriation.
If, on paper, this sounds as enticing as a bowl of footnotes, it's worth pointing out that Harrison's work is also funny as hell. Playing intricate games with modes of looking and making, she creates paradoxical objects that invite the viewer into their looped and loopy dialogues. (SS)

Represented by Greene Naftali C10

Selected Bibliography

2002 'Shelf Life', Saul Anton, 'Blind Alleys', Bruce Hainley, *Artforum*, November
'Rachel Harrison', Helen Molesworth, *Documents,* 21, Fall-Winter
'Rachel Harrison', Kirsty Bell, *frieze*, 68, Summer

2000 *Walker Evans & Company*, Peter Galassi, Museum of Modern Art, New York
'The Harrison Effect', Bill Arning, *Trans>Art and Culture*, 7

Selected Exhibitions

2004 Greene Naftali, New York
Camden Art Centre, London

2003 Bergen Kunsthalle, Gallery No. 5
'Rachel Harrison, Hirsch Perlman, Dieter Roth, Jack Smith, Rebecca Warren', Matthew Marks Gallery, New York
'The Structure of Survival', Venice Biennale
Brighton PhotoBiennal

2002 Whitney Biennial, Whitney Museum of American Art, New York
'Currents 30: Rachel Harrison', Milwaukee Art Museum

2001 'Perth Amboy', Greene Naftali Gallery, New York

1998 'New Photography 14', Museum of Modern Art, New York

Atmos
2003
Digital c-type print
90×90cm
Courtesy Taka Ishii Gallery

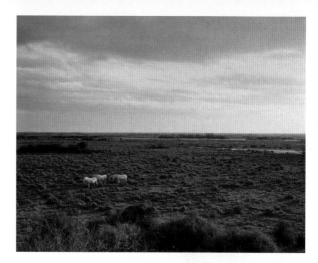

Selected Bibliography

2002 *Naoya Hatakeyama*,
Kunstverein Hanover; Kunsthalle
Nuremberg; Huis Marseille,
Amsterdam; Hatje Cantz,
Ostfildern-Ruit
Slow Glass, Light Xchange and the
Winchester Gallery, Winchester

2001 *Under Construction*, Kenchiku
Shiryo Kenkyusha Co., Ltd., Tokyo

2000 *Underground*, Media Factory,
Tokyo

1997 *Lime Works*, Synergy Inc.,
Tokyo

Selected Exhibitions

2003 'Atmos', Taka Ishii Gallery,
Tokyo

2002 'Naoya Hatakeyama',
Kunstverein, Hanover,
'Slow Glass', Winchester Gallery,
L.A. Galerie, Frankfurt
'The History of Japanese
Photography', Museum of Fine
Arts, Houston

2001 Victoria and Albert Museum,
London
Japanese Pavilion, Venice Biennale

1998 'Photography Today',
National Museum of Modern Art,
Tokyo
'Asia City', The Photographers'
Gallery, London

1997 'Surface Exposed', Museum
of Contemporary Art Tokyo

1994 'Liquid Crystal Futures',
touring

Naoya **Hatakeyama**

Born 1958
Lives Tokyo

Naoya Hatakeyama's photographs reveal that
natural beauty still lurks in the built-up world –
we just have to search harder for it. Early shots of
excavated lime cliffs and freeze-framed explosions
in quarries paved the way for his late 1990s
breakthrough series 'Underground'. These gleaming
images followed a river's course through Shibuya,
Tokyo, pitting stencil-sharp architecture against
flowing, serpentine nature; then, chasing the river
into the sewers, Hatakeyama found a world of
extraordinary reflections. In 2001, continuing this
binary opposition of the liquid and the man-made,
he visited the English new town Milton Keynes.
The ensuing series 'Slow Glass' alchemized drops of
water on a car windscreen into shining constellations
of refractory bubbles: an against-the-odds reclaiming
of drab Englishness that felt quietly heroic. (MH)

Represented by Taka Ishii Gallery G9

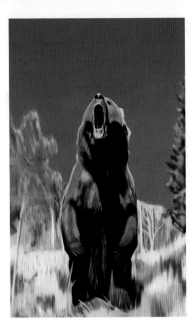

Beauty Walks a Razor's Edge
2003
Oil on canvas
270×170cm
Courtesy Galerie Gebr. Lehmann

Selected Bibliography

2002 Marcus Lütkemeyer, *Kunstforum*

2000 Stephanie Cash, *Art in America*, December
Martha Schwenderer, *Flash Art*, 213, Summer
Hans Rudolf Reust, *Kunstforum*, 143

1999 Hans Rudolf Reust, *frieze*, 44, January-February

Selected Exhibitions

2003 'Beauty Walks a Razor's Edge', Galerie Gebr. Lehmann, Dresden
'Painting Pictures', Kunstmuseum, Wolfsburg
'Interview with Painting', Fondazione Bevilacqua La Masa, Venice
'deutschemalereizweitausenddrei', (German painting 2003) Kunstverein, Frankfurt

2002 'Square', Anton Kern Gallery, New York

2001 'Driver', Museu de Arte Contemporanea de Serralves, Porto
'Painting at the Edge of the World', Walker Art Center, Minneapolis

2000 'Goldener – Der Springer – Das kalte Herz', White Cube, London

1999 'Druck Druck', Galerie für Zeitgenössische Kunst, Leipzig

1998 'Fenster-Fenster', Kunstmuseum, Lucerne

Eberhard **Havekost**

Born 1967
Lives Berlin/Dresden

Eberhard Havekost paints cool, impersonal, realist images that recall unspecified film and video stills. High-rise buildings, wild animals and close-ups of faces populate his paintings, as if plucked from a story with no punchline. Even when depicting outdoor scenes, the light is artificial and flattening. As in photographs, occasionally details are blurred.
Often the lines of a building or arrangements of cloth are cropped to a point of near-abstraction; despite the clarity of Havekost's anti-gestural palette and paint application, unsettling compositions and shifts in focus create a sense of deliberate confusion and alienation. (JH)

Represented by Galerie Gebr. Lehmann C18, White Cube F6

Willküren No. 6
2003
Acrylic on canvas
250×410cm
Courtesy Jablonka Galerie Linn
Lühn

Sophie von **Hellermann**

Born 1975
Lives London

Sophie von Hellermann has commented that 'with each painting I try to capture something which would otherwise be lost to me.' This may explain the topical eclecticism of her colorful, briskly brushed acrylics on canvas. One painting re-imagines Edouard Manet's *Déjeuner sur l'herbe* (1863) as a cannibalistic picnic hastily painted by someone like Erich Heckel; another depicts the artist as a young supermodel, reclining on a divan surrounded by self-portraits and a copy of *Hello!* magazine with her face on it. A founding member of Hobbypop-Museum, a Dusseldorf-based group of artists devoted to kinds of satirical 'performance parties', von Hellermann shares with her companions a healthy fascination with the similarities between the art world and other subcultures – fashion, pop music – that rely heavily on glamour, celebrity and a predominant youth mythos. (JT)

Represented by Marc Foxx G12, Galerie Ghislaine Hussenot F15, Jablonka Galerie Linn Lühn G11, Vilma Gold G5

Selected Bibliography

2002 *Dear Painter, Paint Me*, ed Alison M Gingeras, Centre Georges Pompidou, Paris; Kunsthalle, Vienna; Schirn Kunsthalle, Frankfurt

2001 *Sophie von Hellermann at Underwood Street*, Suzanne Patterson, Saatchi Gallery, London
New Contemporaries, New Contemporaries Ltd

1999 *Trouble Spot. Painting*, Moca, Antwerp

Selected Exhibitions

2003 Jablonka Galerie, Linn Lühn, Cologne
Kunstverein Konstanz
Ghislaine Hussenot, Paris

2002 'Dear Painter, Paint Me', Centre Georges Pompidou, Paris; Schirn Kunsthalle, Frankfurt; Kunsthalle, Vienna

2001 'Saatchi Gallery presents Sophie von Hellermann', Saatchi Gallery, London
Marc Foxx Gallery, Los Angeles

1999 Weltausstellung 99/ Robolove, Kölnerstrasse, Dusseldorf
'Trouble Spot. Painting', NICC and Museum van Hedendaagse Kunst, Antwerp

Intelligence & Sacrifice
2003
Milled steel, stainless steel, nylon,
thistles, copper sulphate
162×227×63cm
Courtesy Corvi-Mora

Roger **Hiorns**

Born 1975
Lives London

Over the past few years Roger Hiorns' practice has been guided by the concept of creating a home for his work; somewhere that's both 'semi-devotional and a place of manufacture'. Right now it's nothing more than an idea, a structure shimmering on the event horizon full of strange, hermetic objects barnacled with copper sulphate crystals, foaming with self-generated effluvia or else pointing, in their own perverted way, to the work of arch-Modernist Anthony Caro. Allusive yet never symbolic, yearning yet never utopian, Hiorns' sculptures are an oddly poetic response to our imperfect world. They may dream of somewhere else – or even of their own obsolescence – but somehow it seems like they're already home. (TM)

Represented by Corvi-Mora F10

Selected Bibliography

2003 'Fire and Ice', Richard Cork, *New Stateman*, 11 August 2003

2002 'The Crystal Method', Tom Morton, *frieze*, 70, October 'Sign and Substance in Recent Sculpture', J. J. Charlesworth, *Artext*, Fall

2001 Michael Archer, *Artforum*, December

1999 Dan Crowe, *Butterfly*, 5

Selected Exhibitions

2003 Corvi-Mora, London Hammer Project, UCLA Hammer Museum of Art, Los Angeles 'Art Now', Tate Britain, London Marc Foxx, Los Angeles

2002 'Still Life', Museo Nacional de Bellas Artes, Santiago and touring

2001 Corvi-Mora, London

2000 '... comes the spirit', Jerwood Gallery, London

1999 'Heart and Soul', 60 Long Lane, London

1998 'Cluster Bomb', Morrison Judd, London

1997 'European Couples and Others', Transmission Gallery, Glasgow

Laundrette
2001
Wood, cardboard, foil, tape, plastic,
stickers, plastic tubes, 16 televisions,
16 videos, tables, chairs, plastic
flowers, books, magazines, plastic
bins, stools, mixed media
Dimensions variable
Installation at Stephen Friedman
Gallery
Courtesy Stephen Friedman Gallery

Selected Bibliography

2002 *The Empire of the Senses*,
Nicolas de Oliveira, Nicola Oxley
and Michael Petry, Museum of
Installation and Thames & Hudson,
London

2000 *Jumbo Spoons and Big Cake*,
Art Institute of Chicago
World Airport, James Rondeau,
Hamza Walker, interview by
Okwui Enwesor, Renaissance
Society, University of Chicago,

1999 *World Corners: United
Emmerdements of New Order*, Jean-
Charles Massera, Musée d'Art
Moderne de Saint-Etienne

1998 *Rolex etc., Freundlich's 'Aufstieg'
und Skulptur-Sortier-Station-
Dokumentation*, Marcus Steinweg,
Museum Ludwig, Cologne

1997 *Antropologie I*, Manuel Joseph,
Galerie Chantal Crousel, Paris

Selected Exhibitions

2003 Musée Precaire Albinet,
Les Laboratoires d'Aubervilliers
'Doppelgarage in der Schirn',
Schirn Kunsthalle, Frankfurt
'Common Wealth', Tate Modern,
London
'Utopia Station', Venice Biennale
'GNS', Palais de Tokyo, Paris

2002 Documenta, Kassel
'Archeologie of Engagement',
MACBA, Barcelona

2000 'World Airport', Renaissance
Society, University of Chicago

1998 'Dokumentation', Museum
Ludwig, Cologne
'Ein Kunstwerk, ein Problem' (An
Artwork, a Problem), Portikus,
Frankfurt

Thomas **Hirschhorn**

Born 1957
Lives Aubervilliers

At Thomas Hirschhorn's 1998 exhibition at Frankfurt's
Portikus visitors were confronted by thousands of
newspaper cuttings on plywood walls, with items on
conflict in the Near East, environmental disasters,
increasing obesity and so on. Abstract cardboard
sculptures encased in blue bin-liner plastic were
connected to each of these stories by umbilical cords
of aluminium foil. As the title promised: One Artwork,
One Problem. Hirschhorn's contribution to
Documenta in 2002 took the deadpan clash between
art and politics even further. Situated in a Turkish
working-class district of Kassel, the piece refrained
from serving sociological hors d'oeuvres on migration,
while actually introducing something radically foreign
in a highly accessible way: a monument to the writings
of Georges Bataille. With Hirschhorn, art is always
inappropriate, in the best sense of the word. (JöH)

Represented by Galerie Chantal Crousel C17,
Stephen Friedman Gallery E6

Amazing Revelations
2003
Butterfly wings on canvas
213.5cm triangle
Courtesy White Cube

Selected Bibliography

2003 *Damien Hirst. From the Cradle to the Grave, Selected Drawings*, Annushka Shani, 25th International Biennale of Graphic Arts, Ljubljana

2001 *On the Way to Work*, Damien Hirst and Gordon Burn, Faber and Faber, London

2000 *Damien Hirst. Theories, Models, Methods, Approaches, Assumptions, Results and Findings*, Gordon Burn and George Poste, Gagosian Gallery, New York

1997 *I Want to Spend the Rest of My Life Everywhere, With Everyone, One to One, Always, Forever, Now*, Gordon Burn, Booth-Clibborn Editions, London

1996 *Damien Hirst. No Sense of Absolute Corruption*, interview by Stuart Morgan, Gagosian Gallery, New York

1991 *Damien Hirst*, Charles Hall, Jay Jopling and ICA, London

Damien **Hirst**

Born 1965
Lives London

It's rare, in Britain at least, for an artist to become a household name, but Damien Hirst is a byword for artistic notoriety and a particular form of immediate, iconic, neo-Conceptualism that rose to prominence in the UK during the 1990s. Hirst is central to the creation myth and success story of the 'young British artist', a maverick figure straddling zones of both public infamy and critical acclaim. Whether it's the vitrines filled with embalmed animals, his medicine cabinets or the Pop seriality of his spot paintings, Hirst's spectacularly imaginative work concerns itself with the grand themes connecting us all – life, love, death. As he remarked in an interview with Stuart Morgan in the pilot issue of *frieze*, 'I'm having a relationship with everyone I've ever thought about or communicated with, and every object I've ever seen ...' (DF)

Represented by Gagosian Gallery F7, The Paragon Press A5, White Cube F6

Selected Exhibitions

2003 'Romance in the Age of Uncertainty', White Cube, London 'From the Cradle to the Grave: Selected Drawings', International Biennale of Graphic Arts, Ljubljana

2000 'Theories, Models, Methods, Approaches, Assumptions, Results and Findings', Gagosian Gallery, New York

1999 'Pharmacy', Tate Gallery, London

1997 'The Beautiful Afterlife', Bruno Bischofberger, Zurich 'Solo Exhibition', Astrup Fearnley Museum of Modern Art, Oslo

1995 Turner Prize, Tate Gallery, London 'Still', Jay Jopling/White Cube, London

1992 Istanbul Biennial

Floating 'I'
2001
Power print mounted on Perspex
140×100cm
Photo: Yoshitaka Uchida,
Nomadic Studio
Courtesy Tomio Koyama Gallery

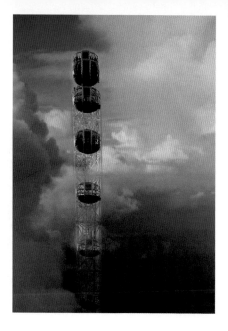

Selected Bibliography

2003 *Photo Active. Tamami Hitsuda &
Toshinao Yoshioka*, Satsuki
Yamamoto, Nagoya University of
Arts, Aichi

2001 Maria Damianovic, *Tema
Celeste*, June
Yuri Mitsuta, *Ryuko Tsushin*, 452,
March

Selected Exhibitions

2002 'The Place Without Name',
Tomio Koyama Gallery, Tokyo
'Henshin Ganbou', Fukui City
Museum
'Photo Active: Tamami Hitsuda &
Toshinao Yoshioka', Nagoya
University of Arts, Aichi

2001 'Tamavivant 2001', Tama
Art University, Tokyo
'Illusional Life', Tomio Koyama
Gallery, Tokyo

1999 'What you want is not so far',
Tomio Koyama Gallery, Tokyo

Tamami **Hitsuda**

Born 1958
Lives Nagoya

Although Tamami Hitsuda studied as a painter,
she now creates images by digitally manipulating
photographs she has taken of 'real' places. These
images hover somewhere between fact and fiction;
one recent body of work was entitled 'The Place
without a Name'. Clouds, trees, the sky, dislocated
objects and dreamy intimations abound. Meaning
is suspended somewhere in the spaces between the
floating poetry of Hitsuda's images; the world she
describes appears to be holding its breath as it
decides what will happen next. (JöH)

Represented by Tomio Koyama Gallery C5

Tom and Charles Guard
2002
Watercolour on paper (4 sheets)
122×91.5cm
Courtesy Annely Juda Fine Art

David **Hockney**

Born 1937
Lives Los Angeles

In 1960 David Hockney read the complete works of Walt Whitman and began to travel; poetry and the infinite variations of the physical world are still enduring themes in his work. Originally from Yorkshire, Hockney moved to Los Angeles and made his first paintings of showers and swimming pools in the mid-1960s. Dazzled by the sensual possibilities of sunshine, these joyful depictions of lovers, friends, rooms and places are bathed in light. More recently, Hockney, who is also a prolific creator of drawings, watercolours and prints, has become interested in digital imagery and in the relationship between painting and photography. He has also designed stage sets for several operas including productions at Glynebourne, the Royal Opera House in London and the Metropolitan Opera in New York. (JH)

Represented by Annely Juda Fine Art F3

Selected Bibliography

2003 *Painting on Paper*, Annely Juda Fine Art, London

2001 *David Hockney – Exciting Times are Ahead – A Retrospective*, Kunst- und Ausstellungshalle der Bundesrepublik Deutschland, Bonn

1999 *David Hockney – Espace/Paysage*, Centre Georges Pompidou, Paris

Selected Exhibitions

2003 'Painting on Paper', Annely Juda Fine Art, London

2001 'David Hockney Painting 1960–2000', Louisiana Museum of Modern Art, Humlebaek
'David Hockney – Exciting Times are Ahead – A Retrospective', Kunst- und Ausstellungshalle der Bundesrepublik Deutschland, Bonn

1999 'David Hockney – Espace/Paysage', Centre Georges Pompidou, Paris
'Dialogue avec Picasso', Musée Picasso, Paris
'David Hockney: Photographies', Maison Européene de la Photographie, Paris

Coming Through 2
2002
Wood and metal panel, ceramic
sockets and light bulbs
56×65×37.5cm
Courtesy CRG Gallery

Selected Bibliography

2003 'Jim Hodges at CRG,' Susan
Harris, *Art in America*, January

2002 'Jim Hodges', Stuart
Horodner, *Bomb Magazine*, 79,
Spring

2000 Review, Charles Labelle,
frieze, 54, September–October

1999 *Regarding Beauty*, Neal
Benezra and Olga M. Viso, essay
by Arthur C. Danto, Hirschhorn
Museum and Sculpture Garden,
Washington DC

1998 *Abstract Painting – Once
Removed*, Dana Friis-Hansen, David
Pagel, Raphael Rubinstein, Peter
Schjeldahl, Contemporary Arts
Museum, Houston

Selected Exhibitions

2003 'Jim Hodges', Addison
Gallery of American Art, Phillips
Academy, Andover
'Jim Hodges' Tang Teaching
Museum and Art Gallery at
Skidmore College; Weatherspoon
Art Museum, Greensboro
'Jim Hodges', Henry Art Gallery,
Seattle
'Group Show', PS1, New York
'Returning', ArtPace, San Antonio
'Colorsound', Addison Gallery of
American Art, Phillips Academy,
Andover

2002 'This and This', CRG
Gallery, New York
'Jim Hodges: Constellation of an
Ordinary Day', Jundt Art Museum,
Gonzaga University, Spokane
'Jim Hodges: Subway Music Box',
Day-Ellis Gallery, Museum of Arts
& Culture, Spokane

2001 'Jim Hodges', Camargo
Vilaça, São Paulo

Jim **Hodges**

Born 1957
Lives New York

Jim Hodges' delicate objects often inspire an odd sort
of tenderness. You want to protect and hold on to the
feelings they evoke, like the memory of a perfect day.
He has created an intimate art of simple materials
and small gestures: wispy silver-chain spider webs
hanging in corners, curtains of artificial flowers,
arrays of coloured lights, handmade shirts nested one
inside another. Moving freely through disparate media
– his ever-changing work has involved painting,
photography, video and assemblage – Hodges brings
a refreshingly uncynical attention and sensitivity to
each project. Running through everything he does is
a constantly renewed engagement with specific
materials, a fascination with the play of light and
a love of things that fade. (SS)

Represented by CRG Gallery F8, Marc Foxx G12,
Stephen Friedman Gallery E6

Light Corner
2001
Exhibition view, 'Instruments from the Kirna Psycho Laboratory', Schipper & Krome, Berlin
Photo: Howard Sheronas
Courtesy Schipper & Krome

Selected Bibliography

2003 *Spiritus*, Magasin 3, Stockholm Konsthall

2000 *Carsten Höller*, Registro, Fondazione Prada, Milan
Liukuratoja – Slides, Tuotanto – Production, ed Daniel Birnbaum and Patrik Nyberg, Kiasma, Studio K, Helsinki

1999 *Neue Welt* (New World), Museum für Gegenwartskunst, Basel

1998 'Genuß und Wahrheit/Pleasure and Truth', Gerrit Gohlke, *BE Magazin*, 6, Winter

Carsten **Höller**

Born 1961
Lives Stockholm

Trained as a scientist, Carsten Höller creates technically sophisticated objects and installations that function as open-ended experiments: he has called his interactive pieces 'confusion machines'. Designed to toy with mental states and trouble perceptual certainties, they are elaborately disorienting devices: the term 'hallucinatory' is, for once, hardly a metaphor at all. Encountering Höller's work, viewers might negotiate pitch-black corridors by feel, slide down tubes twisting through buildings or have their brainwaves readjusted by banks of flashing lights. These carnivalesque encounters simultaneously engage body, mind and that uncertain area in between. (SS)

Represented by Air de Paris B16, Galerie Martin Janda F14, Schipper & Krome E8

Selected Exhibitions

2003 'Half Fiction', Institute of Contemporary Art, Boston
'Utopia Station', Venice Biennale

2002 'Ciudades', Saõ Paulo Biennale
'Light Corner', Museum Boijmans van Beuningen, Rotterdam

2001 'Instrumente aus dem Kiruna Psycholabor', Schipper & Krome, Berlin

2001 'Mega-Wave. Towards a New Synthesis', International Triennale of Contemporary Art, Yokohama

2000 'Vision and Reality. Conceptions of the 20th Century', Louisiana Museum of Modern Art, Humlebaek
'Synchro System', Fondazione Prada, Milan

1999 'Ny Värld' (New World), Moderna Museet, Stockholm
Istanbul Biennale

Public Sculpture
2002
Steel, plaster and paint
157×101×61cm
Courtesy Marc Foxx

Selected Bibliography

2003 'A video exhibit that mocks video: Evan Holloway at Marc Foxx', David Pagel, *Los Angeles Times*, 17 January 2003

2002 'Evan Holloway', Sally O'Reilly, *frieze*, 65, March

2001 'Evan Holloway: When Bad Attitude Becomes Form', Giovanni Intra, *Artext*, 72, February–April 'Towards a Funner Lacoon', Bruce Hainley, *Artforum*, Summer

2000 'Evan Holloway: Infinity and Beyond', Bruce Hainley, *frieze*, 47, June–August

Selected Exhibitions

2003 Marc Foxx, Los Angeles 'Guided by Heroes', Z33, Hasselt 'Baja to Vancouver: The West Coast in Contemporary Art', Seattle Art Museum; Museum of Contemporary Art, San Diego; Vancouver Art Gallery; CCAC Wattis Institute, San Francisco

2002 Xavier Hufkens, Brussels Whitney Biennial, Whitney Museum of American Art, New York

2001 'the americans. new art', Barbican Art Gallery, London The Approach, London

2000 'Mise en Scène; New LA Sculpture', Santa Monica Museum of Art; CCAC, San Francisco

1999 'The Moderns', Castello di Rivoli, Museo d'Arte Contemporanea, Turin Marc Foxx, Los Angeles

Evan **Holloway**

Born 1967
Lives Los Angeles

The Sculpture That Goes With the Bank (2001) by Evan Holloway is a model of the kind of bland low-rise building found in anonymous new towns or at the edges of American strip malls. An equally anonymous piece of abstract public sculpture is fixed to a plinth outside the building, yet this metallic form appears to have taken on a demented and frenzied life of its own, twisting up into the air to create a three dimensional squiggle dwarfing its corporate home. Holloway's work is suffused with a West Coast sense of humour that belies his serious reconsideration of traditional sculptural notions of scale and our relationship to objects. (DF)

Represented by The Approach D8, Marc Foxx G12

Selected Bibliography

2001 *Jenny Holzer – Neue Nationalgalerie Berlin*, Henri Cole and Angela Schneider, American Academy Berlin and Nationalgalerie, Berlin
Jenny Holzer: Xenon, Peter Schjeldahl, Beatrix Ruf and Joan Simon, Inktree Editions, Küsnacht

1998 *Jenny Holzer*, David Joselit, Joan Simon and Renata Salecl, Phaidon, London

1996 *Jenny Holzer, Lustmord,* Beatrix Ruf, Yvonne Volkart, Markus Landert and Noemi Smolik, Kunstmuseum des Kantons Thurgau

1989 *Jenny Holzer*, Diane Waldeman, Guggenheim Museum and Harry N. Abrams, Inc., New York; German edition, Cantz Verlag, Stuttgart

Jenny **Holzer**

Born 1950
Lives New York

In 1977 New York-based Jenny Holzer began 'Truisms', simple statements on social and political issues printed on T-shirts or posters distributed anonymously around the city. In 1982 she achieved wide recognition for her deadpan slogans which appeared on LED displays in Time Square. Since then *Protect me from what I want* (1985–6) has become a classic haiku on capitalist commodification of desires. Holzer's prose is aggressive, touching, thoughtful. Her 2001 project at Mies van der Rohe's Neue National-galerie building in Berlin was among her most impressive: from 50-metre-long LED strips installed under its Modernist ceiling a stream of consciousness flowed into the city like coded messages beamed from a spaceship. (JöH)

Represented by Galerie Yvon Lambert D16, Sprüth Magers Lee B3

Selected Exhibitions

2002 Permanent installation for Palais de Justice, Nantes
Permanent installation, Neue Nationalgalerie, Berlin

2001 'Oh, Jenny Holzer', CAPC Musée d'Art Contemporain, Bordeaux

1999 Installation for the Reichstag, Bundestag, Berlin
'Jenny Holzer: Proteja – me do que eu quero', Centro Cultural Banco do Brasil, Rio de Janeiro

1997 Permanent installation for the Guggenheim Museum, Bilbao

1994 'Black Garden', permanent installation, Städtische Galerie, Nordhorn

1990 United States Pavilion, Venice Biennale
'Jenny Holzer', Guggenheim Museum, New York

1990 'Jenny Holzer: Laments 1988–89', Dia Art Foundation, New York

Bande
(Gang)
2002–3
Wood, resin, paint
Life-size figures
Courtesy Matthew Marks Gallery

Selected Bibliography

2003 *Martin Honert*, Matthew Marks Gallery, New York

1998 *Martin Honert*, Institut für Auslandsbeziehungen, Bonn

1997 *Young German Artists 2,* Saatchi Gallery, London

1995 *Martin Honert, Fliegende Klassenzimmer* (The Flying Classroom), Venice Biennale

1994 *Martin Honert*, Jean-Christophe Ammann, Museum für Moderne Kunst, Frankfurt

Selected Exhibitions

2002 'Martin Honert', Kunstverein, Hanover

2001 'Monika Brandmeier, Ulrike Grossart, Martin Honert, Carl-Emmanuel Wolff', Museum für Moderne Kunst, Frankfurt

2000 'Martin Honert: Mutprobe (Test of courage)', Gemäldegalerie Neue Meister, Albertinum, Dresden

1999 'Szenenwechsel XVI', Museum für Moderne Kunst, Frankfurt

1997 'Martin Honert: Fata Morgana', Museu d'Art Contemporani, Barcelona

1996 'Zuspiel: Martin Honert and Stefan Hoderlein', Kunstverein, Stuttgart
'Views from Abroad, European Perspectives on American Art 2', Whitney Museum of American Art, New York

1995 German Pavilion, Venice Biennale (with Katharina Fritsch and Thomas Ruff)

1993 'Aperto' Venice Biennale
'Menschenwelt (Interieur)', Portikus, Frankfurt and touring

Martin **Honert**

Born 1953
Lives Dusseldorf

Martin Honert's sculptures often have their source in the artist's memories of childhood – scenes remembered or imagined or borrowed from storybooks. Out of this material Honert creates meticulously rendered objects in painted polyester, perfectly crafted and strangely frozen: enlarged illustrations magically extended into the third dimension. They resemble stage sets or giant toys, but are too excessively detailed to be either. They come perilously close to kitsch, but stop just short, too earnest and strange. What do these hermetic objects actually represent? Not things themselves, but images of things – images locked in the mind, unchanging. (SS)

Represented by Galerie Gebr. Lehmann C18, Matthew Marks Gallery C7

The Juggler
2003
Wood, lace, plaster, clay, acrylic
Courtesy Milton Keynes Gallery

Georgie **Hopton**

Born 1967
Lives London/New York

Despite the inclusion of glitter, pom-poms, Napoleon hats and magic wands, a mixed tone of melancholia and amusement drifts through Georgie Hopton's drawings, paintings, sculpture and photographs of the past decade. This is evident in their cast of characters – harking back to the imagery of early Pablo Picasso and marking our distance from his optimistic era, she favours sad-eyed Pierrots and harlequins – and in their craft-like facture. Having made a series of papier-mâché jugs, for instance, Hopton painted them bronze, photographed them and made paintings from the photos. This circular process, which typifies her art, she calls 'l'hommage pathétique'; its watery humour and imbricated lack of progress sometimes feel very close to real life. (MH)

Represented by Milton Keynes Gallery H8

Selected Exhibitions

2003 'Laughed – I Could Have Cried', Milton Keynes Gallery

2002 'Summer Show', Royal Academy of Arts, London

2001 'Tattoo Show' (in collaboration with Josephine Soughan), Modern Art, London

2000 '00', Barbara Gladstone Gallery, New York

1999 'Beautiful Drawings', Mayor Gallery, London

1998 'Nirvana', The British Council Window Gallery, Prague 'Lovecraft' (with Simon Periton), South London Gallery

1997 'Some Kind of Heaven' (in collaboration with Josephine Soughan), South London Gallery

1996 'Co-Operators' (with Simon Periton), Southampton City Art Gallery

1994 'WM Karaoke' (with Josephine Soughan), Portikus, Frankfurt

Balkon
(Balcony)
2002
Steel, stucco, wood, unique acrylic
cast of a towel
113×100×380cm
Photo: David Brandt
Courtesy Galerie Barbara Thumm

Selected Bibliography

2002 'Sabine Hornig', Jordan
Kantor, *Artforum*, Summer

2001 'Space Invader', Dominic
Eichler, *frieze*, 62, October

2000 *Sabine Hornig*, Karl-Schmidt-
Rottluff-Grant, Kunstakademie
Dresden and Kunsthalle Dusseldorf

2000 'Sabine Hornig', Harald
Fricke, *Artforum*, April
Heidi Fichtner, *Flash Art*,
March–April

Selected Exhibitions

2003 Project Space, Museum of
Modern Art, New York
Galerie Barbara Thumm, Berlin

2002 'The invisible and the visible
as an indivisible unity',
Mendelsohn-Haus, Berlin
'Balkon', Galerie Barbara Thumm,
Berlin
'Out Front', Tanya Bonakdar
Gallery, New York

2001 'Berlin-London', ICA,
London

2000 Karl Schmidt-Rottluff Grant
Exhibition, Kunstakademie
Dresden and Kunsthalle Dusseldorf
'Clockwork', PS1, Clocktower
Gallery, New York
'Rauhputz City', Galerie Barbara
Thumm, Berlin

Sabine **Hornig**

Born 1964
Lives Berlin

Sabine Hornig's sculptures are usually based on actual
or stereotypical architecture, whether it's stuccoed scale
models of entrances to social housing blocks, surgically
isolated and turned into monuments to the absurdly
surreal character of supposed functionalism (*Rauhputz
City, Roughcast City*, 2000), or a balcony, complete with
a towel hung casually over the balustrade, jutting out
into the exhibition space like a gravity-defying
hallucination (*Balkon, Balcony*, 2002). Hornig's large-
scale photographs of Berlin's empty shop-fronts – the
window frames aligned with the edge of the image –
flat-iron picture-as-window on to window-as-picture
like a steamroller in a cartoon strip. Both the sculptures
and the photographs create semiotic wormholes
between outside and inside, aesthetic illusion and
economic disillusion, Modernist dreariness and
deadpan eeriness. (JöH)

Represented by Tanya Bonakdar Gallery E7,
Galerie Barbara Thumm A4

The Soul of Tammi Terrell
2001
Video sculpture: two DVDs
(5 minute 30 second), two metal
stands, 25" monitor, 20" monitor,
two DVD players
Courtesy Greene Naftali

Jonathan **Horowitz**

Born 1966
Lives New York

Jonathan Horowitz' videos and installations take it for granted that the borders between Pop culture and the self are more than a little fuzzy. The mass media aren't something 'out there': they are always internalized, structuring the way we understand our own lives. Old sitcoms create lasting memories; celebrities are imaginary friends and ego surrogates. Horowitz' witty work catches the slippages in this televisual fantasy world, highlighting uncanny moments of identification. Through seemingly simple gestures – re-editing and recontextualizing scenes from films, reversing music videos, matching autobiographical fragments with TV clips – he offers glimpses at the all too familiar strangeness of our media landscape. (SS)

Represented by Sadie Coles HQ B8, Greene Naftali C10, Galerie Yvon Lambert D16

Selected Bibliography

2002 *The Object Sculture*, Tobias Rehberger, Jöelle Tuerlinckx, Keith Wilson and Penelope Curtis, Henry Moore Institute, Leeds
Dark Spring, Liam Gillick, Nicolaus Schafhausen, Ursula Blickle Stiftung, Unteröwisheim
Tableaux Vivants: Lebende Bilder und Attituden in Fotografie, Film, und Video (Tableaux Vivants: Living Images and Attitudes in Photography, Film and Video), Sabine Folie, Michael Glasmeier, Kunsthalle, Vienna
Art Now, Uta Grosenick, Taschen, New York
Casino 2001, Jeanne Greenberg Rohatyn, Lars Bang Larsen, Libby Lumpkin, Midori Matsui, Saul Anton and Andrea Scott, SMAK, Ghent

Selected Exhibitions

2004 Galerie Yvon Lambert, Paris

2003 'Surreal Estate', Gavin Brown's enterprise, New York
Galerie Yvon Lambert, Paris
Wadsworth Atheneum Museum of Art, Hartford

2002 'The Object Sculpture', Henry Moore Institute, Leeds
'Go Vegan!', Greene Naftali Gallery, New York
'Pillow Talk', Sadie Coles HQ, London

2001 'Time, Life, People', Kunsthalle St. Gallen
'We the People', China Art Objects, Los Angeles

2000 'The Jonathan Horowitz Show', Greene Naftali Gallery, New York

*Mountain with no Name
(Pandjshêr Valley, Afghanistan)*
2003
Lambda print
126.5×133cm
Courtesy MW projects

Selected Bibliography

2002 *Marine Hugonnier*, Centro
Galego de Arte Contemporanea,
Santiago de Compostela
*Presentness is Grace: Experiencing the
Extended Moment*, Catsou Roberts,
Arnolfini Gallery, Bristol
'Marine Hugonnier', Martin
Herbert, *Camera Austria
International*, 73

2000 'Marine Hugonnier', Liam
Gillick, *La revista del Centro Gallego de
Arte Contemporanea*, Santiago de
Compostela
*Conversation between Pierre Huyghe
and Marine Hugonnier*, Chantal
Crousel, Paris

Selected Exhibitions

2003 'Ariana', Chisenhale Gallery,
London; Spacex Gallery, Exeter;
MW projects, London
'Impact', Yokohama Red Brick
Warehouse Number 1, Yokohama
'Utopia Station', Venice Biennale
'Spiritus', Magasin 3, Stockholm
Konsthall

2002 'Marine Hugonnier &
Bernard Joïsten', FRAC,
Languedoc Roussillon, Montpellier
'Towards Tomorrow', MW
projects, London

2001 Centro Galego de Arte
Contemporanea, Santiago de
Compostela
'Presentness is Grace: Experiencing
the Extended Moment', Arnolfini,
Bristol

2000 Fig. 1, London

Marine **Hugonnier**

Born 1969
Lives London

Hugonnier's films and sculptures reflect on art's
capacity to respond to significant and historical
political events. In response to the Austrian
government's swing to the extreme right in 1999,
Hugonnier arranged the live radio broadcast of an
Arvo Part serialist composition, performed by a
pianist who had survived the concentration camps.
For her recent film *Ariana* (2003) she travelled to
Afghanistan, to examine the state of the country
post–Taliban. As the film progresses she begins to
question her own motives in making the piece, and
how art functions when faced by the magnitude of
political and social crises. (DF)

Represented by Galerie Yvon Lambert D16, MW
projects C1

Point of Sale
2002
Video still
Courtesy maccarone inc.

Christian **Jankowski**

Born 1968
Lives Berlin

Christian Jankowski's videos have a charmingly gentle way of robbing his audience of any confidence it might have regarding what is scripted fiction and what is 'real'. Whether he is staging threadbare one-act skits derived from his personal email correspondences, employing bright-eyed eight-year-olds to impersonate real-life contemporary artists at a make-believe reunion, or persuading his art dealer and a neighbouring electronics salesman to describe their business models each in the highly specialized lingo of the other, Jankowski's emphasis on processes of exchange and transformation is consistent. In each work some role reversal or other type of elucidating trade-off occurs (he often gives a degree of determinative control over a piece's form – whether they know it or not – to strangers, amateurs or non-artists) that flips potentially awkward situations into catalytic moments. (JT)

Represented by Klosterfelde B9, maccarone inc. H2, Giò Marconi C14, Galerie Meyer Kainer F1

Selected Bibliography

2002 'Poisoned Arrow', James Trainor, *frieze*, 66, April
Art and Economy, Deichtorhallen, Hamburg

2000 'Der Zeitspieler' (The Timeplayer), Raimar Stange, *Kunst-Bulletin*, 3
German Open 1999 – Gegenwartskunst in Deutschland (Contemporary art from Germany), Kunstmuseum, Wolfsburg

1996 *Texte zur Kunst*, 23, August

Selected Exhibitions

2003 'Puppet Conference', Carnegie Museum of Art, Pittsburgh
Museum für Gegenwartskunst, Basel

2002 Whitney Biennial, Whitney Museum of American Art, New York

2001 'New Works: 01.2', ArtPace, San Antonio
Berlin Biennale

2000 De Appel Foundation, Amsterdam
2000 'The Matrix Effect', Wadsworth Atheneum, Hartford

1999 'German Open 1999 – Gegenwartskunst in Deutschland', Kunstmuseum, Wolfsburg
'Aperto', Venice Biennale

1998 'Mein erstes Buch' (My first book), Portikus, Frankfurt

Ohne Titel
(Untitled)
2002
Leather on silk
110×70cm
Courtesy Galerie Neu

Sergej **Jensen**

Born 1973
Lives Berlin

The paintings of Sergej Jensen evoke a sense of fractured beauty. Jensen paints with gouache, latex and chlorine on jute, silk or denim. Casually composed repetitive patterns, stripes, rhomboids or hexagons occupy only odd segments of the painting's surface, which is otherwise untouched. Picture Blinky Palermo (in another world) drawing ornaments on his jeans on a lazy Saturday afternoon outside a youth club where New Wave music from cheap transistor radios fills the air and mixes with the sound of gently roaring mopeds. This, or something like it, is the atmosphere that pervades Jensen's paintings. Their beauty sticks in the mind the way the smell of cigarettes and sweat stays in your clothes for days after a night out clubbing.
(JV)

Represented by Galerie Neu E10

Selected Bibliography

2003 'Zu früh unvollendet', David Grubbs, *Texte zur Kunst*, 49, March *deutschemalereizweitausenddrei* (German Painting 2003), Nicolaus Schafhausen, Kunstverein, Frankfurt

2002 *Vitamin P: New Perspectives in Painting*, Phaidon, London *Urgent Painting*, ARC, Paris

Selected Exhibitions

2003 Kunstverein, Braunschweig
Greene Naftali, New York
'New Abstract Painting', Museum Morsbroich
'deutschemalereizweitausenddrei' (German Painting 2003), Kunstverein, Frankfurt

Untitled (Heads in Profile)
2002
Acrylic on wood
101×114cm
Courtesy Jack Hanley Gallery

Chris **Johanson**

Born 1968
Lives San Francisco

Chris Johanson is 'really into the ethnic culture blender of San Francisco. The air smells like hepatitis shit, incense, cigarettes, exhaust, the Bay breeze, and food from all the incredible restaurants, it's a good aroma.' His spirited installations, which include murals, paintings and drawings often rendered on found materials, reflect his affection for urban chaos. He is best known for his inventive, often childlike, portraits of people on the street, use of words in images, and cosmic, comic-book landscapes. As influenced by skateboarding, social activism, surfing and music as by art, artists and graffiti, Johanson's DIY aesthetic reflects a folksy, fluid approach to image production. (JH)

Represented by Jack Hanley Gallery G4, Georg Kargl E11

Selected Bibliography

2003 Hilarie M. Sheets, *New York Times*, 20 April 2003

2002 Ken Johnson, *New York Times*, 22 November 2002
Massimiliano Gioni, *Flash Art*, May–June
Dimitri Ehrlich, *Interview*, July

2001 James Yood, *Tema Celeste*, 84

Selected Exhibitions

2003 Georg Kargl, Vienna
SFMOMA Seca award show, San Francisco Contemporary Arts Center
Comic Release, New Orleans
'Uneasy Space', SITE Santa Fe

2002 'Now is Now', Deitch Projects, New York
Whitney Biennial, Whitney Museum of American Art, New York
Museum Boijmans van Beuningen, Rotterdam

2001 Jack Hanley Gallery, San Francisco
Hammer Projects, UCLA Hammer Museum of Art, Los Angeles
'East Meets West', Institute of Contemporary Art, Philadelphia

Terrace 49 (No.3)
2003
Mixed media
107×107×51cm
Courtesy Patrick Painter, Inc

Selected Bibliography

2002 *Won Ju Lim: Elysian Field North*, Melanie O'Brian, Vancouver Art Gallery
Art Now: 137 Artists at the Rise of the New Millennium, Uta Grosenick and Burkhard Riemschneider, Taschen, Cologne

2001 *Sous les ponts, le long de la riviere* … (Under the Bridges, along the River), Casino Luxembourg – Forum d'Art Contemporain
Snapshot: New Art from Los Angeles, James Elaine, Russell Ferguson, Claudine Isé and Ann Philbin, UCLA Hammer Museum of Art, Los Angeles

2000 *Won Ju Lim*, Noëllie Roussel, Künstlerhaus Bethanien, Berlin

Selected Exhibitions

2004 Galerie Max Hetzler, Berlin

2003 'Memory Palace', Patrick Painter, Inc, Santa Monica
Art Unlimited, Art Basel

2002 'Won Ju Lim: Elysian Field North', Vancouver Art Gallery
'California Dreamin', Galerie Max Hetzler, Berlin
'Gwangju Biennale 2002: Sites of Korean Diaspora', Gwangju

2001 Patrick Painter, Inc, Santa Monica
'Won Ju Lim: Longing for Wilmington', Museum für Gegenwartskunst, Siegen, Munster Sculpture Biennale
'Sous les ponts, le long de la riviere …' (Under the Bridges, along the River), Casino Luxembourg – Forum d'Art Contemporain

2000 'Longing for Wilmington', Künstlerhaus Bethanien, Berlin

Won **Ju Lim**

Born 1968
Lives Los Angeles

Won Ju Lim's translucent cityscapes conjure a wealth of associations, from the generic to the specific: the suburban sprawl of Anytown, USA, the sci-fi dystopia of *Blade Runner* (1982), the glass towers of Vancouver or the modern bungalows of Southern California. Modelling her sculptural components on blueprints of prefab homes advertised in catalogues, Lim spins modest architectural aspirations into Perspex and polystyrene ice palaces illuminated by dramatic lighting and projection. With titles such as *Elysian Field North* (2002) and *Schliemann's Troy* (2001), her structures encourage futuristic fantasy while maintaining their proximity to mythic ruin. (KR)

Represented by Patrick Painter, Inc B1

Untitled (Baltimore)
2003
Pigment ink print on paper
Triptych. Each panel 100×112cm
Courtesy Hare & Hound Press, the
artist and Victoria Miro Gallery

Selected Bibliography

2002 *Documenta*, Kassel

2001 *Isaac Julien*, Ellipsis, London
Turner Prize, Tate Publishing,
London

2000 *The Film Art of Isaac Julien*, Bard
Center, Annandale-on-Hudson

Selected Exhibitions

2003 'Isaac Julien', Bohen
Foundation, New York
'Isaac Julien', Fact, Film Art &
Creative Technology, Liverpool

2002 Documenta, Kassel
Turner Prize, Tate Gallery, London

2001 'Isaac Julien', Fabric
Workshop, Philadelphia
'MIT List Visual Arts Center',
Cambridge, Massachusetts

2000–2 'The Film Art of Isaac
Julien', Bard Curatorial College,
Annandale-on-Hudson; Museum of
Contemporary Art, Sydney;
Bildmuseet Umeå; Henie Onstad
Kunstcenter, Oslo; Yerba Buena
Center, San Francisco

2000 'Vagabondia', Studio
Museum, Harlem, New York
'The Long Road to Mazatlan',
Museum of Contemporary Art,
Chicago
'Cinerama', Cornerhouse,
Manchester, and South London
Gallery
'The Long Road to Mazatlan',
Grand Arts, Kansas City

Isaac **Julien**

Born 1960
Lives London

Isaac Julien's lyrical films have roamed through
many places, times and social scenes – 1930s Harlem,
1970s London, the contemporary Caribbean and the
timeless American West – but they return again and
again to scenes of dance. Such representations might
be thought of as emblematic: in the rhythmic motion
of bodies in space, desire is activated and troubled.
Informed by critical theory and a nuanced awareness
of cinematic history, Julien's work highlights those
places where the personal and the political rub
together. He sets myths and stereotypes of blackness,
masculinity and national and sexual identity against
each other and against themselves, always following
the wayward paths of desire, those moments when
the body takes the lead. (SS)

Represented by Galerie Yvon Lambert D16, Victoria
Miro Gallery F4

Polygone HD
2002
Oil on canvas
330×330cm
Courtesy Galerie Hammelehle und
Ahrens

Selected Bibliography

2002 *Stephan Jung*, Kunstverein,
Leipzig

1998 *Stephan Jung*, Kunstverein,
Kassel and Kunstverein, Lüneburg
'Malerei mit neuen Chancen'
(Painting with new Chances),
Ruth Händler, *Art Kunstmagazin*, 9,
September

1997 *Stephan Jung*, Giti
Nourbakhsch, Galerie Hammelehle
und Ahrens, Stuttgart

1995 *Technik-Techno*, Harald Fricke,
Württembergischer Kunstverein,
Stuttgart

Selected Exhibitions

2003 'New Abstract Painting
Painting Abstract Now', Museum
Morsbroich, Leverkusen
'Actionbutton', Collection of the
Federal Republic of Germany,
Hamburger Bahnhof, Berlin
'Der silberne Schnitt' (The silver
Cut), Württembergischer
Kunstverein, Stuttgart

2002 Kunstverein, Leipzig

2001 'Musterkarte – Modelos de
pintura en Alemania', Centro
Cultural Conde Duque, Madrid
'Offensive Malerei' (Offensive
Painting), Künstlerhaus Lothringer
Straße, Munich
Kunststiftung Baden-Württemberg,
Stuttgart

2000 Staatsgalerie Stuttgart
'Reality bytes. Der medial
vermittelte Blick.' (Reality bytes.
The Gaze mediated by the Media),
Kunsthalle, Nuremberg

1998 Kunstverein, Kassel and
Kunstverein, Lüneburg

Stephan **Jung**

Born 1964
Lives Berlin

'First I painted a washing machine' Stephan Jung
once remarked, 'and everyone asked me why. Now
I paint the details of a spin-dryer, and no one asks for
the reason.' Jung, a Berlin-based painter who studied
with Joseph Kosuth (like his friend the late Michel
Majerus), has increasingly turned his microscopic
gaze to the steely, perfect surfaces of industrial goods.
He computer-enlarges abstract close-ups from
advertisements or pieces of graphic design, then
transfers them on to canvas. The resulting paintings
are like peering into the depths of a crystal ball: the
fetishistic quality of the surface of products is
revealed, with all their juicy colours and gleaming
reflections. (JöH)

Represented by Galerie EIGEN + ART F12,
Galerie Hammelehle und Ahrens E13

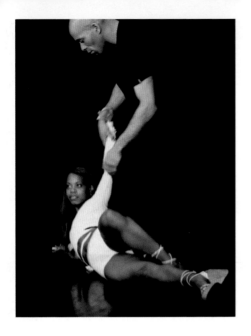

Tonight
2001
Video installation
(5 minute 19 second loop)
Edition of 3 ex + 1AP
Courtesy Galerie Almine Rech

Selected Bibliography

2003 *Johannes Kahrs: Down 'n' out*,
Joao Fernandes, Holzwarth
Publications and Künstlerhaus
Bethanien, Berlin
*Warum! Bielder diesseits und Jenseits des
Menschen* (Why! Images Before and
After Man), Hatje Cantz,
Ostfildern-Ruit

2001 *A-h, Johannes Kahrs*,
Kunstverein, Munich; FRAC des
Pays de la Loire Carquefou; SMAK,
Ghent

2000 *Rencontre 3, Johannes Kahrs*,
Almine Rech Editions/Editions
Images Modernes, Paris

1999 *Why don't you paint my portrait*,
Johannes Kahrs, Gesellschaft für
Aktuelle Kunst, Bremen

Johannes **Kahrs**

Born 1965
Lives Berlin

Johannes Kahrs takes moments of imminent trauma
and translates them into various media. Films and
press photography become paintings, charcoal
drawings and video loops; fact and fiction are
blurred. His varied productions – a painting, fuzzy
like a detuned TV, in which *Taxi Driver*'s Travis
Bickle psyches himself up for battle in his room; a
massive photographic billboard image of F. W.
Murnau's vampire Nosferatu placed menacingly
across from a building site; heavy chiaroscuro
charcoal drawings of nervous-looking black men
and white police – seek to query the coercive power
of specific presentational modes. But they also add up
to an archive of violence that, though often fictional,
is sufficiently transmogrified to feel like a shadowy
documentary of contemporary reality. (MH)

Represented by Galerie Almine Rech H7

Selected Exhibitions

2003 'Warum! Bilder Diesseits und
Jenseits des Menschen' (Why!
Images Before and After Man),
Martin-Gropius-Bau, Berlin
'deutschemalereidreitausenddrei'
(German Painting 2003),
Kunstverein, Frankfurt

2002 'The Drunken Boat',
Galerie Almine Rech, Paris
Taipei Biennale

2001 'A-h', Kunstverein, Munich
and SMAK, Ghent
'Squatters', Museo de Art
Contemporain de Serralves, Porto

2000 'La Révolution permanente'
(The Permanent Revolution),
Galerie Almine Rech, Paris

1999 'Why don't you paint my
portrait', Gesellschaft für Aktuelle
Kunst, Bremen
'Indoor', Musée d'Art
Contemporain, Lyons

Desktop Operation: There's no Place like Home (10th Example of Rapid Dominance: Em City)
2003
Wood, paint, plastic tarp, sand, water
Courtesy The Project

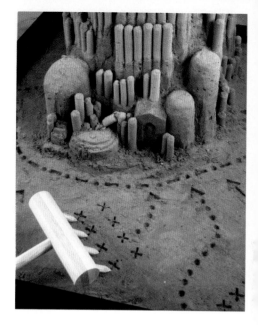

Selected Bibliography

2003 'Glenn Kaino', Franklin Sirmans, *Time Out New York*, 24 April 2003
'Goings on About Town', *New Yorker*, 10 April 2003
'color blind', Christine Y. Kim, *V magazine*, March–April 2003
Flavor Pill, *This Week's Flavor*, 18 March 2003

2001 'Water is Key to Kaino Show', Christopher Knight, *Los Angeles Times*, 26 January 2001

Selected Exhibitions

2003 The Project, New York

2001 'Style Telegraphie', Rosamund Felsen Gallery, Santa Monica
'One Nation Under a Groove', Bronx Museum, New York

2000 'Blue', Venetia Kapernekas Fine Art Inc., New York
'Chasing Perfect', Three Rivers Gallery, Pittsburgh
'Surf Trip', Track 16 Gallery, Santa Monica

1999 'Scratch', Rosamund Felsen Gallery, Santa Monica

1998 'Access All Areas', Fellows of Contemporary Art, Japanese American Cultural and Community Center, Los Angeles
'Xtrascape' (with Matthew K. Fukuda), Los Angeles Municipal Art Gallery

Glenn **Kaino**

Born 1972
Lives Los Angeles

Glenn Kaino's Conceptual sculptures often take the form of quirky landscapes: an upside-down Atlantis submerged in an aquarium; an oversized desktop Zen garden modelled on the Emerald City of Oz. Others, such as the rotating Aeron chair seen at the 2003 Armory Show, put a kinetic spin on the ready-made. Kaino has collaborated with fellow Japanese-American artist Matthew Fukuda on an Agit-prop series meant to challenge stereotypes of Asian culture. This young artist also moonlights as a comic-book writer and a co-founder of the LA alternative space Deep River. (KR)

Represented by The Project H4

Alba
2003
Stainless steel and lacquer
230cm diameter
Courtesy Lisson Gallery

Anish **Kapoor**

Born 1954
Lives London

Anish Kapoor makes sculptures and installations that are concerned with their own 'wholeness', something he believes is achievable through the play of opposites: absence and presence, body and spirit, male and female, darkness and light. A noted colourist, Kapoor's works often appear untouched by human hands – soft Kubrickian monoliths that, in the artist's words, are 'self-manifest, as if there by [their] own volition'. The void is an important concept here, providing a glimpse of the sublime and acting as a repository for the viewer's spiritual beliefs. Unashamedly concerned with big, bold binaries, Kapoor's art succeeds through its quiet humour and easy grace. (TM)

Represented by Lisson Gallery B4

Selected Bibliography

2002 *Anish Kapoor: Marsyas*, Donna de Salvo and Cecil Balmond, Tate Publishing, London

1998 *Anish Kapoor*, Homi Bhabha and Pier Luigi Tazzi, University of California Press; Hayward Gallery, London

1995 *Anish Kapoor*, Germano Celant, Milan, Charta

1991 *Anish Kapoor*, Centro de Arte Reina Sofia, Madrid and The British Council, London

Selected Exhibitions

2002 'Marsyas', Turbine Hall, Tate Modern, London

1998 Hayward Gallery, London CAPC Musée d'Art Contemporain, Bordeaux

1995 Prada Milanoarte, Milan

1991 Palacio de Velazquez, Reina Sofia, Madrid (with British Council)

1990 British Pavilion, Venice Biennale

Promises Kept and Promises Unfulfilled
2003
Ink marker on paper
70×100cm
Courtesy Galerie Karin Guenther
and Galerie Giti Nourbakhsch

Selected Bibliography

2003 'Fantastic Voyage', Dominic Eichler, *frieze*, 72, January–February

2002 'Kerstin Kartscher', Jennifer Allen, *Artforum*, April
'Somewhere over the Rainbow', Esther Buss, *Texte zur Kunst*, 45, March
'The position of hatching between retro and vision', Gunter Reski, *Kunststätte Bleckede*

2001 'Spatzen pfeifen in digitaler Harmonie' (Sparrows Sing in Digital Harmony), Jörn Ebner, *Frankfurter Allgemeine Zeitung*, 15 December 2001

Selected Exhibitions

2002 'The Collective Unconsciousness', Migros Museum für Gegenwartskunst, Zurich
'A Holiday Unwasted', Galerie Giti Nourbakhsch, Berlin

2001 'Refuse to know', Galerie Karin Guenther, Hamburg

2000 'Landscape', Galerie Giti Nourbakhsch, Berlin
Galerie Karin Guenther, Hamburg (with Silke Otto-Knapp)
'Include Me Out', Provost St., London

1999 'Mondo imaginario', Shedhalle, Zurich
'Videoclub', Kunsthalle, Hamburg

1998 'High Fidelity', Halle für Kunst e.V., Lüneburg

1997 'Time Out', Kunsthalle, Nuremberg

Kerstin **Kartscher**

Born 1966
Lives London

The drawings of Kerstin Kartscher transport you to parallel universes. Infinite landscapes, boundless oceans and huge expanses of sky are sketched out in rhythmically flowing lines, ornamental shapes and geometric graphs. Crystalline utopian architecture looms up amid thick clouds. Sometimes a solitary female figure inhabits this dreamscape, returning radiant with the silent wisdom of apocalyptic prophets. At other times the only sign of life might be a balloon drifting among the mountains, presumably carrying adventurous travellers off to unknown continents that Jules Verne would have loved. Writers such as William Gibson have tried to investigate the limitless virtual spaces animated by personal dreams and desires. Kartscher manages precisely this, with effortless ease. (JV)

Represented by Galerie Karin Guenther G10, Galerie Giti Nourbakhsch H6

Photo Show Portrays the Familiar 14.
(Zug Island, Detroit River)
2001
26 silver gelatin prints
Edition of 5
Each 40.5× 51cm
Courtesy Patrick Painter, Inc

Selected Bibliography

1999 *Mike Kelley*, ed Yves Aupetitallot, Magasin, Centre d'Art Contemporain, Grenoble
Mike Kelley, Essays John C. Welchman et al, Phaidon, London
Mike Kelley – Two Projects, Karola Grässlin, Kunstverein, Braunschweig, and Verlag der Buchhandlung Walther König, Cologne

1997 *Mike Kelley 1985–1996*, ed Lebrero Stals, Museu d'Art Contemporani de Barcelona

1993 *Mike Kelley: Catholic Tastes*, ed Elizabeth Sussman, Whitney Museum of American Art, and Harry M. Abrams Inc., New York.

Selected Exhibitions

2002 'Black Out', Patrick Painter, Inc, Santa Monica
'Reversals, Recyclings, Completions, and Late Additions', Metro Pictures, New York
'Sonic Process', Museu d'Art Contemporani de Barcelona and touring

2001 'Memory Ware', Jablonka Galerie, Cologne

2000 'Mike Kelley', Migros Museum für Gegenwartskunst, Zurich
'The Poetics Project: 1977–1997', Centre Georges Pompidou, Paris

1999 'Mike Kelley: Framed and Framed, Test Room, Sublevel', Magasin, Centre d'Art Contemporain, Grenoble

1998 'Mike Kelley and Paul McCarthy', Secession, Vienna

1997 'Mike Kelley', Museu d'Art Contemporani de Barcelona; Rooseum, Malmö
'The Poetics Project: 1977–1997', Documenta, Kassel

Mike **Kelley**

Born 1954
Lives Los Angeles

Among contemporary artists Mike Kelley is a good candidate for both most prolific and most misunderstood. Taken as a whole, his 25 years of performances, videos, sculptures, paintings and various hybrids amount to a one-man crusade against artistic purity. This work has often been read as simple in-your-face bad-boyism, yet his transgressions involve more than scatology and abjection. Usually the taboos he activates are precisely those of the art world: amateurism, failure, sentimentality, narcissism, class resentment and the messy fumblings of adolescence. Working with materials ranging from soiled plush toys to elaborate architectural models, Kelley repeatedly enacts a return of the repressed, systematically ferreting out the sticky secrets of cultural pieties. (SS)

Represented by 1301PE B11, Galerie Ghislaine Hussenot F15, Patrick Painter, Inc B1

Studio Portrait V
2003
Charcoal and pastel on paper
213.5×150cm
Courtesy Marian Goodman
Gallery

Selected Bibliography

2001 *William Kentridge*, New Museum of Contemporary Art, New York; Museum of Contemporary Art, Chicago

1999 *William Kentridge*, Dan Cameron et al, Phaidon, London

1998 *William Kentridge*, Carolyn Christov-Bakargiev, Palais des Beaux-Arts, Brussels
'William Kentridge's History of the Main Complaint: Narrative, Memory, Truth, Michael Godby', in Sarah Nuttal and Carli Coetzee, *Negotiating the Past: The Making of Memory in South Africa*, Oxford University Press, Cape Town

1993 *Incroci del Sud: Affinities – Contemporary South African Art*, Fondazione Levi Palazzo, Venice Biennale

Selected Exhibitions

2003 Baltic Art Centre, Visby

2002–3 'William Kentridge', South African National Gallery, Cape Town

2002 'Confessions', Centre Georges Pompidou, Paris
Marian Goodman Gallery, New York
Documenta, Kassel

2001–2 'William Kentridge', Hirshhorn Museum and Sculpture Garden, Washington DC and touring

1999 'Stereoscope, Projects 68', Museum of Modern Art, New York

1998–9 'William Kentridge', Palais des Beaux-Arts, Brussels, and touring
'Weighing … and Wanting', Museum of Contemporary Art, San Diego and touring

1997 Documenta, Kassel

William **Kentridge**

Born 1955
Lives Johannesburg

William Kentridge's drawings, animated films and theatre productions form a sustained meditation on ethics and responsibility at both macro and microcosmic levels. His animations, which the artist creates using a process of drawing, erasure and redrawing, follow the lives of fictional characters such as the exploitative businessman Soho Eckstein, or the semi-autobiographical figure of Felix Teitlebaum. Kentridge's work focuses upon the political and social upheavals of South Africa, reflecting the processes of individual and collective remembrance – literal and allegorical imperfections staining our perception of the world around us. (KR)

Represented by Marian Goodman Gallery C8

Leben im Spiegel
(Life in a Mirror)
2002
Oil on canvas
140×180cm
Photo: Simon Vogel
Courtesy Galerie Christian Nagel

Selected Bibliography

2003 *deutschemalereizweitausenddrei* (German painting 2003), Nicolaus Schafhausen, Kunstverein, Frankfurt

2002 *Kiron Khosla, one hundred golden leaves*, Viola Klein, Arndt + Lamont, Peter Mertens Stipendium Kunstverein, Bonn
Christine Fricke, *Süddeutsche Zeitung*, 2–3 November 2002
Kunstzeitung, November
'The will towards beauty. Landscapes and sea songs captured in paintings: Kiron Khosla exhibits at Christian Nagel', Frank Frangenberg, *Kölner Stadtanzeiger,* 16 May

Selected Exhibitions

2003 'Deutschemalereizweitausenddrei' (German painting 2003), Kunstverein, Frankfurt

2002 Peter Mertens Stipendium (with Viola Klein), Kunstverein, Bonn
'Landscapes and Sea Songs', Galerie Christian Nagel, Cologne
'Hossa. Arte Alemán del 2000', Centro Cultural Andraxt, Mallorca

2001 'Poetry after Auschwitz – a Eunuch's Way', Lab of Graviton, Hamburg
'Horror Vacui', INIT Athens

1999 'Rediscovering elegance and dignity', Galerie für Landschaftskunst, Hamburg

1998 'After all, what is a fine lie? (parts 2,3 & 4> 3+1 <)', Galerie Annette Gmeiner, Stuttgart

1993 '6 names and picasso', Osthaus-Museum, Hagen

1992 'Featuring Nils Norman and Merlin Carpenter', Long Gallery, Old Town Hall, London

Kiron **Khosla**

Born 1967
Lives Cologne

The paintings of Kiron Khosla are radically eclectic. Iconography from various religions and different centuries is scattered across the bare canvas, mixed with motifs that look like they have been taken from book illustrations, past or present. Although they include little text the pictures seem inextricably linked to untold narratives. In this sense they look like illustrations to a bible that has yet to been written, like depictions of the founding myths of a future society. At a time when ancient religions and beliefs are routinely re-invented by countries in crisis to support their politics, Khosla's paintings reflect the need for belief by exposing the iconography of faith as a deliberate construct. (JV)

Represented by Galerie Christian Nagel E4

Endless House Project (Salisbury Walk, Grey File)
2002
Two parts: model made
from acetate cardboard file;
acetate cardboard file
22×42×28cm
Courtesy aspreyjacques

Selected Bibliography

2002 *Artists Imagine Architecture*,
Jessica Morgan, Institute of
Contemporary Art, Boston

2001 *Atlas der bewegingen and Watou
Poëziezomer 2001*, Christoph Fink,
two vols., Poëziezomers Watou,
Belgium

2000 *UBS Art Award 2000. A tribute
to the painting of tomorrow
Borderline Syndrome Energies of
Defence*, ed Igor Zabel, CIP,
Ljubljana

1999 *New Contemporaries 99*, ed Bev
Bytheway, published by New
Contemporaries Ltd.

Selected Exhibitions

2003 ArtNow, Tate Britain,
London
'Endless Theatre Project', Tanya
Bonakdar Gallery, New York
'Harmony, at Happiness: A
Survival Guide to Art & Life', Mori
Art Museum, Tokyo
Venice Biennale
'Ian Kiaer/Jeff Ono', aspreyjacques,
London

2002 'Building Structures', PS1,
New York
'Artists Imagine Architecture',
Institute of Contemporary Art,
Boston

2000 Manifesta, Ljubljana

1999 'New Contemporaries 99', Sir
John Moore's, Liverpool;
Beaconsfield, London

Ian **Kiaer**

Born 1971
Lives London

Ian Kiaer is concerned with ratty historical threads,
end-of-line stories told through his detailed, often
elusive works. His *Hakp'o dang* (2001), for example,
takes as its subject the life of Yang Paeng Son,
hinting at the 16th-century Confucian scholar,
painter and poet's banishment and 'aesthetic
resistance' by means of a tea table, a small grey
monochrome painting and models of a Korean
house and mountain. This is quiet work that refuses
to yield up its stories easily, and perhaps that's
Kiaer's point. A fugitive stealing across meaning's
borders in search of some unknown but better future,
Kiaer makes art that's best approached as an act of
hopeful self-exile. (TM)

Represented by aspreyjacques D14,
Tanya Bonakdar Gallery E7

Basic Emotions
2002
C-type print on aluminium
70×70cm
Courtesy Taka Ishii Gallery

Selected Bibliography

2003 Charles LaBelle, *frieze*, 74
April

2002 Mark Von Schlegell, *Artext*

2001 *Yuki Kimura*, Amus Art Press,
Osaka
Holly Meyers, *Los Angeles Times*

1999 Ahu Antman, *Flash Art*

Yuki **Kimura**

Born 1971
Lives Kyoto

In his *Camera Lucida* (1980) a photograph prompts
Roland Barthes to ponder his own existence: 'Why is it
that I am alive here and now?' Yuki Kimura takes this
question, which runs through photography like a sad,
underground stream, and siphons it to the surface.
Couples and the act of coupling are important motifs
in her work (siblings and twins proliferate), as are
smiles and mortal remains. But while Kimura's photos
and films might insist on the omnipresence of death,
they also point – a little wide-eyed – to the dogged
persistence of life. (TM)

Represented by Taka Ishii Gallery G9

Selected Exhibitions

2003 'New Garden', Taka Ishii
Gallery, Tokyo

2002 'Sister', Kodama Gallery,
Osaka

2001 'Handkerchiefs', Low,
Los Angeles
'Articulate Voice', Yokohama Civic
Gallery, Yokohama

2000 '1,2,3', Taka Ishii Gallery,
Tokyo
'B&B', Colette, Paris

1999 'Handkerchiefs', Kodama
Gallery, Osaka
'Criterium 39', Art Tower Mito,
Ibaragi
'Emotion and Wave', Istanbul
Biennale

1995 'Yuki Kimura', Taka Ishii
Gallery, Tokyo

Scott **King**

Born 1969
Lives London

Scott King is certainly not the first designer to shuttle from pop to art and back again. What distinguishes his work is its sneaky ability to play each against the other, often effacing boundaries between the commercial and the critical. As art director for the style magazines *i-D* and *Sleazenation*, King brought a subversive intelligence to fashion spreads and celebrity coverage. The work he's done on his own (and as part of the collective Crash!) sardonically deflates the very idea of subversion. Tweaking the symbols of radical chic, reducing pop heroics to arcane charts and graphs, his sly designs mock and celebrate their own complicity. (SS)

Represented by Magnani F11, Galleria Sonia Rosso C2

Selected Bibliography

2003 *Graphic Design for the 21st Century*, Taschen, Cologne

2002 'Matthew Higgs on Scott King', *Artforum*, January
Air Guitar, Emily Pethick, Milton Keynes Gallery
Restart: New Systems in Graphic Design, 2, Thames & Hudson, London

2001 Helen Walters, *Creative Review*, November

Selected Exhibitions

2003 Cneai, Chatou
Galleria Sonia Rosso, Turin

2002 'Scott King', Magnani, London
'Air Guitar', Milton Keynes Gallery; Cornerhouse, Manchester; Angel Row Gallery, Nottingham

Aufnahmeprüfung in Rot (Entrance Exam in Red)
1987
Mixed media
232×90×66cm
Estate Martin Kippenberger
Courtesy Galerie Gisela Capitain

Martin **Kippenberger**

Born 1953 **Died** 1997

Martin Kippenberger's untimely death at the age of 44 in 1997 added a bitterly nostalgic taste to stories of the social mayhem he created around him. Many pieces did in fact develop from immediate reactions to individuals and issues, taking the piss out of everyone and everything. *No matter how hard I try I cannot discern a swastika* is a 1984 painting of mock abstract-expressionist angular forms, a punchy pun on amnesia skills in post-Nazi Germany. But an anecdotal understanding of Kippenberger seems as wrong as purifying him into a stately figure of prudent self-reflection. Recent retrospective exhibitions, not least highlighting witty large-scale installations such as *Tiefes Kehlchen* (Deep Throat, 1995), have made it easier to make out the largely untapped richness that lies beyond this deadlock. (JöH)

Represented by 1301PE B11, Galerie Gisela Capitain D11

Selected Bibliography

2003 *Kippenberger Multiple*, Walther König, Cologne
Nach Kippenberger (After Kippenberger), Museum Moderner Kunst Stiftung Ludwig, Vienna; Van Abbemuseum, Eindhoven

2002 *Bücher* (Books), Walther König, Cologne

1998 *Die gesamten Plakate 1977–1997* (Posters 1977–1997), Kunsthaus Zurich

1997 *Kippenberger*, Taschen, Cologne

Selected Exhibitions

2003 'Das 2. Sein' (The Second Being), Museum für Neue Kunst/ ZKM, Karlsruhe
'Multiples', Kunstverein, Braunschweig
'Nach Kippenberger' (After Kippenberger), Museum Moderner Kunst, Stiftung Ludwig, Vienna; Van Abbemuseum, Eindhoven

2002 'Dear Painter, Paint Me', Centre Georges Pompidou, Paris; Kunsthalle, Vienna; Schirn Kunsthalle, Frankfurt

1997 'Der Eiermann und seine Ausleger' (The Egg man and his Jib), Städtisches Museum Abteiberg, Mönchengladbach

1994 'The Happy End of Franz Kafka's Amerika', Museum Boijmans van Beuningen, Rotterdam

1993 'Candidature à une retrospective' (Candidature for a retrospective), Centre Georges Pompidou, Paris

1991 'Put Your Eye In Your Mouth', Museum of Modern Art, San Francisco

1986 'Miete Strom Gas' (Rent Electricity Gas), Hessisches Landesmuseum, Darmstadt

Pure Freude 60
(Pure Joy 60)
2002
Acrylic on aluminium
160×114.5×4.5cm
Courtesy Galerie Thaddaeus Ropac

Selected Bibliography

1996 *Imi Knoebel Retrospective 1968–1996*, Marja Bloem, Hubertus Gassner, Stedelijk Museum, Amsterdam

1994 *Imi Knoebel*, Dirk Luckow, Galerie Fahnemann, Berlin

1991 *Imi Knoebel – Grace Kelly 1989–1990*, Masanaru Ono, Akira Ikeda Gallery, Taura

1992 *Imi Knoebel/Hessisches*, Johannes Stütteen, Landes Museum, Zurich

Selected Exhibitions

1998 'Imi Knoebel', Bonnefanten Museum, Maastricht

1997 'Tag & Nacht & Bund', Kunstmuseum, Lucerne

1996 'Linienbilder 1966–1968' Kunstmuseum, St. Gallen 'Monochrome Geometrie', Sammlung Goetz, Munich

1995 'Rot, Gelb, Weiss, Blau' (Red, Yellow, White, Blue), Galerie Wilma Lock, St. Gallen

1992 'Mennigebilder', Deichtorhallen, Hamburg

1983 'Imi Knoebel', Kunstmuseum, Winterthur/Städtisches Kunstmuseum, Bonn

Imi **Knoebel**

Born 1940
Lives Dusseldorf

In the early 1960s Wolf Knoebel and Rainer Giese formed the duo IMI & IMI and joined Joseph Beuys' class at the Dusseldorf Academy. Together with Blinky Palermo they immediately challenged the idea of social sculpture with a more fundamentally perceptual, transcendental twist, courtesy of Malevich (underpinned with US Minimal). In Knoebel's legendary *Room 19* (1968) stretchers, cubes and MDF panels are stacked or leaned against the wall, short-circuiting compositional display with the accumulative matter-of-factness of a storage space. Until today Knoebel has continued to explore the dialectics of confinement and opening-up through stacking and serializing, through grids and lines – creating strange hybrids between the image and its physical support, the framed and the frameless, the material and the immaterial. (JöH)

Represented by Galerie Thaddaeus Ropac B14

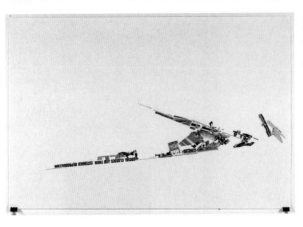

Social Classes and their Reproduction
2002
Collage on paper
72×110cm
Courtesy Galleri Nicolai Wallner

Jakob **Kolding**

Born 1971
Lives Copenhagen

Jakob Kolding's black and white collages address the politics of suburbia with a straightforward cut-and-paste simplicity. The Danish artist draws a direct line from Dada montage (Hannah Höch, Raoul Hausmann, John Heartfield) through 1970s Conceptual (Martha Rosler) and Punk (Jamie Reid) to today's sampling culture. Reminiscent of El Lissitzky, he rams discrete elements into the empty white page like so many semiotic spikes. For example, the headline 'SOCIAL EXCLUSION AND THE NEIGHBOURHOOD' clashes with '8:21 dub version', both elements surrounded by grid patterns, the grimace of a comic book villain and a football player's overhead kick. Posters stacked on the ground (a nod to Felix Gonzales-Torres) or plastered across the city return the collages back to the spatial and public sphere they address. (JöH)

Represented by Galerie Martin Janda F14,
Galleri Nicolai Wallner B12

Selected Bibliography

2002 'Neighbourhood Threat' Lars Bang Larsen, *frieze,* 66, April

2001 *Jakob Kolding*, Kunstverein, Hamburg
Rooseum Provisorium 2:2001, Jan Verwoert, Malmö

Selected Exhibitions

2002 Galleri Nicolai Wallner, Copenhagen
'Concrete Garden', Museum of Modern Art, Oxford

2001 Kunstverein, Hamburg
'Intentional Communities', Rooseum – Centre for Contemporary Art, Malmö

2000 'Organising Freedom', Moderna Museet, Stockholm
Galleri Nicolai Wallner, Copenhagen

1999 'Power, Corruption & Lies', Galerie Enja Wonneberger, Kiel

1997 'The Louisiana Exhibition', Louisiana Museum of Modern Art, Humlebaek

Pam
2001
Oil on canvas
274×213.5cm
Courtesy Gagosian Gallery

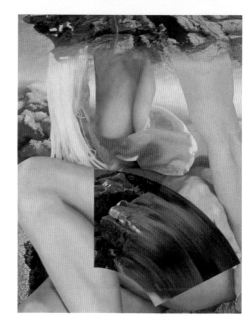

Selected Bibliography

2002 *Jeff Koons*, Eckard Schneider, Alison Gingeras, Kunsthaus, Bregenz

2000 *Easyfun-Ethereal*, Lisa Dennison, Robert Rosenblum, Craig Houser, Guggenheim Museum Publications, New York

1999 *Jeff Koons*, Katerina Gregos, Deste Foundation's Centre for Contemporary Art, Athens

1992 *Jeff Koons*, John Caldwell, San Francisco Museum of Modern Ar

1988 *Jeff Koons*, Michael Danoff, Art Institute of Chicago.

Selected Exhibitions

2003 'Jeff Koons', Museo Archeologico Nazionale, Naples

2001 'Jeff Koons', Kunsthaus Bregenz
'Jeff Koons', Gagosian Gallery, Beverly Hills

2000 'Easyfun-Ethereal', Deutsche Guggenheim, Berlin

1999–2000 'Jeff Koons, A Millennium Celebration', Deste Foundation, Athens

1995 'Puppy', Museum of Contemporary Art, Sydney

1992 'Jeff Koons Retrospective', Stedelijk Museum, Amsterdam; San Francisco Museum of Modern Art

1988 'Banality', Sonnabend Gallery, New York
Museum of Contemporary Art, Chicago

1980 'The New' (window installation), New Museum of Contemporary Art, New York

Jeff **Koons**

Born 1955
Lives New York

Unless ensconced within the comfy parameters of intellectual discussion, 'taste' and 'consumerism' are usually explicit, dirty words in the art world, yet for the last 20 years Jeff Koons has systematically sought to engage with the notion of art as pure product. Early works, such as a pristine vacuum cleaner housed in a glass vitrine, spun the idea of the Duchampian readymade around issues of 'newness' and use-value, whilst sculptures such as *Michael Jackson and Bubbles* (1988) and *Puppy* (1992) took on arguments about taste with kitsch relish. Recent paintings blast the viewer with a seductive cornucopia of advertising imagery, adding further depth to an already complex artistic investigation into desire and possession. (DF)

Represented by Gagosian Gallery F7

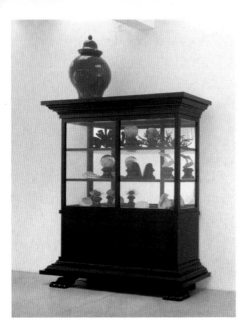

Alexej **Koschkarow**

Born 1972
Lives Dusseldorf

For the Situationists a 'situation' was an unforeseeable occurrence in everyday life that created an opportunity for interventionist acts. In his installations and performances Alexej Koschkarow produces just such provocative situations. He has staged a public battle involving 300 cream cakes at a prestigious opening ceremony; for his first major museum show he built a stage set resembling a Rococo park, with statues of masturbating saints on pillars; and in another exhibition created an archive with shelves apparently full of documents that turned out to be just a façade with as much documentary value as a strip of wallpaper. It's up to the viewer to respond to these situations, to join in the cake-throwing, pose like Louis XIV or reflect on why the History Channel has recently made the past seem so telegenic. (JV)

Represented by Jablonka Galerie Linn Lühn G11

Selected Bibliography

2001 *Alexej Koschkarow*, Valeria Liebermann, Sammlung Ackermans, Xanten

1999 *Damenwahl* (Ladies' choice), Katharina Fritsch, Alexej Koschkarow, Kunsthalle Dusseldorf

Selected Exhibitions

2004 'Moderne Reservate – Teil 1: Seele' (Modern Reserves Part 1: the Soul), Staatliche Kunsthalle, Baden-Baden

2002 Kunstverein für die Rheinlandes und Westfalen, Dusseldorf
'Videolounge Tortenschlacht' (Cake Battle), Art Basel Miami Beach
Jablonka Galerie Linn Lühn, Cologne

2001 Haus Fürstenberg, Sammlung Ackermans, Xanten
'Between Earth and Heaven', PMMK, Museum of Modern Art, Ostende

2000 'Tortenschlacht', Malkasten, Dusseldorf

1999 'Damenwahl', Kunsthalle Dusseldorf, (with Katharina Fritsch)

1998 'Mayday Party is Over', Boehler Werke, Dusseldorf

Madam I'm Adam
2001
Acrylic on canvas
70×50cm
Courtesy Georg Kargl

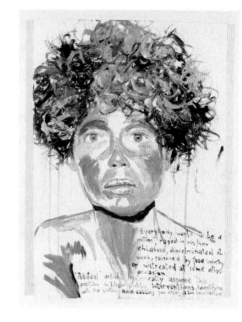

Selected Bibliography

2002 *Mirroring Evil. Nazi Imagery / Recent Art*, Jewish Museum, New York
De la représentation de l'action (About representation of action), Le Plateau, Paris

2000 *Elke Krystufek – Nobody Has to Know*, Portikus, Frankfurt

1994 *Migrateurs* (Migrants), Musée d'Art Moderne de la Ville de Paris

Selected Exhibitions

2003 'Nackt & Mobil' (Naked & Mobile) Elke Krystufek', Sammlung Essl, Klosterneuburg, Vienna
Galerie Georg Kargl, Vienna

2001 'Gefesselt – entfesselt: Österreichische Kunst des 20. Jahrhunderts' (Tight – Unleashed: Austrian art of the 20th century), Galerie Zacheta, Warsaw

2000 'Nobody Has to Know', Portikus, Frankfurt
'Protest & Survive', Whitechapel Art Gallery, London
'Die verletzte Diva. Hysterie, Körper, Technik in der Kunst des 20. Jahrhunderts' (The Wounded Diva: Hysteria, body, and technique in 20th century art), Galerie im Taxispalais, Innsbruck

1999 'Elke Krystufek, Anne Schneider, Franz West', Austrian Pavilion, Melbourne Biennial

1998 Manifesta, Luxembourg

1995 'Feminin/Masculin X/Y, le sexe de l'art' (Feminine/Masculine, X/Y, gender in art), Centre Georges Pompidou, Paris

1994 'Migrateurs', Musée d'Art Moderne de la Ville de Paris

Elke **Krystufek**

Born 1971
Lives Vienna

Elke Krystufek's performances and photocollages could be seen as a send-up of 1970s figuration, an unstable marriage of that decade's feminist explorations and its predominantly male narcissism. Using her often naked body as both a model and a medium, Krystufek updates the confrontational approach of Carolee Schneemann and Lynda Benglis with a raw, confessional slant more suggestive of Tracy Emin. As in the recent series 'Economical Love' (1998), in which she linked the Nazis, the male gaze and yBa machismo, Krystufek elevates the 1990s obsession with identity politics to a level of near-absurdity. (KR)

Represented by Georg Kargl E11, Gallery Side 2 H10

Carretilla I
(Wheelbarrow 1)
1999
Wheelbarrow, popcorn
55×140×66cm
Courtesy kurimanzutto

Gabriel **Kuri**

Born 1970
Lives Mexico City

Gabriel Kuri has written, 'I like to see work which is more intelligent, swift, sharp, ambitious or more eloquent than the creator himself realizes.' His own light-handed Conceptualism, based on an interplay of opposing forces, seems to meet these requirements: a tree spotted with chewing gum, a sheet of newsprint tacked to the wall with colourful pins, a bunch of plastic bags inflated by a pivoting fan. An occasional collaborator with Liam Gillick, who shares his interest in habitual systems, Kuri is one of the most promising young artists to have emerged recently from the currently dynamic Mexico City scene. (KR)

Represented by kurimanzutto B2

Selected Bibliography

2001 'Chemist Offer Leaflet Gobelin', *Parachute*, 104
Momento de Importancia/ Moment of Importance.VIII, Cuauhtemoc Medina, Museo Rufino Tamayo, Mexico City
Plan de San Lunes, 20 Question Interview, Matthew Higgs, Museo de las Artes de Guadalajara

2000 *Contemporary Projects 3: New Sitings*, Jill Martínez-Krygowski, Los Angeles County Museum of Art
'One × One', Gabriel Kuri, *Trans>Art and Culture*

Selected Exhibitions

2003 'Por favor gracias de nada', Gabriel Kuri and Liam Gillick, kurimanzutto, Mexico City
'Interludes', Venice Biennale
'Bienal Americas de Ponta Cabeza', Fortaleza

2002 'Exhile on Main Street', NICC, Amberes
'Recent Works', Sara Meltzer Gallery, New York

2001 'Momento de Importancia', Museo Rufino Tamayo, Mexico City
Sonsbeek, Arnhem

2000 'New Sitings. Contemporary Projects 4', Los Angeles County Museum of Art

1999 'Plan de San Lunes', Museo de las Artes de Guadalajara

Grassland Drifters
2001
Satin-laminated C-type print in
wood frame
Edition of 8
76×102cm
Courtesy Galerie Rodolphe Janssen
and Gorney Bravin + Lee

Selected Bibliography

2001 *Justine Kurland: Spirit West*,
Coromandel Design, Paris/New
York/Geneva
*Settings and Players: Theatrical
Ambiguity in American Photography,
1960–2000*, Louise Neri, White
Cube, London

1999 *Another Girl, Another Planet*,
A.M. Homes, Gregory Crewdson
and Jeanne Greenberg Rohatyn,
Greenberg Van Doren Fine Art,
New York

Selected Exhibitions

2002 Gorney Bravin + Lee,
New York

2001 Torch Galerie, Amsterdam
Galerie Rodolphe Janssen, Brussels
Módulo, Lisbon
Gorney Bravin + Lee, New York
'Sonsbeek', Arnhem
Galleria Laura Pecci, Milan
'Settings and Players (…)', White
Cube, London

2000 'Lemon Tree Hill', asprey-
jacques, London
PS1, New York

1999 Patrick Callery Gallery, New
York

Justine **Kurland**

Born 1969
Lives New York

Justine Kurland's photographs radiate an other-
worldly intimacy, a curious mix of storybook
loveliness and vague menace. Her earliest works were
staged idylls of teenage girls, runaway pixies moving
in packs and lounging about in forests. Citizens of
some unspecified adolescent utopia, the languid teens
enact perfect moments for the camera's idealizing
gaze, their self-possession both engaging and
deflecting voyeurism. Much of the power of these
images comes from the slight ripple of tension
between the artist's scenario and the real world of
her models, the bits of documentary creeping into
the theatrical. Continuing to investigate the pastoral
with a series of nudes in landscapes, Kurland's work
plays with the ambiguities of looking at paradise.
(SS)

Represented by Galerie Rodolphe Janssen D2,
Emily Tsingou Gallery A6

Darren **Lago**

Born 1965
Lives London

A sculpture in the shape of a fridge colliding with
Concorde; a funky red wheelbarrow accessorized
with a car wheel and tail-lights; a bench made from
a giant shoebrush – Darren Lago's work looks like
product design goosed by the spirit of Surrealism.
His invariably pristine hybrids might be recuperated
as critiques of novelty-obsessed product design, but
they also illuminate surprising interstices between
disparate objects. Conflating flight and fridges, for
example, Lago discovered that the earliest iceboxes
used technology from aeroplane insulation. Such
interesting links pale, however, beside the boggling
phenomenological splits enforced by objects such
as Lago's combined vacuum cleaner and urinal:
a twisted familiarity that the mind can't process.
(MH)

Represented by Annely Juda Fine Art F3

Selected Bibliography

2001 *Darren Lago & Co.*, New Art
Gallery, Walsall

2000 *7×5 Sculptures*, Annely Juda
Fine Art, London

Selected Exhibitions

2001 'Darren Lago & Co.',
New Art Gallery, Walsall

2000 '7×5 Sculptures', Annely Juda
Fine Art, London

1999 'Lago Rosso', 1000 Eventi,
Milan

1998 Haus Bill, Zumikon

No Problemo/Head & Shoulders (With Conditioner)
2003
Mirrors, modrock, gloss paint/
album sleeves, duct tape
Installation view at Inverleith
House, Edinburgh
Courtesy The Modern Institute

Selected Bibliography

2003 *El Pollo Diablo Loco*, Will Bradley and Rob Tufnell, The Modern Institute, Glasgow

2002 'Drastic Plastic' Alex Farquharson, *frieze*, 68, June–August

2001 *Here + Now, Scottish Art 1990–2001*, Katrina M. Brown, John Calcutt and Rob Tufnell , Dundee Contemporary Arts

1999 Elisabeth Mahoney, *Artext*, 65
ZOBOP, Rob Tufnell (7 inch record and essay),The Showroom, London and Transmission, Glasgow

Selected Exhibitions

2003 'Zenomap', Venice Biennale
'Male Stripper', Modern Art Oxford
'The Moderns', Castello di Rivoli, Museo d'Arte Contemporanea, Turin
'Tate Triennial', Tate Britain, London
'Kebabylon', Inverleith House, Edinburgh

2002 'Salon Unisex', Sadie Coles HQ, London
'Early One Morning', Whitechapel Art Gallery, London
'My Head is on Fire But My Heart is Full of Love', Charlottenborg Exhibition Hall, Copenhagen

2001 'Jim Lambie', The Modern Institute, Glasgow
'Boy Hairdresser', Anton Kern, New York

Jim **Lambie**

Born 1964
Lives Glasgow

Best known for his 'Zobop' series of dizzying psych-out floors made from concentric strips of coloured tape, Jim Lambie's sculptural confabulations conjure up a freely associative world in which devotional objects of teenage desire – mirrors, glittery turntables, record sleeves, leather jackets – happily dance with formal ideas of space and objecthood. Recent works such as *Rhythm Clone* and *Mental Oyster* (both 2003) have pushed Lambie's unique vocabulary further into a boisterous but glitzy dialogue between the prosaic functions of his material's origins and their relationship to the use value of both art and popular culture. (DF)

Represented by Sadie Coles HQ B8, The Modern Institute G8, Galleria Franco Noero G13, Galleria Sonia Rosso C2

Stroll in the Park
2002
Watercolour and pencil on paper
150×202cm
Courtesy Galleri Nicolai Wallner

Peter **Land**

Born 1966
Lives Copenhagen

Samuel Beckett's proverb 'Ever tried, ever failed. No matter. Try again. Fail again. Fail better' is a particularly apt description of Peter Land's slapstick shenanigans. Working primarily in video and performance, Land shows himself involved in comic acts of drunken misadventure and almost abject humiliation. Whether repeatedly tumbling down an endless set of stairs, or drowning in a forest lake, or whisky-sodden, dressed in traditional Bavarian costume, Land considers questions about failure, success and the value we ascribe to our individual actions. In his own words, 'when you start asking yourself these questions […] you have in effect stumbled over the edge of the stairs into an eternal fall, a kind of existential limbo from which there's seldom any escape. I'm still falling.' (DF)

Represented by Klosterfelde B9, Galleria Sonia Rosso C2, Galleri Nicolai Wallner B12

Selected Bibliography

2000 Ulrike Knöfel, *Der Spiegel*, 5 June 2000
Ken Johnson, *New York Times*, 15 October 2000
Peter Land, Hatje Cantz Verlag, Ostfildern-Ruit,

1999 Gregory Williams, *frieze*, 50, January-February
Art at the Turn of the Millennium, Taschen, Cologne

Selected Exhibitions

2002 Musée d'Art Moderne et Contemporain, Geneva
'The Ride', X-rummet, Statens Museum for Kunst, Copenhagen

2001 Herzilya Museum of Art, Herliva

2000 'An Introduction to My Videoworks', The Lux, London
Galleri Nicolai Wallner, Copenhagen
'Let's Entertain', Walker Art Center, Minneapolis and touring

1999 Centre d'Art Contemporain, Fribourg

1998 The Video Gallery, Museum of Modern Art, Chicago

1997 Secession, Vienna

Beaver
2003
Oil on linen
81.5×135.5cm
Courtesy greengrassi

Selected Bibliography

2001 'Appropriating Picasso "because I want to be as great as him"', Adrian Dannat, *Art Newspaper*, May

1999 'Wanting it: Sean Landers at Andea Rosen Gallery', Jerry Saltz, *Village Voice*, 25 May 1999

1995 'Sean Landers', Ronald Jones, *frieze*, 24, September–October

1994 'Sean Sucks … Not: Portrait of the Artist as a Young Man', Jan Avgikos, *Artforum*, April

1992 'Examining a Multi Media Personality', Roberta Smith, *New York Times*, 21 February 1992

Selected Exhibitions

2003 greengrassi, London

2001 Galerie Jennifer Flay, Paris

1999 Contemporary Fine Arts, Berlin
'Examining Pictures: Exhibiting Paintings', Whitechapel Art Gallery, London; Museum of Contemporary Art, Chicago; UCLA Hammer Museum of Art, Los Angeles

1998 Taka Ishii Gallery, Tokyo

1995 Galerie Jennifer Flay, Paris

1994 Jay Jopling/White Cube, London
'Backstage', Kunstmuseum, Lucerne

1993 'Aperto', Venice Biennale

1992 Andrea Rosen Gallery, New York

Sean **Landers**

Born 1962
Lives New York

A few years ago Sean Landers wrote on a painting, 'People think I'm a fucking comedian. Hey, I'm a serious artist for god's sake, look at this painting […] OK, this painting isn't a good example but I've made lots of serious art before, right?' Funny, narcissistic and obsessed with the idea of genius – other people's and his own – in the early 1990s Landers made diaristic text pieces, paintings, sculptures, videos and sound works dealing with the roller-coaster of anxiety and egotism he was experiencing in his life, his art and the weight of art history. Particularly inspired by Pablo Picasso, more recently Landers has painted a series of portraits of 20th-century artists including Max Ernst and Giorgio de Chirico. (JH)

Represented by greengrassi A3, Taka Ishii Gallery G9, White Cube F6

Shepherd's Purse No. 2
2002
Etching
87.5×75cm
Courtesy The Paragon Press

Michael **Landy**

Born 1963
Lives London

Michael Landy's practice pivots on how and why we value things. His early work *Market* (1990), an installation of abandoned, Astroturf-ed stalls, hints at his preoccupation with systems, capitalism as a sort of theatre of absence, and stark, utilitarian presentational gambits. *Market* was followed by *Scrap Heap Services* (1995), a work in which uniformed men 'cleansed' a gallery floor of tiny figures fabricated from fast-food debris, and then *Breakdown* (2001), a major project in which the artist itemized and then destroyed all of his 7,227 possessions. Recently Landy has turned to botany, systematically cultivating weeds from urban brownfields. His delicate, Dürer-like drawings of these forgotten flora suggest re-routed taxonomies and hold out allegorical hope that, someday, everybody's stock will rise. (TM)

Represented by The Paragon Press A5

Selected Bibliography

1995 *Contemporary British Art in Print*, Jeremy Lewison and Duncan Macmillan, Scottish National Gallery of Modern Art, Edinburgh and The Paragon Press, London

Selected Exhibitions

2002–3 'Nourishment', Sabine Kaust, Munich; Maureen Paley Interim Art, London

2001 'Michael Landy – Breakdown', Artangel at C&A store, Marble Arch, London

2000 'Handjobs' (with Gillian Wearing), The Approach, London

1999 'Scrap Heap Services', Tate Gallery, London

Kyoto
2003
Colour photograph, aluminium,
Perspex
Edition of 3 ex + 1 AP
134×200cm
Courtesy Galerie Almine Rech

Ange **Leccia**

Born 1952
Lives Paris

Classed as an Appropriation artist in the 1980s because of his use of found footage – *Pierrot Le Fou* (1986), for example, endlessly looped an explosion from Jean-Luc Godard's eponymous 1965 film – Ange Leccia has always been more interested in rendering wordless emotional states through whatever means necessary and, increasingly, in mining complexity via forced juxtaposition. Playing an image of an exploding aeroplane against one of an Ophelia-like drowning girl, or projecting together films of the sea, billowing smoke and a violent storm, Leccia creates situations where meaning is necessarily provisional. The piled-on intensity and rampantly allegorical nature of his chosen imagery, however, make it impossible to refuse his challenge to make sense of it all. (MH)

Represented by Galerie Almine Rech H7

Selected Bibliography

2002 *Ange Leccia, les Eléments,* Musée Fesch, Ajaccio

1996 *Ange Leccia,* Villa Medici, Académie de France, Rome

1990 *Ange Leccia,* Centre d'Art Contemporain, Grenoble

Selected Exhibitions

2003 Galerie Almine Rech, Paris
'Vidéotrafic', Yokohama Culture Foundation
'Anemic Cinema', Sketch, London
'Our Mutual Friend', Bloomberg Space, London

2002 'Christophe', Video with Dominique Gonzalez Foerster, Palais de Tokyo, Paris

2000 'Elysian Fields', Centre Georges Pompidou, Paris
'La Beauté', Palais des Papes, Avignon

1997 Musée d'Art Moderne de la Ville de Paris

1996 Villa Médici, Rome

1993 Venice Biennale

Mark **Leckey**

Born 1964
Lives London

Mark Leckey's work is like a street corner conversation between Baudelaire and British youth culture, as if J.K. Huysmans' character Des Esseintes were to trawl through London's late night grime rather than through the endless permutations of his own desires. Leckey's carefully tuned videos, sculptures and performances with the group donAteller identify a subcultural thread that elegantly twists its way around Victorian dandyism, Minimalist sculpture and UK dance music. For the recent performance *Big Box Statue Action* (2003) at Tate Britain he pitted Jacob Epstein's monumental sculpture *Jacob and the Angel* (1940–1) against a sound system of the same dimensions – history and art in street corner conversation. (DF)

Represented by Galerie Daniel Buchholz A2, Cabinet C9, GBE (Modern) D5

Selected Bibliography

2003 'Surround Sound', Gigiotto del Vecchio, *Tema Celeste*, 95, January–February

2002 'Openings', Matthew Higgs, *Artforum*, April

2001 'Revolutions per Minute', Nathaniel Mellors, *frieze*, 62, October
'Mark Leckey', Steve Laffreniere, *Index*, September–October

Selected Exhibitions

2003 'Big Box Statue Action', Tate Britain, London (Tate Live Event)

2002 'Hotel Sub Rosa', curated by Cabinet, Marc Foxx Gallery, Los Angeles
Santa Monica Museum of Modern Art

2001 'Century City', Tate Modern, London

2000 Galerie Daniel Buchholz, Cologne
'Crash', ICA, London

Green Window
2001–2
C-type print
Edition of 6
61×45cm
Courtesy Galerie Gisela Capitain

Selected Bibliography

2003 *Zoe Leonard, Mouth Open, Teeth Showing II*, Museum für Gegenwartskunst, Siegen

1998 *Zoe Leonard*, Centre National de la Photographie, Paris

1997 *Zoe Leonard*, interview with Anna Blume, Secession, Vienna *Zoe Leonard*, Kunsthalle Basel

Selected Exhibitions

2003 Galerie Giti Nourbakhsch, Berlin
'Mouth Open, Teeth Showing', Museum für Gegenwartskunst, Siegen

2002 'Startkapital', K21 Kunstsammlung im Ständehaus, Dusseldorf
'Prophets of Boom', Staatliche Kunsthalle, Baden-Baden

2001 'Die unheimliche Frau. Weiblichkeit im Surrealismus' (The eerie Woman. Womenhood in Surrealism), Kunsthalle, Bielefeld Galerie Gisela Capitain, Cologne

1997 Secession, Vienna
Kunsthalle Basel
Museum of Contemporary Art, North Miami

1992 Documenta, Kassel

Zoe **Leonard**

Born 1961
Lives New York

Probably the most memorable moment at Documenta IX came when Zoe Leonard reinstalled the staid galleries of Kassel's Neue Galerie, hanging her own black and white photographs of vaginas alongside the museum's 18th-century paintings of burgher's wives and mythic nymphs. Typical of Leonard's 1990s uppity bad-girl style, the installation marked the start of a decade of work in photography and other media which held up a mirror to the art world and its biases, while chipping away at the visual conventions surrounding gender and taste. Her more recent photographs and installations – images of flayed game animals shot in the Yukon, a taxonomical display of loved-to-death and discarded dolls unearthed in junk shops – defy the constraints of her agent provocateur reputation, while continuing to ask who gets to decide what is beautiful and why. (JT)

Represented by Galerie Gisela Capitain D11, Galerie Giti Nourbakhsch H6

Untitled
2001
Colour pencil and gesso on paper
56×37cm
Courtesy aspreyjacques

Selected Bibliography

2004 *Fashion Illustration Next*, Thames & Hudson, London

2003 *Drawing Now: Eight Propositions*, Laura Hoptman, Museum of Modern Art, New York

2002 Claire Canning, *Tank*, March

2001 *tailsliding*, ed Colin Ledwith, British Council, London

2000 'Stealing Beauty', Niru Ratnam, *The Face*, December

Selected Exhibitions

2003 aspreyjacques, London 'Images of Society', Kunstmuseum, Thun

2002 Works on Paper, Los Angeles 'Drawing Now: Eight Propositions', Museum of Modern Art at Queens, New York

2001 'tailsliding', British Council/ Bergen Contemporary Art Centre and touring
Camden Arts Centre, London

2000 aspreyjacques, London 'www.blackandwhite.colour.3d. com', Giò Marconi, Milan

1999 'Heart and Soul', 60 Long Lane, London and Sandroni/Rey Gallery, Los Angeles

1998 'dumbpop', Jerwood Gallery, London and LMU Gallery, Leeds 'New Contemporaries 98', Tea Factory, Liverpool, touring to Camden Arts Centre, London; Hatton Gallery, Newcastle

Graham **Little**

Born 1972
Lives London

Flipping through art magazines and finding revivals of Minimalism next to Prada adverts, Graham Little blends the two in his sculptures and drawings. His early approach – long, low boxes goosed with Paul Smith stripes – has given way in recent years to more baroquely structured and inventively decorated objects, sprouting geometric sections interconnected by narrow struts and colliding formal references to Roy Lichtenstein and Miu Miu. His crosshatched crayon drawings of Vogue models, meanwhile, have taken on an intricate, almost Degas-like cast. It's not an inapt reference: like the early Moderns, Little monitors the contemporary – the merging of catwalk and gallery – picks up its energies, and reports back the scene as if it were inevitable. (MH)

Represented by aspreyjacques D14

Forest at Dawn
2003
Watercolour and emulsion on found board
69×51cm
Courtesy Paul Stolper

Selected Bibliography

2003 'Exhibitions Preview', Jessica Lack, *Guardian Guide*, 24 May 2003

2002 'RARE Gallery', Mason Klein, *Artforum*
'RARE Gallery', Tim & Frantiska Gilman Sevcik, *Flash Art*, January–February

2001 *Artists' Multiples 1935–2000*, Steve Bury, Ashgate Publishing, Burlington

2000 'MUL-TE-PL-SHO', Steve Bury, *Art Monthly*, July

Selected Exhibitions

2003 'The West', Richard Salmon Gallery, London with Paul Stolper, London

2002 'Deluxe', Comunidad de Madrid and touring

2001 RARE, New York
'Perspective' Ormeau Baths Gallery, Belfast
'Multiplication', British Council touring show, Romania
'Desire and Pursuit of the Whole', Museum of St Petersburg

2000 'From Space', 142 Chapel Street, Manchester
'John Moores 21', Walker Art Gallery, Liverpool
'Better Scenery', (with Adam Chodzko), Pand Paulus, Schiedam

1999 Paintings and sculpture, Paul Stolper, London

Peter **Liversidge**

Born 1973
Lives London

Peter Liversidge's paintings are aspirational, yet their upwardly mobile ambitions are thwarted by their own clunky materiality. Depicting the glamorous brands and objects of consumer desire – watches, cameras, high-class airlines – Liversidge celebrates the limits of his technical skill in order to debase the absurd levels of value and status ascribed to luxury products. A recent series of works explored the North Montana Plains – an area he's never actually visited or seen. Liversidge revels in the bathetic, finding humour in failure but always travelling hopefully. (DF)

Represented by Paul Stolper H13

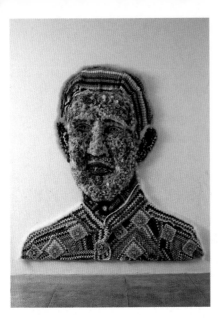

Heir Apparent
2002
Mixed media
160×160×9cm
Courtesy Hales Gallery

Hew **Locke**

Born 1959
Lives London

Transplanted as a child from Edinburgh to British Guyana, Hew Locke saw images of Britain's royal family everywhere and found himself alternately fascinated and disgusted by the notion of heritage. In his artistic career these feelings first surfaced in grotesque charcoal remakes of William Hogarth and Diego Velázquez; they peak, however, in galumphing installations that use numinous shards of cardboard packing material to construct spaces that are half-bazaar, half-church, and for which in 2000 he won both an East International Award and a Paul Hamlyn Award. *Hemmed in Two* (2000) bulged between marble pillars in London's Victoria and Albert Museum; the grotto-like *Cardboard Palace* (2002), mixing Victorian fairground stylings with huge, atavistic cardboard heads of the royal family, recently pointed a delirious way forward. (MH)

Represented by Hales Gallery A8

Selected Bibliography

2003 *Jerwood Sculpture Prize,* Peter Murray, Jerwood Charitable Foundation, London

2002 'Cardboard Palace', *Art Review*, April
Dan Smith, *Art Monthly*
Jonathan Jones, *Contemporary*, June–July
Kobena Mercer, *frieze*, 70, October

Selected Exhibitions

2002 'The Cardboard Palace', Chisenhale Gallery, London
'Hemmed in Two', installation, Victoria and Albert Museum, London
'Somewhere – Places of Refuge in Art and Life', Angel Row Gallery, Nottingham; Towner Gallery, Eastbourne; Bury St Edmunds Art Gallery
'YesteryearNowadays', Hales Gallery, London

2000 'Beautiful', Oxo Tower, London
'East International', Norwich Art Gallery

1999 'Hemmed In', Millais Gallery, Southampton

Mahalakshmi Hill Line, Warli Tribal Land, Maharashtra, India
2003
Giclee print on Somerset paper
117.5×80cm
Courtesy Haunch of Venison

Selected Bibliography

2002 *Richard Long: Walking the Line*, Anne Seymour, Paul Moorhouse, Denise Hooker and Richard Long, Thames & Hudson, London
A Moving World, Paul Moorhouse, Tate Publishing, London

1997 *A Walk Across England*, Thames & Hudson, London

1991 *Richard Long: Walking in Circles*, Richard Long, Hamish Fulton and Anne Seymour, George Braziller Inc., New York

1986 *Richard Long*, R.H. Fuchs, Thames & Hudson and Guggenheim Museum, New York

Selected Exhibitions

2003 'Here and Now and Then', Haunch of Venison, London

2002 'Richard Long', Tate St Ives

2000 'Changing Perceptions: The Panza Collection at the Guggenheim Museum', Guggenheim Bilbao

1999 'Every Grain of Sand', Kunstverein, Hanover

1993 'Richard Long', ARC Musée d'Art Moderne de la Ville de Paris

1991 'Richard Long: Walking in Circles', Hayward Gallery, London

1989 Turner Prize, Tate Gallery, London

1986 'Richard Long', Guggenheim Museum, New York

1971 'Richard Long', Whitechapel Art Gallery, London

1968 'Richard Long', Konrad Fischer Gallery, Dusseldorf

Richard **Long**

Born 1945
Lives Bristol

The practice of Richard Long, winner of the Turner Prize in 1989, involves making sculptural works from 'found' natural materials such as mud, water and stone, and taking lengthy walks in remote rural locations, which he documents in photographs and texts. His seminal piece *A Line Made by Walking* (1967) was precisely that – an ephemeral impress on the landscape made by his own footfalls. Although there is a romanticism in Long's work that keys into the English tradition of Constable and Wordsworth, there is also a conceptual rigour, evidenced by his concern with modes of measurement (time, distance, poetic response) and his deceptively complex comment: 'I like common means given the simple twist of art.' (TM)

Represented by Haunch of Venison G14

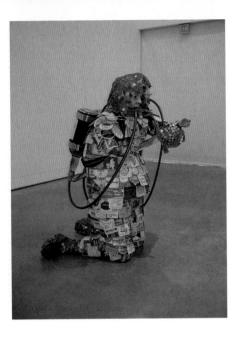

Colin **Lowe** & Roddy **Thomson**

Born 1966/1965
Live London

As with many British artists, for Lowe and Thomson the pub and its attendant culture of boozy excess provide the starting-point for many of their works. *The Dark Throttle* (2002), for instance, is a small, mobile kiosk in the form of a pub, replete with optics, beer taps and bar towels, bedecked in the wood-panelled manner of a cosy English boozer. Texts such as *The Hurangutang Letters* (1999) (which includes a missive asking the manufacturers of Kendal Mint Cake for enough of their product to recreate Caspar David Friedrich's *The Wreck of the Hope,* 1848), lampoon artists' pleas for corporate sponsorship. Holed up in the corner of a dark pub, national identity, death, destruction, fear and loathing are this duo's drinking companions. (DF)

Represented by Milton Keynes Gallery H8

Selected Bibliography

2002 *The Galleries Show*, Royal Academy of Arts, London
100 Reviews (3), Alberta Press

2001 *Art Crazy Nation*, Matthew Collings, 21 Publishing Ltd, London

1997 *Peripheral Visionary, An Account*, De Fabriek, The Netherlands
Blimey!, Matthew Collings, 21 Publishing Ltd, London

Selected Exhibitions

2003 'Temple of Bacchus' (with Sarah Lucas), Milton Keynes Gallery

2002 John Moores Prize, Walker Art Gallery, Liverpool
'International Netzwerk', Kunstsommer Wiesbaden; CCAC, Wattis Institute for Contemporary Arts, San Francisco
'Art Crazy Nation Show', Milton Keynes Gallery
'The Pain Insider', Vilma Gold, London
'XXX Girlfriends', Hoxton Distillery, London

2001 'City Racing (A Partial History)', ICA, London

2000 'Century City', Tate Modern, London

1996 'Sex with Girls', De Verschijning, Tilburg

Zufall
(Coincidence)
2002
Casein on canvas
140×100cm
Courtesy Entwistle

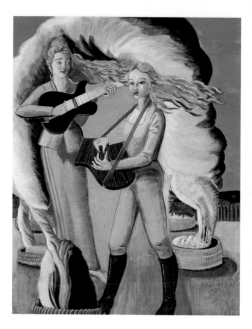

Rosa **Loy**

Born 1958
Lives Leipzig

Selected Bibliography

2003 *Die Verbuendenten* (The Allies), *Rosa Loy*, Kunstsammlung Gera

1999 *Rosa Loy*, Veag, Berlin
Pictures of Pictures, Arnolfini, Bristol; Norwich Art Gallery

Selected Exhibitions

2003 Entwistle, London
Galerie Wilma Tolksdorf, Frankfurt
Kunstsammlung Gera-Orangerie, Gera and touring

2001 'The Big ID', James Cohan Gallery, New York
'The Intimate, The Beautiful and The Curiosity', Badischer Kunstverein, Karlsruhe; Haus am Waldsee, Berlin

1999 'Pictures of Pictures', Arnolfini, Bristol; Norwich Art Gallery

Rosa Loy's paintings feature matching pairs of women absorbed in their own worlds, often in an agrarian setting and always painted in milk casein, which gives them a nostalgic efflorescence. Works such as *The Snails Are Coming* (2000) – in which a gardening twosome are menaced by giant escargot – or *Initiation* (2000), in which a couple tend a flame that emerges from between their legs, have been analysed along lines from the psychological to the historical (the latter apt since Loy was raised in communist Leipzig). Which take is correct? Perhaps all of them: travelling simultaneously along multiple vectors while refracting painterly styles from the Renaissance to Surrealism, Loy fashions ticklish enigmas that can only be unlocked by the viewer's preconceptions. (MH)

Represented by Entwistle E2

Gefährlich klug und angriffslustig
(Dangerously clever and Trigger-happy)
2003
Acrylic paint, crayon on wood
140×100cm
Courtesy Contemporary Fine Arts

Robert **Lucander**

Born 1962
Lives Berlin

Do people control their gestures or are they controlled by them? In his paintings Robert Lucander investigates the principles of body language. He scans magazines for photographs of people in significant poses and extracts telling details. It might be a peculiar blink of the eye, a specific exchange of glances, a theatrical flick of the wrist or a unique way of resting a hand on one's hip. These details are then magnified and analysed with painterly means – a hand or a pair of eyes might be framed by monochrome colour fields or isolated on an unpainted patch of the wooden board Lucander uses as a support for his paintings. The more you study the gestures, the more you wonder whether they are communicative or compulsive by nature. (JV)

Represented by Contemporary Fine Arts D4

Selected Bibliography

2002 *Warum bellen, wenn man auch beissen kann* (Why bark if you can bite as well), Galerie Anhava, Helsinki
Stop for a moment – Painting as narrative, Nordic Institute for Contemporary Art, Helsinki

2001 *Kunstpreis der Böttcherstraße in Bremen 2001* (Art prize, Böttcherstraße, Bremen), Kunsthalle Bremen
Party with Attitude – Sait mitä hait, Robert Lucander, Turun Taidemuseo and Abo Konstmuseum, Turku

2000 *Accattone*, Robert Lucander, Melitta Kliege, Contemporary Fine Arts, Berlin

Selected Exhibitions

2003 'Finlandia', Contemporary Fine Arts, Berlin

2002 'The Second Coming', Kunsthall, Bergen
'Warum bellen, wenn man auch beissen kann', Galerie Anhava, Helsinki
'Stop for a moment – Painting as narrative', Istanbul Museum of Contemporary Art

2001 'Alibi', Contemporary Fine Arts, Berlin
'Party with Attitude – Sait mitä hait', Turun Taidemuseo, Turku; Amos Andersson, Helsinki

2000 'Knock on Wood', Contemporary Fine Arts, Berlin
'Labyrintti', Helsingin Taidehalli , Helsinki
'Soft Parade', Konsthall, Skövde

Drag-On
2003
Cigarettes, resin, jesamite
161×308×283cm
Courtesy Sadie Coles HQ

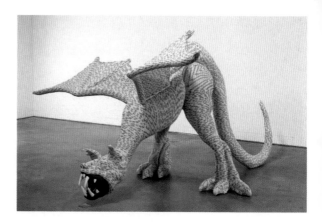

Selected Bibliography

2002 *Sarah Lucas*, Matthew Collings, Tate Publishing, London

2000 *Sarah Lucas: Self Portraits and More Sex*, Victoria Combalia and Angus Cook, Tecla Sala, Barcelona

1996 *Sarah Lucas*, ed Karel Schampers, Museum Boijmans van Beuningen, Rotterdam

Selected Exhibitions

2003 'Sogni e conflitti – La dittatura dello spettatore', Venice Biennale
'Temple of Bacchus' (with Roddy Thomson and Colin Lowe), Milton Keynes Gallery

2002 'Charlie George', Contemporary Fine Arts, Berlin

2000 'Sarah Lucas – Beyond the Pleasure Principle', Freud Museum, London
'Sarah Lucas – Self Portraits and More Sex', Tecla Sala, Barcelona

1998 'The Old In Out', Barbara Gladstone Gallery, New York

1997 'The Law' (organized by Sadie Coles), St Johns Lofts, London

1996 'Sarah Lucas', Museum Boijmans van Beuningen, Rotterdam

Sarah **Lucas**

Born 1962
Lives London

Sarah Lucas has said that 'you have to use what you've got, and either it does the job or it doesn't'. Since the early 1990s, she has employed everyday objects (kebabs, work boots, seamy mattresses) to speak about how vernacular language and culture processes our sloppy, craving bodies. Although her use of brash imagery has preoccupied many critics, Lucas also has a sophisticated sculptural sensibility, demonstrated in recent works in which she encased telling items in pristine Marlboro Lights. Here, a crucifix promises post-emphysema resurrection, a Paolo Uccello-like dragon embodies snarling nicotine pangs, and a burnt-out car – made as soft and fresh as an unsullied lung by its coating of unsmoked cigarettes – becomes a death-drive image that can't quite kick the pleasure principle. (TM)

Represented by Sadie Coles HQ B8, Contemporary Fine Arts D4

Parents Lake
2003
Acrylic on canvas
208×258cm
Courtesy Emily Tsingou Gallery

Dietmar **Lutz**

Born 1968
Lives London

The effect of a Dietmar Lutz painting can best be described as cinematic, with scripted references to the films of Pasolini and Fassbinder. Working with diluted acrylic, he saturates vast canvases to produce a screen-like surface for his hip, leisurely characters: they loll about on beaches and stroll through the park looking coolly self-important. A member of the German art collective known as hobbypopMuseum, Lutz has a flair for narrative that transcends the parameters of his chosen medium – a medium that, to judge from his confident brushwork, seems to suit him none the less. (KR)

Represented by Emily Tsingou Gallery A6

Selected Bibliography

2003 *deutschemalereizweitausenddrei* (German painting 2003), Kunstverein, Frankfurt

Selected Exhibitions

2003 Tache-Lew Gallery, Brussels
'Frost', Alberto Peola Gallery, Turin
Arndt & Partner, Berlin
'deutschemalereizweitausenddrei' (German Painting 2003), Kunstverein, Frankfurt

2002 'Present Futures', Artissima, Turin
'Geometry of the Heart', Emily Tsingou Gallery, London

Die Band Probe
(Sound Check)
2002
Oil on canvas
155×140cm
Courtesy Galerie Meyer Kainer

Selected Bibliography

2003 *Zachowujmy sie normalnie*,
(Let's behave normally) PGS/
Galerie Meyer Kainer, Sopot,
Vienna
Nicole Scheyerer, *frieze*, 75 May
*Dekada: Laureaci Paszportow Polityki
1993–2003* (Decade: Prize Winners
of 'Politika' Passports 1993–2003),
Warsaw

2002 *Dobrze, in Ordnung* (Good,
OK), Kunstbüro, Vienna,

2001 *Polska* (Poland), Galerie
Zderzak, Kraków

Selected Exhibitions

2003 'Zachowujmy sie normalnie'
(Let's behave normally), PGS,
Sopot
'Dessinez avec Desirée', (Draw with
Desire), Galerie Meyer Kainer,
Vienna

2002 'Traurig, schön', (Sad,
beautiful) Galerie Meyer Kainer,
Vienna
'Hier leben sie und hier geht es
ihnen gut', (They live here and they
feel fine), Polish Institute, Berlin
'Tu zyja i tu jest im dobrze' (They
live here and they feel fine), Gallery
Zacheta, Maly Salon, Warsaw
'Rzeczywiscie, mlodzi sa
realistami', (Really, the youngsters
are realists), CWS, Zamek
Ujazdowski, Warsaw,
'Dobrze, in Ordnung' (Good OK),
Kunstbüro, Vienna
'Nowe miejsca pracy' (New work
places), Galerie Manhattan, Lodz

2001 'Damit die Kinder solche
Szenen nicht Sehen' (So that
Children can't Watch those Scenes),
Galerie Raster, Warsaw
'Polska', Galerie Zderzak, Kraków

Marcin **Maciejowski**

Born 1974
Lives Kraków

Truth is on the surface of the image. In his paintings
Marcin Maciejowski takes the pictures popular visual
culture produces at face value. He reproduces press
photographs and similar mass-produced imagery:
young soldiers playing billiards, farmhouses seen over
the barrel of a tank gun, a roadside gangster shoot-
out, a guy in an Adidas track suit with the caption
'Polska' across his back. Scenes from a male-
dominated world, where masculinity is asserted
through swaggering poses and acts of violence.
The pictures show it like it is. What you see is all
there is to say. But sometimes, Maciejowski seems to
suggest, not without a cynical smile, the closest thing
to the truth is the cliché. (JV)

Represented by Marc Foxx G12, Galerie Meyer
Kainer F1

Layde Trees
2003
Oil on canvas
41×46cm
Courtesy Kerlin Gallery

Selected Bibliography

2002 *Glen Dimplex Artists' Awards*, Annie Fletcher, Irish Museum of Modern Art, Dublin

2000 *51 Premio Michetti*, Gianni Romano, Museo Michetti, Pescara *Places in Mind*, Suzanna Chan, Ormeau Baths Gallery, Belfast

1999 *The Lie of the Land*, Caomhín MacGiolla Leith, Southampton City Art Gallery

1994 *Fred's Leap of Faith*, Fiona Bradley, Bluecoat Gallery, Liverpool

Elizabeth **Magill**

Born 1959
Lives London

Elizabeth Magill's paintings seem, at first glance, to fit squarely into the Romantic landscape tradition: lone trees or figures are silhouetted against sunsets straight out of Caspar David Friedrich. Her idyllic scenes, however, are subject to intrusive elements such as an airport baggage scanner or a tangle of power lines. Born in Canada, brought up in Northern Ireland and now based in London, Magill is often miscategorized as a painter of the Irish landscape, even though she has incorporated elements of the mythic American West into her ambiguous, beguiling scenery. (KR)

Represented by Kerlin Gallery F16, Wilkinson Gallery E1

Selected Exhibitions

2004 Ikon Gallery, Birmingham

2003 Artemis Greenberg Van Doren Gallery, New York Ghislaine Hussenot, Paris

2002 Anthony Wilkinson Gallery, London

2001 IMMA/Glen Dimplex Exhibition, Irish Museum of Modern Art, Dublin Galerie Deux, Tokyo Peer, London

2000 'Places in Mind: Elizabeth Magill, Adam Chodzko, Stan Douglas', Ormeau Baths Gallery, Belfast

1999 Kerlin Gallery, Dublin '0044', PS1, New York, touring to Albright-Knox Art Gallery, Buffalo; Ormeau Baths, Belfast; Crawford Municipal Art Gallery, Cork

Untitled
2003
C-type print
126×157.5cm
Courtesy Blum & Poe

Selected Bibliography

2002 'Testing the Bounds of Photographic Truth', Holly Myers, *Los Angeles Times*, 13 September 2002

2001 'A "Snapshot" of L.A. Artists', Christopher Knight, *Los Angeles Times*, 6 June 2001
'Snapshot: New Art From Los Angeles', Ali Subotnick, *frieze*, 62, October
'Snapshot', Jan Tumlir, *Artforum*, October
Snapshot: New Art from Los Angeles, UCLA Hammer Museum of Art, Los Angeles

Selected Exhibitions

2003 Gallery Min Min, Tokyo
'Gilbert & George, Cristina Iglesias, Mike Kelley, George Lappas, Florian Maier-Aichen, Nikos Navridis, Tony Oursler, Thaddeus Strode', Bernier/Eliades, Athens

2002 'Constructed Realities', Grand Art, Kansas City; Las Vegas Art Museum
'Anti-Form: New Photographic Work from Los Angeles', Society for Contemporary Photography, Kansas City
Blum & Poe, Santa Monica
'Ich ging im walde so für mich hin: Markus Amm, Florian Maier-Aichen, Gondi Norola, Nicole Wermers' (I was walking in the woods all by myself), Borgmann-Nathusius, Cologne

2001 'Jennifer Bornstein, Mark Grotjahn, Dave Muller, Florian Maier-Aichen', Blum & Poe, Santa Monica
'Snapshot: New Art From Los Angeles', UCLA Hammer Museum of Art, Los Angeles

Florian **Maier-Aichen**

Born 1973
Lives Los Angeles

The colour photography accompanying travel brochures and tourist postcards is often of such a familiar generic beauty that we fail to notice how fundamentally unreal it is. Something of that bland surface perfection is captured in Florian Maier-Aichen's photographs of corporate architecture, sweeping Alpine vistas and aerial urban views. Maier-Aichen is of a generation for whom digital manipulation of banal photographic images is a given, and he has no qualms about using technology to demonstrate the unreliability of photography while enjoying the formal possibilities of such alteration. Clever details – such as a small segment missing from a motorway interchange – tip off the viewer without detracting from the allure of appearances. (JT)

Represented by Blum & Poe D9

Anas Platyrhynchos?
2001
C-type print
Courtesy Galerie Nordenhake

Eskö **Männikkö**

Born 1959
Lives Oulu

For decades, Eskö Männikkö has been making documentary photographs of the inhabitants of remote Northern Finland. Aloof yet seemingly unfazed by the camera, Männikkö's largely male subjects pose in their thick woollens with the dignified expressions of Walker Evans' sharecroppers. Resisting the label of an essentially Finnish provincialist, Männikkö has recently expanded his scope to include the rural populations of Texas and Brazil, demonstrating an uncanny ability to hone in on rugged landscapes and weathered frontier personalities in far-flung corners of the globe. (KR)

Represented by Galerie Rodolphe Janssen D2, Galerie Nordenhake D12, White Cube F6

Selected Bibliography

2000 *Naarashauki – The Female Pike,* Eskö Männikkö, Leipzig

1999 *Mexas –* Eskö Männikkö Maaretta Jaukkuri, Gary Michael Dault, Museum of Contemporary Art, Helsinki

1996 *Eskö Männikkö,* Heikki Kastemaa and Rudolf Schmitz, Portikus, Frankfurt

1995 *Eskö Männikkö – Young Artist of the Year 1995,* Anneli Ilmonen and Ritva Kovalan, Tampere Art Museum

Selected Exhibitions

2002 'Flora & Fauna', Galerie Nordenhake, Berlin

2000 'Organized Freedom', Moderna Museet, Stockholm

1999 'Photographs 1980-1998', Hasselblad Centre, Gothenburg

1998 'Nuit Blanche', Musée d'Art Moderne de la Ville de Paris

1997 'Wounds', Moderna Museet, Stockholm Malmö Konsthall

1996 'Eskö Männikkö', Portikus, Frankfurt; De Pont, Tilburg; Lenbachhaus, Munich

Untitled (F)
2002
Graphite, watercolour and charcoal
on paper
77.5×57.5cm
Courtesy greengrassi

Selected Bibliography

2003 'Margherita Manzelli',
Lee Trimming, greengrassi, *Flash
Art*, 228, January–February

2002 Exhibition brochure, Saõ
Paulo Biennale

2000 'Margherita Manzelli',
Alessandra Pioselli, *Artforum*,
October
Perché?, 1, discussion between
Franco Bolelli, Giovanni Levanti,
Margherita Manzelli, Cristina
Morozzi, Antonio Somaini, May
'Giving Sense to the Senseless',
Helena Kontova, interview with
Margherita Manzelli, *Flash Art*,
January–February

Selected Exhibitions

2002 'Drawings, paintings to
follow', greengrassi, London
Saõ Paulo Biennale

2001 'Casino 2001', SMAK, Ghent
'New to the Modern: Recent
Acquisitions from the Department
of Drawings', Museum of Modern
Art, New York
'Painting at the Edge of the World',
Walker Art Center, Minneapolis

2000 'Un cielo senza fine', Studio
Guenzani, Milan
'Parete Pavimento', Link, Bologna

1999 'The Passion and the Wave',
Istanbul Biennale
'Examining Pictures: Exhibiting
Paintings', Whitechapel Art
Gallery, London; Museum of
Contemporary Art, Chicago;
UCLA Hammer Museum of Art,
Los Angeles

1997 'Fatto in Italia', Centre d'Art
Contemporain, Geneva and ICA,
London

Margherita **Manzelli**

Born 1968
Lives Milan

Something is worrying the women who inhabit
Margherita Manzelli's paintings and drawings.
The tired skin of their other-worldly faces is
riddled with insomnia, their eyes caught in the
hallucinogenic light of late-night supermarkets.
Colour is peeled away like a layer of clothing,
until only the solid threads of canvas or paper
remain. Dangling limbs, manipulated by subtle
distortions in scale, fade away. The drawing is
exquisite. Fluctuating between an intense scrutiny
of detail and a disparaging disdain of surface,
it lends these excursions into nocturnal dissolution
a dream-like combination of oppression and
equivocation. These are pictures complicated by
the things that usually cause complications –
a glance, a gesture, the ambiguous meanings that
reside in and confuse the bluntest of intentions. (JH)

Represented by greengrassi A3

Monkiness is the Whatness of All Monkey
2000–3
Mixed media
167.5×92.5×82.5cm
Courtesy Counter

Simon **Martin**

Born 1965
Lives London

Simon Martin's career trajectory – from Minimalist paintings to Photorealism and Appropriation art – would be perplexing but for one perpetual aspect: his works invariably strategize to slow our understanding of them, making the forced interval between experience and comprehension into their default subject. Martin evades capture via systemic innovation: recent projects have included a perfect replica of a sculpture by German artist Martin Honert, making a perfect white sphere with a grinning monkey's face smoothly sculpted into it and a Photorealist painting of a poisonous tree frog. And if accepting the wilful arbitrariness of such works is a learning curve for the viewer, the erasure of authorial marks and favouring of internal logic seem equally to satisfy the maker. (MH)

Represented by Counter B13

Selected Exhibitions

2003 Counter Gallery, London
CHOCKERFUCKINGBLOCKED
Jeffrey Charles Gallery, London
Sharjah International Biennale

2002 'It's only words', Mirror,
London

2001 'Reconstruction of Big Blue;
Century City', Tate Modern,
London
'Empty Shoe Box', Mellow Birds,
London

2000 'Serial Killers & Cereal
Killers', Platform, London and
Christopher Cutts Gallery, Toronto

1999 'Untitled Painting show',
The Lux, London

1995 'Simon Martin', Javier Lopez
Gallery, London

Awning (Kevlar)
2001
Kevlar and aluminium
91.5×81.5×244cm
Courtesy Mai 36 Galerie

Selected Bibliography

2002 *Rita McBride. Croissance Générale/General Growth*, Institut d'Art Contemporain, Villeurbanne

2001 *Rita McBride 472 New Positions*, De Pont Foundation for Contemporary Art, Tilburg

2000 *Werkshow*, Marí Bartomeu et al, Staatliche Kunsthalle, Baden-Baden

1999 *Rita McBride & To Be Announced,* Annette Choon, Dirk Snauwaert, Matthias Winzen, Siemens Kulturprogramm, Kunstverein Munich; Oktagon Verlag, Cologne
Rita McBride, Annemarie Verna Galerie; Mai 36 Galerie, Zurich; Alexander and Bonin, New York

Selected Exhibitions

2002 'Croissance Générale', Institut d'Art Contemporain, Villeurbanne

2001 'Rita McBride: 472 New Positions', De Pont Foundation for Contemporary Art, Tilburg

2000 'Werkshow', Staatliche Kunsthalle, Baden-Baden and Neuer Aachener Kunstverein, Aachen

1999 'Aloof and Incidental', Annemarie Verna Galerie and Mai 36 Galerie, Zurich
'Rita McBride & To Be Announced', Kunstverein, Munich

1997 'Arena & National Chain', Witte de With, Rotterdam
'Rita McBride', Alexander and Bonin, New York

1996 'Rita McBride and Piggybackback' (with Catherine Opie and Lawrence Weiner), Galerie Bela Jarzyk, Cologne

1992 'Parts', Des Moines Art Center

1990 'Rita McBride', Margo Leavin Gallery, Los Angeles

Rita **McBride**

Born 1960
Lives Cologne/New York

Form following function may be the cardinal rule of Modernist architecture, but if a bronze replica of a multi-storey car park is rendered at a scale that reduces it to the size of a footstool, then function is going to take a holiday. Rita McBride takes common, useful structures and objects – often those associated with mass production and bastardized, trickle-down versions of Modernist design – and recreates them in ways that relieve them of their humdrum utility. An ordinary chair is reproduced full-size in delicate Murano glass; a Toyota is woven out of crafty rattan; video game consoles get recast in vitreous enamel, transforming them into spare human-scaled formalist sculptures and establishing links between high Modernist ideals and the artless forms all around us. (JT)

Represented by Mai 36 Galerie D12

Boxhead Chocolate Factory 2000–2
2003
Inkjet print with drawings
Unique
105×166cm
Courtesy Galerie Hauser & Wirth/
Luhring Augustine

Paul **McCarthy**

Born 1945
Lives Altadena

Trained as a painter yet fascinated with cinema,
in the late 1960s Paul McCarthy used his body as
canvas and his penis and face as brush. Gradually,
materials such as ketchup and mayonnaise replaced
paint; food for the artist is intensely metaphorical.
Until 1984 Paul McCarthy did around 50 live
performances which often involved vomiting,
shitting, cooking, eating, painting and spinning;
since then he has created sculptural tableaux, and
the video camera has replaced the audience.
His subject-matter usually concerns power struggles
between psychotic males – including fathers,
grandfathers, artists, sea-captains, and cartoon
characters – and children or animals. He has also
collaborated extensively with Mike Kelley. This
summer McCarthy designed a huge inflatable
sculpture – Blockhead, a grotesquely distorted take
on Pinocchio. (KR)

Represented by Galerie Hauser & Wirth B5,
Luhring Augustine D10

Selected Bibliography

2003 *Paul McCarthy at Tate Modern*,
Tate Publishing, London
Paul McCarthy, Video, ed Yilmaz
Dziewior, Verlag der
Buchhandlung Walther König,
Cologne

2002 *Paul McCarthy*, ed Laurence
Gateau, Pinocchio, Villa Arson,
Nice
Paul McCarthy, Hatje Cantz, New
Museum of Contemporary Art,
New York

1996 *Paul McCarthy*, Ralph Rugoff,
Kristine Stiles, Giacinto di
Pietrantonio, Phaidon, London

Selected Exhibitions

2003 Lyon Biennale
'Paul McCarthy at Tate Modern',
Tate Modern, London

2002 'Paul McCarthy. Clean
Thoughts', Luhring Augustine, New
York
'Paul McCarthy & Jason Rhoades.
Shit Plug', Galerie Hauser & Wirth,
Zurich

2001 'Paul McCarthy –The Box',
New York, Public Art Fund/IBM
Building, New York
'Paul McCarthy. Videos und
Fotografien', Kunstverein,
Hamburg
Villa Arson, Nice

2000 Museum of Contemporary
Art, Los Angeles
New Museum of Contemporary
Art, New York

1999 'Dimensions of the Mind',
Sammlung Hauser und Wirth,
Lokremise, St. Gallen

1998 'Out of Actions: Between
Performance and the Object,
1949–1979', Museum of
Contemporary Art, Los Angeles

Conjured
2003
Coloured pencil, acrylic and
charcoal on paper
55.5×68cm
Courtesy Hales Gallery

Selected Bibliography

2003 'Palm Reading', Emily King, *frieze,* 73, March

2002 'Play it as it Lays', Richard Blandford, *frieze,* 69, September
'Reverberator', J J Charlesworth, *Art Monthly,* 258, July–August
'Paul McDevitt – Piranesi Penguin Pool & Other Stories', *Der Atom #3*
Paul McDevitt 'Lost Weekend', Pocko Editions, London

Selected Exhibitions

2003 'The Horns of Moses', Habitat, Kings Road, London
'Phillip Allen, Diana Cooper, Paul McDevitt', Kerlin Gallery, Dublin
'Air Guitar: Art Reconsidering Rock Music', Milton Keynes Gallery

2002 'Lost Weekend Galala', Fukuoka
'YesteryearNowadays', Hales Gallery, London
'Lovely', Kohlenhof, Nuremberg

2001 'Half Life', Hales Gallery, London
The Jerwood Drawing Prize 2001
Freie Wahlen (McDevitt, Purdy, Quabeck), Staatliche Kunsthalle, Baden-Baden

Paul **McDevitt**

Born 1972
Lives London

Paul McDevitt's biro and coloured-pencil drawings of tattoos, constellations, fireworks and observatories seem to ponder their own complexity. There's an obvious visual chain to this subject matter: a spiralling tattooist's design recalls a pyrotechnic display, which in turn apes a skyscape, which may in turn be observed by a telescope-touting astronomer. These micro-to-macro shifts, however, are undermined by the circumstances of McDevitt's labour: it takes him no longer to draw an inky heart than a whole, heaving hemisphere. Asking awkward questions about the ontology of the art object, McDevitt's drawings reach, a little gingerly, for the stars. (TM)

Represented by Hales Gallery A8

Untitled (Closed)
2002–3
Installation view at The Wrong Gallery
Flashe on paper
30.5×40.5cm
Courtesy the artist and The Wrong Gallery

Selected Bibliography

2003 'On the Underbelly of the Zeitgeist', Christopher Knight, *Los Angeles Times*, 21 February 2003

2002 'Yes We're Excerpts', Roberta Smith, *New York Times*, 2 August 2002

2001 'A New York state of mind', Nicholas Wapshott, *The Times*, 22 October 2001

Selected Exhibitions

2003 Alessandra Bonomo Gallery, Rome
'Melvins', Anton Kern Gallery, New York
'The Great Drawing Show', Michael Kohn Gallery, Los Angeles
'I See A Darkness', Blum & Poe, Los Angeles
'Group Show', Grant Selwyn Gallery, Los Angeles
Greener Pastures, Toronto

2002 'Happy Birthday' newspaper project, Gavin Brown's enterprise, New York; greengrassi, London
'Yes We're Excerpts', Andrew Kreps Gallery, New York
'COPY', Roth Horowitz, New York
Sleeper, Edinburgh

2001 'Drawing Show,' Greene Naftali Gallery, New York
'Art Transplant', British Consulate, New York

1999 'Untitled Painting Show,' LEA Gallery, London
'Free Coke', Greene Naftali Gallery, New York

1998 'Grapeshot Bullseye Harvest,' Attache Gallery, London
'Super Freaks Part 2', Greene Naftali Gallery, New York
'Much Better', 17 Rosebery Avenue, London

Adam **McEwen**

Born 1965
Lives New York

Adam McEwen's tricksterish text-based pieces seem to point towards an alternative universe – one much like our own, but not quite the same. For starters, Malcolm McLaren is deceased: a convincingly simulated full-page newspaper obituary memorializes the impresario of simulation. And in deadpan paintings the sorts of signs found on the doors of old-fashioned shops are made to speak in new voices: 'Sorry, We're Dead', they proclaim, or 'Sorry, We're Sorry'. In addition to his art-making, McEwen also writes and curates, as well as playing drums for Martin Creed's high-concept rock band Owada. If a common thread unites these activities, it's a love of words and the off-kilter rhythms of pop life. (SS)

Represented by The Wrong Gallery H1

Untitled
2002
Mixed media on wood
30×40cm
Courtesy Modern Art

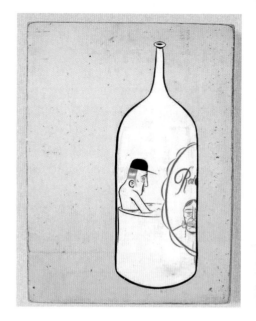

Selected Bibliography

2002 *Barry McGee*, Prada
Foundation, Milan

2000 *Street Market*, Littlemore
Publishing, Tokyo
Indelible Market, Alex Baker,
Institute of Contemporary Art,
Philadelphia

1999 *Buddy System*, Deitch Projects,
New York

Selected Exhibitions

2002 Prada Foundation, Milan
Modern Art, London
'Drawing Now:Eight Propositions',
Museum of Modern Art at Queens,
New York
'Street Market', Liverpool Biennal

2001 'Un Art Populaire',
Fondation Cartier pour l'Art
Contemporain, Paris
'Street Market', Venice Biennale

2000 'Indelible Market', Institute of
Contemporary Art, Philadelphia
UCLA Hammer Museum of Art,
Los Angeles

1999 'The Buddy System', Deitch
Projects, New York

Barry **McGee**

Born 1966
Lives San Francisco

A veteran of the 1980s San Francisco Graffiti art
scene, Barry McGee – aka 'Twist' – has lost little of
his street credibility since moving indoors to show his
paintings in galleries and museums. His work riffs off
various populist *plein air* art traditions, including the
work of Mexican and WPA-type muralists and the
kinds of Depression-era commercial American
signage that once bluntly extolled the virtues of Miss
Emily's Castor Oil or Dapper Dan Hair Pomade
from the sides of downtown buildings. His signature
motifs include bleary-eyed, stubble-jowled average
Joes, cartoonish street urchins, creepily animated hot
water bottles and limp syringes competing for space
on an end-of-the-line, surrealistic skid row. (JT)

Represented by Modern Art A1

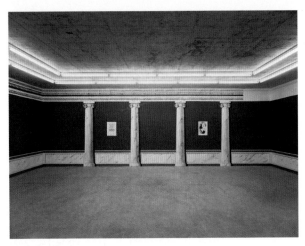

The Integrity Gap (detail with Florish Winter Solstice and Florish Nights poster II)
2003
Wall painting, posters, photocopies
Courtesy Cabinet and Galerie Daniel Buchholz

Lucy **McKenzie**

Born 1977
Lives Glasgow

When the Soviet Union decomposed during the 1990s and socialist parties across Europe mutated into New Labour-type representatives of the middle classes, the rich imagination that socialism once inspired faded away. The large reserve of socialist murals, posters and stock images celebrating history, the working class or the Olympics is one of the many visual sources Lucy McKenzie taps into in her paintings. Playing with her reference material, she frequently empties it of its content to bring out the promise and atmosphere implicit in its aesthetic form. The socialist dream may be a thing of the past, but the aesthetics it produced comes alive in McKenzie's paintings as a particular form of Modernism that may still await a new future. (JV)

Represented by Galerie Daniel Buchholz A2, Cabinet C9

Selected Bibliography

2001 'A Star is Born, Global Joy', Isabelle Graw, *Texte zur Kunst*, 44, December
'Openings: Lucy McKenzie', Michael Archer, *Artforum*, September
'Enigmatic Girls; Paulina Olowska & Lucy McKenzie in conversation', Polly Staple, *Untitled*, 25, Summer
'Lucy McKenzie', John Slyce, *Artext*, 73, May–July
'Lucy McKenzie', Alex Farquharson, *Art Monthly*, 243, February

Selected Exhibitions

2003 'Brian Eno', Kunstverein, Aachen

2002 'The Best Book on Pessimism I've Ever Read', Kunstverein, Braunschweig (curated by Lucy McKenzie)

2001 'Global Joy', Galerie Daniel Buchholz, Cologne
'Heavy Duty', (with Paulina Olowska), Inverleith House, Edinburgh
Festival Malarstwa Sciennego Kliniczna, Shipyard, Gdansk (with Paulina Olowska)

2000 'Decemberism', Cabinet, London
'Dream of a Provincial Girl', Bloc Apartment, Gdansk

1999 'Mandelson of Rio' (with Keith Farquhar), Gallery Charisma, Glasgow

Squaw
2002
Wood, Perspex, tape, canvas, paint, hardware
204.5×72×124.5cm
Courtesy Marc Foxx

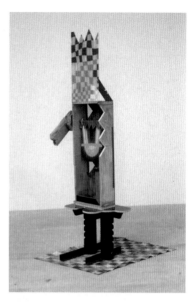

Selected Bibliography

2002 'Mute Matter and Stuttering Machines: Sign and Substance in Recent Sculpture', J.J. Charlesworth, *Artext*

2001 'Jason Meadows at Corvi-Mora', Alex Farquharson, *Art Monthly*, 246, May

2000 'Towards a Funner Lacoon', Bruce Hainley, *Artforum*, Summer
'Jason Meadows at Marc Foxx', Bruce Hainley, *Artforum*, February

1998 'Openings: Jason Meadows', Dennis Cooper, *Artforum*, May

Selected Exhibitions

2003 'Order in the Court', Marc Foxx, Los Angeles
Els Hanappe Underground, Athens
Corvi-Mora, London

2002 'Animal Eyes', Marc Foxx, Los Angeles
'Microcarving', Tanya Bonakdar Gallery, New York
Studio Guenzani, Milan

2001 'Brown', The Approach, London

2000 'Mise en Scène', Santa Monica Museum of Art; CCAC, San Francisco
Marc Foxx, Los Angeles

1999 Monika Sprüth, Cologne; Philomene Magers Projekte, Munich

1998 'Jason Meadows/Jorge Pardo', Brent Peterson, Los Angeles

Jason **Meadows**

Born 1972
Lives Los Angeles

Ever since Robert Smithson came back from the half-built, half-ruined Hotel Palenque in Mexico with renewed appreciation for the haphazard beauty of construction sites, it has been sort of all right to admit to an aesthetic regard for down-to-earth, blue-collar materials that don't pretend to be anything other than what they are. Jason Meadows makes medium-sized sculptures that revel in their jury-rigged honesty and clearly demonstrate that he has been spending plenty of time at his local DIY centre. Suggesting a handyman's exuberance and a deep reading of the late Formalist constructions of Anthony Caro or David Smith, Meadows' bolted together readymades are composed of off-the-shelf hardware – laminated chipboard, aluminum mesh, metal clamps, two-by-four – that sometimes still sports the manufacturer's label, a detail that keeps his quasi-abstractions from getting too high and mighty. (JT)

Represented by Tanya Bonakdar Gallery E7, Marc Foxx G12

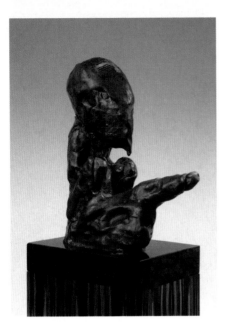

Archaeopteryx
2003
Bronze
Edition of 3
48.5×22×35cm
Courtesy Contemporary Fine Arts

Selected Bibliography

2002 *Young Americans,*
Contemporary Fine Arts, Berlin
Love, Galerie Ascan Crone,
Hamburg
Revolution, Carsten Ahrens and Carl
Haenlein, Kestner-Gesellschaft,
Hanover

2001 *Jonathan Meese*, Thomas
Kellein, Leo Koenig, Inc, New York

2000 *Stierhoden und Absinth – Erwin
Meese* (Bulls' Testicles and Absinth –
Erwin Meese), Veit Loers,
Contemporary Fine Arts , Berlin

1999 *Gesinnungsbuch '99* (Book of
Convictions '99), Jonathan Meese
and Erwin Kneihsl, Walther König,
Cologne

Selected Exhibitions

2003 'The Empire Portraits 1903',
Modern Art, London
'Grotesk!' (Grotesque!), Schirn
Kunsthalle, Frankfurt; Haus der
Kunst, Munich
'deutschemalereizweitausenddrei',
(German painting 2003),
Kunstverein, Frankfurt
'Warum!' (Why!), Martin-Gropius-
Bau, Berlin
'Berlin – Moskau/Moskau – Berlin
1950–2000', Martin-Gropius-Bau,
Berlin

2002 'Young Americans',
Contemporary Fine Arts, Berlin
'Revolution', Kestner-Gesellschaft,
Hanover
'L'Amour', Galerie Daniel
Templon, Paris

2001 'Jonathan Meese', Leo
Koenig, Inc, New York

2000 'Wounded Time',
Städtisches Museum Abteiberg,
Mönchengladbach

1999 'Information – Ressurection –
Return/Richard Wagner's Private
Army Lichterz', Kunsthalle Bielefeld

1998 'Die Räuber' (The robbers),
Contemporary Fine Arts, Berlin

Jonathan **Meese**

Born 1971
Lives Berlin/Hamburg

The clandestine codes and rules so beloved of cults
are the starting point for thinking about the work
of Jonathan Meese. In these secret organizations,
however, Meese finds not strength and glory so much
as the forces of regression and the seductive allure of
a collective death wish. The atmosphere of his
installations could be compared to the other-wordly
air of terminal stagnation in Kurtz' camp in
Apocalypse Now (1979). In his performances Meese
feeds his followers mannequins of dead soldiers with
canned meat, while he rants about the Holy Grail
like a slapstick version of Charles Manson. The true
joy of the cult, if you follow Meese, lies in the
satisfaction of the priest who, drowsy with fever, rises
from his sweaty deathbed to find his church is dying
too. (JV)

Represented by Contemporary Fine Arts D4,
Modern Art A1

Untitled
2003
Oil on canvas
80×60cm
Courtesy Galerie Neu

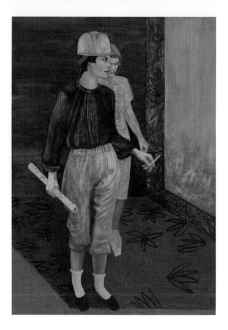

Selected Bibliography

2003 'Kurzhaarschopf auf bunter Tagesdecke' (Short shock of hair on a colourful Bedspread), Andrea Hilgenstock, *Berliner Morgenpost*, 13 May 2003
Die bessere Hälfte (The better Half), Isabelle Graw, Cologne

2002 'Rising Angels', Anke Kempkes, *Modern Painters*, Winter

Selected Exhibitions

2003 'Losung Loslösung' (Slogan Disentanglement), Galerie Neu, Berlin
'Malerei II Ausstellung Nulldrei' (Painting II Exhibition zero three), Galerie Christian Nagel, Cologne Kunstverein, Frankfurt

2002 'Schöne Aussicht, Herr Schweins' (Nice View, Mr Schweins), Galerie Otto Schweins, Cologne

2000 'Ungehorsam bleibtreu' (Disobedient stay faithful), Galerie Nomadenoase, Hamburg

Birgit **Megerle**

Born 1975
Lives Berlin

Painted in a flat, faux naive way that is at times reminiscent of fellow Berlin painters Katharina Wulff and Lukas Duwenhögger, Birgit Megerle's androgynous bohemians are caught in awkward domestic situations. It's as if Tamara de Lempicka's 1920s heroines had been subjected to a major overhaul by an odd combination of Dalí and Balthus. Décor and iconic figure flow into one another as in a daydream. And yet Megerle's protagonists never give in to libido, as if they were frozen in protestant reserve. (JöH)

Represented by Galerie Neu E10

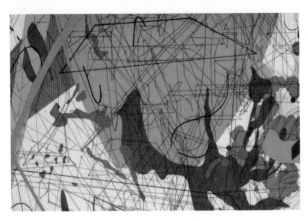

Ruffian Logistics
2001
Ink and acrylic on canvas
152×334cm
Courtesy The Project

Julie **Mehretu**

Born 1978
Lives New York

In epic, vertiginous canvases and dense, information-laden drawingsk, New York-based artist Julie Mehretu constructs oblique narratives of urban dislocation. Her multi-layered images incorporate architectural elevations, plans for airports and shopping malls, fragments of recognizable buildings and grids, and superimpose swirling lines of force, darting vectors and jagged planes of colour. Poised between abstract and representational, this work carries out an idiosyncratic sort of mapping – plotting hybrid spaces that are simultaneously geographical, temporal and social. Mehretu's project – reconceiving history painting for a globalized, nomadic world – marks her as one of the most ambitious artists to emerge in the last decade. (SS)

Represented by The Project H4, Ridinghouse G15, White Cube F6

Selected Bibliography

2002 '10 Artists to Watch', Carley Berwick, *ArtNews*, March
Susan Harris, *Art in America*, March
'Julie Mehretu', Lawrence Chua, *Black Book Magazine*, December
'Julie's World', Alexander Dumbadze, *Branna*, Winter

2000 'Crosstown Traffic', Laura Hoptman, *frieze*, 54, September–October

Selected Exhibitions

2003 'Drawing into Painting', Walker Art Center, Minneapolis
'The Moderns', Museo d'Arte Contemporanea, Turin
'Ethiopian Passages: Dialogues in the Diaspora', National Museum for African Art, Smithsonian Institution, Washington DC
'GPS', Palais du Tokyo, Paris

2002 'Out of Site', New Museum of Contemporary Art, New York
'Drawing Now: Eight Propositions', Museum of Modern Art at Queens, New York
'Stalder-Mehertu-Solakov', Kunstmuseum, Thun

2001 White Cube, London
The Project, New York
ArtPace, San Antonio

Untitled
2003
Oil on canvas
140×120cm
Courtesy Galerie Krinzinger

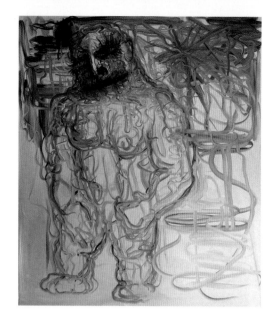

Selected Bibliography

2002 *Bjarne Melgaard, Société Anonyme*, Beate Ermacora, Kunsthalle zu Kiel, Bielefeld
Bjarne Melgaard, Black Low, ed Jan Hoet and Ann Demeester, M.art.A, Herford, Bielefeld

1999 *Everything American is Evil, The Return to Constantinople*, Kiasma Museum of Contemporary Art, Helsinki

1998 *More Pricks than Kicks*, Astrup Fearnley Museum of Modern Art, Oslo

1997 *Free from Content*, Stedelijk Museum, Amsterdam

Selected Exhibitions

2003 'Tirol Transfer', Krinzinger Projekte, Vienna
Bergen Kunsthall

2002 'Black Low', M.art.A, Herford, Bielefeld
'Interface to God', Kunsthalle zu Kiel
Galleria d'Arte Moderna, Bologna

2001 Galerie Krinzinger, Vienna

2000 Lyons Biennale
'Civil Disobedience', Sammlung Falckenberg, Kestner Gesellschaft, Hanover

1999 'Moon over Islam', Stedelijk Museum for Aktuelle Kunst, Ghent
'Umfeld, Umwelt' (Surrounding, Environment), Palais des Beaux Arts, Brussels

1998 Manifesta, Luxembourg
Saõ Paulo Biennale
Soft Core Arkipelag TV, Historical Museum, Stockholm

Bjarne **Melgaard**

Born 1968
Lives Berlin

Bjarne Melgaard is a fiercely happy de Sade, producing sculptures of Planet of the Apes-type humanoids that engage in acrobatic gay sex or give you the finger, and drawings of steroid-pumped Death Metal fans with hard-ons, holding a retro-punk-fan at gunpoint. In Melgaard's world gay SM and homophobic Norwegian Black Metal become part of the same wild-style bricolage. The Marquis de Sade revealed the dark side of enlightenment: he was the Mr Hyde to Immanuel Kant's Dr Jekyll. The Vienna Actionists shattered the repressed social climate of post-Nazi Austria with their ritualized, sexualized performances. Similarly, Melgaard's work can be seen as a brutally frank reaction to the apparent complacency of Scandinavia's social values. (JöH)

Represented by Galerie Krinzinger E9

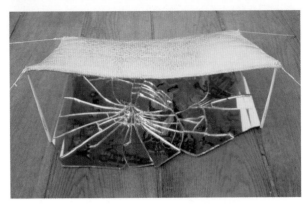

Zelt / Tent
2003
Mixed media
25×70×80cm
Courtesy Barbara Wien

Selected Bibliography

2003 'Isa Melsheimer', Angela Rosenberg, *Flash Art*, 228, January–February

2002 *Come-In, Kunst und Design*, Tourneeausstellung des Institut für Auslandsbeziehungen, Stuttgart

2001 'Isa Melsheimer', Cornelia Gockel, *Kunstforum International*, 155, June–July
'Modelle', Hanne Loreck, *Political Landscape*, Cologne

2000 'Isa Melsheimer', Hanne Loreck, Behausungen (Habitations), *Art on Paper*, 7/8, July–August

Selected Exhibitions

2003 'Unbuilt Cities', Kunstverein, Bonn
Kunstverein, Arnsberg
Galerie Barbara Wien, Berlin

2002 'dreiineins' (threeinone), essor gallery project space, London
Galerie Thomas Rehbein, Cologne
Projektraum Rosenthaler 11, Berlin
'Come-In, Kunst und Design', Tourneeausstellung des Institut für Auslandsbeziehungen, Stuttgart

2001 Kunstraum, Munich
'Patterns of Life', Schloß Ringenberg, Hamminkeln
'New Heimat', Kunstverein, Frankfurt

2000 'Behausung', Galerie Barbara Wien, Berlin
'Sur-face Oberflächen im Raum', Ausstellungsforum FOE 156, Munich
'Die Gründung der Akademie' (The Foundation of the Academy), Galerie der Stadt Sindelfingen

1999 'Visitez ma tente' (Visit my tent), Bahnhof Westend, Berlin

1995 'Focus', Galerie Lelong, Zurich (with Karl-Heinz Schwind)

Isa **Melsheimer**

Born 1968
Lives Berlin

If interior designers from Heaven and Hell could join forces to realize their collective concept of the ideal home, the result might be something like the model houses produced by Isa Melsheimer. Melsheimer constructs miniature buildings under, in and around benches, sideboards or kitchen sinks, and decorates them lusciously with landscape photographs, digital prints and embroidered fabrics. Yet this fantasy architecture, in which Modernist bungalows, nostalgic family homes and escapist tree houses are all jumbled together, is as much a manifestation of the utopian dream of living freely in organically growing houses as it is an articulation of the claustrophobia of an introverted existence in a secluded doll's house. (JV)

Represented by Galerie Barbara Wien G2

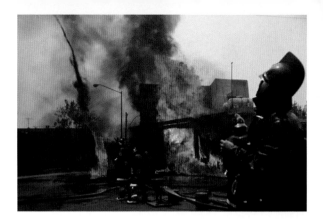

Mexico State
1982
C-type print
Courtesy Ridinghouse

Selected Bibliography

2003 'Enrique Metinides', Iván Carrillo, *Quo Magazine*, 64, February

2002 'La camara roja de Metinides' (Metinides' red camera), Fabrizio Mejía
Isadora Hastings, *Gatopardo Magazine*, 64, October
Periodismo Charter (Charter Journalism), Juan Manuel Servín, Nitropress-INBA-Conaculta, Mexico City
'Enrique Metinides', Juan Manuel Servín, *Uno Mas Uno*, 11 May 2002

2000 *El teatro de los hechos* (The theatre of the facts), Enrique Metinides, Instituto de Cultura de la Ciudad de México, Ortega y Ortiz Editores, Mexico City

Selected Exhibitions

2003 'Enrique Metinides', The Photographers' Gallery, London

2002 'Fair', Royal College of Art, London
'Trottoirs' (Pavements), Poste du Louvre with Galerie Chantal Crousel, Paris
'Artists Living in Mexico', PS1, New York
'Foto periodismo en Mexico' (Photojournalism in Mexico), Centro de la Imagen, Mexico City

2000 'El teatro de los hechos', MUCA CU, Mexico City

Enrique **Metinides**

Born 1934
Lives Mexico City

Enrique Metinides had his first photograph published at the age of 12, in the Mexican newspaper *La Prensa*. He proceeded to work for the publication for 50 years, specializing in investigative photography touched with elements of everyday Surrealism. Although his best-known pictures document accidents, disasters and tragedies, he always focused – often with great tenderness – on the minutiae of life, which he depicted in sharp relief to death's brutal interruption. Metinides' photographs explore the social history of Mexico City as it developed from a relatively peaceful town in the 1950s to the crime-ridden megalopolis of the 21st century. His work has had a profound influence on a recent generation of contemporary Mexican artists. (JH)

Represented by kurimanzutto B2, Ridinghouse G15

TV Mania, 1991 to 2002
Installation view
Courtesy Galerie Barbara Weiss

Boris **Mikhailov**

Born 1938
Lives Kraków/Berlin

For almost 40 years Boris Mikhailov has been producing photographs of his hometown, the bleak Ukrainian city of Kharkov. Often harrowing, sometimes touching or humorous, these images chronicle daily life before and after the collapse of communist rule. Yet Mikhailov has never been a simple documentarian or diarist. Working in thematic series, employing a range of strategies and styles, his concerns are essentially Conceptual. Steeped in moral and aesthetic ambiguity, the photographs acknowledge and trouble the artist's own position as an observer and a subject of history. (SS)

Represented by Galerie Barbara Weiss F14

Selected Bibliography

2002 *Boris Mikhailov: Salt Lake*, Steidl and Pace MacGill Gallery, New York

2000 *Boris Mikhailov: The Hasselblad Award 2000*, ed Gunilla Knape, Brois Groys, Hasselblad Centre, Gothenburg

1999 *Boris Mikhailov: Case History*, Scalo, Zurich, Berlin, New York

1998 *Boris Mikhailov: Unfinished Dissertation*, Scalo, Zurich, Berlin, New York

1995 *Boris Mikhailov*, ed Brigitte Kolle, Portikus Frankfurt; Kunsthalle, Zurich

Selected Exhibitions

2003 'Boris Mikhailov', Fotomuseum, Winterthur
'Cruel and Tender, The Real in the Twentieth-Century Photograph', Tate Modern, London
'Warum', Martin-Gropius-Bau, Berlin
'Berlin – Moskau, Moskau – Berlin, 1950–2000,' Martin-Gropius-Bau, Berlin

2002 'TV Mania', Galerie Barbara Weiss, Berlin
'The Insulted and the Injured', Pace MacGill Gallery, New York

2001 'Boris Mikhailov', Saatchi Gallery, London
'How you look at it, photographs of the 20th Century', Sprengel Museum, Hanover; Städelsches Kunstinstitut, Frankfurt

1999 'Case History', DAAD Galerie, Berlin

1995 'Boris Mikhailov', Portikus, Frankfurt; Kunsthalle Zurich

Utopian Ornament
2003
Polystyrene sphere with plastic fruit
61cm diameter
Courtesy Galerie Praz-Delavallade

Selected Bibliography

2000 *Consolation Prize* (with Mike Kelley), the Morris and Helen Belkin Gallery, University of British Columbia, Vancouver

1999 'When Down Is Up', *John Miller, Ausgewählte Schriften 1987–1999*, Revolver Blanco, Frankfurt
Economies Parallèles, Magasin, Centre d'Art Contemporain, Grenoble

1998 *White Studies*, Richard Hoeck & John Miller, Kunsthalle, Vienna

1992 *Rock Sucks Disco Sucks*, Daadgallery, Berlin

Selected Exhibitions

2003 'Everything is You', Galerie Praz-Delavallade, Paris

2001 'Double Date', Galerie Barbara Weiss, Berlin
'Trade', Fotomuseum Winterthur, touring to Nederlands Foto Instituut, Rotterdam

2000 'Consolation Prize' (with Mike Kelley), the Morris and Helen Belkin Gallery, University of British Columbia, Vancouver

1999 'Parallel Economies', Magasin, Centre d'Art Contemporain, Grenoble; Kunstverein, Hamburg
'Opposite Day', Metro Pictures, New York
'Pl@ytimes', Magasin – L'Ecole, Centre d'Art Contemporain, Grenoble
'Get Together: Art as Teamwork', Kunsthalle, Vienna
'Malerie', INIT Kunsthalle Berlin

1998 'John Miller: Painting and Sculpture', PS1, New York

John **Miller**

Born 1954
Lives Berlin/New York

During the 1980s, while the slick surfaces of Pop and Minimalism returned with Appropriation art, John Miller covered dolls or miniature suburban homes in a brown impasto that did more than just allude to shit, treating the fetish object with the brutish playfulness of the popular vernacular. Miller then moved on to explore the latter's many facets: from his paintings of TV game-show sets (*The Price is Right*) to his picture postcard canvases of the American West. Recently the New York-based artist has turned to ads in the personal columns: accompanied by analytical diagrams, he reproduces examples on posters or on sandwich-boards, using their ambivalent confessional code as a kind of derailed poetry of desire. (JöH)

Represented by Meyer Riegger Galerie B7, Galerie Christian Nagel E4, Galerie Praz-Delavallade B18, Galerie Barbara Weiss F14

Another Tequila Sunset
2002
Oil on canvas
152×183cm
Courtesy Luis Campaña Galerie

Selected Bibliography

2001 *Lisa Milroy*, Tate Publishing, London

1998 *Lisa Milroy: Paintings*, Waddington Galleries, London

1994 *Lisa Milroy, Tokyo Story*, Gallery Shoko Nagai, Tokyo

1990 *British Art Now: A Subjective View*, Setagaya Art Museum, Tokyo (British Council)

Selected Exhibitions

2001 Tate Liverpool

1998 'Every Day', Sydney Biennial

1996–8 'About Vision: New British Painting in the 1990s', Museum of Modern Art, Oxford, touring to Fruitmarket Gallery, Edinburgh; Wosley Art Gallery, Ipswich; Laing Art Gallery, Newcastle

1997 Luis Campaña Galerie, Cologne

1995–6 Chisenhale Gallery, London, touring to Ikon Gallery, Birmingham; Fruitmarket Gallery, Edinburgh

1993 Waddington Galleries, London
Museum Schloß Hardenberg, Velbert
'Der zerbrochene Spiegel/The Broken Mirror', Museumsquartier Messepalast and Kunsthalle Vienna and touring

1991 'Carnegie International 1991', Carnegie Museum of Art, Pittsburgh

1990 Kunsthalle Bern
'British Art Now: A Subjective View', Setagaya Art Museum, Tokyo, touring to Fukuoka, Nagoya, Utsunomiya, Kobe, Hiroshima

1989
Third Eye Centre, Glasgow and touring

Lisa **Milroy**

Born 1959
Lives London

Lisa Milroy is best known for her aggregations of everyday objects, realistically detailed and laid out in taxonomic fashion. With the eye of a collector or a compulsive shopper, she has catalogued both decorative and utilitarian items: Japanese ceramics and rare butterflies are given the same treatment as door handles and light bulbs. Recently, Milroy has adopted a looser, more autobiographical style, covering canvases with cheerful blossoms and narrative vignettes of her time in the studio. As Jeffrey Kastner has written in *frieze*, Milroy's paintings reveal both 'a classical faith in objects and a post-modernist scepticism about the contexts in which they are usually framed.' (KR)

Represented by Luis Campaña Galerie E3

Death Notice
2002
Sharpie on photocopy
22×28cm
Courtesy the artist and The Wrong
Gallery

Death Notices

Selected Bibliography

2003 *How to be a Joshua Tree*,
Aleksandra Mir, self-published,
New York
Corporate Mentality, Aleksandra Mir,
Lukas & Sternberg, New York

2002 *Daily News*, Aleksandra Mir,
Gavin Brown's enterprise, New
York; greengrassi, London
*Living & Loving #1 – The Biography of
Donald Cappy!*, Aleksandra Mir,
Cubitt Gallery, London; Dundee
Contemporary Arts
Strike, ed Gavin Wade,
Wolverhampton Art Gallery

Selected Exhibitions

2003 'Welcome Back to Earth',
Kunsthalle, St Gallen
'Ill Communication', Dundee
Contemporary Arts
'Publicness', ICA, London

2002 '(The World May Be)
Fantastic', Sydney Biennial
'Living & Loving #1 – The
Biography of Donald Cappy',
Cubitt Gallery, London
'HELLO Berne', Galeria Francesca
Pia, Bern

2001 'HELLO New York', Gavin
Brown's enterprise, New York
'Pyramids of Mars', The Curve,
Barbican Centre, London

2000 'Democracy!', Royal College
of Art, London

1999 'Empires without States',
Swiss Institute, New York

Aleksandra **Mir**

Born 1967
Lives New York

Aleksandra Mir's work could be described as a
practical sociology that, as Will Bradley has written
in *frieze*, 'makes visible the gap between the scale and
power of art and that of other forces at work in the
world'. From *Hello* (2000– ongoing) – her potentially
endless archival demonstration of the six degrees of
separation theory – to *Pink Tank*'s (2002) day-glo
reconfiguration of Soviet military might and
Stonehenge II (2003) (a proposal for a replica
Stonehenge visitors can actually enjoy up close),
Mir's social interventions are as fiercely analytical as
they are generous in spirit. (DF)

Represented by GBE (Modern) D5, greengrassi A3,
The Wrong Gallery H1

Selected Bibliography

2003 *Cream*, Phaidon, London
Land, Land!, Christina Végh,
Kunsthalle, Basel

2002 *Thread Skies*, Hamza Walker,
Renaissance Society, University of
Chicago

2001 'Helen Mirra', James Yood,
Artforum, September

1999 'Helen Mirra', Laurie Palmer,
frieze, 46, May

Helen **Mirra**

Born 1971
Lives Chicago

Helen Mirra is as influenced by the ways we navigate
the natural world as she is by literature, music and
Modernism, and her work – a complex web of
allusions and illusions that employs myriad materials
– reflects this. *Arrow* (2002), for example, takes place
in a pitch-black room that comprises ghostly,
blinding samples from D.W. Griffith's 1916 film
Intolerance and a moody, threatening soundtrack
which evokes a gathering storm. Recently shown
with *Arrow* is a floor piece, *Sky-wreck* (2001). It may
look like an exercise in Minimalism, but its fabric
was woven on an old-fashioned loom in India and its
shape is a fragment of a scale map of the sky, which
was created using the same mathematical principles
as the geodesic dome. (JH)

Represented by Stephen Friedman Gallery E6,
galleria francesca kaufmann H3, Meyer Riegger
Galerie B7

Selected Exhibitions

2003 'Matrix', Art Museum,
University of California, Berkeley
'Land, Land!', Kunsthalle, Basel
Venice Biennale

2002 'Zusammenhänge herstellen'
(Making connections), Kunstverein,
Hamburg
'Declining Interval Lands', Whitney
Museum of American Art, New
York

2001 'Sky-wreck', Renaissance
Society, University of Chicago
'Miller's View', Meyer Riegger
Galerie, Art Statements, Art Basel

2000 'Beforsten', Meyer Riegger
Galerie, Karlsruhe
'Age of Influence', Museum of
Contemporary Art, Chicago

1998 'Trance', Philadelphia
Museum of Art

1997 'Some Kind of Heaven',
Kunsthalle, Nuremberg; South
London Gallery

Orlando East, Soweto
2002
Black and white print
70×100cm
Edition of 7
Courtesy carlier | gebauer

Selected Bibliography

2001 *Santu Mofokeng*, David Krut Publishing, Johannesburg

2000 *Rhizomes of memory: Three South African Photographers*, Henie Onstad Kunstsenter, Oslo 'Trajectory of a Street Photographer', Santu Mofokeng, *NKA: Journal of Contemporary African Art*, 11–12

1996 'The Black Photo Album / Look at Me', Santu Mofokeng, *NKA: Journal of Contemporary African Art*, 4

Selected Exhibitions

2003 'On Sacred Ground', Africalia 03, Memling Museum, Bruges
Bamako Biennale, Mali

2002 Documenta, Kassel

2001 'The Short Century: Independence and Liberation Movements in Africa 1945-1994', Museum Villa Stuck, Munich; Martin-Gropius-Bau, Berlin; Museum of Contemporary Art, Chicago; PS1, New York

2000 'The Song of the Earth', Museum Fridericianum, Kassel 'L´Etat des choses', Kunst-Werke, Berlin

1999 'Chasing Shadows', Haus der Kulturen der Welt, Berlin

1998 'Lunarscapes', Nederlands Foto Instituut, Rotterdam

1997 Johannesburg Biennale

1996 'In/Sight: African Photographers, 1940 to the Present', Guggenheim Museum, New York

1993 'In Transit', New Museum of Contemporary Art, New York

Santu **Mofokeng**

Born 1956
Lives Johannesburg

For years Santu Mofokeng has been working as a professional photographer, concentrating predominantly on life in and around South African townships. Photojournalism often caters to the demand for shocking yet easily consumable images of human suffering. The work of Mofokeng stands out by virtue of avoiding such simplifications. Instead, he shows everyday life in the towns and landscapes of South Africa in photographs that are both matter-of-fact and atmospheric. His pictures powerfully convey the reality of a life frustrated by unresolved political struggles, without ever succumbing to the comforting idea that the complexities of these struggles could be captured in an iconic image on the front pages of the daily papers. (JV)

Represented by carlier | gebauer H9

Untitled
c. 1960–73
Unique polaroid
10.5×8cm
Courtesy Salon 94 and Hamiltons

Carlo **Mollino**

Born 1905 **Died** 1973

The multiple activities of the mid-twentieth century Italian polymath Carlo Mollino (1905–73) – architecture, interior design, furniture design, fashion, film criticism, teaching, skiing, aeronautics, literature and photography – provided him with a seemingly endless vocabulary with which to articulate Modernity. Taken for his private use, Mollino's nude and semi-nude Polaroids of prostitutes and dancers have all the strangeness of an opera performed in an empty playhouse. Shot in his Turin home, every aspect of their production (from the Mollino-designed props to the Paco Rabanne dresses to the dramatic, almost Baroque lighting) has the precision of a high-end sports car, as though these Polaroids are the pornographic fantasies of not a man, but an obsessive, sentient machine. (TM)

Represented by Salon 94 D6

Selected Bibliography

2003 'Reviews: Carlo Mollino', Andrea Scott, *Time Out New York*, 12 June 2003
'A World of His Own', Pablo Lafuente, *Art Review*, May
'Carlo Mollino: Polaroids', Richard Pinsent, *Art Newspaper*, May
'Review: Polaroids by Carlo Mollino', New Yorker, 7 April 2003
'The Chamber of Secrets', Emma O'Kelly, *Elle Décor*, February

Selected Exhibitions

2003 'Polaroids', Salon 94, New York
'Polaroids', Hamiltons, London

1997 'Polaroids', Robert Miller Gallery, New York

1973 Fiat Headquarters completed, Candiolo
Transport Office completed, Turin

1965 Regio Theatre completed, Turin

1960 Milan Triennale

1954 Milan Triannale

Self Portrait # 6 (10 × 15 glossy)
2002
50 colour standard 11×15cm
glossy photographs
Courtesy Galleri Nicolai Wallner

Selected Bibliography

2002 *Sport*, Kunsthalle, Nuremberg

2001 Berlin Biennale

1998 'Jonathan Monk l'imitateur –
Chugalug the beer, don't swallow
the rules', D. Perreau, *Artpress*, 236,
June

1995 'Every time I see you', Daniel
Birnbaum, *Siksi*, 3
'Young at art', Jonas Ekeberg,
Siksi, 1

Selected Exhibitions

2002 Galleri Nicolai Wallner,
Copenhagen
'Free Lane', Casey Kaplan 10/6,
New York
'Sport', Kunsthalle Nuremberg

2001 Berlin Biennale
'If you stare at a printed page for
long enough it starts to move',
Galerie Yvon Lambert, Paris

1998 Lisson Gallery, London

1997 Centre d'Art Contemporain,
Neuchâtel

1996 Salon Ryman, FRAC,
Nantes

1995 'A Brush with Death',
Tramway, Glasgow

1994 'Old Peculiar', Galleri
Nicolai Wallner, Copenhagen

1992 'On the Cheap', Centre for
Contemporary Arts, Glasgow

Jonathan **Monk**

Born 1969
Lives Berlin

A juxtaposed pair of superficially similar 16mm
film projections – one showing a Rubik's cube
being repeatedly scrambled and solved, the other
animating a book of varicoloured gouache cubes
by Sol LeWitt – emblematizes the witty, thoughtful
and increasingly acclaimed practice of self-described
'art history geek' Jonathan Monk. Since the mid-
1990s this peripatetic British artist has replayed
Conceptualism's grand concerns in a studiedly
imperfect and down-home fashion, from Lawrence
Weiner-like wall texts that invite viewers to future
meetings (for which Monk may not turn up) to
austere photographic grids starring his mother's
droopy-eared terrier. It's a clownish courting of
failure by the standards of older art, yet one that
successfully reflects our comparatively uncertain era.
(MH)

Represented by Jack Hanley Gallery G4, Galerie
Yvon Lambert D16, Lisson Gallery B4, Meyer
Riegger Galerie B7, Galleri Nicolai Wallner B12

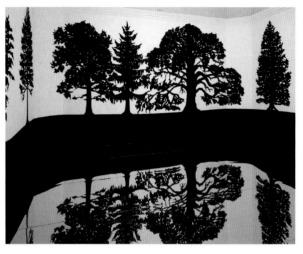

Cambium
2002
360° wall painting at The Royal
Academy, London
Acrylic paint directly on wall,
mirrored Perspex
Dimensions variable
Courtesy aspreyjacques

Selected Bibliography

2003 *Haematoxylon*, Irish Museum
of Modern Art, Dublin
Mesophylle, Magasin, Centre d'Art
Contemporain, Grenoble

2002 *Cognitive Landscape*, Paul
Morrison, aspreyjacques, London
Paul Morrison: Chloroplast, Simon
Wallis, Southampton City Art
Gallery

2000 *Paul Morrison*, Linda Norden,
UCLA Hammer Museum of Art,
Los Angeles

Paul **Morrison**

Born 1966
Lives London

In Paul Morrison's canvases, wall works and films
precise observation is filtered through retina-fizzing
caricature. In his highly stylized black and white
paintings trees, thistles, web-like tendrils and
blooming flowers become magnified. A single
monochromatic petal dwarfs us, drawing us into a
place that's a comical perfidy of the sublime but is
also a little uncanny. Morrison's films also occupy
this territory: in his *Cambium* (2002) footage taken
from the movies *Bambi* (1942), *Marathon Man* (1976),
Fantasia (1940) and *The Evil Dead* (1980) is edited
together to create a patchwork, colour-drained
landscape. By turns tranquil, ersatz, scary and
seductive, Morrison's garden is a place of other-
earthly delights. (TM)

Represented by aspreyjacques D14, Galleria Franco
Noero G13

Selected Exhibitions

2003 'Haematoxylon', Irish
Museum of Modern Art, Dublin
'5 weeks, 5 Films', Max Hetzler
Gallery, Berlin
'Saxifraga' Galleria d'Arte Moderna
et Contemporanea, Bergamo

2002 'Mesophylle', Magasin,
Centre d'Art Contemporain,
Grenoble
'Cambium', aspreyjacques, London
'Chloroplast', Southampton City
Art Gallery; Kunsthalle, Nuremberg

2000 '00', Barbara Gladstone
Gallery, New York

1999 'Colour Me Blind!',
Württembergischer Kunstverein,
Stuttgart, touring to Städtische
Ausstellungshalle am Hawerkamp,
Munster; Dundee Contemporary
Arts
'Trouble Spot. Painting', NICC and
Museum van Hedendaagse Kunst,
Antwerp
'Selections Winter 99', Drawing
Center, New York

1998 'Surfacing', ICA, London

Local + /or General: Toys 'R' Us, Utrecht
2001
Digital print
59×84cm
Courtesy Gimpel Fils

Selected Bibliography

2002 *Gulliver's Travels*, Contemporary Art Services Tasmania (CAST)

2001 *A Person Looks at a Work of Art … The Michael Buxton Contemporary Australian Art Collection*, Museum of Modern Art at Heide
'International Style', Stuart Koop, *Monument*, 1, April–May

1999 *The Persistence of Pop. Works from the Monash University Collection*, ed Zara Stanhope
Mixed Business, Santa Monica Museum of Art

Selected Exhibitions

2003 'Architectural Allusions', Gimpel Fils, London

2002 'The Big Sleep', Karyn Lovegrove Gallery, Los Angeles

2001 'Local +/or General', Roslyn Oxley 9 Gallery, Sydney

2000 'Malice in Blunderland', Gallery Tommy Lund, Copenhagen

1999 'International Style', Santa Monica Museum of Art
'The Queen is Dead', Stills Gallery, Edinburgh

1998 'Everybody Knows', Care of Space d'Arte Contemporanea and Gallery Openspace, Milan

1997 'Sepplet Contemporary Art Award', Museum of Contemporary Art, Sydney
'Now and Then', Govett-Brewster Art Gallery, New Plymouth

1995 'The Heights', Karyn Lovegrove Gallery, Melbourne

Callum **Morton**

Born 1965
Lives Melbourne

Using Modernist architecture as a locus for purity, Australian artist Callum Morton's sculptures and prints embody the souring of 20th-century social programmes. From inside *International Style* (1999), his model of Mies van der Rohe's all-glass Farnsworth House (1951), plays the sound of gunfire and Morton commenting that, since no glass was broken, the bullets surely found their targets. *Now and Then* (1997) features pristine glass doors, blinds pulled, set into a wall and soundtracked by music, barking dogs and copulating couples. Another series transforms Modernist houses into McDonalds and Toys 'R' Us outlets: the collapse of private and rarefied into public and base may be seen as tragic or, as Morton suggests when he calls it 'a merging of worlds', as curiously liberating. (MH)

Represented by Gimpel Fils D1

Sylvester
2002
Acrylic ink on paper
122×96.5cm
Courtesy maccarone inc.

Selected Bibliography

2001 *NB*, Dorothea Strauss,
Kunsthalle, St.Gallen

2000 'Janneke de Vries on Claudia
and Julia Müller', *Artist
Kunstmagazin*, 45
Clockwork 2000, PS1/Clocktower,
New York

1999 *Self Service*, 10,
Spring–Summer
'Free Coke', *New York Times*, 26
February 1999

Claudia & Julia **Müller**

Born 1964/1965
Live Basel

Rather than appropriating found family snapshots
and postcards for the sake of it, Claudia and Julia
Müller trace these images in drawings and video re-
enactments, extracting psycho-social layers of
meaning carried within them like a secret code.
Although the Basel-based sisters often bring out the
washed-out flatness in these quirky depictions of
people wearing masks or folk costumes, their work
has the intimacy of a whispered philosophical
conversation. It seems to flutter freely between cave
painting and urban graffiti, surreal wallpaper and
painted skin. Ultimately the ideal of the multi-ethnic,
multi-sexual, multi-biographical patchwork family
shines at the horizon of their work like a warming
sun. (JöH)

Represented by maccarone inc. H2

Selected Exhibitions

2004 Kunstmuseum, Thun

2003 'Espacio Uno', Reina Sofia,
Madrid

2002 maccarone inc., New York

2001 'New York/Berlin.
Künstlerateliers der
Eidgenossenschaft (New
York/Berlin. Artists' studios of the
Confederation)
Galerie Peter Kilchmann, Zurich

2000 'Clockwork 2000', PS1/
Clocktower, New York
'Prophecies', Swiss Institute, New
York

1999–2000 Kunsthalle, St. Gallen

1998 'Freie Sicht aufs Mittelmeer'
(Clear View on the Mediterranean),
Kunsthaus, Zurich, touring to Schirn
Kunsthalle, Frankfurt

1997 Kunsthalle, Basel

João 1
2003
C-type print
228×183cm
Courtesy Galeria Fortes Vilaça

Selected Bibliography

2002 'Vik Muniz', Wendy Watriss, *Blink, 100 Photographers, 010 Curators, 010 Writers*, Phaidon, London, New York

2001 'Vik Muniz/Ernesto Neto', Germano Celant, *Brasil in Venice*, ed Germano Celant, Brasil Connects Associação Brasil +500, São Paulo 'Vik Muniz Three Dimensional Pictures', Verônica Cordeiro, *Art Nexus*, 41 'Dust to Dust', Jean Dykstra, *Art on Paper*, March–April 'Sweeping Survey', Martha Schwendener, *Artforum*, January

Selected Exhibitions

2004 Irish Museum of Modern Art, Dublin Fundación Telefónica, Madrid

2003–4 Centro Galego de Arte Contemporanea, Santiago de Compostela

2003 Museo d'Arte Contemporánea, Rome Indianapolis Museum of Contemporary Art 'Pictures of Magazines', Paço Imperial do Rio de Janeiro 'Iron Men & Diamond Divas, Monadic Works and Photographs', Galeria Fortes Vilaça, São Paulo 'Strangely Familiar: Approaches to Scale in the Collection of the Museum of Modern Art', New York; New York State Museum, Albany 'Shape', 21st Century Museum of Contemporary Art, Kanasawa

Vik **Muniz**

Born 1961
Lives New York

Brazilian artist Vik Muniz specializes in an unusual kind of trompe l'oeil. He has made drawings from sugar, dust, thread and chocolate syrup, photographing his ephemeral creations for posterity. The resulting artworks are a visual tease – none more so than the public project for which Muniz covered the façade of the Brooklyn Academy of Music with photographs of edible treats, turning it into the world's largest gingerbread house. Lately Muniz has been dreaming big – shaping earth with tractors and even the atmosphere with skywriting. Such moves might appear gimmicky or grandiose, but Muniz' imaginative ambition has lasting presence. (KR)

Represented by Galeria Fortes Vilaça F9, Brent Sikkema G1

Cryptic Dweller
2001
Oil on linen
Courtesy China Art Objects
Galleries

Selected Bibliography

2003 'JP Munro', Tom Morton,
frieze, 74, April

2002 'JP Munro', David Rimanelli,
Interview, May
'The Armory Show, Grown up
and in Love With Color', Roberta
Smith, *New York Times*, 22 February
2002
'JP Munro at China Art Objects,
Los Angeles' Malik Gaines, *Artext*,
78 Fall
'Morbid Curiosity' Jan Tumlir,
ACME., Los Angeles

JP **Munro**

Born 1975
Lives Los Angeles

According to Tom Morton, writing in *frieze*, JP
Munro's painting *Ending is Better than Mending* (2002)
'looks like somewhere mythologies go to die'. Replete
with references to various gods from myriad cultures,
and to painters such as Gustave Moreau, Jacques-
Louis David and Eugène Delacroix, Munro's
paintings are equally in thrall to kitsch imagery, pre-
Modernism and loose brushwork. Writhing, high-
pitched landscapes populated with corpses, heroes
and references to Old Master paintings and famous
dead people, these are paintings not backward in
coming forward; hallucinogenic worlds that treat
history as a complicated carnival and painting as
a ghost train. (JH)

Represented by China Art Objects Galleries G6,
Sadie Coles HQ B8

Selected Exhibitions

2003 'Drop Out!', China Art
Objects Galleries, Los Angeles
'The Great Drawing Show',
Michael Kohn Gallery, Los Angeles
'Works for Giovanni', China Art
Objects Galleries, Los Angeles

2002 'Fair', Royal College of Art,
London
China Art Objects Galleries,
Los Angeles
Sadie Coles HQ, London

2001 'The Cult', China Art Objects
Galleries, Los Angeles
'Morbid Curiosity', ACME., Los
Angeles, touring to I-20 Gallery,
New York
'Psychobobble', Raucci/
Santamaria, Naples
China Art Objects, Los Angeles

2000 'New School', Works on
Paper, Los Angeles
'The Revolutionary Power of
Women's Laughter', China Art
Objects Galleries, Los Angeles

Untitled (We live in a twilight …)
2002
Acrylic on canvas
200×100cm
Courtesy Georg Kargl

WE LIVE IN A TWILIGHT OF CONSCIOUSNESS, NEVER IN ACCORD
WITH WHOM WE ARE OR THINK WE ARE.

Selected Bibliography

2002 *Art Now*, Adam Szymczyk, ed
Uta Grosenick and Burkhard
Riemschneider, Taschen, Cologne
'Muntean/Rosenblum at De
Appel', Priya Bhatnagar, *Flash Art*,
October
*Vitamin P: New Perspectives in
Painting*, ed Valérie Breuvart,
Phaidon, London

2000 'Muntean/Rosenblum',
Patricia Grzonka, *frieze*, 47

1995 'Muntean/Rosenblum', Julie
Canoglia, *Artforum*, Summer

Selected Exhibitions

2003 Maureen Paley Interim Art,
London
Kunstverein, Salzburg
'Billboards', Kunsthaus, Bregenz

2002 'To Die For', De Appel,
Amsterdam

2001 Georg Karl, Vienna
'Body Shop', Galerie Kidmat Eden,
Tel Aviv

2000 'Where Else?', Secession,
Vienna
'I Always Tell You the Truth Unless
of course I am Lying to You',
Kunsthaus, Glarus
Art Statements, Art Basel

1994 Steirischer Herbst,
Minoritengalerie, Graz

Muntean/Rosenblum

Born 1962/1962
Live London/Vienna

Based in Vienna, Muntean/Rosenblum make
paintings of global teens in Ballardian nowhere
places: bland, wooden-floored flats, hotel rooms and
nondescript parks. Cribbed from style magazines, the
adolescents are sulky and affectless, as though they're
restaging the existential angst of Albert Camus'
L'Etranger (1942) for a Calvin Klein campaign.
Muntean/Rosenblum's brushwork is as dry and
uneasy as faltering desire, while beneath the images
text appears – high-slacker axioms transformed into
hipster ad copy. Nevertheless, these paintings have
an odd emotional charge, speaking of the emptiness
of a world in which even our own disenchantment is
sold back to us as a fashion accessory. (TM)

Represented by Art:Concept G7, Georg Kargl E11,
Galleria Franco Noero G13, Maureen Paley Interim
Art C11, Sommer Contemporary Art C15

Lemon Swirl
2003
Oil on cotton
59×51cm
Courtesy Taka Ishii Gallery

Kyoko **Murase**

Born 1963
Lives Dusseldorf

Half immersed in water, the girls that Kyoko Murase's languid brushwork depicts appear serene and deep in peaceful meditation. In one painting a dappled, lemon coloration swirls from the lilac-toned water, encircling the dreaming figure's head. In another, the same lilac hues give way to darker purples that plunge deep into the liquid. The bodies of these half-submerged Ophelias appear in some places distorted by the water, while in other areas their peaceful countenances rise above the fluid surface, suggesting a liminal threshold between unconsciousness and consciousness. (DF)

Represented by Taka Ishii Gallery G9

Selected Bibliography

2003 *Girls Don't Cry*, Parco Museum, Tokyo

2002 *Fiction*, Museum of Contemporary Art, Tokyo

2001 *Standard*, Naoshima Contemporary Art Museum, Kagawa
Reinhard Ermen, *Kunstforum*

Selected Exhibitions

2003 'Girls Don't Cry', Parco Museum, Tokyo

2002 'Chasing Butterflies', Taka Ishii Gallery, Tokyo
'Fiction', Museum of Contemporary Art, Tokyo

2001 'Standard', Naoshima Contemporary Art Museum, Kagawa

1996 'The Future of Painting', Osaka Contemporary Art Centre

Vulture
2003
Two mannequins, fabric, black and
white photocopy, plinth
Dimensions variable
Courtesy Galleria Sonia Rosso

Selected Bibliography

2002 *Presence (New Work Scotland)*,
Fruitmarket Gallery, Edinburgh
Caroline Woodley *October* ed Karla
Black and Katie Exley, Glasgow
Project Space, Rob Tufnell, Breeder
Projects, Athens
Untitled (Bottle Project)?, with
Dundee Contemporary Arts
Royston Library Residency?,
The Centre, Glasgow

Selected Exhibitions

2003 Jack Hanley Gallery,
San Francisco, (forthcoming)
Galleria Sonia Rosso, Turin
Galerie Fons Welters; (Play
Station), Amsterdam
'Someone to share my life With',
The Approach, London
'The Fragile Underground',
Bart Wells Institute, London

2002 'What Will Become Of Us
(with Fred Pedersen)', Tramway,
Glasgow
'There is a Light that Never Goes
out', Galleria Sonia Rosso, Turin
'Presence (New Work Scotland)',
Fruitmarket Gallery, Edinburgh
Project Space at Breeder Projects,
Athens

2001 The Modern Institute,
Glasgow

Scott **Myles**

Born 1975
Livs Glasgow

Scott Myles' art involves the public and his friends in
gift exchanges that operate at an almost subliminal
level. He has treated large chains of newsagents as
libraries, 'borrowing' magazines and returning them
at other branches, their pages concealing a flyer
informing the buyer of what has occurred; he has
infiltrated corporate culture by paying individuals
to join cigarette breaks outside offices, and made
bronze desk paperweights from casts of melted ice
cream; given a pair of trainers by friends, he lined
the box with gold leaf and sent it back to them.
The product of an era uncertain of art's social
efficacy, Myles proposes a hopeful chaos theory:
one in which the tiniest positive gesture may have
broader repercussions. (MH)

Represented by The Modern Institute G8,
Galleria Sonia Rosso C2

Die Ohnmacht der Natur: Music of Changes
2000
Acrylic on canvas
100×100cm
Courtesy Klosterfelde

Nader

Born 1964
Lives Berlin

What does the spirit of philosophy look like? In his paintings Nader attempts to answer this unanswerable question. He does so with a surreal humour that de Chirico would have loved. In his works thinkers and belief systems are staged as mechanichal dolls on the stage of a universal world theatre. Twisted limbs are mixed with dysfunctional-looking bits of ancient machinery. Strangely enough, these automata seem to work – they communicate and interact. The pictures thus capture the strange fascination of the great idealist philosophies of the 19th century: over-complicated and megalomaniac in their attempt to explain the principles governing the world, they reinvent that world as the self-contained mechanical ballet depicted in Nader's paintings. (JV)

Represented by aspreyjacques D14, Klosterfelde B9

Selected Bibliography

2003 *Nader Ahriman*, Kunstverein, Freiburg

2002 *Pertaining to Painting*, Contemporary Arts Museum, Houston

2001 *Painting at the Edge of the World*, Douglas Fogle, Walker Art Center, Mineapolis

1999 'Nader at The Project', Max Henry, *Art in America*, 63, July

1998 'Mechanical Thinking' Daniel Birnbaum, *frieze*, 38, January– February

Selected Exhibitions

2003 Kunstverein, Freiburg
The Project, Los Angeles

2002 'The Void between Saturn and the Fixed Stars', aspreyjacques, London

'Pertaining to Painting', Contemporary Arts Museum, Houston and Austin Museum of Art

2001 'Painting at the Edge of the World', Walker Art Center, Minneapolis
'E il naufragar m'e dolce in questo mare', The Project, New York

1999 'Equilibrium, intensity and mental geometry of the philosopher S', Helga Maria Klosterfelde, Hamburg
'Examining Pictures: Exhibiting Paintings', Whitechapel Art Gallery, London; Museum of Contemporary Art, Chicago; UCLA Hammer Museum of Art, Los Angeles

1998 'Warming', The Project, New York
'Revolution des Viaducte', Klosterfelde, Berlin

In the White Room
2003
Crayon on paper
72×51.5cm
Courtesy Stephen Friedman Gallery

Selected Bibliography

2002 *Who Snatched the Babies?*
Yoshitomo Nara, Centre National
de l'estampe et de l'art imprimé,
Chatou

2001 *Nobody knows, Yoshitomo Nara
drawings*, Little more, Tokyo
Lullaby Supermarket, Yoshitomo
Nara, Verlag für oderne Kunst,
Nuremberg
I Don't Mind if You Forget Me,
Yoshitomo Nara, Tankosha
Publishing, Kyoto

1999 *Ukiyo*, Yoshitomo Nara,
Little more, Tokyo

Selected Exhibitions

2003 'Yoshitomo Nara', Museum
of Contemporary Art, Cleveland
and touring
'Splat, Boom, Pow! The Influence
of comics in Contemporary Art',
Contemporary Arts Museum,
Houston

2002 'Drawing Now: Eight
Propositions', Museum of Modern
Art at Queens, New York
Centre National de l'estampe et de
l'arte imprimé, Chatou

2001 'Yoshitomo Nara: in those
days', Hakutosha, Nagoya
'I Don't Mind if You Forget Me',
Yokohama Museum of Art and
touring
'Painting at the Edge of the World',
Walker Art Center, Minneapolis

2000 'Walk On', Museum of
Contemporary Art Chicago
'Lullaby Supermarket', Santa
Monica Museum of Art
'Super Flat', Parco Gallery, Tokyo,
touring to Nagoya and other cities
in Japan and MOCA Gallery at
the Pacific Design Center, West
Hollywood; Walker Art Center,
Minneapolis

Yoshitomo **Nara**

Born 1959
Lives Tokyo

What's going on in those lopsided, engorged heads?
The menacingly grumpy children in Yoshitomo
Nara's paintings and drawings stare up at us with
suspicious eyes. They've been through a lot, these
kids, or so it seems. They know something very un-
childlike. Sometimes they're bandaged or clutch
small weapons in self-defence. If it feels like you've
seen them before, that's because you have, even if
you haven't – they are assembled, Frankenstein-
style, out of free-floating, mass-mediated images of
childhood gone bad. Nara's cartoonish imagery taps
into that shadow doppelgänger of sweetness, always
lingering somewhere off to the side. (SS)

Represented by Blum & Poe D9, Stephen Friedman
Gallery E6, Tomio Koyama Gallery C5

Ernesto **Neto**

Born 1964
Lives Rio de Janiero

If Ernesto Neto could redesign the cosmos to his liking, it would have no nasty hard edges, no grim right angles. The Brazilian artist's soft biomorphic sculptural environments hark back to a more optimistic moment during the late 1960s, when beanbag furniture, inflatable shelters and bold squishy supergraphics promised a dawning utopia by design. Neto's sprawling crash-pad installations, defined by droopy, glottal networks of polyester stretch fabric filled with polystyrene pellets, suck viewers into a tactile romper room alternative to mere 'viewing'. Like his Brazilian Neo-Concrete forebears Lygia Clark and Hélio Oiticica, Neto wants his audience to stop analysing from a safe distance and start participating up close, considering the body and all its senses as being fundamental to a fuller experience of art. (JT)

Represented by Tanya Bonakdar Gallery E7, Galeria Fortes Vilaça F9, Galerie Yvon Lambert D16

Construção Orgânica com Propriedaldes Morfológicas de Relacionamento, A Feto Gravitacional. Oba!
2003
1535×150cm
Courtesy Galeria Fortes Vilaça and Tanya Bonakdar Gallery

Selected Bibliography

2003 'Lo sensorial y la temporalidad "Mis trabajos son lugares de sensación"' (The sensorial and temporality 'My works are places of sensations'), Lisbeth Rebollo Gonçalves, *Art Nexus*, April–June

2002 'inuteroquanticum-sacanagem', Richard Lydier, *Art Press*, 276, February
Towards Identifying Shape; Form as it Undergoes Transformation, Echizen Toshiya, Shape 21st Century Museum of Contemporary Art, Kanasawa
Miguel Cid Fernandéz, Adriano Pedrosa, Cecília Pereira & Ernesto Neto, in *Ernesto Neto, o corpo nu tempo*, Centro Galego de Arte Contemporânea, Santiago de Compostela
'Genealogy of Life', Andréas Jurgensen, *Ernesto Neto: Genealogy of Life*, Württembergisher Kunstverein, Stuttgart

Selected Exhibitions

2003 MOCA, Los Angeles
'Happiness: a survival guide for art and life', New Museum of Contemporary Art, Tokyo
'From Dust to Dusk – art between light and dirt', Charlottenborg Exhibition Hall, Copenhagen
Fabric Workshop and Museum, Philadelphia
Museu de Arte Moderna Aloísio Magalhães, Recife

2002 Hirshhorn Museum and Sculpture Garden, Washington DC
Kunsthalle, Basel
Art Gallery of New South Wales, Sydney
Württembergischer Kunstverein, Stuttgart

2001 Brazilian Pavilion, Venice Biennale

Who Has Turned Us Around Like This?
2002
Glass, water, resin, plastic,
enamel paint, salt
Approx 170×125×50cm
Courtesy Galerie Barbara Thumm

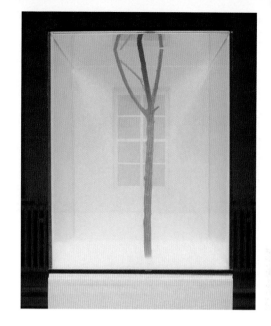

Selected Bibliography

2003 *Mariele Neudecker: Between Us*,
Chapter and Howard Gardens
Gallery, Cardiff
micro/macro – British Art 1996–2002,
The British Council and
Mücsarnok/Kunsthalle, Budapest

2002 'The Ironic Sublime –
A profile of Mariele Neudecker',
Bernard van Lierop, *Planet*, 156,
December–January

2001 *Mariele Neudecker – Until Now*,
Juliana Engberg, Künstlerhaus
Bethanien and Galerie Barbara
Thumm, Berlin

1999 *Mariele Neudecker*, Eszter
Barbarczy, Maite Lorés and Francis
McKee, First Site at the Minories,
Colchester

Selected Exhibitions

2004 Galerie Barbara Thumm,
Berlin
'Into My World', Aldrich
Contemporary Art Museum,
Ridgefield

2003 'Liquid Sea', Museum of
Contemporary Art, Sydney
'Berlin-Moskau, Moskau-Berlin
1950-2000', Martin-Gropius-Bau,
Berlin and State Tretyakov Gallery,
Moscow

2002–3 'Between Us', Chapter Art
Centre and Howard Gardens
Gallery, Cardiff and touring

2001 Yokohama International
Triennale of Contemporary Art
'Locus Focus', Sonsbeek, Arnhem
'At Sea', Tate Liverpool

2000–1 'Mariele Neudecker: Until
Now', Ikon Gallery, Birmingham;
Galerie Barbara Thumm, Berlin
and Künstlerhaus Bethanien,
Berlin; First Site at the Minories,
Colchester

1999 Melbourne Biennale

Mariele **Neudecker**

Born 1965
Lives Bristol

The Romantic experience of Sublime nature is
both a real possibility and a cultural stereotype.
Mariele Neudecker's works thrive on this
ambivalence. Her large scale models of Romantic
landscapes encased in glass tanks simulate deep
woods or jagged mountain ranges, often shrouded
in numinous mist or illuminated by celestial light.
Although they are displayed like artefacts, the
landscapes seem alive with the promise of spiritual
experience. For her film *Another Day* (2000)
Neudecker co-ordinated teams on opposite sides
of the globe to record a sunset and sunrise
simultaneously – an experiment as scientifically
sober as it is magical. As commodified as it has
become, the seductive power of Romanticism
remains irresistible. (JV)

Represented by Galerie Barbara Thumm A4

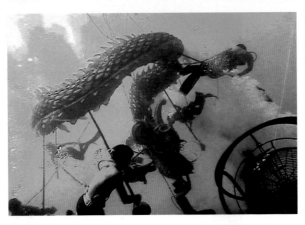

Selected Bibliography

2003 *The Moderns*, Castello di
Rivoli, Museo d'Arte
Contemporanea, Turin

2002 'Asian Art Now', Jane Farver,
Art Asia Pacific, 37
'Crosscurrents in Yokohama',
Christopher Phillips, *Art in America*,
January

2001 'Best of 2001',
Daniel Birnbaum, *Artforum*,
December
'Speaking in Tongues', Gioni
Massimililano, *Flash Art*,
November–December

Selected Exhibitions

2003 'Matrix program 2003:
Memorial Project Vietnam',
Berkeley Art Museum, University of
California and touring
'Moderns',Castello di Rivoli,
Museo d'Arte Contemporanea,
Turin
Venice Biennale
'Poetic Justice', Istanbul Biennale

2002 '(The World May Be)
Fantastic', Sydney Biennial
Saõ Paulo Biennale
'Memorial Project Minamata:
Neither Either nor Neither –
A Love Story', Mizuma Art
Gallery, Tokyo
'Towards the Complex (video
screening)', De Appel, Amsterdam

2001 'Mega Wave – Toward
a New Synthesis', International
Triennale of Contemporary Art,
Yokohama

2000 'Xich Lo 2001 – The Making
of Alternative History', Mizuma
Art Gallery, Tokyo

Jun **Nguyen-Hatsushiba**

Born 1968
Lives Ho Chi Minh City

Growing up in Japan, the United States and
Vietnam, Jun Nguyen-Hatsushiba learned a thing
or two about existing in states of in-betweenness.
Now living in Ho Chi Minh City, his dreamlike
videos touch on issues of confused cultural identity.
His best-known work, *Memorial Project Nha Trang,
Vietnam: Toward the Complex – For the Courageous, the
Curious, and the Cowards* (2001), was shot beneath the
Indo-China Sea and features underwater cyclos
endlessly peddling (hand-drawn taxis at one time
ubiquitous in Vietnamese cities) whose real-life
disenfranchised drivers must hold their breaths and
hope for the best. (JT)

Represented by Mizuma Art Gallery C13

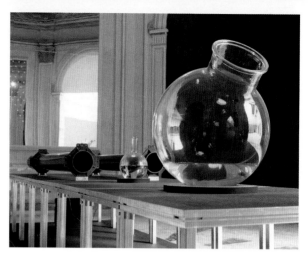

Frozen Water
2001
Installation view, Venice Biennale
1 glass flask (150cm), 2 glass flasks
(40cm), 2 Bose Subwoofer Accoustic
Wave Canons (each: 102×54cm), 2
Bose Awes II Barrel Accoustic Wave
Canons (each: 292×54cm), 2 Bose
amplifiers, 2 Bose controllers,
Doepfer sound modular system,
mixer, distilled water, platform,
various cables
Dimensions variable
Courtesy Galerie EIGEN + ART

Selected Bibliography/ Discography

2002 alva noto, *transrapid ep*, raster-noton
alva noto + ryuichi sakamoto, *vrioon*, raster-noton
noto.autorec. (autopilot), raster-noton
2001 *cyclo.* (ryoji ikeda + noto), raster-noton
1999 *noto.time.dot, 20' to 2000 September* (twelve releases about the cutting edge of the millennium), raster-noton

Selected Exhibitions

2003 Venice Biennale

2002 'Parallel lines cross at infinity' Watari-Um, Watari Museum of Contemporary Art, Tokyo
'Frequenzen (hz)', Schirn Kunsthalle, Frankfurt

2001 Venice Biennale
Milch, London

1999 'Examining Pictures: Exhibiting Paintings', Whitechapel Art Gallery, London; Museum of Contemporary Art, Chicago; UCLA Hammer Museum of Art, Los Angeles
Liverpool Biennial

1997 Documenta, Kassel

Carsten **Nicolai**

Born 1965
Lives Berlin/Chemnitz

How do you picture sound? Album covers and music videos have established their own associative logic to match music and image. Carsten Nicolai, however, goes for the principles of raw physics to find logical links between the visual and the audible. Nicolai (who also runs the record label raster-noton and produces minimal techno and musique concrète) creates experimental set-ups in which, for example, the vibrations of bass frequencies generate structures on the surface of water inside glass flasks – or little steel balls bounce up and down on the pulsating membrane of a loudspeaker and create complex chance compositions. With his stripped-down aesthetics Nicolai thus visualizes the no-nonsense spirit of purist electronic music where the bass shakes the body but the mind stays clear. (JV)

Represented by Galerie EIGEN + ART F12

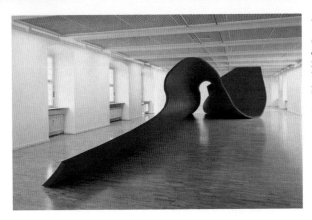

Die Flamme der Revolution, liegend (in Wolfsburg)
(The Flame of Revolution, lying down (in Wolfsburg))
2002
Wood, steel, cement cast, special paint
1440×1700×610cm
Courtesy Galerie EIGEN + ART

Selected Bibliography

2003 *Rewind Forward*, Olaf Nicolai and Suzanne Pfleger, Hatje Cantz, Ostfildern-Ruit

2002 *Reader*, Olaf Nicolai and Jan Wenzel, Spector

2002 'House Style', Holger Liebs, *frieze*,64, January–February

2001 'Olaf Nicolai', Harald Fricke, *Artforum*, Summer
'Bedürfnis nach Bedürfnis?' (Need for Need?), Raimar Stange, *Kunstbulletin*, April

Selected Exhibitions

2003 Award of the town of Wolfsburg, Städtische Galerie Wolfsburg

2002 '(The World May Be) Fantastic', Sydney Biennial
'P_A_U_S_E' (Break), Gwangju Biennale, Korea

2001 'Enjoy Survive Enjoy', Migros Museum für Gegenwartskunst Zurich
Venice Biennale
'Loch Lomond', project for the Scottish National Park
'Casino 2001', SMAK, Ghent

2000 'Pantone Wall, instrumented and odds and ends (Editions 1994–2000)', Kunstverein, Bonn

1999 'Labyrinth', Galerie für Zeitgenössische Kunst, Leipzig

1998 Berlin Biennale

1997 Documenta, Kasel

Olaf **Nicolai**

Born 1962
Lives Berlin

For Olaf Nicolai good taste is an essential. His books, posters, wallpaper designs, paintings and sculptures not only constitute a design for life; they also explore the wider ramifications of designer living. At the heart of the world of Prada suits, tasteful minimal techno, Niemeyer houses and Apple Macs that Nicolai explicitly references there lies an implicit critique of the way in which art and culture have been accessorized and reduced to mere options in a range of lifestyle choices. In his own words, 'questions about form, atmospheres, attitudes, and style are not a luxurious game with surfaces. They are questions about how we organize our actions.' (DF)

Reprsented by Galerie EIGEN + ART F12

POG-33-02
2002
Oil on canvas
290×350cm
Courtesy Galerie Gebr. Lehmann

Selected Bibliography

2003 'Ainsi peignait Nitsche', Olivier Cena, *Télérama*, 1–7 February 2003

2002 'Frank Nitsche – Winterorbit', Alexi Worth, *Artforum*, May
'Frank Nitsche', Malissa Kuntz, *Art in America*, July
Standards, Frank Nitsche, Leo Koenig,Inc, New York

2000 *Goldener, der Springer, das kalte Herz*, Anna Moszynska, White Cube, London

Selected Exhibitions

2003 'Construction Time Again', Galerie Gebr. Lehmann, Dresden
'Nanorobs', Galerie Nathalie Obadia, Paris
'deutschemalereizweitausenddrei', (German painting 2003) Kunstverein, Frankfurt
'New Abstract Painting', Museum Morsbroich, Leverkusen

2002 'Winterorbit', Leo Koenig, Inc, New York
Galerie Max Hetzler, Berlin

2001 'J.F.B. – Hobby Industries' (with E. Havekost), Galerie Onrust, Amsterdam
'Musterkarte – modelos de pintura', Centro Cultural Conde Duque, Madrid

2000 'Goldener, der Springer, das kalte Herz', White Cube, London

1999 'Sauerstoff' (Oxygen), Galerie Gebr. Lehmann, Dresden

Frank **Nitsche**

Born 1968
Lives Berlin

Berlin-based Frank Nitsche first came to recognition along with fellow Dresden painters Thomas Scheibitz and Eberhard Havekost, and like them, he owes more to Hermann Glöckner (1889–1987), a great dissident figure of painterly abstraction in the former East Germany, than to any brand of West German neo-figuration, let alone Socialist Realism. Based on technological and organic structures carefully picked out from print media, Nitsche paints steeping forms and icily pastel colours entangled in an elegant headlock. While reminiscent of cells or crystals growing in a Petri dish, his works are nevertheless clearly rooted in the ongoing painterly discourse of composition. (JöH)

Represented by Galerie Gebr. Lehmann C18, Galerie Nathalie Obadia F2, White Cube F6

Acumulus Noblitatus
2000–01
Pencil on paper
390×550cm
Courtesy Maureen Paley Interim Art

Selected Bibliography

2002 *Drawing Now: Eight Propositions*, Museum of Modern at Queens Art, New York

2000 *Nobson Central*, Verlag der Buchhandlung Walther König, Cologne

1998 *Introduction to Nobson Newtown*, Salon Verlag, Cologne

1996 *Semikolon*, Portikus, Frankfurt

1995 *Doley*, published by Paul Noble

Selected Exhibitions

2003 Albright Knox Art Gallery, Buffalo
'Drawing Contemporary Life', Vancouver Art Gallery
'Living inside the Grid', New Museum of Contemporary Art, New York
'Days Like These, Tate Triennial of Contemporary British Art', Tate Britain, London

2002 'Drawing Now: Eight Propositions', Museum of Modern Art at Queens, New York
'(The World May Be) Fantastic', Sydney Biennial

2001 Maureen Paley Interim Art, London
Musée d'Art Moderne et Contemporain, Geneva, Switzerland

1998 'Nobson', Chisenhale Gallery, London

1995 'Ye Olde Worke', Cubitt Gallery, London

1990 City Racing, London

Paul **Noble**

Born 1963
Lives London

Paul Noble's vast pencil drawings of the fictional 'Nobson Newtown' take postwar urban planning as their starting-point. Each building in Noble's settlement (the public toilets, the private residences, the 'Nobslum') is constructed from stone-hewn letters that spell out the structure's name, creating a rotting, Corbusian alphabet city. This is architecture as malapropism, as a rusty hinge between the word and the world – Nobson's job centre, after all, is a temple to unemployment. Often misunderstood as a straightforward dystopia, Noble's teeming fantasy is rather an intelligent, funny and oddly moving attempt to push the viewer back into the real, politicized world of poverty, shameful public housing and blasted hopes. (TM)

Represented by Maureen Paley Interim Art C11

Real Life is Rubbish
2002
Tools, wood, projector
Dimension variable
Courtesy Modern Art

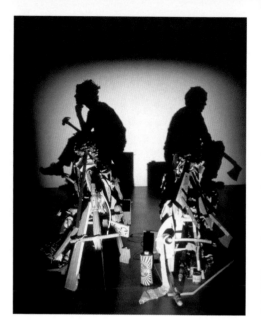

Selected Bibliography

2002 *The Fourth Sex:Adolescent Extremes*, Stazione Leopolda, Florence

2001 *Form Follows Fiction*, Castello di Rivoli, Museo d'Arte Contemporanea, Turin
Instant Gratification, Gagosian Gallery, Los Angeles

2000 *Apocalypse: Beauty and Horror in Contemporary Art*', Royal Academy, London

1998 *The New Barbarians*, Modern Art, London

Selected Exhibitions

2003 PS1/MOMA, New York

2002 'Ghastly Arrangements', Milton Keynes Gallery
'The Fourth Sex: Adolescent Extremes', Stazione Leopolda, Florence

2001 'Instant Gratification', Gagosian Gallery, Los Angeles
'Form Follows Fiction', Castello di Rivoli, Museo d'Arte Contemporanea, Turin
'Casino 2001', SMAK, Ghent

2000 'Masters of the Universe', The DESTE Foundation, Dakis Joannou Collection, Athens
'British Wildlife', Modern Art, London
'I Love You', Deitch Projects, New York
'Apocalypse: Beauty and Horror in Contemporary Art', Royal Academy of Arts, London

1999 'The New Barbarians', Chisenhale Gallery, London

Tim **Noble** & Sue **Webster**

Born 1966/1967
Live London

Lurid yet surprisingly delicate, the earlier work of Tim Noble and Sue Webster parodied the conflation of ambition and faux street-smart that Pop mythology attributed to the 1990s 'yBas'. Here punky collages squatted next to impoverished paintings, while the resin model *The New Barbarians* (1997–9) depicted the artists as cautious, naked primates, slouching towards a troubling dawn. More recently Noble and Webster have been concerned with accessing a sort of capitalist romanticism, creating silhouette self-portraits by projecting light on to carefully arranged piles of rubbish, taxidermy specimens, dildos and dollars. Along with the artists' end-of-the-pier neon signs, these pieces point to a sensibility that's half in love with the status quo and plotting its escape. (TM)

Represented by Gagosian Gallery F7, Modern Art A1

Tam **Ochiai**

Born 1967
Lives New York

Tam Ochiai's paintings and installations explore, in semi-absurd fashion, the diverse origins of Japanese youth culture. Rife with such seemingly incongruous motifs as waifish Godard heroines, macho American guitar solos, and classic Colour Field painting, Ochiai's work blurs the lines between the consumer, the connoisseur and the obsessive fan. He often paints, in a light, feminine hand, over shopping bags from chic stores – adding free-associative texts that echo the lyrics of Japanese Pop–Punk girl bands. Often grouped with Takashi Murakami and Yoshitomo Nara, Ochiai is closer to a painter like Hiroshi Sugito in his unselfconscious embrace of Western styles and subjects. (KR)

Represented by galleria francesca kaufmann H3, Tomio Koyama Gallery C5

Selected Bibliography

2001 'New Openings in Japanese Painting: Three Faces of Minority', Midori Matsui, *Painting at the Edge of the World*, Walker Art Center, Minneapolis
'Tam Ochiai', Giovannotti Micaela, *Tema Celeste*, 83, January–February

1998 'Tam Ochiai', Charles Dee Mitchell, *Art in America*, March

Selected Exhibitions

2002 Arndt and Partner, Berlin
Team Gallery, New York
'Fiction? Painting in the Age of the Virtual', Museum of Contemporary Art, Tokyo

2001 'Installation No. 8', Dorothee De Pauw Gallery, Brussels
'The Place of Happiness', Watari-um, Tokyo
'E/Motion Studies', Queens Museum of Art, New York

2000 galleria francesca kaufmann, Milan
Team Gallery, New York
'Dark Mirrors of Japan', De Appel, Amsterdam
Pat Hearn Gallery, New York

1999 'Madeleine', Tomio Koyama Gallery, Tokyo

Axis Horizon of Emerging Consensus
2002
Ink and gouache on paper
58.5×48cm
Courtesy Jack Hanley Gallery

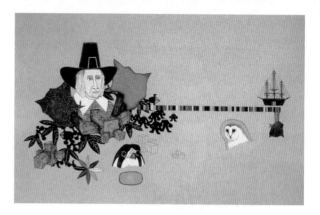

Shaun **O'Dell**

Selected Bibliography

2003 Peter Frank, *Art on Paper*,
April

2002 Glen Helfand, *Modern Painters*,
Autumn

Selected Exhibitions

2003 'Mark', Gallery 16,
San Francisco
'International Paper', UCLA
Hammer Museum of Art, Los
Angeles
Vox Populi, Philadelphia

2002 'Bay Area Now', Yerba
Buena Center for the Arts, San
Francisco
'When Will I Ever Be Simple Again',
Jack Hanley Gallery, San Francisco
'Fast Forward II', Berkeley Art
Museum, University of California
'Marked, Bay Area Drawing' at
Hunter College, New York
'Errand Projections from Pilgrim
Glacier', Southern Exposure
Gallery, San Francisco

Born 1968
Lives San Francisco

Shaun O'Dell often ponders the human and natural
heritage of northern California and, like the work
of fellow 'Mission School' artists Barry McGee and
Margaret Kilgallen, his ink and gouache drawings
wouldn't look amiss blown up as murals on San
Francisco's streets. His works on paper combine
natural elements – eucalyptus trees, sea creatures,
Audubon-ish bird illustrations – with historical
references such as sailing ships, uncomfortable-
looking pilgrim hats and puzzling log constructions
in what he likens to 'root systems' of visual and
cultural association. While reflecting his
ambivalence about living in an urban area that
increasingly imperils the wild character of the
California coast, his drawings are too weird and
ambiguous to be dismissed as 'eco-art'. (JT)

Represented by Jack Hanley Gallery G4

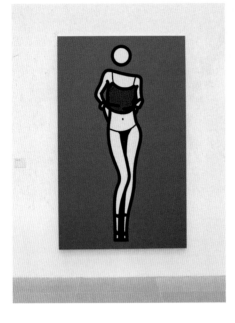

Julian **Opie**

Born 1958
Lives London

Effortlessly modern, Julian Opie's art reduces reality to sign systems by translating complex forms – people, architecture, vehicles – into etiolated outlines and unmodulated blocks of colour. From his early 1990s paintings of motorway landscapes based on the featureless aesthetic of driving-simulation computer games to the aluminium cut-outs of schematic figures he made almost a decade later, Opie's work has invariably exaggerated and airbrushed aspects of contemporary life: the smoothness of travel, the reduction of people to types. And while he's increasingly been in demand for commissions for window displays for department stores and theatres, billboards for the Grands Prix, murals for Tate Britain and album covers for Blur, his work invariably walks a fine Warholian line between celebration and critique.(MH)

Represented by Lisson Gallery B4, Galerie Barbara Thumm A4

Selected Bibliography

2003 *Julian Opie Portraits*, Daniel Kurjakovic Codax Publisher, Zurich

2002 *Julian Opie,Wallpaper*, Julian Opie, Thomas Trummer, Zentrum für Zeitgenössische Kunst der Österreichischen; Galerie Belvedere, Vienna

2000 *Julian Opie*, Jonathan Watkins, Ikon Gallery, Birmingham

1997 *Julian Opie*, Indian Triennale, New Delhi, foreword by Andrea Rose, British Council

1994 *Julian Opie*, Wulf Herzogenrath, Ulrich Look, James Roberts, Lynne Cooke, Michael Newman, Hayward Gallery, London

Selected Exhibitions

2003 'Einladung Julian Opie', Neues Museum, Nuremberg,

2001 Ikon Gallery, Birmingham
Lisson Gallery, London

2000 Abbaye Saint-André, Centre d'Art Contemporain, Meymac

1999 'Outdoor Portrait Gallery', Tate Britain, John Islip Street, London
Städtische Galerie im Lenbachhaus, Munich

1996 CCC, Tours

1994 Hayward Gallery, London and Kunstverein, Hanover

1992 Secession, Vienna

1991 Kunsthalle, Bern

Total Perception
2002
Fuji crystal chromogenic archive
c-type print mounted on Sintra
board
86×119cm
Courtesy Marian Goodman Gallery

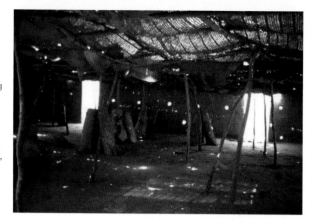

Selected Bibliography

2003 *Trabajo* (Work), Molly Nesbit,
Angeline Scherf, Jean-Pierre Criqui,
Galerie Chantal Crousel, Paris,
Walther König, Cologne

2000 *Gabriel Orozco*, Alma Ruiz et
al, Museum of Contemporary Art,
Los Angeles

1996 *Gabriel Orozco*, Kunsthalle,
Zurich; ICA, London; DAAD,
Berlin

1995 *Gabriel Orozco, Triunfo de la
libertad No. 18, Tlalpan, C.P. 14000*,
ed Hans-Ulrich Obrist, Oktagon
Verlag, Stuttgart
Migrateurs, ARC, Musée d'Art
Moderne de la Ville de Paris

Selected Exhibitions

2003 Marian Goodman Gallery,
New York

2002 'Gabriel Orozco', Galerie
Chantal Crousel, Paris
Documenta, Kassel
'Sonic Process', MACBA,
Barcelona and Centre Georges,
Pompidou, Paris

2000 'Gabriel Orozco', Museum of
Contemporary Art, Los Angeles
and touring
'Blue Memory', Shigemori
Residence, Kyoto

1999 'Gabriel Orozco –
Photogravity', Philadelphia
Museum of Art

1998 'Clinton is Innocent', Musée
d'Art Moderne de la Ville de Paris

1997 'Recordings and Drawings',
Stedelijk Museum, Amsterdam

1995 'Migrateurs', Musée d'Art
Moderne de la Ville de Paris

1994 'Gabriel Orozco', Museum of
Contemporary Art, Chicago

1993 'Gabriel Orozco', Galerie
Crousel-Robelin, Paris

Gabriel **Orozco**

Born 1962
Lives New York/Mexico/Paris

Gabriel Orozco's chameleon-like work might best be
thought of as a series of elegant gestures. 'Gesture' is
an often overused word in art writing, but it is also a
tricky, almost oxymoronic concept: it can signify
either an offhand, high-concept riff or an intimate
inscription of the body. Orozco manages to activate
both meanings, creating art that engages intellectual
concerns while remaining always tethered to the real
and the personal. In essence, his project is to poeticize
the overlooked. The results can take the form of a
garland of lint from a tumble dryer, a single floating
soap bubble, oranges on window-sills or a lily pond
in the middle of a ping-pong table – small, potent
interventions that remind us of the endless novelty of
the world. (SS)

Represented by Galerie Chantal Crousel C17,
Marian Goodman Gallery C8, kurimanzutto B2

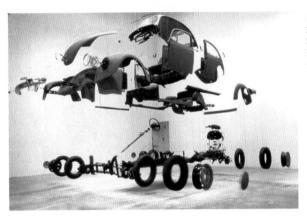

Cosmic Thing
2002
Sculpture/installation
Dimensions variable
Courtesy kurimanzutto

Damian **Ortega**

Born 1967
Lives Mexico City

Damian Ortega works in the grand tradition of political satire. His sculptures play with pre-conceptions about his native Mexico and Latin America's socio-economic relationship to the rest of the world. Subtly referencing the strategies of Arte Povera, works such as *Cosmic Thing* (2002) – a VW Beetle with its component parts suspended mid-air like an exploded diagram – speak of that car's place within Mexican culture, and by extension the economic pragmatism of a poverty-stricken country. The South America-shaped urinal of *America Latrina*, on the other hand, is a more pointed barb that directly addresses the continent's political status and treatment by more economically powerful countries. Ortega's work is imbued with the immediacy of the satirical cartoon, and provides a biting commentary for a politically volatile age. (DF)

Represented by kurimanzutto B2

Selected Bibliography

2003 'Kate Bush on Damian Ortega', *Artforum*, January

2002 'Damian Ortega, D'Amelio Terras New York', Michael Wilson *frieze*, 67, May
'Look Back in Anger', Massimiliano Gloni, *Flash Art*, May–June 2002
'Damian Ortega', Holland Cotter, *New York Times*, 22 March 2002

Selected Exhibitions

2003 'Il quotidiano alterato', Venice Biennale

2002 'Damian Ortega', Institute of Contemporary Art, Philadelphia
'Damian Ortega', D'Amelio Terras Gallery, New York
'The Air is Blue', Casa Barragán, Mexico City
'Arte All Arte', Arte Continua, Italy
Gwanju Biennale

2001 'Alguem Me soletra', Artist in Residence, Museu Serralves
'Animation', PS1, New York
'Ars 2001', Kiasma Museum of Contemporary Art, Helsinki

Untitled
2002
Acrylic and oil on canvas
137×122cm
Courtesy ACME.

Selected Bibliography

2003 *Laura Owens*, Paul Schimmel, The Museum of Contemporary Art, Los Angeles

2001 *Laura Owens*, Anne Hawley, Jennifer Gross, Russell Ferguson, Isabella Stuart Gardner Museum, Boston

2000 *New Work by Laura Owens (1999–2000) & John Hutton Balfow's Botanical Teaching Diagrams (1840–1879)*, Susan Morgan, Harry Noltie, Inverleith House, Royal Botanic Gardens, Edinburgh

Selected Exhibitions

2003 Museum of Contemporary Art, Los Angeles

2002 'Drawing Now: Eight Propositions', Museum of Modern Art at Queens, New York
'Painting on the Move', Kunstmuseum, Museum für Gegenwartskunst and Kunsthalle, Basel

2001 Isabella Stuart Gardner Museum, Boston
'Public Offerings', Museum of Contemporary Art, Los Angeles
'Painting at the Edge of the World', Walker Art Center, Minneapolis, Minnesota

2000 Inverleith House, Royal Botanic Gardens Edinburgh

1999 'Carnegie International', Carnegie Museum of Art, Pittsburgh
'Examining Pictures: Exhibiting Paintings', Whitechapel Art Gallery, London; Museum of Contemporary Art, Chicago; UCLA Hammer Museum of Art, Los Angeles
'Nach-Bild', Kunsthalle, Basel

1998 'Young Americans 2', Saatchi Gallery, London

Laura **Owens**

Born 1970
Lives Los Angeles

Laura Owens' paintings usually comprise colourful swathes of emptiness interrupted by startled renderings of animals, trees and flowers. Recently she seems particularly fond of bats, monkeys, bears and birds. These are playful, often unashamedly decorative paintings that revel in the pleasure of their execution. Their exuberant subject matter never belies the fact that Owens is exploring, with great inventiveness and humour, the possibilities of what paint can do. According to Benjamin Weissman, writing in *frieze*, Owens is at times 'looking over the shoulder of Joan Miró […] and at other times she's affectionately reconsidering Henri Rousseau's horse and rider or Helen Frankenthaler's washy world […] though Lewis Carroll is probably the writer most closely akin to her'. (JH)

Represented by ACME. C16, Galerie Gisela Capitain D11, Sadie Coles HQ B8, GBE (Modern) D5

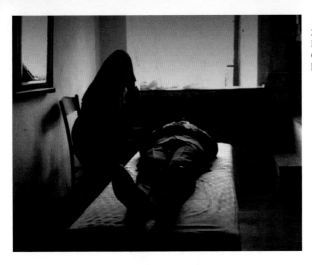

Vajtojca
2002
Film on DVD
Courtesy galleria francesca
kaufmann

Adrian **Paci**

Born 1969
Lives Milan

The proverb 'Home is where the heart is' is possibly one that Adrian Paci understands all too well. Originally from Albania, he and his family fled their homeland for Milan in the mid-1990s, and his videos and photographs are shaped by his experiences as an exile trying to assert his personal and artistic identity in a new country. In the video *Believe Me, I'm an Artist* (2000), Paci is seen attempting to convince Italian police that photographs of his daughter's bare shoulders are not pornographic images but in fact artworks. For the recent installation *Piktor* (2002) he persuaded a famous Albanian painter to forge his death certificate – both a bureaucratic assertion of status and a symbolic gesture articulating an extreme sense of loss in moving from his homeland. (DF)

Represented by galleria francesca kaufmann H3

Selected Bibliography

2003 'Adrian Paci', Francesca Pasini, *Artforum*, May
Piktori, Angela Vettese, Galeria Claudio Poleschi , Lucca
'Zukunft ist am Balkan'(The future is in the Balkans), Harald Szeemann, Blut &Honig

2001 'Interview with Adrian Paci', Jan-Erik Lundstrom, *Tema Celeste*, December–January
'Aperto Albania', Edi Muka, *Flash Art*, January–February

Selected Exhibitions

2003 Peter Kilchmann Galerie, Zurich

2002 Manifesta, Ljubjiana
galleria francesca kaufmann, Milan
Galleria d'Arte Moderna e Contemporanea, Bergamo

2001 Bildmuseet, Umea
Venice Biennale
Tirana Biennale

2000 'In Search of Balkania', Neue Galerie, Graz
'Premio Furla', Fondazione Querini Stampalia, Venice

Untitled (Lamps for Rivoli)
2000
Perspex, light bulb, fixture
Each 45×40cm
Courtesy neuggerreimschneider

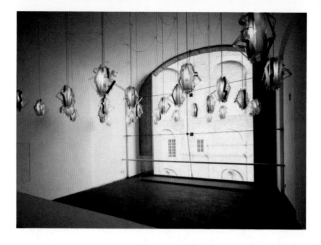

Selected Bibliography

2002 'Jorge Pardo: The Butler Did It', Jan Tumlir, *Flash Art*, 35, November–December

2001 'L.A.-Based and Superstructure', Lane Relyea, *Public Offerings*, Museum of Contemporary Art, Los Angeles

2000 *Jorge Pardo*, ed Jorn Schafaff, Barbara Steiner, Hatje Cantz Verlag, Ostfildern-Ruit

1999 *4160 Pardo Untitled*, Jan Tumlir, Royal Festival Hall, London

Selected Exhibitions

2002 Le Consortium, Dijon

2000 Dia Art Foundation, New York
Kunsthalle, Basel

1999 Fabric Workshop, Philadelphia
Royal Festival Hall, London
'Swish I'm a Fish', Museum Abteiberg, Mönchengladbach

1998 'Jorge Pardo. 4166 Sea View Lane', Museum of Contemporary Art, Los Angeles

1997 'Lighthouse', Museum Boijmans van Beuningen, Rotterdam
Museum of Contemporary Art, Chicago
'Skulptur. Projekte in Munster'

Jorge **Pardo**

Born 1963
Lives Los Angeles

The history of Modernist design is probably as rich and complex as that of modern art. In his work Jorge Pardo exploits this plentiful resource. As an artist, he has produced objects, furniture and graphic design as well as architectural works that interpret and modify the designs of Alvar Aalto, Frank Gehry or Arne Jacobsen. Pardo, however, strips his designs of the utopian promise latent in their Modernist predecessors. His works are not mass-produced avant-garde exercises but individual solutions to specific situations and individual requirements. Yet, as artworks they still echo the historical discourse from which they have been plucked and thus raise a variety of questions. Can design make beauty a public property? How much design do you want in your daily life? (JV)

Represented by 1301PE B11, Galerie Gisela Capitain D11, Haunch of Venison G14, Galerie Ghislaine Hussenot F15, Taka Ishii Gallery G9, Giò Marconi C14, Galerie Meyer Kainer F1, neugerriemschneider C6

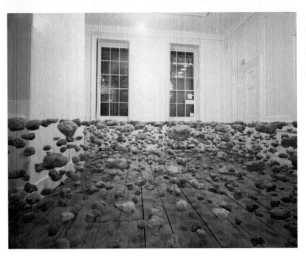

*Subconscious of a Moment,
Soil Excavated from beneath the Leaning
Tower of Pisa*
2002
Dimensions variable
Courtesy Frith Street Gallery

Cornelia **Parker**

Born 1956
Lives London

Cornelia Parker is best known for exhibiting actress Tilda Swinton in a glass case in *The Maybe* (1995) and for *Cold Dark Matter* (1991), a blown-up shed, painstakingly reconstituted and suspended from clear filaments as if in permanent mid-explosion, its title a reference to the material that makes up the majority of the universe. But it is her smaller-scale works – microscopic photographs of the relativity equations on Einstein's blackboards, lone feathers plucked from Freud's pillow, earplugs made of dust from the British Library – that most clearly delineate Parker's art: one in which the small and graspable provides a metonymic stand-in for the vast or ineffable, offering a prism through which we can begin to view and accept complexity. (MH)

Represented by Frith Street Gallery C4

Selected Bibliography

2002 *A Meteorite Lands …*, Jessica Morgan, Ikon Galley, Birmingham

2001 *Cornelia Parker:Avvistamenti-Sightings*, Iwona Blazwick, Ewa Lajer-Burcharth, Galleria d'Arte Moderna e Contemporanea, Turin

2000 *Cornelia Parker – The Institute of Contemporary Art*, Jessica Morgan, Bruce Ferguson, Institute of Contemporary Art, Boston

1996 *Cornelia Parker – Avoided Object*, Guy Brett, Cornelia Parker, S. Cameron, Antonia Payne, Chapter Arts Centre, Cardiff

Selected Exhibitions

2003 Frith Street Gallery, London

2001 Galleria d'Arte Moderna e Contemporanea, Turin

2000 Institute of Contemporary Art, Boston

1997 Turner Prize, Tate Britain

1995 'The Maybe' (with Tilda Swinton), Serpentine Gallery, London

Untitled
2003
Pigment print
29×42cm
Edition of 12
Courtesy Air de Paris

Selected Bibliography

2002 *No Ghost Just a Shell*, Walther König, Cologne
Alien Affection, Alien Seasons, ARC, /Musée d'Art Moderne de la Ville de Paris, Les Presses du réel, Dijon
Philippe Parreno, Peio Aguirre, Moderna Museet, Stockholm

1998 *Dominique Gonzalez-Foerster/Pierre Huyghe/Philippe Parreno*, ARC, Musée d'Art Moderne de la Ville de Paris

Selected Exhibitions

2003 'Alien Seasons', Friedrich Petzel Gallery, New York
'In the future everything will be chrome', CCA, Kitakyushu

2002 'Alien Seasons', ARC, Musée d'Art Moderne de la Ville de Paris
'The Dream of a Thing', Portikus, Frankfurt

2001 'Mont Analogue', Air de Paris, Paris; Friedrich Petzel Gallery, New York; Rirkrit Tiravanija's Studio, Bangkok
'The Dream of a Thing', Museet Project, Moderna Museet, Stockholm
'One Thousand Pictures Falling from One Thousand Walls', Friedrich Petzel Gallery, New York

2000 'No Ghost Just A Shell: Anywhere Out of the World', Air de Paris, Paris; Schipper & Krome, Berlin

1998 'One Thousand Pictures Falling from One Thousand Walls', Musée d'Art Moderne et Contemporain, Geneva
ARC, Musée d'Art Moderne de la Ville de Paris

Philippe **Parreno**

Born 1964
Lives Paris

In his exhibitions Paris-based Philippe Parreno creates intricate, dramatized walk-through scenarios: lights, sounds and video are turned on and off with precise orchestration, as for example when a Manga character called AnnLee (whom Parreno and Pierre Huyghe bought cheaply from a Japanese animation company) tells you about her empty status as a commodity (*Anywhere out of the World*, 1999). Yet the point is not to lead the spectators, like mice in a maze, through a fixed space–time relation, but conversely to engage them in a wild interplay between narration and abstraction, empathy and rupture. (JöH)

Represented by Air de Paris B16, Schipper & Krome E8

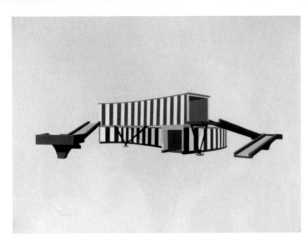

The Theatre of Illusion
2003
Wall painting
Installation view at CCA, Glasgow
Courtesy The Modern Institute

Toby **Paterson**

Born 1974
Lives Glasgow

Legions of skateboarders have repurposed the UK's decaying postwar architecture as their playground; Toby Paterson has made art from this experience and won the Beck's Futures Award (in 2002, after scant years of exhibiting). His murals, paintings on Perspex and sculptures depict decrepit Modernist buildings – such as Victor Pasmore's Peterlee Pavilion – in a clean, colourful graphic style, fresh as the day they were blueprinted, and often with highly exaggerated perspective. While lamenting lost idealism, though, Paterson's work re-enchants such edifices by filtering them through an unfamiliar optic: that of a disenfranchised, hyperactive, skateboarding youth entranced by a new set of curves to master. (MH)

Represented by The Modern Institute G8

Selected Bibliography

2003 'The New Architecture', Caroline Woodley; 'Tracing Urban Fascination', Steven Gartside; 'Platon and The Skateboard', Lars Bang Larsen, *Toby Paterson*, CCA, Glasgow

2002 *Becks Futures*, Will Bradley, ICA, London
Moira Jeffrey, *The Herald*, 8 March 2002

2001 Susan Mansfield, *The Scotsman*, 18 December 2001
Here + Now, Scottish Art 1990 – 2001, Katrina M. Brown, John Calcutt and Rob Tufnell, Dundee Contemporary Arts

Selected Exhibitions

2003 'Toby Paterson', The Modern Institute, Glasgow
'New Facade', CCA, Glasgow

2002 'Toby Paterson', Franco Noero, Turin
'Baltic Babel', Rooseum, Malmö
RomaRomaRoma, Rome
'Greyscale CMYK', Tramway, Glasgow
'Toby Paterson & Martin Boyce', Foksal Gallery Foundation, Warsaw
'Happy Outsiders', Zacheta Gallery, Warsaw and City Gallery of Contemporary Art, Katowice
'Becks Futures', ICA, London and touring

2001 'Circles °4 One for One', ZKM, Karlsruhe

Repo Man
2000
Oil on canvas
244×161cm
Courtesy Private Collection, New
York

Selected Bibliography

2003 *Painting Pictures, Painting and Media in the Digital Age*, Annelie Lütgens et al Kunstmuseum Wolfsburg, Kerber Verlag, Bielefeld

2001 *Casino 2001*, Jeanne Greenberg Rohatyn, Lars Bang Larsen, Libby Lumpkin, Midori Matsui, Saul Anton and Andrea Scott, SMAK, Ghent

2000 *Concentration 35: Richard Patterson*, Dallas Museum of Art

1999 *Richard Patterson: New Paintings*, short story by J.G. Ballard 'The Overloaded Man', James Cohan Gallery, New York

1997 Stuart Morgan, 'Tonight We Improvise', in *Richard Patterson*, Anthony d'Offay Gallery, London

Selected Exhibitions

2003 'Painting Pictures', Kunstmuseum, Wolfsburg

2001 'My Reality – Contemporary Art and the Culture of Japanese Animation', Des Moines Art Center, Iowa and touring until 2004
'Casino 2001', SMAK, Ghent

2000 'Concentration 35: Richard Patterson', Dallas Museum of Art
'Richard Patterson', James Cohan Gallery, New York

1997 'Richard Patterson', Anthony d'Offay Gallery, London
'Sensation: Young British Artists from the Saatchi Collection', Royal Academy of Arts, London and touring

1995 'Richard Patterson', Project Space, Anthony d'Offay Gallery, London

1988 'Freeze', Surrey Docks, London

Richard **Patterson**

Born 1963
Lives New York

Among the mid-1990s paintings for which Richard Patterson became known were images of a toy Minotaur, whose effortless Photorealism the British painter casually torpedoed with multicoloured horizontal brushstrokes. An ambiguous negation of machismo, this approach has recrudesced throughout the British painter's career: since the late 1990s his virtuoso gumbos have blended self-conscious abstraction with motor bikes, cheerleaders, Daisy Duke from the TV show *The Dukes of Hazzard*, the stars of John Schlesinger's *Midnight Cowboy* (1969) and the Spice Girls, among other subjects. Yet Patterson is a complicit critic, clearly enthralled by the psycho-sexual aspects of painting. *Relief* (2001) – a sensual, red-and-white trompe l'oeil swirl of what might be half-mixed oil paint or raspberry ripple ice cream – could almost be his logo. (MH)

Represented by Timothy Taylor Gallery F13

Mao (Chinese Vermilion #6)
2001
Oil on canvas
250×250cm
Courtesy Galerie Rodolphe Janssen

Yan **Pei-Ming**

Born 1960
Lives Dijon/Paris

Often towering above the viewer, Yan Pei-Ming's portraits typically break down into masses of aggressive paint-strokes in a narrow, photo-derived palette of black, white and grey. Coruscating expressionism is, however, destabilized by the Chinese painter's perpetually returning, throughout his career, to the same subjects – himself, his family, Mao Tse-Tung – denuding them of personality by mechanical repetition and, he has suggested, turning each into a portrait of Everyman. Yet all this fiercely contradictory effort (and he is a prodigious worker) may be in the service of something outside art: 'It is by insisting on his painting', writes Hou Hanrou, 'that Ming has constructed his own life as a meaningful existence.' (MH)

Represented by Galerie Rodolphe Janssen D2

Selected Bibliography

2003 *Yan Pei-Ming. Fils du Dragon*, Les Presses du réel, Dijon

2002 *Yan Pei-Ming, Benner, Boucher, Bouguereau…*, Musée des Beaux-Arts de Mulhouse

2000 *Yan Pei-Ming, Autoportraits*, Faggionato Fine Arts, London

1998 *Yan Pei-Ming*, Magasin, Centre d'Art Contemporain, Grenoble

Selected Exhibitions

2003 'Dream and Conflicts', Venice Biennale
'Fils du dragon, portraits Chinois', Musée des Beaux-Arts, Dijon

2002 'Buddha and his warriors', Galerie Bernier/Eliades, Athens

2001 'Chinese Vermilion – In Memory of Mao', Galerie Max Hetzler, Berlin
'Yan Pei-Ming: Victims', Galerie Art & Public, Geneva

2000 'Tête de vertu', Studio Massimo de Carlo, Milan
'Oncle aveugle et homme invisible', Galerie Rodolphe Janssen, Brussels
'Man+Space', Kwangju Biennial
'Partage d'exotismes', Lyons Biennale
Shanghai Biennale

Mint Poisoner
2003
Black, white, green, fluorescent pink
paper
222×131cm
Courtesy Sadie Coles HQ

Simon **Periton**

Born 1964
Lives London

Simon Periton's Punk-Victorian doilies, lanterns
and paper garlands suggest both leisured luxury and
the painstaking process of making art. There is
something almost hobbyist about these flimsy
constructions (and what is a hobby but a half-way
house between free time and work?), like matchstick
sculptures or late 1970s Sex Pistols fanzines. Intricate,
speckled with anarchy logos, barbed wire and rioting
workers, they prod craft into unfamiliar places where
it falls on its backside and laughs a self-deprecating
laugh. Eschewing the academic politics of the
handmade decorative object (connected with
anthropology, women's studies and Marxian theories
of kitsch), Periton's work is concerned with the
persistence of its own, fragile beauty. (TM)

Represented by Sadie Coles HQ B8

Selected Bibliography

2003 *Simon Periton*, Sadie Coles
HQ, London

1998 *Simon Periton*, Isabella Blow
and Adam McEwen, Camden Arts
Centre, London

Selected Exhibitions

2003 'Mint Poisoner', Inverleith
House, Royal Botanic Gardens,
Edinburgh
'Premonitions', Gorney Bravin &
Lee, New York
'Flag', Henry Moore Gallery, Leeds

2001 'Cold warmed up',
Sadie Coles HQ, London
'Tailsliding', British Council
touring show
'SchattenRisse/Shadows, Silhouettes
and Cut-outs', Lenbachhaus
Kunstbau, Munich
'Century City', Tate Modern,
London

Mai-Thu **Perret**

Born 1976
Lives New York/Geneva

Mai-Thu Perret's work revolves around an elaborate fictional scenario: that, at some point in recent history a group of women went into the desert of New Mexico to form New Ponderosa Year Zero, an autonomous community dedicated to the invention of a new, disalienated relation to labour and nature. Perret's often handmade sculptures – from ceramics to stitched fabrics – and multi-authored diary entries are, then, the 'work' of these women. This storyline functions as a rationale for the generation of determinedly raw objects that draw attention to their own commodification as art; it also seeks to examine loss. Her dreamed-up utopia implicitly queries why such projects never became permanent, and why what one diary entry describes as 'our own personal Eden' is seemingly impossible in the present. (MH)

Represented by Galerie Francesca Pia C3

Selected Bibliography

2003 *The Return of the Creature*, Steven Parrino, Künstlerhaus Thurn+Taxis, Bregenz

2001 'Fabrice Stroun Talks with Mai-Thu Perret', *CAN*, Neuchâtel

2000–01 *The Crystal Frontier*, Mai-Thu Perret, www.airdeparis.com/guest

Selected Exhibitions

2003 'The Return of the Creature', Künstlerhaus Thurn+Taxis, Bregenz
'25 Sculptures of pure self-expression: Mai-Thu Perret', Galerie Francesca Pia, Bern
'Mai-Thu Perret', The Modern Institute, Glasgow
'Mai-Thu Perret', Glassbox, Paris

2002 'Land of Crystal', CAN, Neuchâtel

2001 'Rock, Paper, Scissors', Galerie Francesca Pia, Bern
'The New Domestic Landscape', Galerie Javier Lopez, Madrid

2000 'Dr Wings', Air de Paris, Paris

Selected Bibliography

2002 *Grayson Perry – Guerrilla Tactics*, Louisa Buck, Marjan Boot, Rudi Fuchs, Andrew Wilson, Stedelijk Museum, Amsterdam

2001 *New Labour*, Saatchi Gallery, London

Selected Exhibitions

2003 Turner Prize, Tate Britain, London
'For the Record: Drawing Contemporary Life,' Vancouver Art Gallery

2002 'Guerrilla Tactics', Barbican Art Gallery, London and Stedelijk Museum, Amsterdam

2001 'New Labour', Saatchi Gallery, London

2000 Fig-1, London
Laurent Delaye Gallery, London
'British Art Show 5', curated by the Hayward Gallery, touring

1996–7 Anthony d'Offay Gallery, London

1994 Anthony d'Offay Gallery, London

Grayson **Perry**

Born 1960
Lives London

Ceramicist Grayson Perry's nomination for the 2003 Turner Prize made quite a few headlines, the most absurdly succinct of which ran: 'Transvestite Art on Turner List'. This journalistic shorthand – collapsing the artist's public persona (he often appears in the guise of his female alter ego, Claire) into the work itself – is perhaps more insightful than it knows. In essence, Perry makes pots that cross-dress. Their forms are simple and classic, evoking suburban hobbies and middle-class objects of desire. The glazed surfaces, however, are replete with madly collaged image and text – scenes of abjection and bits of radical polemic. These hybrid forms occupy a contested area between art and craft, drawing on and repudiating both. (SS)

Represented by Victoria Miro Gallery F4

Nick (Chateau Marmont, Los Angeles,
September 2002)
2002
Oil on canvas
101.5×76cm
Courtesy GBE (Modern)

Elizabeth **Peyton**

Born 1965
Lives New York

Peyton's works depict people – her friends, her idols, the odd refugee from history. In a drawing of Kurt Cobain, who often appears in her art, sparse, pencil-crayoned lines show the Nirvana singer jack-knifed over a desk, doodling in his diary, completely absorbed in a private moment. Peyton painted David Hockney in 1997, working from a photo of the artist as a young man. In her hands he resembled a prettified Jarvis Cocker, the subject of one of her mid-1990s Brit Pop portraits. Looking back over Peyton's oeuvre, you begin to suspect that she is, in a sense, a genealogist – that she's tracing a sensibility that's born in the gutter but gazes at the stars. (TM)

Represented by Sadie Coles HQ B8,
GBE (Modern) D5, neugerriemschneider C6,
Gallery Side 2 H10

Selected Bibliography

2003 Tom Morton, *frieze*, 75, May

2002 'Artist Project', *Tate*,
September–October

2000 'Elizabeth Peyton', Rob Pruitt
and Steve Lafreniere, *Index*, July

1998 Linda Pilgrim, David
Rimanelli, Philip Ursprung,
Lisa Liebmann, *Parkett*, 53

1996 'Boys Keep Swinging',
John Savage, *frieze*, 31,
November–December

Selected Exhibitions

2003 Regen Projects, Los Angeles

2002 Kunstverein, Salzburg

2001 Deichtorhallen, Hamburg
Gavin Brown's enterprise, New
York

2000 Westfälischer Kunstverein,
Munster
Aspen Art Museum

1999 Castello di Rivoli, Museo
d'Arte Contemporanea, Turin

1998 Kunstmuseum, Wolfsburg,
touring to Museum für
Gegenwartskunst, Basel
Seattle Art Museum

1997 St Louis Art Museum

Girl Drowning
2001
Charcoal on paper
91.5×91.5cm
Courtesy Klemens Gasser &
Tanja Grunert, Inc

Selected Bibliography

2003 'Chloe Piene', *Artforum*,
April

2002 'Liverpool Biennial',
Lee Triming, *Flash Art*, November–
December
Cabinet, December
Tema Celeste, January
Make, March

Selected Exhibitions

2003 Art Unlimited, Art Basel

2002 Liverpool Biennial
'Video Topiques', MAMCS,
Strasbourg
'Videodrome', New Museum of
Contemporary Art, New York

2001 'Legitimate Theatre', County
Museum of Art, Los Angeles

2000 Helsinki City Art Museum
'New Video', Barbara Gross
Galerie, Munich
'Russia Is Still Dangerous',
Kunstverein, Munich
'Infoscreen', Museum in Progress,
Vienna

Chloe **Piene**

Born 1972
Lives New York

Chloe Piene courts danger and darkness, staging
ambiguous psychodramas. In a series of starkly
expressive charcoal drawings, skeletal nudes seem
to be decaying before our eyes. These images hover
close to necrophilia – delicate and violent, monstrous
and erotic. It's difficult to look, and difficult to look
away. The drawings are just one facet of Piene's
provocative strategies. Video loops present
confrontations with threatening children and bestial
women, take us inside roiling mosh pits. Published
as a book, the artist's seven-month-long
correspondence with an incarcerated murderer
brings her theatrical edge-walking into the realm
of real life. Her work attempts to get under the skin
– the viewer's, the subjects' and her own. (SS)

Letter to Berllin
2003
Notepaper, museum entrance ticket,
photograph, frame
62×47cm
Courtesy Klosterfelde

Kirsten **Pieroth**

Born 1970
Lives Berlin

One central concern of Conceptual art has always
been to redefine the poetic. Kirsten Pieroth picks up
on this tradition. Her works thrive on an inventive
humour: she has transported a puddle of rainwater
from Berlin to Tirana, posted some air to
Copenhagen and sent postcards to strangers, asking
people in the country depicted on the cards to write
back. The mind is irresistibly taken on the imaginary
trajectories sketched out in her works. In *Around the
World in 40 Days* (2001) Pieroth split Jules Verne's
classic in two. What if Phileas Fogg had stopped
half-way round the planet to look at his past and
future laid out in front of him in equal-sized piles
of paper. Would he have continued his journey?
Or would he have reread the first 40 days? (JV)

Represented by Klosterfelde B9

Selected Bibliography

2003 *Global Navigation System*,
Palais de Tokyo, Paris
Haunted by Detail, De Appel,
Amsterdam

2002 *Kirsten Pieroth: Reise um die
Erde in 40 Tagen* (Around the world
in 40 days), Nikola Dietrich and
Jens Hoffmann, Mellemdaekket
Projektrum, Charlottenborg
Exhibition Hall, Copenhagen, Pork
Salad Press, Copenhagen
'Kirsten Pieroth', Raimar Strange,
Artist – Kunstmagazin, June
'Possible Works. Henrik Olesen and
Kirsten Pieroth', Jacob Fabricius
Flash Art, May–June

Selected Exhibitions

2003 Klosterfelde, Berlin
'Global Navigation System', Palais
de Tokyo, Paris
'Open Studio', Townhouse Gallery,
Cairo
'Utopia Station', Venice Biennale

2002 Mellemdaekket Projektrum,
Charlottenborg Exhibition Hall,
Copenhagen
'Haunted by Detail', De Appel,
Amsterdam
'There are two temperatures: one
outside, one inside', Kirsten Pieroth
Henrik Olesen, Galleria Franco
Noero, Turin

2001 Helga Maria Klosterfelde,
Hamburg
'Retur', Copenhagen, organized
by Jacob Fabricius
Sparwasser HQ, Berlin (with
Kirstine Roepstorff)

Untitled
2002
Acrylic on canvas
211×180cm
Courtesy Sprovieri

Selected Bibliography

2002 *Cristiano Pintaldi 1991–2001*,
Centro per le Arti Visive, Pescheria,
Pesaro
'Giovane pittura italiana'
(Young Italian Painting), *Flash Art*,
February

1999 *Cristiano Pintaldi*, Mario
Sequeira Gallery, Braga

1992 *Cristiano Pintaldi*, Aidan
Gallery, Moscow
Avvistamenti, Galleria Sprovieri,
Rome

Selected Exhibitions

2002 'Landscape', Sprovieri,
London
'Cristiano Pintaldi 1991–2001',
Centro per le Arti Visive, Pescheria,
Pesaro

2001 1000eventi gallery, Milan

2000 'L'altra metà del cielo
(The other half of the sky)',
Städtische Kunstsammlungen,
Chemnitz and touring
Mario Sequeira Gallery, Braga

1999 'Jump', Galeria Franco
Noero, Turin

1996 'Collezionismi a Torino',
Castello di Rivoli, Museo d'Arte
Contemporanea, Turin

1993 'Xenografia', Venice Biennale

1992 Aidan Gallery, Moscow
Galleria Sprovieri, Rome

Cristiano **Pintaldi**

Born 1970
Lives Rome

Cristiano Pintaldi's paintings of pixellated images
wear their internal contradictions lightly. Revisiting
neither Roy Lichtenstein's pumped-up comic-book
pages nor Sigmar Polke's spots, they are rather an
attempt – through the alchemy of painting – to make
the infinitely reproducible stuff of film and TV special.
Often based on sci-fi movies (he believes in imminent
alien contact), Pintaldi's paintings have hung in the
Italian Big Brother house, where, he says: 'they were
the only thing that was real, because they were made
up of pixels, like the television screen that was
presenting them'. Like the Wachowski brothers' *The
Matrix* (1998), Pintaldi's work is plump with parboiled
simulation theory and techno paranoia. (TM)

Represented by Sprovieri D15

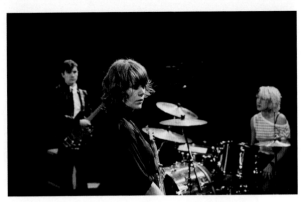

Actualité
2002
C-type print
76×94cm
Courtesy Galerie Meyer Kainer

Selected Bibliography

2002 *Actualité*, Grazer Kunstverein,
Revolver – Archiv für aktuelle
Kunst, Stuttgart

1999 *Sharawadgi*, with Christian
Meyer, Felsenvilla, Vienna/Cologne

1998 *The making of*, Generali
Foundation, Vienna/Cologne

Selected Exhibitions

2003 Museum Moderner Kunst,
Vienna

2002 Richard Telles Fine Art, Los
Angeles
Galerie Meyer Kainer, Vienna

2001 Kunstverein, Graz

2000 'Light Extra Bold',
Pop Unlimited, Internationales
Kurzfilmfestival, Oberhausen

1999 'Einblicke in die Sammlung',
(Insights into the Collection),
Generali Foundation, Vienna
'Moving Images', Galerie für
Zeitgenössische Kunst, Leipzig

1998 'The making of', Generali
Foundation, Vienna
'The Century of Artistic Freedom',
Secession, Vienna

1997 'Postproduktion',
(Postproduction) Generali
Foundation, Vienna
'Zonen der Verstörung' (Zones of
Disturbance), Steirischer Herbst,
Graz

1996 Manifesta, Rotterdam
'Scan', Depot, Vienna

1993 'Backstage', Kunstverein,
Hamburg
'On taking a normal situation and
retranslating it into overlapping and
multiple readings of conditions past
and present', Museum van
Hedendaagse Kunst, Antwerp
'Kontext Kunst' (Context Art), Neue
Galerie, Graz

Mathias **Poledna**

Born 1965
Lives Los Angeles

In Austrian artist Mathias Poledna's film installation
Actualité (2002) a fictitious Punk band is filmed
during rehearsal. The images are as stripped down
and simple as the tunes. The protagonists are put into
a strange limbo between acting and actually making
music – and the viewer situated somewhere between
1979 and current retro chic. Like *Actualité*, *Western
Recordings* (2003) – a band recording made in the
studio where the Beach Boys' 1966 *Pet Sounds* sessions
took place – traces the looks, moves and sounds of
collective creation. The fractured style of Godard's
One Plus One (1968), featuring the Rolling Stones
rehearsing 'Sympathy for the Devil', suggested the
heat of the moment. LA-based Poledna's work never
pretends immediate access to history, and offers
condensed recollection instead. (JöH)

Represented by Galerie Meyer Kainer F1

'N.P', 'T.B', 'W–S'
2001
Lambda prints
Installation view at Kunstverein
Braunschweig
Each 88×100cm
Photo: Simon Vogel
Courtesy Galerie Christian Nagel

Selected Bibliography

2001 *Jewels-in-Art, Sarah Staton, Merlin Carpenter, Josephine Pryde, Jeremy Glogan*, Galerie Bleich-Rossi, Graz
Josephine Pryde, Serena, Kunstverein, Braunschweig
'Josephine, die Sängerin oder das Volk der Mäuse' (Josephine, the Singer, or the Mouse Folk), Michael Krebber, *Texte zur Kunst*, September

2000 'Lose Enden' (Loose Ends), Isabelle Graw, *Texte zur Kunst*, 38

1997 'Josephine Pryde – Vicinage', Stefan Römer, *Kunstforum*, 137

Selected Exhibitions

2002 'Metalltanz' (Metal Dance), Steirischer Herbst and Galerie Bleich-Rossi, Graz

2001 'The Hands', New Art Center, Salisbury
'6am Summer 2001', Galerie Neu, Berlin
'Serena', Kunstverein, Braunschweig
'Jewels-in-Art', Galerie Bleich-Rossi, Graz

2000 'Honour, without money, is just a disease', Succession, London
'Marooned', Christian Nagel, Cologne

1999 'Space', Witte de With, Rotterdam

1997 'Vicinage', Christian Nagel, Cologne

1995 Galerie Neu, Berlin.

Josephine **Pryde**

Born 1967
Lives London/Hamburg

Josephine Pryde's performances and still-lives methodically evoke the unhip. Her photograhic subjects – crystals surrounded by china figurines of rabbits, shirts from high-street stores – nod to outdated versions of bourgeois good taste or knock-off versions of high fashion; her technique, sourced in commodity photography of the early 20th century, portrays these relics through kaleidoscopes and frosted glass, shattering them into myriad reticules and, by such unsophisticated attempts to seduce and disguise, rendering them ever more undesirable. In determinedly picturing the outmoded, however, Pryde elegantly figures its reverse: if contemporary artists continue to echo fashion's endless desire for novelty and surface, her gentle jeremiad suggests, then today's art – and its methods of display – will be tomorrow's kitsch. (MH)

Represented by Galerie Christian Nagel E4, Galerie Michael Neff C20, Galerie Neu E10

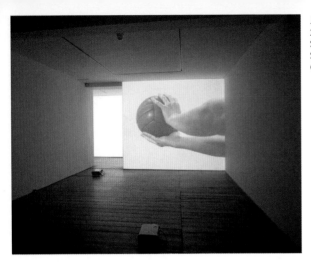

Fatica n 19
2003
Still from audio-visual installation at
Sprovieri
Courtesy Sprovieri

Selected Bibliography

2002 Maria Rosa Sossai, *Flash Art*,
December
Giorgio Verzotti, *Artforum*, March

2001 Giacinto di Pietrantonio, PS1,
New York

1998 *Contestura*, Giuliana Stella,
Complesso Monumentale di S.
Salvatore in Lauro, Rome

1997 Achille Bonito Oliva, *Art
Dossier*, 129

Daniele **Puppi**

Born 1970
Lives Rome

Daniele Puppi believes that every space has an
essence, which he attempts to unleash and animate
using video and sound. He describes his often
disorientating approach – which involves videoing
himself in a space while repeating an intense, often
tiring action such as leaping from a Baroque cupola,
throwing a ball against a closed door or demolishing
a wall – as transforming ideas into pure events.
The decision to perform a certain movement or
gesture is motivated by the space itself – its history
mingling with the artist's imagination. The sound
that accompanies the videos is generated by, and
recorded in, the space itself. (JH)

Represented by Sprovieri D15

Selected Exhibitions

2003 'Fatica n. 19', Sprovieri,
London

2002 'Fatica n. 17', Magazzino
d'Arte Moderna, Rome
'Big Social Game', International
Biennale of Young Art, Turin

2001 'Fatica n. 14', Galleria
Massimo De Carlo, Milan
'Fatica n. 10, Perpendicolare',
Eldorado, Galleria d'Arte Moderna
e Contemporanea, Bergamo
'Camera Italia', Pescara
PS1, New York, Italian Studio
Progam 2000–2, Palazzo delle
Esposizioni, Rome

1999 Franco Noero, Turin
'Killing Me Softly', Kunsthalle Bern

1998 CACC Kunsthaus, Zurich

Moonlite Bunny Ranch
2003
Oil, acrylic on canvas
231×190.5cm
Courtesy Timothy Taylor Gallery

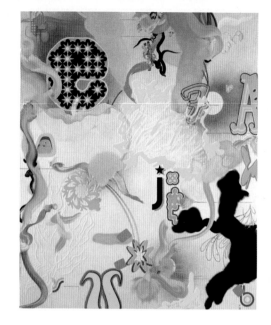

Selected Bibliography

2002 *Fiona Rae*, Carré d'Art-Nîmes

1999 *Colour Me Blind*, Württembergischer Kunstverein, Stuttgart

1997 *Sensation:Young British Artists from the Saatchi Collection*, Royal Academy of Art, London
About Vision, New British Painting in the 1990s, Museum of Modern Art, Oxford
Fiona Rae – Gary Hume, Saatchi Collection, London

Selected Exhibitions

2003 'Painting Pictures', Kunstmuseum, Wolfsburg
'Hong Kong Garden', Timothy Taylor Gallery, London

2002 'Künstlerräume/Sammlerräume', Kunstverein, St. Gallen
Carré d'Art – Musée d'Art Contemporain, Nîmes
'Recent Paintings', Buchmann Galerie, Cologne
Galerie Nathalie Obadia, Paris

2000 'Hybrids', International Contemporary Painting, Tate Liverpool

1999 'Colour Me Blind', Württembergischer Kunstverein, Stuttgart
Luhring Augustine, New York

1997 Saatchi Gallery, London
'Fiona Rae', British School at Rome

Fiona **Rae**

Born 1963
Lives London

Episodes from the history of Modernism skid across Fiona Rae's paintings. Scrawled Cy Twombly lines, scraped passages from a Gerhard Richter, bits and bobs from Brice Marden and Pablo Picasso pile up and interpenetrate. Rae's works display technical virtuosity but also intellectual vigour; an ability – against all the odds – to make some sort of visual and conceptual sense of the sources she clashes together. Her canvases are wrestling mats on which Modernist masters slug it out in an art-historical end game, but they are also juggling acts. Here an air of tension – of postponed failure or success – persists alongside bravura visual pleasures. (TM)

Represented by Galerie Nathalie Obadia F2, Timothy Taylor Gallery F13

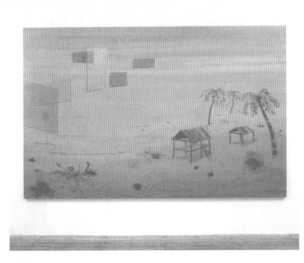

Someone said that the world's a stage
2002
Acrylic and thread on canvas
200×320cm
Courtesy The Approach

Selected Bibliography:

2002 *Michael Raedecker – instinction*,
Museum für Gegenwartskunst,
Basel, Centro Nazionale per l'Arte
Contemporanea, Rome
Vitamin P: New perspectives in Painting,
ed Valérie Breuvart, Phaidon,
London
'Michael Raedecker', Martin
Herbert, *Tema Celeste*, 94,
December
Parkett, 65, September

2000 'Flatland', Kate Bush, *frieze*,
54, September

Michael **Raedecker**

Born 1963
Lives London

Writing in *frieze*, Kate Bush described Michael
Raedecker's paintings as 'remnants of real scenes
and remembered places, fished out from the reservoir
of a collective imagery and yet never quite caught'.
Raedecker's pictures are full of space and suburbs,
which murmur warnings difficult to fathom –
a vision hot-housed in the ateliers of northern Europe
and raised on TV. Windows shine like hopeful eyes;
twilight always hovers. These are contradictory
paintings – representational yet often abstract, and
seduced by paint, even when paint is rejected in
favour of other materials such as thread. Less
descriptive of place than of a state of mind,
Raedecker evokes a place where time is slippery –
a present that can't help looking over its shoulder
to see where it came from. (JH)

Represented by The Approach D8

Selected Exhibitions

2003 'That's the way it is',
Andrea Rosen Gallery, New York
'Painting Pictures; Painting and
Media in the Digital Age',
Kunstmuseum, Wolfsburg

2002 'Sensoria', The Approach,
London

2002–3 'Instinction', Centro
Nazionale per l'Arte
Contemporanea, Rome, touring to
Museum für Gegenwartskunst, Basel
2001 'Painting at the Edge of the
World', Walker Art Center,
Minneapolis
2000 'Ins and Outs', The Approach,
London
Turner Prize, Tate Britain, London
'Trouble Spot. Painting', NICC and
Museum van Hedendaagse Kunst,
Antwerp
'Examining Pictures: Exhibiting
Paintings', Whitechapel Art Gallery,
London; Museum of Contemporary
Art, Chicago; UCLA Hammer
Museum of Art, Los Angeles
'Extract', Van Abbemuseum,
Eindhoven

Moor
2003
Oil on canvas
250×210cm
Courtesy Galerie EIGEN + ART

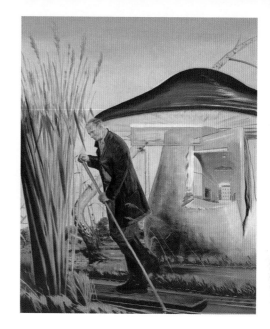

Selected Bibliography

2003 'Sturmnacht' (Stormy night), Florian Illies, *Thalia Bücher Magazin*, January
'Die Nachbilder des modernen Lebens' (The After Images of Modern Life), Niklas Maak, *Frankfurter Allgemeine Zeitung*, 25 January 2003
'Im sozialistischen Amerika' (In socialist America), Sebastian Preuss, *Berliner Zeitung*, 17 January 2003

2002 'Neo Rauch', Alison Gingeras, *Flash Art*, November–December
'The staying power (and it's not a freeze frame) of paint', Roberta Smith, *New York Times*, 21 July 2002

Selected Exhibitions

2003 'Die Erfindung der Vergangenheit' (The Invention of the Past), Pinakothek der Moderne, Munich
'Monumente der Melancholie' (Moments of Melancholy), Kunstmuseum, Wolfsburg

2002-3 'Dear Painter, Paint Me', Centre Georges Pompidou, Paris; Kunsthalle, Vienna; Schirn Kunsthalle, Frankfurt

2002 'Drawing Now: Eight Propositions', Museum of Modern Art at Queens, New York
'The Vincent Award', Bonnefanten Museum, Maastricht

2001 'Randgebiet' (Border area), Haus der Kunst, Munich
Deutsche Guggenheim, Berlin
Kunsthalle Zurich
Venice Biennale

2000 Galerie für Zeitgenössische Kunst, Leipzig

1997 Museum der Bildenden Künste, Leipzig

1995 'Marineschule' (Marine school), Overbeck-Gesellschaft, Lübeck

Neo **Rauch**

Born 1960
Lives Leipzig

Neo Rauch has claimed that 'I cannot convey a dream to anyone', but his paintings seem to contradict him. Based, some critics have claimed, on the failed paradise of communist East Germany, Rauch's canvases depict an acid-tinged world that's half Socialist Realist sci-fi Eden, half spruced-up Edward Hopper. Here men in hunting hats play airborne ice hockey, a huge curl of paint snuggles up against a Zeus-like artist's leg and workers build a diner-cum-hospital, mindless of their allegorical weight. Pointing to Germany's past but pitted with ruptures and ellipses, Rauch's paintings replace the idea of 'collective memory' with scraps picked up on the shores of idle daydreams. (TM)

Represented by Galerie EIGEN + ART F12, David Zwirner F5

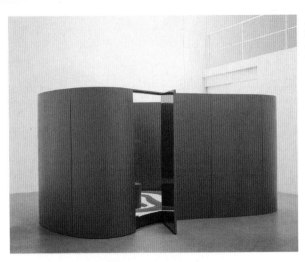

Nancy's Sunny 11.10.78
2000
MDF, lacquer, Perspex, lamps
432×300×200cm
Courtesy Ghislaine Hussenot

Tobias **Rehberger**

Born 1966
Lives Frankfurt

All clean lines and bright colours, Tobias Rehberger's sculptures and environments often seem to have dropped out of some forgotten 1970s sci-fi film or the pages of a mod interior magazine. Imaginary artefacts of a forward-looking past, they are eminently desirable objects, but their function is an open question: who, and what, are they for? Issues of use and value are central to Rehberger's work, thematized in novel collaborative strategies: remaking his father's amateur artwork, enlisting African artisans to reproduce classic Modernist chairs, designing wish-fulfilling interiors for and with his friends. Working as a translator, he reconfigures and recombines the familiar furnishings of daily life. (SS)

Represented by Galerie Ghislaine Hussenot F15, Giò Marconi C14, neugerriemschneider C6, Galerie Micheline Szwajcer E5

Selected Bibliography

2002 …(whenever you need me), Westfälischer Kunstverein, Munster

2001 'Zwei sehr schöne Dinge, auf die man in der Stadt treffen kann; Tobias Rehberger' (Two very beautiful things you might meet when in town), Florian Matzner in *Public Art*, Hatje Cantz, Ostildern-Ruit
Tobias Rehberger, 005-000 [Pocket Dictionary], Florian Matzner, Hatje Cantz, Ostildern-Ruit

1999 'Raumnachbildungen und Erfahrungsräume' (Reproductions and Spaces of Expression), Maria Lind, *Parkett*, 54

1997 'Things in Proportion', Carl Freedman, *frieze*, 33, March–April

Selected Exhibitions

2002 'Prescriçoes, descriçoes, receitas e recibos', Museu Serralves, Porto
'Night Shift', Palais de Tokyo, Paris
'Treballant/Trabajando/Arbeitend', Fundacio La Caixa, Barcelona
Galeria Civica d'Arte Moderna e Contemporanea, GAM, Turin
'Geläut – bis ichs hör', Museum für Neue Kunst, Karlsruhe

2001 'Do Not Eat Industrially Produced Eggs', Förderpreis zum Internationalen Preis des Landes Baden-Württemberg, Staatliche Kunsthalle, Baden-Baden
'DIX-Preis 2001', Kunstsammlung Gera; Orangerie, Gera
Viafarini, Milan
'Whenever you need me', Westfälischer Kunstverein, Munster

2000 Berkeley Art Museum, Univeristy of California
'The Sun from Above', Museum of Contemporary Art, Chicago

House & Garage
2000
DVD still
Courtesy GBE (Modern)

Selected Bibliography

2003 'West End Boys', *frieze*, 75, May

2002 Roberta Smith, *New York Times*, 4 October 2002

2001 Michael Wilson, *frieze*, 63, November–December
'Craving Grace', Jerry Saltz, *Village Voice*, 23 October 2001
'First Take', Matthew Higgs, *Artforum*, January

Selected Exhibitions

2003 Museum of Modern Art, Knoxville
Prague Biennale
Venice Biennale
'Days Like These: Tate Triennial of Contemporary British Art', Tate Britain, London
'Mixtape', CCAC Wattis Institute for Contemporary Art, San Francisco

2002 Gavin Brown's enterprise, New York
Beck's Futures, ICA, London

2001 'The Essential Selection', Gavin Brown's enterprise, New York
'Sound and Vision', ICA, London

2000 'Protest and Survive', Whitechapel Art Gallery, London

Nick **Relph** & Oliver **Payne**

Born 1979/1977
Live London

Relph and Payne's lyrical films are mordant updates of the 'state-of-the-nation' treatise. Reminiscent of the work of British avant-garde filmmakers Derek Jarman, Peter Greenaway and Patrick Keiller, their trilogy *Driftwood* (2000), *House & Garage* (2000) and *Jungle* (2001) examined the city, suburb and countryside respectively. Incisive narrative observation accompanies both beautiful and banal imagery, serving to paint a complex portrait of contemporary Britain. *Gentlemen* (2003), their most recent work, focuses on London's Carnaby Street and the corporate appropriation of youth subcultures, inflected throughout with by an ambivalent attitude to contemporary lifestyle culture. (DF)

Represented by GBE(Modern) D5

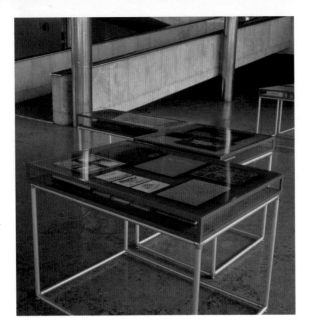

Bibliotheca (Group 3)
2002
Mixed media
80×114.5×81.5cm
80×93×43cm
80×79.5×70.5cm
Courtesy Galeria Fortes Vilaça

Rosângela **Rennó**

Born 1962
Lives Rio de Janeiro

A single photograph is more malleable than anyone could have ever once suspected, having the slippery tendency to represent conflicting truths at different times or in different contexts. It's a fact not lost on Brazilian artist Rosângela Rennó, who has taken to heart Susan Sontag's oft-repeated warning that the exponential glut of photographs in the world has irreparably numbed us to their strange power. For this reason Rennó often forgoes taking her own images, acting instead like a photo archivist determined to thwart social amnesia. Turning to discarded family albums, unclaimed ID pictures culled from cheap photographers' studios or portraits of innumerable long-forgotten individuals pulled from dusty public archives, Rennó constructs new works that synthesize collective human narratives from out of the reams of anonymous likenesses. (JT)

Represented by Galeria Fortes Vilaça F9

Selected Bibliography

2003 *Shattered Dreams*, Alfons Hug, Brazilian Pavilion, Venice Biennale

2001 *Rosângela Rennó. Espelho Diário* (Daily Mirror), Pedro Lapa & Alice Duarte Penna, Museu do Chiado, Lisbon
'Rosângela Rennó. Vera Cruz', and 'Rosângela Rennó, Virgin Territory'. Women, Gender, History' in *Contemporary Brazilian Art*, The National Museum of Women in the Arts, Washington DC
'Memory and Amnésia', *Rosângela Rennó, El final del eclipse*, Fundación Telefónica Madrid

1998 'Rosângela Rennó', Dan Cameron, *Cream. Contemporary Art in Culture*, Phaidon, London

Selected Exhibitions

2003 Brazilian Pavilion, Venice Biennale
Galeria Fortes Vilaça, São Paulo
Centro Cultural Banco do Brasil, Rio de Janeiro

2002 Museu de Arte da Pampulha, Belo Horizonte
'La Mirada' (The glance), Daros Latin America, Zurich

2001 Instituto Tomie Ohtake, São Paulo
'Denkzeichen Project', Alexander Platz, Berlin
'Espelho diário', Museu do Chiado, Lisbon

Untitled
2003
Mixed media on canvas
135×114cm
Courtesy Galerie Giti Nourbakhsch

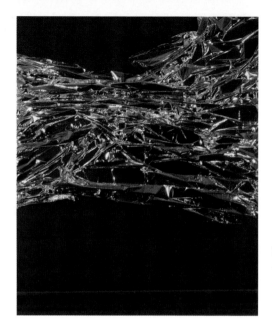

Selected Bibliography

2003 *deutschemalereizweitausenddrei* (German painting 2003), Kunstverein, Frankfurt

2002 *My head is on fire but by heart is full of love*, Charlottenborg Exhibition Hall, Cophenhagen
Der Zauber des Verlangens (The Enchantment of Passion), Neuer Berliner Kunstverein and Kunstverein Göttingen
Flash Art, 224, May–June

2000 *Flash Art*, Summer

Selected Exhibitions

2003 Gavin Brown's enterprise, New York
'deutschemalereizweitausenddrei' (German Painting 2003), Kunstverein, Frankfurt

2002 'At the Edge of Forever', RomaRomaRoma, Rome
'Trust', Galerie Jennifer Flay, Paris
'My head is on fire but my heart is full of love', Charlottenborg Exhibition Hall, Copenhagen
'Hell', neugerriemschneider, Berlin

2001 'Beyond', Galerie Giti Nourbakhsch, Berlin
'Musterkarte', Galerie Heinrich Ehrhardt, Madrid

2000 Galerie Giti Nourbakhsch, Berlin
'Sympathie', Montparnasse, Berlin

Anselm **Reyle**

Born 1970
Lives Berlin

During the making of his films *The Red Desert* (1964) and *Blow-up* (1966), Michelangelo Antonioni painted his outdoor locations in order to emphasize their psychological effect on his characters. Anselm Reyle's day-glo found objects and paintings perform a similar trick. An old wooden cart painted in acid green or a wine press covered with a pungent purple livery become ciphers for psychedelic mind states rather than functional rustic tools. Similarly, his paintings take odd symbolic shapes far out on a trip into neon-coloured gestural abstraction. His paintings and sculptures are in dialogue with each other, their incongruous coloration describing psychological states beyond the sum of their parts. (DF)

Represented by Galerie Giti Nourbakhsch H6, GBE (Modern) A2

PeaRoeFoam - My Special Purpose
2002
Installation view, MuMoK, Vienna
Courtesy Galerie Hauser & Wirth
and David Zwirner

Selected Bibliography

2003 *PeaRoeFoam – The Impetuous Process, My Special Purpose and The Liver Pool*, Jason Rhoades, Museum Moderner Kunst Stiftung Ludwig, Vienna

2000 *Jason Rhoades – Perfect World*, Zdenek Felix, Deichtorhallen Hamburg, Oktagon, Cologne 'Tangential Talk on Rhoades, Eva Meyer-Hermann and Christian Scheidemann', *Parkett*, 58

1999 *The Snowball – a collaborative project by Peter Bonde & Jason Rhoades*, Marianne Øckenholt and Jérôme Sans, Hatje Cantz, Ostildern-Ruit

1998 *Jason Rhoades.Volume A Rhoades Referenz*, ed Eva Meyer-Hermann, Kunsthalle, Nuremberg; Van Abbemuseum, Eindhoven; Oktagon, Cologne

Jason **Rhoades**

Born 1965
Lives Los Angeles

Jason Rhoades once said 'If you know anything about my work you know that it is never finished.' Since his 1993 debut – when he installed himself in the midst of a scatter-installation of automotive tools and brandished a drill powered by a Chevrolet engine, Rhoades has created an ever-mutating body of work, extending his warped-DIY aesthetic to allegorically query the value of art production. In works such as the giant, smoke-emitting, phallus-shaped installation *Uno Momento / The Theatre in My Dick / A Look to the Physical / Ephemeral* (1996), this value is conflated with a hypertrophied masculinity. More recently, for *Costner Complex (Perfect Process)* (2001), he created a processing plant exposing vegetables to the entire oeuvre of Kevin Costner . Although he may appear unconvinced of art's value, his unhinged delight in choreographing disparate materials shines through. (MH)

Represented by Galerie Hauser & Wirth B5, David Zwirner F5

Selected Exhibitions

2002 'PeaRoeFoam, My Special Purpose', Museum Moderner Kunst Stiftung Ludwig, Vienna
'PeaRoeFoam, The Liver Pool', Liverpool Biennial

2001 'The Costner Complex Perfect Process', Portikus, Frankfurt

1999 'Perfect World', Deichtorhallen, Hamburg
Danish Pavilion (with Peter Bonde), Venice Biennale

1998 'The Purple Penis and the Venus (and Sutter's Mill) for Eindhoven: A Spiral with Flaps and Two Useless Appendages. After the Seven Stomachs of Nuremberg ', Van Abbemuseum, Eindhoven
'Sunshine & Noir: Art in Los Angeles 1960–1997', UCLA Hammer Museum of Art, Los Angeles

1997 Lyons Biennale
Whitney Biennial, Whitney Museum of American Art, New York
Venice Biennale

Die Verschaffung des Guten
(Procuring the Good)
2003
Oil on canvas
242×270cm
Courtesy Contemporary Fine Arts

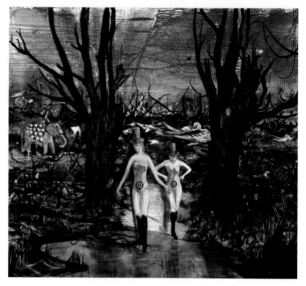

Selected Bibliography

2003 *Hirn* (Brain), ed Alexander Tolnay, Neuer Berliner Kunstverein and Hatje Cantz, Ostfildern-Ruit

2002 *Grünspan* (Verdigris), ed Julian Heynen, K21 Kunstsammlung Nordrhein-Westfalen, Bielefeld

2001 *Billard um halb Zehn* (Pool at half past nine), Kunsthalle zu Kiel

2000 *Kunsthalle Kiel – Acquisitions 1990–2000,* ed Beate Ermacora and Hans-Werner Schmidt, Kiel *Die Frau – Rock'n'Roll – Tod, Nein Danke!* (The woman – Rock'n'Roll – death, no thank you!), Daniel Richter, Contemporary Fine Arts, Berlin

1997 *17 Jahre Nasenbluten* (17 years of nosebleeds), Daniel Richter, Contemporary Fine Arts, Berlin

Selected Exhibitions

2003 'Hirn' (Brain), Neuer Berliner Kunstverein, Berlin
'Berlin – Moskau/Moskau – Berlin 1950–2000', Martin-Gropius-bau, Berlin
'Ludwig Richter and his followers + Daniel Richter', Hochschule für Bildende Künste, Dresden
'Hearn', Galerie Benier/Eliades, Athens

2002 'Grünspan' (Verdigris), K21 Kunstsammlung Nordrhein-Westfalen , Dusseldorf
'Preis der Nationalgalerie' (National gallery prize), Hamburger Bahnhof, Berlin
'Art after Art', Neues Museum Weserburg, Bremen

2001 'Billard um halb Zehn', Kunsthalle zu Kiel
'Vantage Point', Irish Museum of Modern Art, Dublin

2000 Contemporary Fine Arts, Berlin

Daniel **Richter**

Born 1962
Lives Berlin/Hamburg

Daniel Richter's earlier work looks as if someone had locked up a bunch of Abstract Expressionists and forced them to paint over each other's marks. Every single smudge and splash resonates with art history. While critical appraisal has often tried to explain Richter's work by referring to his éducation sentimentale in Hamburg's leftist Punk and Hip Hop scene, the artist himself has taken a less easy way out. Confidently juggling the urgency of early Baselitz, the cool mimesis of Gerhard Richter and the Brechtian canvas theatre of Immendorff, the winner of the prestigious Otto Dix prize paints monumental scenes of social struggle, saturated in a broad range of painterly strokes. (JöH)

Represented by Contemporary Fine Arts D4

865-5 Abstraktes Bild
(865-5 Abstract Picture)
2000
Oil on canvas
67×52cm
Courtesy Marian Goodman Gallery

Gerhard **Richter**

Born 1932
Lives Cologne

In 1963 painters Sigmar Polke, Konrad Lueg and
Gerhard Richter announced the birth of a movement
they called 'Capitalist Realism'. For Richter the
name cut both ways: a former disciple of Socialist
Realism, he had fled from East to West Germany.
In the ensuing decades he has subjected everything
from the abstractions of art to the death of politics
to his characteristic soft-edge technique: like eerie
apparitions behind frosted glass. Catherine David
made Richter's *Atlas* (1962– ongoing) – his vast and
ever-expanding grid of possible motifs – the focal
point of the 1997 Documenta. Recent works such
as the series of eight steel-mounted glass panels
enamelled in grey (*Acht Grau,* Eight Grey, 2002)
prove Richter's continuing ambition to push the
limits of his oeuvre, and art in general. It's as if planet
Earth, with all its visual variety, was being seen the
first time through the eyes of an alien. (JöH)

Represented by Marian Goodman Gallery C8

Selected Bibliography

2002 *Gerhard Richter: 40 Years of
Painting*, Robert Storr, Museum
of Modern Art, New York

2001 *Gerhard Richter: Paintings
1996–2001*, Benjamin H.D.
Buchloh, Marian Goodman
Gallery, New York

1999 *Gerhard Richter,
Aquarelle/Watercolors 1964–1997*,
Kunstmuseum, Winterthur

1993 *Gerhard Richter*, Musée d'Art
Moderne de la Ville de Paris; Kunst-
und Austellungshalle der
Bundesrepublik Deutschland,
Bonn; Moderna Museet,
Stockholm; Reina Sofia, Madrid
Volume I: exhibition catalogue
Volume II: essays by Benjamin H.D.
Buchloh
Volume III: catalogue raisonné,
1962–1993

Selected Exhibitions

2002 'Gerhard Richter: 40 Years of
Painting', Museum of Modern Art
New York, and touring

2001 Marian Goodman Gallery,
New York

1999–2000 'Gerhard Richter,
Aquarelle und Zeichnungen
1964–1999', Kunstmuseum,
Winterthur; Kupferstich-Kabinett,
Dresden; Kaiser Wilhelm Museum,
Krefeld

1998 'Landschaften', Sprengel
Museum, Hanover

1995 'Atlas', Dia Center for the
Arts, New York

1989 '18 Oktober 1977', Museum
Haus Esters, Krefeld; Portikus,
Frankfurt; ICA, London

1989 'Refigured Painting:
The German Image 1960–1988',
Guggenheim Museum, New York

Crystals X–XII
2003
16mm film, colour, silent, 5 minutes
Film still
Courtesy Galerie Daniel Buchholz

Selected Bibliography

2002 *Jeroen de Rijke & Willem de Rooij: Spaces and Films 1998–2002*, ed Eva Meyer-Hermann, Van Abbemuseum, Eindhoven

2001 'Being There', Dale McFarland, *frieze*, 56, January-February
De Rijke/De Rooij: Directors Cut, National Museum of Contemporary Art, Oslo

1999 *Jeroen de Rijke/Willem de Rooij. After the Hunt*, Kunstverein, Frankfurt; Museum Abteiberg, Mönchengladbach; Lukas & Sternberg, New York

1999 'Off the Silver Screen', Lars Bang Larsen, *nu:The Nordic Art Review*, 1

Selected Exhibitions

2003 Kunsthalle Zurich
Douglas Hyde Gallery, Dublin

2002 Galerie Daniel Buchholz, Cologne
ICA, London
Villa Arson, Nice

2001 The National Museum of Contemporary Art, Oslo
Regen Projects, Los Angeles

2000 Stedelijk Museum Bureau, Amsterdam
'Still/Moving', National Museum of Modern Art, Kyoto

1999 Galerie Daniel Buchholz, Cologne
Museum Abteiberg, Mönchengladbach

Jeroen de **Rijke** & Willem de **Rooij**

Born 1970/1969
Live Amsterdam

Jeroen de Rijke and Willem de Rooij make highly mannered, non-narrative, 16 and 35mm films, which are occasionally accompanied by photographs. These films are made to be screened in a specially constructed viewing area in museums and galleries and shown at regulated intervals. The images are concentrated, near-static, often exquisite studies of, for example, a flower, a church interior, a shantytown or a love affair. In a world of visual overload these films, even while referencing film and painting, offer some respite. What is important to de Rijke and de Rooij, according to Dale McFarland in *frieze*, is 'the preservation of unique images […] a kind of aesthetic autocracy in which the work itself must be protected from overexposure'. (JH)

Represented by Galerie Daniel Buchholz A2

Gerwald **Rockenschaub**

Born 1952
Lives Berlin

Working across painting, sculpture, architecture, animation and music, Gerwald Rockenschaub's icily cool installations reference Minimalist sculpture, Neo-Geo painting and stripped-back, minimal techno. Having been involved in the German and Austrian techno scenes and in co-running the Audioroom club in Vienna, his work is a carefully constructed refutation of crossovers between art and the idealistic social spaces of club culture. As Martin Pesch has written in *frieze*, his practice is 'a handling of the institutional character of gallery spaces that removes the illusion once and for all that art can leap out of its context and claim the successes achieved in other cultural spheres'. (DF)

Represented by Georg Kargl E11, Galerie Eva Presenhuber D7, Galerie Thaddaeus Ropac B14

Selected Bibliography

1999 'Junge Kunst: Techno', Silke Müller, *Art*, March

1996 'Die Entmythologisierung des White Cube', Anselm Wagner, *Noema,* 41

1993 'Nice – Villa Arson', Christian Kravagna, *Artforum*, February *Stellvertreter, Representatives, Rappresentanti, Andrea Fraser, Christian Philipp Müller, Gerwald Rockenschaub,* Austrian Pavilion, Venice Biennale

1984 *Gerald Rockenschaub*, Galerie nächst St Stephan, Vienna

Selected Exhibitions

2004 MUMOK, Vienna

2003 Chouakri Brahms, Berlin
Galerie Thaddaeus Ropac, Salzburg

2002 'No Red Tape', Georg Kargl, Vienna

2000 'Sentimentale', GAM, Turin
'Variations on Classic', Bawag Foundation, Vienna
Victoria Miro Gallery, London

1999 'Funky Minimal', Kunstverein, Hamburg; Le Consortium, Dijon
Georg Kargl, Vienna

1995 Galerie Susanna Kulli, St. Gallen

1993 Austrian Pavilion, Venice Biennale

It's late and the wind carries a faint sound …
1999
Video installation
Dimensions variable
Courtesy Galerie Eva Presenhuber

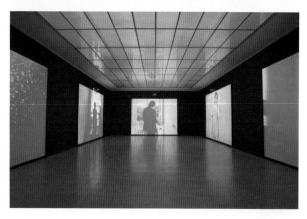

Selected Bibliography

2002 *Ugo Rondinone: No How On,* Kunsthalle, Vienna; Verlag der Buchhandlung Walther König, Cologne

2001 *Ugo Rondinone: Kiss Tomorrow Goodbye,* Palazzo delle Esposizioni, Rome
Rencontre 5: Ugo Rondinone, John Richardson, Almine Rech Editions/Editions Images Modernes, Paris

2000 *Hell,Yes!,* Ink Tree Edition, Kunstnacht

1999 *Ugo Rondinone: Guided by Voices,* Beatrix Ruf, Kunsthaus Glarus

Selected Exhibitions

2003 'Ugo Rondinone: Roundelay', Centre Georges Pompidou, Paris

2002 'Coming up for air', Kunstverein, Stuttgart
'No How On', Kunsthalle, Vienna
'Drawing Now: Eight Propositions', Museum of Modern Art at Queens, New York

2000 'So Much Water Close to Home', PS1, New York
'Eurovision', Saatchi Gallery, London
'Let's Entertain', Walker Arts Center, Minneapolis and touring

1999 'Guided by Voices', Galerie für Zeitgenössische Kunst, Leipzig and Kunsthaus Glarus

Ugo **Rondinone**

Born 1964
Lives New York

The wildly diverse work of Swiss-born, New York-based Ugo Rondinone looks upbeat but feels downhearted. Rondinone has scattered galleries with fibreglass models of disenchanted clowns; erected rainbow-coloured public signs reading 'Love Invents Us' and 'Hell Yes!' which, like adverts without a subject, seem to deny the possibility of effective communication; and made collages that, superimposing his head on supermodels' bodies, exaggerate the gulf between the two. His New York debut in 2000 spliced together Kenneth Noland-like target paintings, comic-like drawings, S&M photographs and a rock soundtrack. Rondinone acts out the role of an incurable romantic trapped in an existentialist play: he can't go on, he must, and he does. (MH)

Represented by Sadie Coles HQ B8, Matthew Marks Gallery C7, Galerie Eva Presenhuber D7, Galerie Almine Rech H7, Schipper & Krome E8, Sommer Contemporary Art C15

Untitled (Ricas y Famosas)
(Untitled (Rich and Famous)
2002
C-type print
76×102cm
Courtesy Greene Naftali

Selected Bibliography

2002 'Daniela Rossell', Holland
Cotter, *New York Times*, 26 April
2002
'Mundos privados, ilusiones
publicas', Cuauhtemoc Medina,
Reforma-cultura, 11 September 2002
'Daniela Rossell: Rich and
Infamous', David Hunt, *Artext*,
August–October

2000 'Profile: Daniela Rossell',
Naief Yehya, *Art Nexus*, August-
October

Selected Exhibitions

2004 Nikolaj Copenghagen
Contemporary Art Center

2003 'Terrorchic', Monika Sprüth
Philomena Magers, Munich
'Girls Night Out', Orange County
Museum of Art, Newport Beach
'Daniel Rossell', ArtPace, San
Antonio

2002 'Third World Blondes Have
More Money', Greene Naftali,
New York
'Mexico City: An Exhibition About
the Exchange Rates of Bodies and
Values', PS1, New York
'The Benefit of Art: Post-Feminist
Positions of the 1990s from the
Goetz Collection', Staatliche
Kunsthalle Baden-Baden
'Axis Mexico: Common Objects
and Cosmopolitan Acts', San Diego
Museum of Art
'Sublime Artificial', La Chapella,
Barcelona

2000 'Policies of Difference:
Iberoamerican Art at the Turn
of the Century',
Pavillao Manoel Nobrega of the
Pinacoteca do Estado de Saõ Paulo
and touring
'All the Best Names Are Taken',
Greene Naftali, New York

1996 'La Laguna des illusiones',
Arena Mexico, Expoarte
Guadalajara

Daniela **Rossell**

Born 1973
Lives Mexico City/New York

Conceptual photographer Daniela Rossell is the
Margaret Mead of Mexico's *ricas y famosas*. Like the
noted anthropologist of the South Seas, she's in the
right place at the right moment and probably can't
quite believe her good luck: the natives are friendly,
eagerly welcoming her into their homes, displaying
themselves in full regalia and showing off their most
cherished magical objects. Unlike Mead, however,
Rossell is also one of the locals, born into the same
privileged social class that she now captures in
elaborately staged photographs. These family friends
and relatives – the wives and daughters of the
country's uppermost elite – have got it all, self-
consciously posing amidst their baroque hordes of
plush possessions. But they also seem captive to the
kitsch dollhouse fantasies that pass for everyday life
in this oppressively insular demi-monde, safely
locked away behind the high walls surrounding
their islands of wealth. (JT)

Represented by Greene Naftali C10

701XXKA
(detail)
2003
Mixed media
Dimensions variable
Courtesy Meyer Riegger Galerie

Selected Bibliography

2003 'Temporal Asymmetry: the Psychogeography of Daniel Roth', Luca Cerizza, *Tema Celeste*, 96, March–April
'Notes from the underground', Daniel Birnbaum, *frieze*, 72, January–February

2000 *Daniel Roth: Das linke Bein des Offiziers* (Daniel Roth: the officer's left leg), Kunsthaus Glarus

1999 'Daniel Roth', Holger Liebs, *frieze*, 47, June–August
Bergsturz, Daniel Roth (landslip), ed Christoph Keller and Christiane Schoeller, Stuttgart

Selected Exhibitions

2003 '701XXKA', Kunstverein, Graz
'Inside the White Cube', White Cube, London

2002 'Schatzhauser Wald' (Forest of Schatzhausen), Meyer Riegger Galerie, Karlsruhe
'The Thermal Bath of the Naked Truth, Vision 1', maccarone inc., New York

2001 Artist Space, New York
Galerie Fons Welters, Amsterdam

2000 Art Statements, Art Basel
'Das linke Bein des Offiziers', Kunsthaus Glarus

1999 'Wie die Leichen der Mafia vorbeitreiben' (As the corpses of the Mafia are drifting by), Galerie Johnen & Schöttle, Cologne

1996 Galerie Thomas Riegger, Karlsruhe

Daniel **Roth**

Born 1969
Lives Karslruhe

In Daniel Roth's world you feel like an Indiana Jones character with a serious drug problem. Falling through a trapdoor in a Jules Verne-like underground command post, you slide through a tunnel, straight into a cellar underneath a hut in the Black Forest, or into a Bond-type villain's mansion or the ship protruding from a hill in Gabriele D'Annunzio's garden at Lake Garda. Yet Roth's 'painted stories' are not just random freak-outs but carefully constructed plots, executed in thin graphite strokes (on the wall or on to polished, rounded white plates), fleshed out with slides and sparse sculptural constructions. His scenarios may seem paranoid, but ultimately Roth's imaginative exuberance feels freer than level-headed nonchalance. (JöH)

Represented by maccarone inc. H2, Meyer Riegger Galerie B7

Nudes eb05
2003
Laserchrome with diasec
120×157cm
Courtesy David Zwirner

Thomas **Ruff**

Born 1958
Lives Dusseldorf

When Thomas Ruff began showing his austere, monumental colour portraits in the 1980s, critics immediately celebrated his vision, even as they argued over interpretations. Since then, Ruff has constantly shifted subjects and techniques, while continuing to produce provocative images. Working in series, he's portrayed suggestively blank interiors, appropriated astronomical photographs and created ominous urban landscapes with surveillance equipment. Recently he has abandoned the camera, using computer-altered pictures downloaded from the Internet: lushly coloured, painterly nudes are created from amateur pornography, and swirling abstractions from cartoons. Essentially, these are puzzle pictures, with some crucial element of photographic convention omitted or altered. It is up to the viewer to make sense of what remains. (SS)

Represented by Contemporary Fine Arts D4, Mai 36 Galerie D12, David Zwirner F5

Selected Bibliography

2003 *Thomas Ruff – Nudes*, Michel Houllebecq and Ulf Poschardt, Harry N. Abrams Inc., New York

2001 *Thomas Ruff – Fotografien 1979–heute*, Matthias Winzen et al, Staatliche Kunsthalle, Baden-Baden; Walther König, Cologne

1997 *Thomas Ruff*, Régis Durand, Centre National de la Photographie, Paris

1991 *Thomas Ruff*, Kunstverein, Bonn; Kunstverein, Arnsberg; Kunstverein, Braunschweig

1988 *Thomas Ruff – Porträts*, Ian Brunskill, Mai 36 Galerie, Lucerne

Selected Exhibitions

2001–3 Staatliche Kunsthalle, Baden-Baden, touring to Städtische Galerie im Lenbachhaus, Munich; Irish Museum of Modern Art, Dublin; Museu Serralves, Porto; Tate Liverpool

2000 'Nudes', David Zwirner, New York

1995 Venice Biennale

1992 Documenta, Kassel

1991 Kunstverein, Bonn, touring to Kunstverein, Arnsberg; Kunstverein, Braunschweig

1989 'Portraits, Houses, Stars', Stedelijk Museum, Amsterdam

1988 Mai 36 Galerie, Zurich Portikus, Frankfurt

1981 Galerie Rüdiger Schöttle, Munich

Cactus Portrait
2002
Photographic print
37×48cm
Courtesy greengrassi

Selected Bibliography

2003 'Karin Ruggaber/
greengrassi', Mark Wilsher,
What's On, 12 March 2003
'Karin Ruggaber/greengrassi',
Martin Coomer, *Time Out*, 12
March 2003

2002 'Rene Daniels, Karin
Ruggaber', Dan Wilkinson, *frieze*,
70, October
'Rene Daniels, Karin Ruggaber',
Alicia Miller, *Art Monthly*,
September
'Rene Daniels, Karin Ruggaber',
Mark Wilsher, *What's On*, July

Selected Exhibitions

2003 'US Work and Men's Shirts',
greengrassi, London

2002 'René Daniëls and Karin
Ruggaber', Bloomberg Space,
London
'Exchange', Richard Salmon,
London
'Predator', KX Kampnagel,
Hamburg
'Cowboy Cinema', Artlab, Mobile
Home, London

2000 'Peter Kapos, David
Musgrave, Karin Ruggaber',
greengrassi, London
Haus der Kunststiftung, Stuttgart

1999 'Set', Arthur R. Rose,
London
'Richard Wentworth's Thinking
Aloud', Kettle's Yard, Cambridge

1998 'New Contemporaries '98',
Tea Factory, Liverpool; Camden
Arts Centre, London; Hatton
Gallery, Newcastle

Karin **Ruggaber**

Born 1969
Lives London

The essence of Karin Ruggaber's disparate sculptures
is their persistent instability. While her rough-hewn
fence and makeshift lighting rig are more, or less,
functional than one expects (the light illuminates the
gallery; the fence serves to block visitors' movement),
Ruggaber's delicate pieces of stitched and draped
fabric tend to wallow happily in multiple associations.
Despite its descriptive title, her wood/material
aggregate *Book and Bag* (2002) more closely suggests
a clotheshorse hung with a harness – a faintly
anthropomorphic suggestion that, in a recent show,
was strengthened by proximity to sheets of metal
lightly stamped by horseshoes. Ruggaber may be
determinedly avoiding a signature style, but playful
ambiguity is her own unmistakable footprint. (MH)

Represented by greengrassi A3

Sex at Noon Taxes
2002
Acrylic on canvas
162.5×190cm
Courtesy Gagosian Gallery

Selected Bibliography

2000 *Edward Ruscha*, Hirshhorn Museum and Sculpture Garden, Washington DC

1989 *New Paintings and Drawings*, Tokyo Museum of Contemporary Art
Edward Ruscha. Paris, Pontus Hulten and Dan Cameron, Centre Georges Pompidou, Paris

1982 *The Works of Edward Ruscha*, Peter Plagens and Dave Hickey, San Francisco Museum of Modern Art

1976 *Edward Ruscha,* Howardina Pindell, Stedelijk Museum, Amsterdam

Ed **Ruscha**

Born 1937
Lives Los Angeles

After 40 years Ed Ruscha's art has come to seem as essential to the meaning of Los Angeles as the Hollywood sign. And like that iconic, block-letter non-monument up in the hills, it serves as a constant reminder of the way geography and language collaborate in forming the American unconscious. Picking up where Jasper Johns and the early Pop artists left off, Ruscha developed his own perfectly pitched iconography of glowing, precisely rendered surfaces and drolly ventriloquized vernacular. From the early artist's books of deadpan roadside photography, through the signature word-and-landscape paintings, to recent map-based images, he has created a body of work that explores the endless mystery of familiar signs. (SS)

Represented by Gagosian Gallery F7, Patrick Painter, Inc B1

Selected Exhibitions

2002 'Ed Ruscha: Made in Los Angeles', Reina Sofia, Madrid

2000 'Edward Ruscha: Retrospective,' Hirshhorn Museum and Sculpture Garden, Washington, DC

1998 'Retrospective of Works on Paper by Edward Ruscha,' J. Paul Getty Museum, Los Angeles

1990 'Edward Ruscha,' Fundacio la Caixa, Barcelona

1989 'New Paintings and Drawings', Tokyo Museum of Contemporary Art
'Edward Ruscha', Centre Georges Pompidou, Paris and touring

1988 'Edward Ruscha: Recent Paintings,' Museum of Contemporary Art, Chicago

1983 'Retrospective: The Works of Ed Ruscha,' San Francisco Museum of Modern Art and touring

1976 Stedelijk Museum, Amsterdam

1963 Ferus Gallery, Los Angeles

Artifical Life
1995
Slide projector with autofocus, dust
Dimensions variable
Courtesy Johann König

Selected Bibliography

2003 *Perform*, Jens Hoffmann, Joan
Jonas, Thames & Hudson, London

2002 *I Promise It's Political*, ed
Dorothea von Hantelmann,
Museum Ludwig, Cologne

2001 *Istanbul Biennale* Catalogue

2000 *Ars Viva*, Unternehmen
Bermuda

1998 *Karl Schmidt-Rottluff
Stipendium*, Kunsthalle Dusseldorf

Selected Exhibitions

2003 'Die Krankheiten des Uhus
und ihre Bedeutung für die
Wiedereinbürgerung in der
Bundesrepublik Deutschland'
(The Maladies of the Eagle-owl
and their Meaning for the
Reintegration in the Federal
Republic of Germany), Johann
König, Berlin
'Animations', Kunst-Werke, Berlin

2002 'Present but not yet active',
Manifesta, Frankfurt
'I Promise It's Political',
Museum Ludwig, Cologne

2001 Istanbul Biennale
'Ars Viva', ZKM, Karlsruhe

1999 'Children of Berlin', PS1,
New York

1998 'Schmidt-Rottluff-
Stipendium', Kunsthalle Dusseldorf

Natascha **Sadr Haghighian**

Born 1967
Lives Berlin

Participating in the group show 'I Promise It's
Political', Natascha Sadr Haghighian piped sound
samples made while the show was being installed –
hammering, sawing, snatches of radio – through
the loudspeakers of Cologne's Museum Ludwig,
producing a catchy institutional feedback. In her
recent show at Johann König the sound of a fluttering
bird was 'attached' to visitors; the sweetness turned
Hitchcockian when the virtual bird, increasingly
panic-stricken, circled the room and crashed against
the window. Berlin-based Haghighian (who took
part in the 2001 Istanbul Biennale) conceptualizes
exclusion and inclusion in works with socio-political
overtones. It's as if Robert Morris' *Box with the Sound
of its Own Making* (1961) – and the semiotic loop it
produces – was opened up to release myriad
contextual bits and bytes. (JöH)

Represented by Johann König B15

31°–131°
2003
Black and white photograph
110×160cm
Edition of 5
Courtesy Galerie Chantal Crousel

Anri **Sala**

Born 1976
Lives Paris

How can the links between personal experience and social reality be traced? In his video work Anri Sala seeks an answer to this question by exploring the potential of documentary images. In *Intervista* (1996) he journeys into the political past of his home country, Albania, by discussing with his mother her engagement in the communist youth party. In *Nocturnes* (1999) he explores one young UN soldier's memories of the Balkan war. Biographies like these open up the broader horizons of history. In recent works Sala has abandoned narrative and instead focused on isolated sequences of images: an old man dozing on a bench in a church, empty cages at a deserted zoo or crabs chased across a beach at night by torchlight. These moments exist outside time but still have the ability to serve as metaphors for history. (JV)

Represented by Galerie Chantal Crousel C17, Galerie Hauser & Wirth B5

Selected Bibliography

2003 *Anri Sala*, Gerald Matt, Hans-Ulrich Obrist and Edi Muka, Kunsthalle, Vienna

2002 *Moulène – Sala, São Paulo 2002*, Carta Blanca Editions, Marseilles

2001 *Anri Sala*, De Appel, Amsterdam

Selected Exhibitions

2003 'Anri Sala', Kunsthalle, Vienna

2002 'Concentrations 41', Dallas Museum of Art
'Missing Landscape and Promises', TRANS>AREA, New York
'Jean-Luc Moulène et Anri Sala', São Paulo Biennale

2001 'It Has Been Raining Here', Galerie Chantal Crousel, Paris
'Anri Sala, Nocturnes', Delfina, London

2000 'Anri Sala', De Appel, Amsterdam
'Nocturnes', Musée d'Art Moderne et Contemporain, Geneva
'El aire es azul/The air is blue', Casa Museo Luis Barragan, Mexico City
'The Gift, Generous Offerings, Threatening Hospitality', Palazzo delle Papesse, Sienna; Centro Culturale Candiani, Mestre

Spirit of Inclusiveness
2002
Wood, cooper, steel, brass, tin
275×277×223cm
Courtesy BQ

Selected Bibliography

2002 *Bojan Sarcevic, Zurvival guid*,
éditions MIX, Paris

2002 *Spirit of Versatility &
Inclusiveness*, BQ, Cologne

2001 *Cover Versions, Bojan Sarcevic*,
Stedelijk Museum Bureau,
Amsterdam

2000 *Die Lieblingskleider, die Frauen
und Männer während der Arbeit getragen
haben* (The favourite dresses women
and men wear during work),
Gesellschaft für aktuelle Kunst,
Bremen

1999 *Bojan Sarcevic*, BQ, Cologne

Selected Exhibitions

2003 Institut d'Art Contemporain,
Villeurbanne
Kunstverein, Munich
'Aperto', Venice Biennale

2002 BQ, Cologne

2001 'Traversée', Musée d'Art
Moderne de la Ville de Paris
Stedelijk Museum Bureau,
Amsterdam
Galerie Gebauer, Berlin

2000 Gesellschaft für aktuelle
Kunst, Bremen

1999 BQ, Cologne

1998 Manifesta, Luxembourg

Bojan **Sarcevic**

Born 1974
Lives Paris

Entering Bojan Sarcevic's installation at 'Manifesta
2' (*Untitled*, 1998) felt like you had taken a wrong
turning into an abandoned wing of Luxembourg's
Musée National. Plaster walls and false ceilings had
been subtly added, and every crack in the walls had
been filled with small plugs of toilet paper, as if to
seal off the space from vermin. More recent pieces
feel almost uplifting in comparison. At the Venice
Biennale 2003 an elegant construction of Perspex
and steel arches jutted into space like the dissected
quarter of the dome of a greenhouse: a concave cave
reserved for dreams of perfect retreat. Paris-based
Sarcevic reinvents modernity's clinical spaces with
what they were often built to exclude: paranoia,
poetry, playfulness. (JöH)

Represented by BQ B6, carlier | gebauer H9,
Galerie Yvon Lambert D16

By the River
2002
Acrylic and marker on MDF
80×120cm
Courtesy Sommer Contemporary Art

Selected Bibliography

2003 'Yehudit Sasportas, Berkeley Art Museum', Barry Schwabsky, *Artforum*, February

2002 *Yehudit Sasportas/Matrix 2000: By the River*, Heidi Zuckerman Jacobson & Phyllis Watts, Berkeley Art Museum, University of California
'What was in the beginning?: On the drawings of Yehudit Sasportas', Christina Végh, *Persönliche: Pläne*, Kunsthalle, Basel

2001 'Total Object Complete with Missing Parts: Tramway, Glasgow', Elizabeth Mahoney, *Art Monthly*, 250, October

1999 *Yehudit Sasportas, Ellen Ginton, Avi Ifargan, David Hunt, Elizabeth Janus, The Israeli Art Prize*, Nathan Gottesdiener Foundation and Tel Aviv Museum of Art

Yehudit **Sasportas**

Born 1969
Lives Tel Aviv

Yehudit Sasportas' bold, schematic drawings are spatial in conception, extending from wall to floor and requiring viewers to meander among compressed geometric carpets of abutting, overlapping imagery. Sasportas says that, for her, growing up in Israel meant acknowledging the 'feeling of being in a culture where everything came from somewhere else', a condition of discontinuity analogous to her decorative patterns, generic representational images and abstruse arrangements of scientific data, maps and diagrams, which fix borders and relationships where there would otherwise be drift and chaos. (JT)

Represented by Galerie EIGEN + ART F12, Sommer Contemporary Art C15

Selected Exhibitions

2003 Sommer Contemporary Art
'Chilufim', Kunstmuseum, Bonn
Kaiser Wilhelm Museum, Krefeld

2002 'Matrix', Berkeley Art Museum, University of California
'Persönliche: Pläne', Kunsthalle, Basel

2001 'How did it ever come so far…', Galerie EIGEN + ART, Berlin
'The Carpenter and the Seamstress 2', Deitch Projects, New York
'Total Object Complete with Missing Parts', Tramway, Glasgow
Kerlin Gallery, Dublin

2000 'The Carpenter and the Seamstress', Tel Aviv Museum of Art

1999 Istanbul Biennale

Orphan (Storm)
2002
ABS resin, steel, glitter, wig, hair
ornaments, ink, lacquer
115×70×47cm
Courtesy Gallery Side 2

Selected Bibliography

2003 'Dress up with Art', *Luca*,
April

2002 'Letter from Tokyo', Ben
Judd and Catherine Wood, *Art
Monthly*, February
'Making the Comfortable
Uncomfortable', Miki Takashima,
Daily Yomiuri, 30 May 2002

2000 'Review', Keiko Okamura,
Bijutsu Techo, LIV, 814, May

Selected Exhibitions

2002 'Shinako 2002', Gallery
Side 2, Tokyo
'Play House', Marella Arte
Contemporanea, Milan

2001 Elizabeth Cherry
Contemporary Art, Tucson
Diehl Vorderwuelbecke, Berlin

2000 'Eroginia', SMAK, Ghent
'Whippersnapper', Vedanta
Gallery, Chicago

Shinako **Sato**

Born 1965
Lives Tokyo

What is perhaps most notable about Shinako Sato's
work is how hard it is to dismiss. Looking at the
sticker-covered Polaroids of Barbie dolls in naughty
lingerie and soft-core poses, the other-worldly child
mannequins and the skewed collages of Ukiyo-e
prints, you might think at first you understand what
makes them tick. Sato mines familiar territory –
childhood, kitsch and a particularly Japanese take on
the erotic – moving in the spaces between innocence
and sensuality, between the uncanny and the cute.
Yet no laundry list of thematic concerns quite
explains away the nagging sense of strangeness
that these works leave in the mind. (SS)

Represented by Gallery Side 2 H10

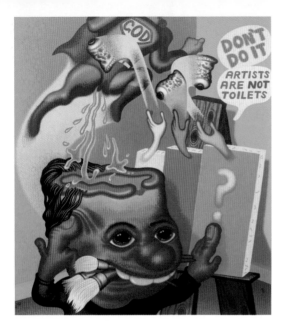

Artists are not Toilets
2002
Acrylic on canvas
188×167.5cm
Courtesy Galerie Aurel Scheibler

Selected Bibliography

2002 *Peter Saul, The Sixties*, Ellen H. Johnson, Nolan/Eckman Gallery, New York

2001 *Eye Infection*, Rudi Fuchs and Robert Storr, Stedelijk Museum, Amsterdam

2000 *Peter Saul, Heads 1986–2000*, including a conversation between Carrol Dunham and Peter Saul, Nolan/Eckman Gallery, New York

1999 *Peter Saul*, Robert Storr, Benoit Decron, Anne Tronche, Musée de l'Abbaye Sainte-Croix

1993 'It's Been Nice Gnawing You', Rhonda Lieberman, *Artforum,* December

Selected Exhibitions

2002 Galerie Aurel Scheibler, Cologne
'Eye Infection', Stedelijk Museum, Amsterdam

2001 'Open Ends', The Museum of Modern Art, New York

1999–2000 'Peter Saul', Musée de l'Abbaye Sainte-Croix and touring

1998 Nolan/Eckman Gallery, New York

1997 'Face à l'histoire 1933–1996', Centre Georges Pompidou, Paris

1995 Whitney Biennial, Whitney Museum of American Art, New York

1992 'Hand painted Pop: American Art in Transition, 1955–1962', Museum of Contemporary Art, Los Angeles and touring

1989 Museum of Contemporary Art, Chicago

1961–1994 Allan Frumkin Gallery, Chicago and New York

Peter **Saul**

Born 1934
Lives Germantown

Beneath the slick veneer of his not-quite-Pop canvases Peter Saul agitates cartoon-y forms and ideas. First shown in early 1960s New York, his paintings – often grand in scale – are so bright and brash that they sometimes threaten to tear free from their supports and duke it out (with you, with me, with the American Dream) in the street. Depicting frazzled historical counterfactuals, art-world let-downs and lame political and sexual jokes, they are utterly unapologetic – a stutteringly energetic hybrid of early Philip Roth, Robert Crumb and *Dumb and Dumber* (1994). (TM)

Represented by Galerie Aurel Scheibler D13

Monarch of the Glen
2002
Iris print
Edition of 25
89×118cm
Courtesy Paul Stolper

MONARCH OF THE GLEN
BY SIR EDWIN LANDSEER
BY SIR PETER BLAKE
PETER SAVILLE 2002

Selected Bibliography

2003 *Designed by Peter Saville*, ed Emily King, frieze, London
'At The Design Museum', Andrew O'Hagan, *London Review of Books*, 19 June 2003
'Hell Ma, You're An Artist', Charlotte Mullins, *Financial Times*, 21 May 2003

1992 *Sublime, the Sol Mix: Manchester Music and Design 1976–1992*, Cornerhouse, Manchester

1990–1 *Peter Saville, Graphics from PSA to Pentogram*, Julia Thrift, Parco Gallery, Tokyo

Selected Exhibitions

2003 Paul Stolper Gallery, London
'The Peter Saville Show', Design Museum, London

2000 'SHOWstudio', ongoing multidisciplinary art project, co-curated by Peter Saville and Nick Knight

1992 'Sublime, the Sol Mix: Manchester Music and Design 1976–1992', Cornerhouse, Manchester

1990–91 'Peter Saville, Graphics from PSA to Pentogram', Parco Gallery, Tokyo

1990 Partner in Pentogram, London

1986 'Festival of the Tenth Summer', installation, Manchester City Art Gallery, Manchester

1983 Peter Saville Associates

1979 Founder partner and Art Director, Factory Records, Manchester

Peter **Saville**

Born 1955
Lives London

Graphic designer Peter Saville holds the unique honour of being turned into a cinematic running gag. In last year's film *24-Hour Party People* – a skewed history of the Manchester post-Punk scene – he's caricatured as a mad-genius perfectionist, his aestheticism repeatedly defying budgets and deadlines. His album covers of the 1980s – all sharp, Bauhaus-inspired typography and austere Neo-Classical imagery, simultaneously lush and cool – remain icons of pop refinement, defining the look of the period. Later work in fashion and advertising continued these elegant high/low crossovers: the recent 'Waste Paintings', cannibalize and repurpose Saville's own earlier commercial work, giving yet another turn of the screw to his wry appropriation games. (SS)

Represented by Paul Stolper H13

Double Fake
2001
Wire, wood, yellow paper, glue
107×110×15cm
Courtesy Galerie Micheline
Szwajcer

Joe **Scanlan**

Born 1961
Lives New York

Joe Scanlan notes that just as 'people didn't know they wanted televisions until televisions were invented, how can the audience for art know what it wants until we, as artists, invent it for them?' For over a decade Scanlan has considered art's relation to commerce and consumption, carving out a 'legitimate niche market' for the avant-garde by constructing usable things that do double-duty as art objects. His projects have their origins in the artist's disposition as a do-it-yourselfer and his inclination to make practical items for himself economically. Scanlan's simple modular wood storage units are splendid as bookshelves when stacked up in a parlour, but don't look out of place as late Minimalist sculptures when nested within each other on the gallery floor. Their nature is potential and contingent, receptive to both contemplation and consumerist desire. (JT)

Represented by Galerie Martin Janda F14, Galerie Micheline Szwajcer E5

Selected Bibliography

1999 *Commerce 1: Nesting Bookcase, The First Decade: 1989–1999*, Store A, New York

1998 *Pay For Your Pleasure (reprise)*, Museum of Contemporary Art, Chicago

1996 *Joe Scanlan*, Kaiser Wilhelm Museum, Museum Haus Lange, Krefeld

Selected Exhibitions

2003 'Pay Dirt', Ikon Gallery, Birmingham
'Do It Yourself – Dead On Arrival – Pay For Your Pleasure', Institut d'Art Contemporain, Villeurbanne

2002 'No Ghost Just a Shell', Kunsthalle, Zurich; Van Abbemuseum, Eindhoven

2001 'Frank, Joe & Co.' (with Frank Gehry), Kunstmuseum, Herford

2000 'Raum Aktueller Kunst', Martin Janda, Vienna

1999 'Product no. 2', Los Angeles Contemporary Exhibitions

1998 'Les Moules', FRAC Languedoc-Roussillon, Montpellier
'Pay For Your Pleasure (reprise)', Museum of Contemporary Art, Chicago

1996 Museum Haus Lange, Krefeld

1995 Yard Sale, Chicago

Aussaat des Schlafmohns
Oil on canvas
2003
150×120cm
Courtesy Galerie Hammelehle und
Ahrens

Selected Bibliography

2003 *Tagebuch einer Frau*, (Diary of a Woman), Brotherslasher, Cologne

2002 *Fear of a Kind Planet*, Possible Press, Berlin

2000 *Matthias Schaufler – Nackte* (Nudes), Robert Fleck, Galerie Hammelehle und Ahrens, Stuttgart; Galerie Karlheinz Meyer, Karlsruhe

1993 'William Holden Company – The Hot Tour', *Kunstforum International*, 122

1991 *William Holden Company – The Hot Tour*, Jutta Koether and Barbara Straka, Wewerka & Weiss Galerie, Berlin

Selected Exhibitions

2003 'Tagebuch einer Frau' (Diary of a Woman), Brotherslasher, Cologne
'In portraiture irrelevance is ugliness', Museum Schloss Hardenberg, Velbert

2002 'Bataille für Kinder' (Bataille for Children), Galerie Hammelehle und Ahrens, Showroom kleiner Schlossplatz, Stuttgart

2000 'Nackte' (Nudes), Galerie Hammelehle und Ahrens, Stuttgart

1999 'Malerei' (Painting), INIT-Kunsthalle, Berlin

1998 Wiensowski und Harbord, Berlin

1996 'Glockengeschrei nach Deutz – das Beste aller Seiten' (Bells shouting towards Deutz – the Best from all Sides), Galerie Daniel Buchholz, Cologne

1995 Galerie Hammelehle und Ahrens, Stuttgart

1994 'Dialogues', Provinciaal Museum, Hasselt

1991 'William Holden Company', Galerie Christian Nagel, Cologne

Matthias **Schaufler**

Born 1964
Lives Cologne

Revisiting the 1950s, Matthias Schaufler rescues Tachisme from its isolated position in the history of abstraction. Untouched by the pathos, clichés and dogmas of Expressionism, Schaufler continues to explore the possibilities of gestural painting left unrealized by artists such as Wols, expanding both the spectrum of colours and the range of articulated emotions. With Schaufler, Tachisme is not limited to grungy ciphers of despair. His works may at times be dark and Gothic, yet at other times they revel in the unashamed beauty of uplifting pastel colours. Many of those who continue to paint do so with an apologetic irony. Schaufler does not need to make excuses. His paintings can afford to be serious. (JV)

Represented by Galerie Hammelehle und Ahrens E13

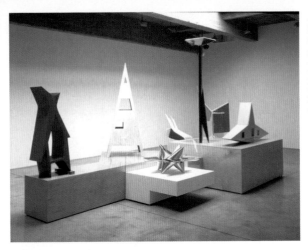

Selected Bibliography

2003 *deutschemalereiz-weitausenddrei*
(German Painting 2003), Nicolaus
Schafhausen, Kunstverein,
Frankfurt

2002 *Vitamin P: New Perspectives in
Painting*, ed Valérie Breuvart
Phaidon, London
Painting Pictures, Kunstmuseum,
Wolfsburg

2001 *Thomas Scheibitz: Bannister
Diamond*, Rudi Fuchs and Maarten
Bertheux, Stedelijk Museum,
Amsterdam
Thomas Scheibitz, Dieter Schwarz
and Hans-Werner Schmidt,
Kunstmuseum Winterthur; Museum
der bildenden Künste, Leipzig

Thomas **Scheibitz**

Born 1968
Lives Berlin

Thomas Scheibitz first achieved recognition together
with fellow Dresden painters Eberhard Havekost
and Frank Nitsche, but has quickly carved out a
distinctive niche for himself – particularly since he
has recently reintroduced sculpture into his work.
Like his canvases, these are full of sharp angles and
awkward couplings, playing off jagged seams against
recognizable icons, colour planes against suggestions
of space, abstraction against representation. Their
deadpan wit is at times reminiscent of Franz West.
Closer to rapture than rupture, Scheibitz' work
embraces the idea of endless mutation and ruthless
joy on the basis of a shared, practical, anti-
hierarchical, maybe even universal, grammar
of form. (JöH)

Represented by Tanya Bonakdar Gallery E7

Luc Tuymans
2002
Acrylic on canvas
90×80cm
Courtesy Jablonka Galerie Linn
Lühn

Selected Bibliography

2003 'Hein-Schellberg-Wohnseifer', Alice Koegel, *Stadt Revue Köln*, February

2002 Jürgen Raap, *Kölner Illustrierte*, December
Wie Räume versinken (When rooms drown), *Helga Meister*, March

Selected Exhibitions

2003 'Sammlung Falckenberg' (Falckenberg collection), Phoenix Hallen, Hamburg
'Jeppe Hein, Christoph Schellberg, Johannes Wohnseifer', Schnitttraum, Cologne

2002 'Auction', Neuer Aachener Kunstverein, Aachen
Jablonka Galerie Linn Lühn, Cologne

2001 'The Complete Dialogue', Kölnerstrasse, Dusseldorf

1999 Glück durch Paarung' (Happiness through Coupling), Suermondt Ludwig Museum, Aachen

Christoph **Schellberg**

Born 1973
Lives Cologne

Name ten people who have influenced your life. Who would they be? Relatives? Celebrities? Contemporaries or figures from the past? Christoph Schellberg paints the people on his list. His oversized portraits show artist friends side by side with stars of the international art world, with everyone getting the same rough painterly treatment. Is painting those who have shaped your life a way to express adoration for, and spend time in the symbolic presence of, the person whose face one reproduces on the canvas? Or is it, conversely, a means of exorcizing the ghost of a personality that has been haunting one's thoughts and emotions? The answer is probably both. It seems that in Schellberg's work love and mockery inevitably go hand in hand. (JV)

Represented by Jablonka Galerie Linn Lühn G11

Note: This is Propaganda 2002 ~~Connemara Landscape, 1980~~, is to be experienced as ~~a~~ Suit ~~projected image~~. The artist kindly requests that the ~~image~~ Piece is not photographed or visually recorded.

♡ Tino Sehgal
~~James Coleman~~

Tino **Sehgal**

Born 1976
Lives London

Tino Sehgal's artwork is almost not there at all. His interventions slip ghostlike into gallery spaces and leave behind the barest trace of their occurrence: a disembodied voice sings 'This is propaganda' over and over; a museum guard flaps his arms and announces 'This is good'. These gestures seem to be pointing to something, but in the end indicate only themselves. Sehgal's dematerialized routines turn their back not only on the idea of art as object but also on the various performative signposts that have historically marked such a refusal: spontaneity, documentation, the body of the artist. What remain are ambiguous, free-floating statements, incidents that enact their own disappearance. (SS)

Represented by The Wrong Gallery H1

Selected Bibliography

2003 'This is Tino Sehgal', Jens Hoffmann, *Parkett*, 68, September Interview, Hans-Ulrich Obrist, *Kunstpreis der Böttcherstrasse*, Kunsthalle Bremen

2002 *Moi je dis, moi je dis*, Stéphanie Moisdon, Galerie Jan Mot, Brussels 'Au commencement était l'équation', Marten Spangberg, *Artpress spécial*, 23

2001 'Art moving politics', Dorothea von Hantelmann, *Lesebuch Badischer Kunstverein*

Selected Exhibitions

2003 'This is wrong', The Wrong Gallery, New York
'Utopia Station,' Venice Biennale
'Kunstpreis der Böttcherstrasse in Bremen', Kunsthalle Bremen
'Le Plein', Galerie Jan Mot, Brussels

2002 'I promise it's political', Museum Ludwig, Cologne
'This is propaganda', Württembergischer Kunstverein, Stuttgart
Manifesta, Städel Museum, Frankfurt

2001 'Do it', Museo de Arte Carillo Gil, Mexico City
'A Little Bit of History Repeated', Kunst-Werke, Berlin
'I'll never let you go', Moderna Museet, Stockholm

2000 SMAK, Ghent

America (Playboy Bunny)
2002
Cibachrome, silicone, Perspex,
wooden frame
152×126cm
Courtesy Gimpel Fils

Selected Bibliography

2000 *Andres Serrano: Placing Time and Evil*, Barbican Art Gallery, London
Andres Serrano: Big Women, Marco Noire Editore, Turin

1999 *The American Century: Art & Culture 1950–2000*, Whitney Museum of American Art, New York

1996 *Andres Serrano: Works 1983–1993*, ed Patrick T. Murphy, University of Pennsylvania, Philadelphia

1995 *Andres Serrano: Body and Soul*, Takarajima Books, New York

Selected Exhibitions

2002 'America', Gimpel Fils, London

2001 'The Interpretation of Dreams', Paula Cooper Gallery, New York

2000–01 'Body and Soul', Barbican Art Gallery, London and touring

2000 'Faith: The Impact of Judeo-Christian Religion on Art at the Millennium', Aldrich Museum of Contemporary Art, Ridgefield

1998 'Andres Serrano: A History of Sex', Photology, Milan; Photology, London

1994–5 'Andres Serrano: Works 1983–93', Institute of Contemporary Art, University of Pennsylvania, Philadelphia and touring

1994–5 'Black Male: Representations of Masculinity in Contemporary American Art', Whitney Museum of American Art, New York, and UCLA Hammer Museum of Art, Los Angeles

1991 'Nomads', Denver Museum of Art

Andres **Serrano**

Born 1950
Lives New York

Andres Serrano has come a long way since his photograph *Piss Christ* (1987) drove America's religious right into apoplexy. A master button-pusher who acts innocent in interviews, he has placed many of polite society's myriad bêtes noires – hooded Klansmen, female bodybuilders, people beaten to death by police – under its collective nose, in a profusion of colour and flawless photographic technique. The ostensible innocuousness of 'America' (2002) accordingly surprised some; created in the aftermath of September 11, these 49 portraits of American citizens were, he says, a patriotic statement. Taken in the context of his career, however, they could be viewed as yet another weird spectacle: that of a powerful nation united by vulnerability. Suggestions that Serrano is softening may well be premature. (MH)

Represented by Gimpel Fils D1, Galerie Yvon Lambert D16

4 January 2000
From 'Washing-Up'
2000
C-type print
47×60cm
Courtesy MW projects

Nigel **Shafran**

Born 1964
Lives London

Nigel Shafran likes looking at the overlooked. 'I'd love to see washing up from Tudor times', he once commented. For a year he took photographs of the dishes in his sink, and listed everything he ate ('Ruth and me, caffe latte and shared a croissant'). He has documented his father's office, charity shops, parking spaces and street markets. His images are quiet and observant; he sees the expressive possibilities in a grubby railing or a knee. Shafran focuses on the melancholy beauty of urban life; cities created by the traces its inhabitants leave on their surface. (JH)

Represented by MW projects C1

Selected Bibliography

2003 *Fourth Sex:Adolescent Extremes*, Francesco Bonami, Raf Simons, Stazione Leopolda, Florence

2002 *Reality Check*, The Photographers' Gallery and British Council, London

1999 *Dad's Office*, artist's book, self-published

1995 *Ruthbook*, artist's book, self-published

Selected Exhibitions

2003 'The Fourth Sex: Adolescent Extremes', Stazione Leopolda, Florence

2002 'reViewing Landscape; Photographs of Contemporary England', art and photographs, London
'Reality Check', Wharf Road, London; organised by The Photographers' Gallery and British Council
'The Spectator', Salzburg, Austria MW projects, London

2001 'Washing Up 2000, Week 25', Fig-1, London

2000 'Photographs by Nigel Shafran, 1992–2000', Taka Ishi Gallery, Tokyo
'Breathless: Photography and Time', Victoria and Albert Museum, London

1999 'Blue Suburban Sky', The Photographers' Gallery, London Exhibition of museum portfolio commissioned by the Victoria and Albert Museum, London

1998 'Look at me', Kunsthalle, Rotterdam

Scenes from the Passion: Late
2002
Humbrol enamel on board
91×121cm
Courtesy Tate Collection/Wilkinson Gallery

Selected Bibliography

2003 *George Shaw*, Michael Bracewell, Ikon Gallery, Birmingham; Dundee Centre of Contemporary Art
Vitamin P: New Perspectives in Painting, ed Valérie Breuvart, Phaidon, London
Micro/Macro: Contemporary British Art, Kunsthalle Mucsarnok, Budapest and British Council

2001 *The New Life*, IDST, Anthony Wilkinson Galley, London

Selected Exhibitions

2003 Ikon Gallery, Birmingham, touring to Dundee Centre of Contemporary Art
'Micro/Macro, Contemporary British Art', Kunsthalle Mucsarnok, Budapest
'Days Like These: Tate Triennial 2003', Tate Britain, London

2001 'The New Life', Anthony Wilkinson Gallery, London

1999 'Of Innocence: Scenes from the Passion', Anthony Wilkinson Galley, London
'Pictures of Pictures', Arnolfini Gallery, Bristol
John Moores, Walker Museum & Art Gallery, Liverpool
'East International', Norwich Art Gallery

1998 'A–Z', The Approach, London

1997 'Interesting Painting', City Racing, London

George **Shaw**

Born 1966
Lives Nottingham

George Shaw depicts the suburbs of his youth, using enamel model aircraft paints to draw out their every damp, bland detail. He presents us with in-between places: underpasses, paths home and the backs of bad pubs. These are spots in which to build dens and bury secrets, to smoke stolen cigarettes and kiss the third-prettiest girl in school. There is nostalgia in Shaw's paintings, but also a muted spirituality and sense of half-absorbed dread. Suffused with the odd, cloudless-day light of memory, these immaculate images – which Shaw has described as 'headstones' – seem to square up to the artist's own flight from suburbia, a place whose flower beds and shrubberies conceal the bodies of his abandoned adolescent heroes. (TM)

Represented by Wilkinson Gallery E1

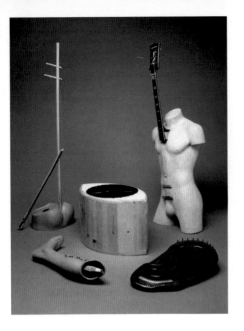

Musical Instrument Sculptures; Torso Guitar, Ear Harp, Foreleg Melodica, Anal Violin, Eye Tongue Drum
2002
Dimensions variable
Courtesy Galerie Praz-Delavallade

Jim **Shaw**

Born 1952
Lives Los Angeles

Imagine a crammed, dusty shop where all the visual styles of the last 50 years – vernacular and highbrow, discarded and venerated – are stacked indiscriminately. That shop could be Jim Shaw's mind, a place where Barnett and Alfred E. Newman are secretly brothers. Masterfully slipping in and out of borrowed forms, Shaw plays cut-and-mix with everything from sci-fi illustration to Minimalist sculpture to ham-handed amateur Surrealism. His multi-part, quasi-narrative projects include a psychedelically rendered 1960s coming-of-age story, a series of cheerfully demented sculptures based on his dreams, and the invention of an entire religion. Dazzling with their giddy excess of reference, these works continually ask where images come from and what they do. (SS)

Represented by Patrick Painter, Inc B1, Galerie Praz-Delavallade B18, Emily Tsingou Gallery A6

Selected Bibliography

2000 'Shaw's Carnival of the Mind', Michael Duncan, *Art In America*, December
Everything Must Go, Smart Art Press, Santa Monica

1995 *Dreams*, Jim Shaw, Smart Art Press, Santa Monica

1990 *Thrift Store Paintings*, Heavy Industry Publications, Los Angeles

1981 *Life and Death: a non narrative narrative by Jim Shaw*, The End Is Here Publications, Los Angeles

Selected Exhibitions

2003 'How High Can You Fly', Kunsthaus Glarus

2002 'French Collection', Musée d'Art Moderne et Contemporain, Geneva
Swiss Institute, New York
'The Rite of the 360° Degree', Galerie Praz-Delavallade, Paris

2001 Metro Pictures, New York
Galerie Praz-Delavallade, Paris

2000 'The Thrift Store Painting', ICA, London
Musée d'Art Moderne et Contemporain, Geneva

1999 Galerie Praz-Delavallade, Paris
Casino Luxembourg– Forum d'Art Contemporain

Conrad **Shawcross**

Born 1977
Lives London

The titular centrepiece of Conrad Shawcross' solo début, *The Nervous Systems* (2002), was a sprawling oaken loom, constantly producing a double-helical twist of wool and designed to deliver a representation of the shape of time. Such vaulting ambition typifies his work. In the guise of alter ego Bruce Springshaw he has driven around in 'The Soulcatcher', a battered Ford Capri fitted with hooks for plucking human souls from the ether; while another oaken machine, *Pre-Retroscope* (2003), is intended to allow its user to make a 360-degree film of the surroundings and thus 'capture a moment'. Is Shawcross mocking, or aspiring to, the figuring of transcendent verities? While making absorbing, beautifully rendered work, he has thus far maintained a poker face. (MH)

Represented by Entwistle E2

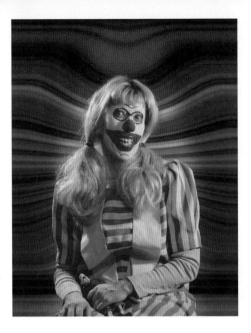

Untitled # 412
2003
C-type print
129.5×104cm
Courtesy Sprüth Magers Lee

Selected Bibliography

2000 *Early Works of Cindy Sherman*, Edsel Williams, Bookseller, New York

1997 *Cindy Sherman*, Katharina Schmidt, Marc Scheps, Museum Ludwig, Cologne
Cindy Sherman: Retrospective, Amanda Cruz, et al, Museum of Contemporary Art, Los Angeles

1996 *Cindy Sherman*, Amelia Arenas, et al, Museum of Modern Art, Shiga; Marugame Genichiro-Inokuma Museum of Contemporary Art; Museum of Contemporary Art, Tokyo

1994 *From Beyond the Pale – Cindy Sherman Photographs, 1977–1993*, Irish Museum of Modern Art, Dublin

1993 *Cindy Sherman: 1975–1993*, Rosalind Krauss, Rizzoli, New York

Cindy **Sherman**

Born 1954
Lives New York

For almost 30 years Cindy Sherman has been taking photographs of herself – images she has never considered self-portraits. Her career began in the 1970s with 69 black and white photographs entitled 'Untitled Film Stills'. As with her subsequent work, Sherman starred in, directed and shot every photograph, in which, variously disguised, she is pictured in the middle of highly charged, imaginary B-movie scenarios. Despite her protestations, Sherman's images have been used by various writers to expound theories from feminist film theory to the Culture of the Spectacle. More recently, she has referenced genres as varied as horror, pornography, Old Master painting and the potent expressive possibilities of the clown. (JH)

Represented by greengrassi A3, Galerie Ghislaine Hussenot F15, Sprüth Magers Lee B3

Selected Exhibitions

2003 Serpentine Gallery, London

2000 Hasselblad Centre, Gothenburg

1997 'The Complete Untitled Film Stills', Museum of Modern Art, New York

1997–2000 'Retrospective', Museum of Contemporary Art, Los Angeles and touring

1996 Museum Boijmans van Beuningen, Rotterdam and touring

1995 'Cindy Sherman Photography, 1975–1995', Deichtorhallen and touring

1991 Kunsthalle, Basel; Staatsgalerie Moderner Kunst, Munich and touring

1987 Whitney Museum of American Art, New York and touring

1984 Art Museum, Akron, Institute of Contemporary Art, Philadelphia and touring

From 'Goter' series
2002
C-type print
50×70cm
Courtesy Sommer
Contemporary Art

Selected Bibliography

2003 *Goter*, Ulrich Look, Nathan Gottesdiener Foundation and the Tel-Aviv Museum of Art

2001 *Unrecognized*, European Parliament, Brussels
Children, ed Hana Kofler, Arab-Jewish Center, Haifa

2000 *Between the Mountain and the Sea*, ed Yehudit Matzkel, Haifa Museums
Unrecognized, ed Tal Ben Zvi, Heinrich Boll Foundation Gallery, Tel Aviv

Selected Exhibitions

2003 'DisORIENTation', Ikon Gallery, Birmingham; House of World Cultures, Berlin
'Goter', Tel Aviv Museum

2002 'Five Senses', Acco Festival of Alternative Israeli Theatre, Acre
'Positioning', Hagar Gallery, Jaffa and Tel Aviv
'Unrecognized' & 'Wadi Saleib in Nine Volumes', Salle Polyvalente, European Parliament, Brussels
'Empathy, Art, Gender & Politics', Fujikawa Gallery, Osaka
'Palestine: Israel 2002/The End of the Future?', Museum für Völkerkunde, Hamburg

2000 'Unrecognized', International Movie Festival For Human Rights, Heinrich Boll Foundation Gallery, Tel Aviv

1999 'Wadi Saleib in Nine Volumes', Heinrich Böll Foundation Gallery, Tel Aviv

Ahlam **Shibli**

Born 1970
Lives Haifa

Brought up in a Bedouin Galilean village, Ahlam Shibli photographs different locations in that region. Expressionist and objective by turns, her most widely exhibited series, 'Personal Voyage in Nine Volumes' (1999), surveys a ghost town and developed, she says, from stories written on an abandoned typewriter she found there. The series 'Unrecognised' (2000) concerns an Arab village that, because it doesn't appear on an official map, is denied water, electricity and sewerage; 'Goter' (2002) explores a Bedouin camp. If you didn't already know that Shibli had laboured for four years as a social worker in such places, her unswerving imagery would furnish a strong clue. (MH)

Represented by Sommer Contemporary Art C15

Episode
2003
Installation view
Dimensions variable
Courtesy Annely Juda Fine Art

Yuko **Shiraishi**

Born 1956
Lives London

Yuko Shiraishi's abstract paintings may appear to share the same severe economy of form as those of that celebrant of the square Josef Albers, yet the attributes she gives to her palette possess an altogether human quality. Placed off-centre against an imperial purple field, a magenta square, we are told in the title, is 'halting'; a pale terracotta background is described as being in the process of 'obtaining' a smaller black quadrilateral in the middle of the canvas; while white squares 'emerge' from pale rectangles. Her colours are entities that work and perform, describing in abstract form a panoply of potential psychological effects. (DF)

Represented by Annely Juda Fine Art F3

Selected Bibliography

2002 *Yuko Shiraishi – Episode*, Mead Gallery, University of Warwick
Die Unendliche Linie, the Infinite Line, Volker Rattemeyer, Renate Petzinger and Katja Blomberg, Museum Wiesbaden

1996 *Yuko Shiraishi*, Hatje Cantz Verlag, Ostfildern-Ruit

Selected Exhibitions

2003 'Yuko Shiraishi – There and Back', Crawford Municipal Art Gallery, Cork
'Episode', Leeds City Art Gallery

2002 'Episode', Mead Gallery, University of Warwick
'Infinite Line', Museum Wiesbaden

2001 'Assemble-Disperse', Annely Juda Fine Art, London

1998 'Yuko Shiraishi', Ernst Museum, Budapest

Trail's End Restaurant, Kanab, Utah,
August 10, 1973
1973–2003
C-type print
Edition of 8
50×60cm
Courtesy Galerie Rodolphe Janssen

Selected Bibliography

1999 *American Surfaces*, Stephen Shore, Schirmer-Mosel, Munich

1998 *The Nature of Photographs*, Stephen Shore, Johns Hopkins, Baltimore

1995 *The Velvet Years: Warhol's Factory, 1965–1967*, Stephen Shore, Thunder's Mouth Press, New York

1994 *Stephen Shore. Photographs 1973–1993*, Schirmer-Mosel, Munich

1983 *The Gardens at Giverny*, Stephen Shore, Aperture, New York

Selected Exhibitions

2003 'Cruel and Tender', Tate Modern, London

1995 PaceWildensteinMacGill, New York
'Stephen Shore: Photographs, 1973–1993', Sprengel Museum, Hanover

1976 Museum of Modern Art, New York

1973 Galerie Rodolphe Janssen, Brussels

1972 Galerie Conrads, Dusseldorf
'Settings and Players (…)', White Cube2, London

1971 'American Surfaces', SK Stiftung Kultur, Cologne; Fotografie Forum, Frankfurt
303 Gallery, New York

1971 Metropolitan Museum of Art, New York

Stephen **Shore**

Born 1947
Lives New York

Stephen Shore began his career as something of a photographic prodigy: his work was acquired by the Museum of Modern Art when he was 14 years old, and at 24 he presented a solo show at the Metropolitan Museum, the first given to a living photographer. Most resonant today, though, are his large-scale colour contact prints done in the 1970s. The carefully composed, light-filled scenes of small-town America are replete with visual information, every bit of space granted equal attention. Looking at these ground-breaking photographs, you are struck by how much this way of seeing set a pattern for later artists. Continuing to work with a range of formats and subjects, Shore remains a masterful influence and innovator. (SS)

Represented by 303 Gallery C12, Galerie Rodolphe Janssen D2

Selected Bibliography

2003 'Andreas Siekmann:
Die Exklusive. Zur Politik des
ausgeschlossenen Vierten/The
Exclusive. On the Politics of the
excluded Fourth', Clemens
Krümmel, *Magazin 7*, Kunstverein,
Salzburg

2002 *Documenta*, Hatje Cantz
Verlag, Ostfildern-Ruit

2000 *Andreas Siekmann:Aus:
Gesellschaft mit beschränkter
Haftung/From: Limited Liability
Company*, Walther König, Cologne

1997 *Andreas Siekmann:Platz der
permanenten Neugestaltung/Square of
permanent Recreation*, Walther König,
Cologne

Selected Exhibitions

2003 'The Structure of Survival',
Venice Biennale

2002 Documenta, Kassel
'Museutopia', Karl-Ernst Osthaus
Museum, Hagen
'ForwArt 2002', Brussels
'Andreas Siekmann: Die Exklusive.
Zur Politik des ausgeschlossenen
Vierten'/The Exclusive. On the
Politics of the excluded Fourth,
Kunstverein, Salzburg

2001 Art Statements, Art Basel
Bundesgartenschau, Potsdam

2000 'Andreas Siekmann:
Welcome to the site of...', Galerie
Barbara Weiss, Berlin

1999 'Andreas Siekmann: Aus:
Gesellschaft mit beschränkter
Haftung/From: Limited Liability
Company', Portikus, Frankfurt

1997 'Andreas Siekmann: Platz der
permanenten Neugestaltung/
Square of permanent Recreation',
Neuer Aachener Kunstverein,
Aachen

1996 'Parkfiction', Elbpark St
Pauli, Hamburg

1993 Sonsbeek 93, Arnhem

Andreas **Siekmann**

Born 1961
Lives Berlin

Together with his colleague Alice Creischer,
Andreas Siekmann commented throughout the 1990s
on political topics, both in his artworks and in his
writings. His criticism focused on issues such as the
conversion of public urban space into commercially
exploited and heavily policed private property – and
the continual economic self-exploitation brought
about by the neo-liberal ideology of flexible
individualism. Indebted to both the analytical rigour
of Hans Haacke and the imaginative Agit-prop of
Jörg Immendorf, Siekmann has articulated his
position in a range of media, from animated films to
series of narrative drawings displayed in installations.
His work reads like a critical essay in which
observations, reflections and associations inform
each other in a dynamic interplay. (JV)

Represented by Galerie Barbara Weiss F14

United World Corp
2002
Watercolour and dry pigment on
paper
20×24cm
Courtesy Brent Sikkema

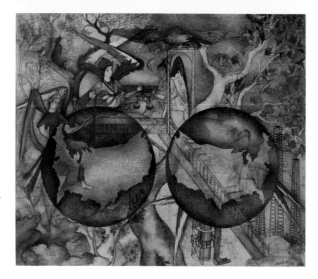

Selected Bibliography

2002 *Drawing Now: Eight
Propositions*, Laura Hoptman,
Museum of Modern Art at Queens,
New York

2000 *Directions, Shahzia Sikander*,
Valerie Fletcher, Hirshhorn
Museum, Washington DC

1999 *Conversations with Traditions:
Nilima Sheikh and Shahzia Sikander*,
Vishakha N. Desai, The Asia
Society, New York

1998 *Chillava Klatch: Shahzia
Sikander interviewed by Homi Bhabha*,
Renaissance Society, University of
Chicago

Selected Exhibitions

2003 'SpiNN', Brent Sikkema,
New York
'Intimacy', ArtPace, San Antonio

2002 'Drawing Now: Eight
Propositions', Museum of Modern
Art at Queens, New York

2001 'Conversations with
Traditions, Nilima Sheikh and
Shahzia Sikander', Asia Society,
New York and touring

2000 'Acts of Balance', Whitney
Museum, New York

1999 'Shahzia Sikander',
Directions, Hirshhorn Museum and
Sculpture Garden, Washington DC

1999 'Shahzia Sikander', Kemper
Museum of Contemporary Art and
Design, Kansas City

1999 Renaissance Society,
University of Chicago

1997 'Miniatures and Murals',
Deitch Projects, New York

1997 Whitney Biennial, Whitney
Museum of American Art, New
York

Shahzia **Sikander**

Born 1969
Lives New York

Shahzia Sikander gives the strict Indo-Persian
tradition of miniature painting a radical update,
with her unorthodox marriage of Eastern and
Western techniques as well as Hindu and Muslim
iconographies. The hybrid creatures that populate
these works reflect Sikander's own composite identity
as a female Pakistani educated in the West, a theme
she has also explored by wearing a veil on excursions
through American public spaces. Sikander has
recently experimented with mural and installation,
recreating the delicate exoticism of her celebrated
miniatures on a larger scale. (KR)

Represented by Brent Sikkema G1

The Instant Decorator (Pink Bedroom)
2001
Cibrachrome
76×102cm
Edition of 5
Courtesy Salon 94

Laurie **Simmons**

Born 1949
Lives New York

Laurie Simmons became interested in photography via Conceptual art in New York City in the early 1970s. Her work spurned the more straightforward documentary aspects of the medium to make pictures that she considers anti-narrative – 'psychological, political, subversive'. She earned her reputation with uneasy, large-format photographs of female dolls, which, according to Matthew Ritchie in *frieze*, 'examined the acute intersection between the remembered pleasures of childhood and the anxieties of incipient adulthood'. The series 'Music of Regret' (1994) features a hand-carved doll of herself. Her work takes place in a twilight world populated by representations of seamless, smiling, somewhat sinister types – for example, the cowboy, the housewife, the ballerina. (JH)

Represented by Salon 94 D6

Selected Bibliography

2001 'People in Glass Houses', Matthew Richie, *frieze*, 57, March

2000 'Crisis of the Real', Andy Grundberg, *Aperture*, New York
'Laurie Simmons', Maura Reilly, *Art in America*, February

1999 'The Century's Most Influential Artists', A.D. Coleman, *Artnews*, May

1998 'Laurie Simmons', Martha Schwendener, *Time Out*, 19 October 1998

Selected Exhibitions

2004 'New Work', Salon 94, New York

2003 'Constructed Realities', Orlando Museum of Art

2002 'Laurie Simmons', Galerie 20/21, Essen

2001 'Moving', Sean Kelly, New York

2000 'Laurie Simmons & Peter Wheelright', Deitch Projects, New York
'The Darker Side of Playland', San Francisco Museum of Modern Art

1999 'The American Century', Whitney Museum of American Art, New York

1998 'Laurie Simmons', Metro Pictures, New York

1997 'Laurie Simmons', Baltimore Museum of Art

Vogelfalle
(Bird Trap)
2003
Tin can, birdseed
61×23.5cm
Courtesy Galerie Neu

Andreas **Slominski**

Born 1959
Lives Hamburg

Andreas Slominski is fascinated by trapping, whether it's traps as sculptural objects, or methods for trapping meaning. From constructing sculptural devices for catching animals to making peculiar bicycles or windmills, conceptual traps are constantly set for the viewer. Take his performances, for example. Elementary tasks are completed using the most contrived, absurd means. To hoop a bicycle tyre around a lamppost, for instance, he had the post dug from its foundations, laid the tyre around the hole and replaced the lamp, rather than just throwing the tyre over its neck. Tasks are executed with clinical precision, underscoring the gentle humour of his endeavours and investing everyday materials with complex networks of meaning. (DF)

Represented by Sadie Coles HQ B8, Galerie Neu E10

Highway Junction 110-105
2002
Carved marble
26×145×150cm
Courtesy David Zwirner

Yutaka **Sone**

Born 1965
Lives Tokyo

Exhaustively detailed Los Angeles freeway interchanges carved from white marble blocks, immense dice towed by a helicopter, an impossible circular bicycle, a search for a magical stick, and a birthday party that never ends – these are some of the elements in Yutaka Sone's endlessly inventive, quixotic projects. Side-stepping anything resembling conventional logic, his work has a giddily absurdist, mix-and-match quality, but this playfulness is informed by an earnest search for connections between people and the spaces they inhabit.
An architect by training and an inveterate traveller by inclination, Sone has a cock-eyed curiosity, which results in resonant, open-ended games – situations for global interchanges. (SS)

Represented by David Zwirner F5

Selected Bibliography

2002 *Paises – The 12th City*, Saõ Paulo Biennale
Travel to Double River Island, Municipal Museum of Art, Toyota City

2001 *Public Offerings*, ed Howard Singerman, Museum of Contemporary Art, Los Angeles
Istanbul Biennale, Yuko Hasegawa

2000 *In Between. The Art Project of Expo 2000*, ed Wilfried Dickhoff and Kasper König, Expo 2000, Hanover

Selected Exhibitions

2003 'Yutaka Sone: Jungle Island', Museum of Contemporary Art at the Geffen Contemporary, Los Angeles
Japanese Pavilion, Venice Biennale

2002 'Travel to Double River Island', Toyota Municipal Museum of Art
'Paises' Saõ Paulo Biennale

2001 'Public Offerings', Museum of Contemporary Art, Los Angeles

2000 'Double Six', ArtPace, San Antonio

1999 David Zwirner, New York
'Alpine Attack', Sogetsu Art Museum, Tokyo

1997–8 'At the End of All the Journeys', Hiroshima City Contemporary Art Museum; Shiseido Art House, Kakegawa

I Wish I Could
2002
Lambda print on aluminium
214×122cm
Courtesy Galerie Nathalie Obadia
and Sommer Contemporary Art

Selected Bibliography

2003 *Beaux Art Magazine*, May

2002 *Herald Tribune*, July
Art Now, Taschen, Cologne
Kunst Bulletin, 10, October

2001 *Port*, Monograph

Selected Exhibitions

2003 Galerie Natalie Obadia, Paris

2002 Art Statements, Art Basel, Miami Beach
Moderna Galeria, Ljubljana
'PORT', Tel Aviv Museum of Art
'Power', Casino Luxembourg–
Forum d'Art Contemporain
Charlottenborg Exhibition Hall, Copenhagen
'From Painting/Object to Painting/Action', Essl Collection, Vienna

2001 Venice Biennale

2000 Havana Biennale
Fondazione Sandretto Re Rebaudengo, Turin

Eliezer **Sonnenschein**

Born 1967
Lives Tel Aviv

In 1994 Israeli provocateur Eliezer Sonnenschein began his 'penetrations' of the Tel Aviv Museum of Art, inserting objects – and on occasion himself – into its exhibitions, a guerrilla tactic which became a performance. Subsequent official installations at museums and biennales have maintained the assault, slamming together the glossy aesthetic of video games, wall-mounted models of guns covered in corporate logos, and violent texts in hard-boiled thriller style. The sardonic peak of this approach thus far, 2001's *PORT*, featured a dozen computer-generated C-prints that presented the art world's various strata – art school, art history, the underground – mapping the hierarchies and the way to the top. (MH)

Represented by Galerie Nathalie Obadia F2, Sommer Contemporary Art C15

Hotel
2000
Oil on canvas
119×168cm
Courtesy Counter

Fergal **Stapleton**

Born 1962
Lives London

An early show by Fergal Stapleton included a slide of
Leonardo da Vinci's *Last Supper* (c. 1495), a beam of
light from a torch and a quote from Philip Roth's
Portnoy's Complaint (1969) in which the hero sexually
assaults his family's dinner. Designed to fuse the
viewer and the viewed into a single entity, it set the
tone for his subsequent output, which has ranged
from a project in which he sent a page of a novel-in-
progress to a gallerist every day, to a fantastical
pastiche of a de la Tour painting featuring a besuited
loris contemplating a large glass tear. A recent show
featured six large, full-face portraits of his own cat,
which gazed back at the viewer from every wall.
Impassive yet also intrusive, it was a typically
Stapletonian challenge to the viewer's equilibrium.
(MH)

Represented by Counter B13

Selected Exhibitions

2003 'I SHALL ARRIVE SOON',
Counter, London
'Picture Room', Gasworks, London
'The Straight or Crooked Way',
Royal College of Art, London
'Chockerfuckingblocked', Jeffrey
Charles Gallery, London

2002 'Crack Whore', Five Years,
London

2001 'Being and Nothingness',
Workplace, Toronto

2000 'This', Platform, London

1997 'The Unadorned Hardcore
World of the Anabolic Mutant in
Stir', with Rebecca Warren, The
Showroom, London

1996 Riutsu Centre, Tokyo

1995 'Tonight', The Agency,
London

Bunny Lake Drive-in
2001–2
Installation view
Courtesy EmilyTsingou Gallery

Selected Bibliography

2002 *Georgina Starr, The Bunny Lakes,* Emily Tsingou Gallery, London

1999 *Georgina Starr,* Ikon Gallery, Birmingham

1996 *Starvision, issue 1* (comic book)

1995 *Visit to a Small Planet,* Kunsthalle, Zurich

Selected Exhibitions

2002 'Rapture, Art's Seduction by Fashion since 1970', Barbican Art Gallery, London

2001 'Il dono, offerta ospitalita insidia', Palazzo delle Papesse, Centro Arte Contemporanea, Sienna
'Plateau of Mankind No. 1', Venice Biennale
'The Bunny Lakes', Städtische Ausstellungshalle, Munster

2000 'Strange Paradises', Casino Luxembourg– Forum d'Art Contemporain

1998 'Tuberama', Ikon Gallery, Birmingham

1997 'Visit to a Small Planet', Museum of Contemporary Art, Los Angeles

1996 'Hypnodreamdruff', Tate Gallery, London

1995 'Visit to a Small Planet', Kunsthalle, Zurich

1992 'Aperto', Venice Biennale

Georgina **Starr**

Born 1968
Lives London

Georgina Starr is curious about how fact, fantasy and autobiography can leapfrog over one another without too much coaxing from the artist. Her *Nine Collections of the Seventh Museum* (1994) turned a succession of boring episodes from a lonely residency programme into a fetishistic museological display, lending a fictionalizing nobility to an otherwise uneventful period of artist's block and acute homesickness. Starr's recent trilogy of installations and video *The Bunny Lakes* (2000–2) imagines what would happen if the innocent schoolgirl of Otto Preminger's 1965 classic kidnapping tale *Bunny Lake is Missing* had actually returned to wreak gun-toting vengeance on the adult world. (JT)

Represented by Emily Tsingou Gallery A6

Sarah **Staton**

Born 1968
Lives London/Sheffield

Although 19th-century Britain found itself in the vanguard of landscape design, industrial architecture and various forms of progressive arts and crafts, in the 20th century Britons became rather wary of the 'damaging' influence that continental Modernism might have on national culture and traditional hearths and homes. It is this contradiction that amuses Sarah Staton, whose mixed media installation *Green, Or How We Missed Modernism* (2003) deals with this streak of insularity in English cultural history. In particular, Staton notes how a new crop of DIY, home-improvement and house and garden-type TV shows are belatedly popularizing a pervasive brand of Modernist aesthetic. This time around, however, it's coming not from the laboratories of the avant-garde but via such mass-market tastemakers as IKEA. (JT)

Represented by Milton Keynes Gallery H8, Galerie Christian Nagel E4

Selected Bibliography

2003 *Green, Or How We Missed Modernism*, Anthony Davies, Simon Ford, Sarah Staton, Milton Keynes Gallery

2001 *Art Crazy Nation*, Matthew Collings, 21 Publishing Ltd, London
Jewels-in-Art, Bleich Rossi Galerie, Graz
Anti-Paintings, Artist's Book

2000 *No Fun without U*, Jeremy Cooper, Ellipsis, London

Selected Exhibitions

2003 'Green, Or How We Missed Modernism', Milton Keynes Gallery
'Multiplication', British Council exhibition, touring to Tallinn, Kibla, Ljubljana, Vigo and Madrid

2002 'Flower Power', Kjubh Kunstverein, Cologne

2001 'The Good, the Bad and the Ugly', MOCAD, Denver
'Century City', Tate Modern, London

2000 'Foundry', Dom, Dom, Moscow
'Telescopic Memories and the International Trash Set', Orbit House, London

1999 'Malerei', Init Kunsthalle, Berlin
'East International', Norwich Art Gallery
'Lifestyle', Kunsthaus Bregenz

Expedition
2002
Watercolour on paper
112×163cm
Courtesy Galerie Aurel Scheibler

Selected Bibliography

2002 *Peter Stauss,Who carries documents? I remember my name*, Marcus Steinweg, Galerie Aurel Scheibler, Cologne

1999 *Peter Stauss: Kartoffelesser* (Potato eaters), Marcus Steinweg, Galerie Aurel Scheibler, Cologne

Selected Exhibitions

2002 'Des Alpes et des Pyrénées', Galerie Aurel Scheibler, Cologne

2000 'Randori' (with Thomas Scheibitz), loop, raum für aktuelle Kunst, Berlin; Leo Koenig, Inc, New York

1999 'Kartoffelesser' (Potato eaters), Galerie Aurel Scheibler, Cologne, 'Förderkoje' at Art Cologne, Galerie Aurel Scheibler, Cologne

1998–9 'Condiciones de Visibilidad/Sichtverhältnisse – 12 Positionen zeitgenössischer Malerei', (Visibilities – 12 Positions of Contemporary Painting), Centro Cultural del Conde Duque, Madrid; Künstlerhaus Bethanien, Berlin

1998 Kunsthalle Luckenwalde 'sehen sehen – Berlin '98' (look, look – Berlin 98), loop, raum für aktuelle kunst, Berlin

1997 'Nimm Deine Bahre und geh' (Take Your Stretcher and Go), loop, Raum für aktuelle Kunst, Berlin

1995 'A Bonnie Situation', Contemporary Fine Arts, Berlin

Peter **Stauss**

Born 1966
Lives Berlin

Amorphous puddles of paint; crisp colours floating on exhausted tones; pirates, beasts and sinister sailors; kaleidoscope eyes that remind you of cartoons you can't quite remember; a mountain exploding with starbursts; animals that look like people, and vice versa – Peter Stauss' paintings and sculptures reflect a world turned on its head. Much of his work expresses a crazed, occasionally sinister, exuberance. Blurred soldiers hover at the edge of the picture plane as naked women flee; in the midst of oozing malevolence a faded swastika emerges from the gloom. In Stauss' world the only logic you can know is your own, and the only order you can recognize is the one the world imposes on you. (JH)

Represented by Galerie Aurel Scheibler D13

Wall painting, installation view at
galleria francesca kaufmann
2001
Dimensions variable
Courtesy galleria francesca
kaufmann

Lily van der **Stokker**

Born 1954
Lives New York/Amsterdam

Lily van der Stokker is best known for the cheerful,
trippy, doodle-like images she paints directly on to
walls. Rendered in cartoon colours, these bright
excursions into the imagination are occasionally
supplemented with sentences, words, numbers and
dates, which might refer to gossip, love affairs, non-
sequiturs or aggressive asides. Particularly fond of
flowers, clouds and friendly, amorphous shapes, van
der Stokker believes that the prime aspect of a work
of art is its capacity to create enjoyment and to
provoke ideas through playfulness. To this end she
often supplies a comfortable sofa for visitors to relax
in while they contemplate her work. (JH)

Represented by Air de Paris B16, Cabinet C9,
galleria francesca kaufmann H3

Selected Bibliography

2001 'Lily van der Stokker',
Jonathan Jones, *frieze*, 57, March
'Wall Painter', Eric Troncy,
Numero, December–January

1999 Lily van der Stokker, Polly
Staple, *Untitled*, Summer

1994 'Ausgrabung und/oder
Unterstand', Liebs Holger, *Texte zur
Kunst*, June
Lily van der Stokker', Keith
Seward, *Artforum*, Summer

Selected Exhibitions

2003 Museum Ludwig, Cologne
Museum Boijmans van Beuningen,
Rotterdam

2002 Le Consortium, Dijon
galleria francesca kaufmann, Milan

2001 Galerie Helga Maria
Klosterfelde, Hamburg

2000 'Let's Entertain', Walker Art
Center, Minneapolis and touring
'In Between', Expo 2000, Hanover

1998 Air de Paris, Paris

1992 Daniel Buchholz, Cologne

1990 Feature, New York

Ella
2003
Brass Brooch
6×3×0.3cm
Courtesy Galerie Giti Nourbakhsch

Selected Bibliography

2003 Review, Felicity Lunn, *Contemporary*, 45
'Something Old, Something New', Dominic Eichler, *frieze*, 74, April
Land, Land! Object of Desire: Modest Models of Infinity, Christina Végh, Kunsthalle, Basel
Minimalism and After II, Friederike Nymphius on Katja Strunz, DaimlerChrysler, Berlin

2002 'Waiting for the ice age', Susanne Jäger, *Flash Art*, May–June

Selected Exhibitions

2003 Galerie Els Hanappe, Athens
'Land, Land', Kunsthalle, Basel
'Minimalism and After II', Collection Daimler Chrysler, Haus Huth, Berlin

2002 'Zeittraum', Galerie Giti Nourbakhsch, Berlin
'RomaRomaRoma', Rome
'My head is on fire but my heart is full of love', Charlottenborg Exhibition Hall, Copenhagen
'Waiting for the Ice Age', Georg Kargl, Vienna

2001 Gavin Brown's enterprise, New York
The Modern Institute, Glasgow

2000 Galerie Giti Nourbakhsch, Berlin

Katja **Strunz**

Born 1970
Lives Berlin

The work of Katja Strunz bears the same relation to much neo-Minimalist work as Batman does to Superman: it is the dark, brooding counterpoint to slick invincibility. In sparse installations of sharp-angled shapes and time-worn scrap metal, echoes of early 20th-century Russian Constructivism are shot through with a Robert Smithson-inspired interest in the derelict sites of the modern age, tracking them with the sensitive vigilance the Romantics reserved for ancient ruins. A brass clock-face or clef gives Strunz' pitch-black, concertina-ed wall sculptures a low-key presence, while her works on acid-yellowed paper look as though they were torn from an obscure book of Concrete poetry. (JöH)

Represented by GBE (Modern) D5, The Modern Institute G8, Galerie Giti Nourbakhsch H6

Beauty is Only the First Touch of Terror
2003
Oil on board
98×122cm
Courtesy The Approach

Mari **Sunna**

Born 1972
Lives London

The women in Mari Sunna's paintings seem to be caught in the act of disappearance. Mostly rendered in greys and curdled whites, their bobbed hair laps their blank faces, betraying only the merest suggestion of a cowed nose or shy mouth. Pear-shaped and wearing slightly dumpy, practical clothes, they appear to value their anonymity. Sunna's women, however, seem to know a few secrets – one of them even cups a crystal ball in her palm. This, I guess, is the nature of a life lived on the wall. Trapped in paint, you not only get to look back – both temporally speaking and at your audience – but you might, like an eternal observer, get to look forward, too. (TM)

Represented by The Approach D8

Selected Bibliography

2002 *Mari Sunna*, Galerie Anhava, Helsinki,

2001 'Mari Sunna', Mark Currah, Time Out, 26 September 2001
Mari Sunna, The Approach, London

Selected Exhibitions

2003 'Dirty Pictures', The Approach, London

2002 'The Galleries Show' Royal Academy of Arts, London
Galerie Anhava, Helsinki

2001 The Approach, London
'The Cap', St Mary Magdalene Church, London
'Polarflex', Aroma Project Space, Berlin
'Baltic Painting Biennale', Vasby

1999 Gallery of the Finnish Institute, Stockholm
'A Scent More Mature than Childhood', Galerie Anhava, Helsinki

1998 'Gestures', Cable Gallery, Helsinki

Unlovable
2002
Urethane on fibreglass
84×114cm
Courtesy Galerie Almine Rech

Vincent **Szarek**

Born 1973
Lives New York

Vincent Szarek, a surfer as well as a sculptor, merges the so-called 'finish fetish' of 1970s Californian Minimalism with the earthy aesthetics of surfboards and custom-car spray jobs. All crimson gloss and parabolic-curve surface, the fibreglass wall relief *Burger Squish* (2002) could be a car bonnet merged with a fast-food carton lid; the symmetrical yellow diptych *Creature Double Feature* (2002) sports delicate ruches at its edges, like the sleeves of an 18th-century dress. These worldly aspects – recognizable enough to make the work seem familiar but not so domineering as to allay its strangeness – were understated or refused in the work of the 1970s generation, to whom Szarek's guilt-free, inclusive art both tips its hat and offers a hedonistic, even kinky antidote. (MH)

Represented by Galerie Almine Rech H7

Pteris, Acrosticum, Sage
1997
Oil pigment on canvas
140×170cm
Courtesy Galerie Thaddaeus Ropac

Philip **Taaffe**

Born 1955
Lives New York

It is easy to slip into musical metaphors in describing Philip Taaffe's work since the early 1980s and the effect his canvases have on viewers. His painted, monotyped and cut-and-pasted surfaces emit a vibratory and rhythmic presence that is structurally analogous to how one might visualize organized sound. Mediating between the distinct enjoyments of ornament and representation, his patterned images of appropriated and repeated motifs – Baroque ironwork, Islamic decorative mosaics, bits of flora and fauna – are regulated by the overarching compositional considerations of phrasing, metre and exposition, and the establishment of themes and variations. As if they were pictorial oscilloscopes, Taaffe's active canvases give one the exotic illusion of having experienced the pleasures of one sense translated into another. (JT)

Represented by Gagosian Gallery F7,
Galerie Thaddaeus Ropac B14

Selected Bibliography

2001 *Philip Taaffe*, Vittoria Coen, Mazzotta, Milan

2000 *Philip Taaffe*, Enrique Junkosa, Ivam, Valencia

1982 'A Sense of Place', James Walker, *Artscribe*, 38, November

Selected Exhibitions

2001 'Philip Taaffe, Galleria Ciuiga d'Arte Contemporanea, Trento 'Give and Take', Victoria and Albert Museum, London

1998 'Philip Taaffe', Peter Blum Gallery, New York

1997 'New York Painters', Sammlung Goetz, Munich

1996 'Philip Taaffe', Galerie Max Hetzler, Berlin

1982 'Philip Taaffe', Roger Litz Gallery, New York

Untitled
2003
Oil on canvas
36×46cm
Courtesy White Cube

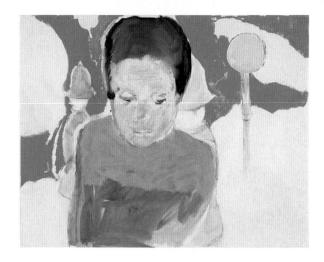

Selected Bibliography

2003 'Private Lives', Jennifer Higgie, *frieze*, 76, July–August

2002 'Ways of Seeing. Neal Tait: Douglas Hyde Gallery', Luke Clancy, *Art Review*, October
'Neal Tait', Catherine Daly, *Sunday Times*, 25 August 2002
Neal Tait, John Hutchinson and Peter Pakesch, Douglas Hyde Gallery, Dublin

2001 *Abbild, Recent Portraiture and Depiction*, Peter Pakesch, Princeton Press; Steirischer herbst, Graz; Springer, Vienna

Selected Exhibitions

2003 'The Burnished Ramp', White Cube, London
'Dirty Pictures', The Approach, London

2002 'Neal Tait', Douglas Hyde Gallery, Dublin
'Painting on the Move', Kunsthalle Basel
'In the Freud Museum', Freud Museum, London
'Neal Allen Tait', Sies & Höke Galerie, Dusseldorf

2001 'Depiction', Steirischer herbst, Graz

2000 'Drawings', Sommer Contemporary Art, Tel-Aviv
'Painting', White Cube, London

1993 'Cottage', Union Street, London

Neal **Tait**

Born 1965
Lives London

Neal Tait paints in the way we dream, when objects and meanings collide with a reasoning that holds your attention even as you dismiss its logic. His paintings and drawings often depict blank-featured people who are laid open less through detail than through gesture, their faces rubbed out or revealed in veiled rhythms. Tait has commented that 'ideal painting is continually open'. Gaze long enough and shapes emerge from his pictures in the way they do from clouds. Scenes are rendered with syncopated, often chalky, paint; at every corner lurk unverifiable but potent clues to oblique mysteries. The pictures are difficult to predict; get used to one, and the next will change your mind. (JH)

Represented by White Cube F6

Disciples III
2003
Lightbox with duraclear
transparency mounted to 5mm
UV-filtered Perspex, framed in
patinated aluminium
Edition of 3
158×125cm
Courtesy Timothy Taylor Gallery

Selected Bibliography

2003 *Disciples*, Timothy Taylor
Gallery, London

2002 *Portraits*, National Portrait
Gallery, London; Bulfinch Press,
Worldwide

2001 *Alive*, Bulfinch Press, Little,
Brown and Co., Boston, New York,
London

1999 *Front Row/Backstage*, Bulfinch
Press, Little, Brown and Co.,
Boston, New York, London

1998 *Any Objections*, Phaidon,
London

Mario **Testino**

Born 1954
Lives London

'I was brought up in South America', says Mario
Testino, 'and a big part of my growing up was about
parties, about being beautiful and having fun. Fun
was the key thing, and glamour.' Possibly the world's
pre-eminent photographer of celebrity, Testino's
shots reek of a slick, familiarly sexy optimism. In one
of his works Elizabeth Hurley lies on a shaggy rug in
her pants, a TV remote in her hand, her skin as shiny
as a magazine page. In another, Gwyneth Paltrow,
like some feminine Jay Gatsby, emerges from a
diaphanous pink cloud, crowned with a gilded lick of
hair. These are images to slide down the surface of.
They leave no foothold for desire, and nor, perhaps,
should they. (TM)

Represented by Timothy Taylor Gallery F13

Selected Exhibitions

2003 'Mario Testino Disciples',
Timothy Taylor Gallery, London

2002 'Mario Testino Portraits',
National Portrait Gallery, London
'Mario Testino', Charlotte Lund
Gallery, Stockholm

2000 'Mario Testino', Vedovi
Gallery, Brussels

1999 'Mario Testino Amsterdam',
Timothy Taylor Gallery, London
'Mario Testino', Visionaire Gallery,
New York

1998 'Mario Testino', Mary Boone
Gallery, New York
'Mario Testino', Fundaçao
Armando Alvares Pentendo,
Saõ Paulo
'Mario Testino', Galleria
Raucci/Santamaria, Naples

1997 'Mario Testino', Bunkamura
Gallery, Tokyo

Pink Daisies, Amber Room
2003
Installation view
Courtesy Haunch of Venison

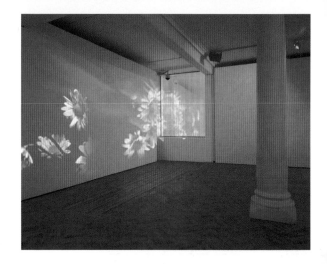

Selected Bibliography

2001 'Splash', Andrea Gilbert, *View*, August
'Dia Center for the Arts', Martha Schwendener, *Art in America*, January

1999 'Moluccan Cockatoo Molly 1–10', Sherri Telenko, *View*, 28 September

1998 *The Best Animals Are the Flat Animals*, ed Peter Noever, Mak Center for Art and Architecture, Los Angeles and Austrian Museum of Applied Arts, Vienna

1996 'Electric Mind', foreword Kathryn Kanjo, reprint of 'Rachel in Love' by Pat Murphy, Imschoot, uitgeversm Ghent

Selected Exhibitions

2001–2 'Knots and Surfaces', Dia Center for the Arts, New York

2001 Tensta Konsthall, Stockholm

2000 Secession, Vienna

1999–2000 'Carnegie International', Carnegie Museum of Art, Pittsburgh

1998 Museum of Modern Art, New York

1997 'Orchids in the Land of Technology', Walker Art Center, Minneapolis

1997 'China', Le Creux de l'Enfer, Thiers and Renaissance Society, University of Chicago

1996 Whitney Biennial, Whitney Museum of American Art, New York

1994 Witte De With, Rotterdam

Diana **Thater**

Born 1962
Lives Los Angeles

Diana Thater's video installations occupy a zone between everyday and cinematic vision, exploring the point where nature and culture intersect. Building on the legacy of Structuralist cinema, she undermines the integrity of the single projected image with multiple cameras, monochromatic channels and other production devices that combine to create a profoundly disorienting atmosphere. Like the swarm of honeybees in *Knots and Surfaces* (2001), Thater attacks from all sides: walls, floors and monitors compete for attention, in the middle of which is exposed the technical apparatus of the onslaught. (KR)

Represented by 1301PE B1, Haunch of Venison G14, Galerie Hauser & Wirth B5, Galerie Ghislaine Hussenot F15, David Zwirner F5

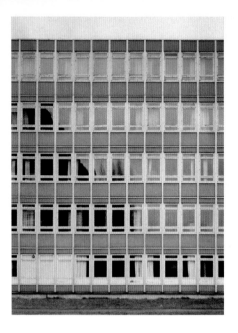

SK 76 / 2-Mp
2000
C-type print
230×176cm
Courtesy Galerie Krinzinger

Frank **Thiel**

Born 1966
Lives Berlin

No artist has tracked Berlin's transformation since 1989 more relentlessly than Frank Thiel. His large-format portraits of Allied soldiers and his pictures of opaque façades fitted with surveillance cameras share the stoic acuteness of the Becher-school of photographers. But what sets Thiel (who was born and grew up in Eastern Germany) apart in this context is his peculiar eye for sites where science fiction of the past clashes with nostalgia for the future: Modernist high-rises of the socialist East or penetrating analyses of the Potsdamer Platz construction site. His pictures show Berlin as a phoenix whose feathers are more ruffled each time it performs its rising-from-the-ashes trick. (JöH)

Represented by Galerie Krinzinger E9

Selected Bibliography

2002 *Brasília – Ruína e utopia*, ed Alfons Hug and Helmut Friede, Fundacão Biennal de Saõ Paulo

2000 *Remake Berlin*, ed Kathrin Becker and Urs Stahel, Steidl Verlag and Fotomuseum Winterthur
90 60 90, Museo Jacobo Borges, Caracas

1999 *La Biennale di Venezia, dAPERTutto*, ed Harald Szeemann and Cecilia Liveriero Lavelli, Marsilio Editori, Venice

1998 *Frank Thiel, Berlin*, Centro Galego de Arte Contemporánea; Santiago de Compostela

Selected Exhibitions

2003 Galeria Helga de Alvear, Madrid
Galerie Krinzinger, Vienna

2002 Sean Kelly Gallery, New York
'Iconografias metropolitanas, cidades', Saõ Paulo Biennale
Galerie Art+Public, Geneva

2000 '90 60 90', Museo Jacobo Borges, Caracas
'Remake Berlin', Fotomuseum Winterthur
'Berlin Binnendifferenz', Galerie Krinzinger, Vienna

1999 'Aperto', Venice Biennale
'After the Wall', Moderna Museet, Stockholm

1998 Centro Galego de Arte Contemporánea, Santiago de Compostela

An event commencing in the Spring of 1997 (Part 2)
2003
Oil on linen
289.5×457cm
Courtesy Andrew Kreps Gallery

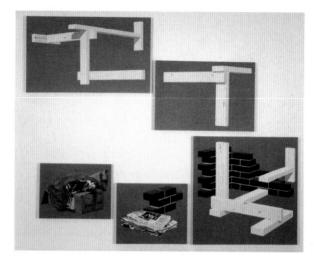

Selected Bibliography

2003 'Very New York', Manam Fujieda, *BT Magazine*, January

2002 'Cheyney Thompson', Johanna Burton, *Time Out New York*, 4 July 2002
'Voice Choice: Cheyney Thompson', Kim Levin, *Village Voice*, 26 June 2002
'Critics Pick', *Time Out New York*, 27 June 2002
'Cheyney Thompson', Edith Newhall, *New York Magazine*, 24 June 2002

Selected Exhibitions

2003 'Aperto', Venice Biennale
'Papers', ACME., Los Angeles

2002 '1 Scenario + 1 Situation', Andrew Kreps Gallery, New York

2001 'Life is Elsewhere', Canada Gallery, New York
'Playground of the Fearless', Entropy Gallery, Brooklyn

2000 James Fuentes Gallery, New York
Parker's Box, Brooklyn

1999 The Norman Project, New York
'Escape', DNA Gallery, Provincetown
'Formula', Oni Gallery, Boston

Cheyney **Thompson**

Born 1975
Lives New York

Cheyney Thompson seems to be working out a poetics of the urban ordinary. His cryptic, sharply rendered still life paintings feel like perceptual riddles. A series depicting bricks and wooden planks claims inspiration from Chardin. Formed into complex rectilinear configurations, the arrangements are portrayed in strict perspective, an abstract alphabet of spatial possibilities. If they were actually built, these constructions might read as Minimalist sculpture, but done as crisp, glowing paintings on organza, they have an oddly weightless delicacy. Thompson's eye for detail is also apparent in his miniature street vendor tables, laden with novelties, mysterious merchandise and still smaller tables. Seductively, they invite the viewer to look closer – which is precisely the point. (SS)

Represented by Andrew Kreps Gallery B10

Good People
2002
Mixed media collage
75×99cm
Courtesy Maureen Paley Interim Art

David **Thorpe**

Born 1972
Lives London

While confining himself to meticulous cut-paper collages, British artist David Thorpe is quietly creating another world. Early images of housing estates featured feral youths running across rooftops beneath circling helicopters; subsequent scenes relocated those Brutalist buildings to landscapes reminiscent of American pioneer art of the late 19th century, where they perched dramatically on the edge of cliffs. Recently his fabulist community has built extraordinary architecture for itself and, moving into sculpture, Thorpe has conjured up micro-gardens accessorized with Lone Star mosaics and bullet-like monuments. Clearly his vision of the escapist desire lurking in the human spirit never quite outruns the darkness at the edge of town. (MH)

Represented by Meyer Riegger Galerie B7, Maureen Paley Interim Art C11

Selected Bibliography

2003 *Proof of Principle*, Akzo Nobel Art Foundation

2002 *Drawing Now: Eight Propositions*, Museum of Modern Art at Queens, New York

2000 *Twisted. Urban and Visionary Landscapes in Contemporary Painting*, Van Abbemuseum, Eindhoven

1998 *New Neurotic Realism*, The Saatchi Gallery, London

Selected Exhibitions

2003 Meyer Riegger Galerie, Karlsruhe
Taro Nasu Gallery, Tokyo

2002 Maureen Paley Interim Art, London
'Drawing Now: Eight Propositions', Museum of Modern Art at Queens, New York
'Per Saldo', Noordbrabants Museum, 's-Hertogenbosch

2001 'Futureland 2001', Museum Abteiberg, Mönchengladbach
'Extended Painting', Monica de Cardenas, Milan

2000 'Future Perfect: art on how architecture imagined the future', Cornerhouse, Manchester
'Twisted. Urban and Visionary Landscapes in Contemporary Painting', Van Abbemuseum, Eindhoven

1998 'Die Young Stay Pretty', ICA, London

Gold
2002
C-type print
Courtesy Galerie Daniel Buchholz

Selected Bibliography

2002 *Wolfgang Tillmans*, J. Verwoert, P. Halley, M. Matsui, Phaidon, London, New York

1999 *Totale Sonnenfinsternis* (Total Eclipse of the Sun), Galerie Daniel Buchholz, Cologne

1998 *Burg* (Castle), Taschen, Cologne

1996 *Wer Liebe wagt lebt morgen* (Who Risks love, lives tomorrow), Kunstmuseum, Wolfsburg, Hatje cantz Verlag, Ostfildern-Ruit

1995 *Wolfgang Tillmans*, Taschen, Cologne

Selected Exhibitions

2003 Tate Britain, London

2001–3 'Aufsicht/View From Above', Deichtorhallen Hamburg; Castello di Rivoli, Museo d'Arte Contemporanea, Turin; Palais de Tokyo, Paris; Louisiana Museum of Modern Art, Humlebaek

1999 'Saros', Galerie Daniel Buchholz, Cologne
'Space between Two Buildings/Soldiers – The Nineties', Maureen Paley Interim Art, London

1998 Andrea Rosen Gallery, New York

1997 'I didn't Inhale', Chisenhale Gallery, London

1996 'Wer Liebe wagt lebt morgen' (Who Risks love lives tomorrow), Kunstmuseum, Wolfsburg

1995 Kunsthalle, Zurich Portikus, Frankfurt

1993 Galerie Daniel Buchholz – Buchholz & Buchholz, Cologne

Wolfgang **Tillmans**

Born 1968
Lives London

Wolfgang Tillmans has said that he doesn't 'believe in snapshots'. Although there's a seemingly casual feel to many of his photographs, it is born of an intense belief in the beauty of everyday things. Illuminating moments of strange and sudden optical wonder, Tillmans' pictures of planes, dishes, aubergines, lovers and laundry lolling on radiators are oddly disquieting, describing something half-way between a fact and a feeling. Recent works in which the artist has allowed lyrical, darkroom-derived abstract marks to stray on to the photographic image only heightens this sense of in-between-ness. It is as though photography itself (with its implications of charged, careful looking) wants to remake the world according to its own higher visual values. (TM)

Represented by Galerie Daniel Buchholz A2, Maureen Paley Interim Art C11, Sommer Contemporary Art C15

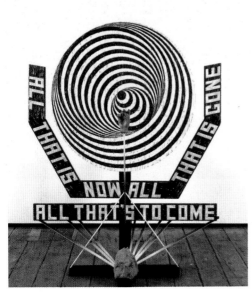

Resolving Conflict by Superficial Means
2002
Concrete, carved wood, electric
motor
160×200×80cm
Courtesy Vilma Gold

Mark **Titchner**

Born 1973
Lives London

Scavenged from crumbling philosophies and ruined ideals, the high-key graphic wall texts that form the spine of Mark Titchner's practice scrutinize the ways in which belief systems function. 'IF YOU CAN DREAM IT YOU MUST DO IT'; 'BE ANGRY BUT DON'T STOP BREATHING' – these stirring epigrams are somewhere between the slick diktats of the advertising strap-line and the galvanizing ideals of Situationist sloganeering. Devices from influential counter-cultural fringes are also reworked – Brion Gysin's 'Dreammachine' and Wilhelm Reich's Orgone Accumulator, for example, are roughly carved from wood, resembling the clunky detritus of dead ideologies. Titchner's work serves as a warning against pick 'n' mix cultural appropriation: 'THE NIHILISM OF THE HIP WILL DESTROY CIVILISATION'. (DF)

Represented by Vilma Gold G5

Selected Bibliography

2003 *Art Now*, Lizzie Carey-
Thomas, Tate Britain, London
'Earache My Ear' (Mark Beasley),
'Powers of Ten', (Colin Ledworth)
Electric Earth, British Council,
London
Talking Pieces, Ute Riess, Museum
Morsbroich, Leverkeusen
'Black Magic', Mark Beasley, *frieze*,
74, April

2001 *Playing Amongst the Ruins*,
Mark Dickenson, Royal College
of Art, London

Selected Exhibitions

2003 Art Now, Tate Britain,
London
'Do not attempt to reform man.
We are what we are', Galerie Jorg
Hasenbach, Antwerp
'We Were Thinking of Evolving',
Vilma Gold, London
'Talking Pieces', Museum
Morsbroich, Leverkeusen
'Film and Video from Britain',
British Council, State Russian
Museum, St Petersburg
'Strange Messengers', The Breeder
Projects, Athens

2002 'The Movement began with
scandal', Lenbachhaus Museum,
Munich

2001 'City Racing (A Partial
History)', ICA, London
'Playing amongst the Ruins',
Royal College of Art, London
'Heart and Soul', Long Lane,
London; Sandroni Ray, Los
Angeles

Random
2001
Cibachrome
Edition of 5
120×150cm
Courtesy Giò Marconi

Selected Bibliography

2002 *Moving Pictures*, R. Scheutle, Hatje Cantz Verlag, Ostfildern-Ruit

2001 *Grazia Toderi.Audience*, L. Cherubini, Galleria Giò Marconi, Milan
Subject Plural: Crowds in Contemporary Art, P. Morsiani and P. Wollen, Contemporary Art Museum, Houston

1999 *Esposizione Internazionale d'arte la biennale di Venezia*, H. Szeemann, P. Joch, G.Toderi, Marsilio, Venice

1998 *Grazia Toderi*, Nancy Spector, Grazia Toderi, Castello di Rivoli, Museo d'Arte Contemporanea, Rivoli and Charta, Milan

Selected Exhibitions

2003 'Grazia Toderi, Jorge Pardo, Alighiero e Boetti', Giò Marconi, Milano

2002 'Grazia Toderi', Fundaciò Joan Mirò, Barcelona
'Slow Motion', Ludwig Forum für Internationale Kunst, Aachen
'Moving Pictures', Villa Merkel, Esslingen am Neckar

2001 'Subject Plural: Crowds in Contemporary Art', Contemporary Arts Museum, Houston
'Squatters', Museo de Arte Contemporanea de Serralves, Porto

2000 'Quotidiana', Castello di Rivoli, Museo d'Arte Contemporanea, Turin

1999 'Grazia Toderi', Project Room, Museum Ludwig, Cologne
'Aperto' Venice Biennale

1998 'Grazia Toderi', Castello di Rivoli, Museo d'Arte Contemporanea, Turin

Grazia **Toderi**

Born 1963
Lives Milan

Grazia Toderi says that in her videos she tries to imagine places 'where falling doesn't exist'. She is clearly partial to the way things look when seen from above, a preference traceable to the childhood experience of watching the 1969 Apollo Moon mission on TV and being struck by the fact that the whole Earth, viewed from outer space, fitted so easily on the screen. Toderi's videos all attempt to recapture that initial sense of wonder. In one, a brightly lit football stadium, shot from high overhead on a dark night, slowly spins away into the void like some drifting celestial body. In another, a darkened concert hall, viewed from the stage, is illuminated by the intermittent popping of flashbulbs blinking the way fireflies do on a summer night. (JT)

Represented by Giò Marconi C14

Livia 2
2003
Cibachrome
Edition of 5 +2 AP
102×127cm
Courtesy carlier | gebauer

Selected Bibliography

2003 'Janaina Tschäpe', Bernard Marcelis, *Art Press*, May

2002 *Stories. Erzählstrukturen in der zeitgenössischen Kunst* (Stories. Structures of narration in contemporary art), Haus der Kunst, Munich

2001 *Sala de espera, Janaina Tschäpe*, Reina Sofia, Madrid
'Janaina Tschäpe', Celso Fioravante, *Tema Celeste*, October

Janaina **Tschäpe**

Born 1973
Lives New York

Janaina Tschäpe, not unlike Matthew Barney, presents her body as a fetishist, hybrid site of myth and wonder. Stereotypical female characters – sirens, mermaids, fairies, angels, gorgons – crowd the young, German-born Brazilian artist's videos, photos, sculptures and watercolours with the nagging insistence of close relatives. Like Louise Bourgeois sculptures swiftly animated by a Philip K. Dick brainwave, they are wrapped in wet sheets, or clad in inflatable, puffed-up fabric that protrudes from their extremities like an octopus' arms, turning wet dreams into nightmares and vice versa. (JöH)

Represented by Art:Concept G7, carlier | gebauer H9, Galeria Fortes Vilaça F9, Brent Sikkema G1

Selected Exhibitions

2003 'After the Rain', Catherine Bastide Gallery, Brussels/Fortes Vilaça, Saõ Paulo
'Chassé-Croisé', Centre d'Art, Albi

2002 'Dream Sequences', Art:Concept, Paris
'Exercises', carlier | gebauer, Berlin
FRAC Champagne Ardenne, Rheims
'Stories. Erzählstrukturen in der zeitgenössischen Kunst' (Stories. Structures of narration in contemporary art), Haus der Kunst, Munich

2001 'Sala de Espera', Reina Sofia, Madrid
'Panorama da Arte Brasileira', Museu de Arte Brasileira

1998 'Der Brasilianische Blick' (The Brasilian Gaze), Haus der Kulturen der Welt, Berlin, Ludwigforum, Aachen

Alice
2002
Mixed media
15×41×13cm
Courtesy Thea Westreich and Ethan
Wagner, New York

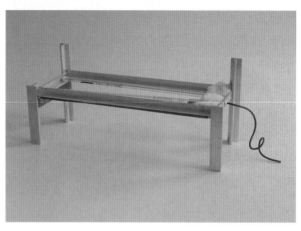

Nobuko **Tsuchiya**

Born 1972
Lives London

Nobuko Tsuchiya has commented 'I want to make something with which to mind-travel.' Recent sculptures such as *Table Rabbit* (2003) and *Alice* (2002), are disorientating both through their titles and dreamy atmosphere. This Tsuchiya achieves by delicately rearranging simple materials into enigmatic objects. Her work is fuelled by the idea of travel, using her imagination and memory as the vehicle. For example, another recent sculpture, *Nike of Samothrace* (2003), refers not only to the Ancient Greek embodiment of flight and victory, but to the cover of a school text book the artist remembers from childhood. Tsuchiya would like her work to be 'a companion or a kind of tool' and believes that 'we are living in a time machine'. (JT)

Represented by Anthony Reynolds Gallery D3

Selected Bibliography

2003 'Nobuko Tsuchiya', K. Tsutsumi, *Luca*, 2

Selected Exhibitions

2003 Anthony Reynolds Gallery, London
Venice Biennale

2002 Anthony Reynolds Gallery, London

2000 Gallery Den, Tokyo

1999 Gallery Den, Tokyo

Untitled (Cross-eyed)
2002
Wooden panels
Two parts, each 200cm diameter
Courtesy GBE (Modern)

Piotr **Uklanski**

Born 1968
Lives New York/Paris

Piotr Uklanski's art doesn't try to counter mass culture's seductions – it simply turns up the volume on kitsch pleasures and lets the viewer do the rest. Sometimes the result is a giddy utopian spectacle, as in the Saturday Night Fever-meets-Dan Flavin pulsing lights of his relocated disco dance floors. In other, darker works glamour is more obviously compromised. His controversial work *The Nazis* (1998) presented a wall of glossy stills of famous actors, from Richard Burton to Leonard Nimoy, playing Nazi soldiers: an unsettling chronicle of Hollywood's continued fascination with fascist aesthetics. 'Entertainment/art – please tell me what the difference is', Uklanski has said. This is not mere rhetoric: it is a request that demands an answer. (SS)

Represented by GBE (Modern) D5

Selected Bibliography

2002 'Once Upon a Time in the East' Kate Bush, *Artforum*, November

2001 'Something I Prepared Earlier', Mark Sanders, *Dazed and Confused*, August
'Piotr Uklanski', Benett Simpson, *frieze*, 59, May

2000 'A Flaming Star', Adam Szymczyk, *NU*, 2

1996 'Ouverture: Piotr Uklanski', Aleksandra Mir, *Flash Art*, October

Selected Exhibitions

2001 'A Façade', illumination design, Museum voor Schone Kunsten, Ghent

2000 'Twin Moons'
'A Norwegian Photograph'

1999 'Summer Love', The First Polish Western (on going)

1998 'The Nazis'
'Full Burn'

1997 'Joy of Photography'

1996 'Dance Floor'

Save Yourself
2002
Mixed media
85×22cm
Courtesy ICA, London

Francis **Upritchard**

Born 1976
Lives London

Selected Bibliography

2002 *The Lost Collection of an Invisible Man*, Bryan Cyril Griffiths, Laing Gallery, Newcastle

Selected Exhibitions

2003 'Beck's Futures', ICA, London
'The Bart Wells Institute', Kapinos Gallery, Berlin
'Lost Collection', Laing Gallery, Newcastle
'Picture Room', Goshka Macuga, Gasworks, London
'Rollout', Karyn Lovegrove Gallery, Los Angeles

2002 '464', Künstlerhaus Bethanien, Berlin
'Another Shitty Day in Paradise', Bart Wells Institute, London
'Break', Govett-Brewster, New Plymouth

When Francis Upritchard moved to London from New Zealand, she converted her squat into a gallery; when she was short-listed for 'Beck's Futures 2002' a short time later, she made her designated area of London's ICA look like a malevolent squat. Ripping up the floorboards, Upritchard installed one of her characteristic small, roughly bandaged mummies on the raw ground, a gold packet of cigarettes attached to it because 'I wanted to avoid the curse of the mummy and make it lucky'. Previously she's exhibited taxidermy snakes and cats and varnished worms, and made paintings devoted to satanic internet-conspiracy theories about Prince Charles: their woozy mix of humour, mortality and intimated occult practices is fast becoming Upritchard's trademark. (MH)

Represented by Kate MacGarry C19

DUBB 0104 (Schiaparelli Donkey)
2000
Ink on paper
42×29cm
Courtesy Magnani

Donald **Urquhart**

Born 1963
Lives London

Drag shows, vegetables as wall decorations, copious gin jellies and a wandering pantomime cow: these are just some of the highlights of the Beautiful Bend, a London club night that Donald Urquhart hosted with Sheila Tequila and DJ Harvey. Begun in 1993, the event featured elaborate themes, absurdist conceits that yoked together, for example, 'a cheese festival in The Hague, a football match, rockabillies in a van, and a bus load of grannies'. Urquhart's demented faux Edwardian pen-and-ink drawings – used for publicity flyers – were perfect expressions of this 'anything goes' aesthetic. Resembling low-budget Beardsley prints, they capture and preserve the handmade glamour and the black humour of the club's heyday. (SS)

Represented by Magnani F11

Selected Bibliography

2003 *Marmalade*, April
Boyz, 607, March

Selected Exhibitions

2003 'A Present from the Zoo',
Magnani, London

Homage to Josef Albers's 'Homage to the Square' (Sympathy for the Devil)
1995
Cotton embroidery on canvas
12×12cm
Courtesy Galleria Franco Noero
and Giò Marconi

Selected Bibliography

2002 *The Needleworks of Francesco Vezzoli*, ed Jan Winkelmann, Galerie für Zeitgenössische Kunst, Hatje Cantz, Leipzig
'Francesco Vezzoli', Dominic Eichler, *frieze*, 71, November–December
'Francesco Vezzoli', David Rimanelli, *Artforum*, XL, 9, May
Francesco Vezzoli, ed M. Beccaria, Castello di Rivoli, Museo d'Arte Contemporanea, Turin

2000 'Opening: Francesco Vezzoli', Richard Flood, *Artforum*, XXXVIII, 7, March

Selected Exhibitions

2003 'The Tale of the Thread – Embroidery and Sewing in Contemporary Art', MART, Rovereto

2002 'Francesco by Francesco: A collaboration with Francesco Scavullo', Giò Marconi, Milan
'The Needleworks of Francesco Vezzoli', Blinky Palermo Award, Galerie für Zeitgenössische Kunst, Leipzig
Art Statements, Art Basel
'The Films of Francesco Vezzoli', New Museum of Contemporary Art, New York
'Francesco Vezzoli', Castello di Rivoli, Museo d'Arte Contemporanea, Turin
Liverpool Biennial

2001 Venice Biennale

2000 'A Love Trilogy – Self-portrait with Marisa Berenson as Edith Piaf', Spazio Aperto, GAM, Galleria Comunale d'Arte Moderna, Bologna

1999 Istanbul Biennale

Francesco **Vezzoli**

Born 1971
Lives Milan/London

You don't find too many artists dabbling with needlepoint these days, but the dandyish Italian artist Francesco Vezzoli manages to insert his love of this gentle domestic handicraft into nearly everything he does. Having lovingly transferred images of porn stars and phone box escort ads to the dainty medium while still at St Martin's School of Art in London, Vezzoli's recent short films find the artist popping up in brief cameos armed with his trusty embroidery hoop. Part campy parodies, part complex multi-referential homages, the shorts are tangentially based on scenes from landmark modern films by such directors as Truffaut, Visconti and Wertmuller, but quickly become fragmentary, tongue-in-cheek digressions on fame, genius and the decorative arts. (JT)

Represented by Giò Marconi C14, Galerie Neu E10, Galleria Franco Noero G13

FastFood
2002
Oil on canvas
194×294cm
Courtesy Vilma Gold

Alexander **Vinogradov** & Vladimir **Dubossarksy**

Born 1963/1964
Live Moscow

Trained in the official Soviet School of Painting, Alexander Vinogradov and Vladimir Dubossarksy reference sources as diverse as Socialist Realism, kitsch, folklore, cartoons, cinema and an array of exhausted signifiers from popular culture such as Marilyn, Elvis and Teletubbies. The results are large, dreamy, high-key paintings that celebrate an image of the world saturated in a kind of weird faux innocence. Rainbows, sunlight and, more recently, Queen Elizabeth II, porn actors and film stars from the Cold War – to name but a few – elbow each other for attention in these crowded tableaux. Imagine painting pictures of somewhere you've never been to but have read the propaganda about, let your imagination travel there and you're getting close. (JH)

Represented by Galerie Krinzinger E9, Vilma Gold G5

Selected Bibliography

2002 *Vitamin P: New Perspectives in Painting*, ed Valérie Breuvart, Phaidon, London

2001 'Dubossarsky e Vinogradov', Ciara Guidi, *Juliet* (Italian edition), June
'Painting for London', Nigel Prince, *Untitled*
'Russian Inertia', A. Osmolovsky, *Flash Art*, January–February
'Two White Russians Please', Cedar Lewisohn, *Sleazenation*, August

Selected Exhibitions

2003 Russian Pavilion, Venice Biennale
'Our Best World', Deitch Projects, New York

2002 'Urgent Painting', Musée d'Art Moderne de la Ville de Paris
'Moscou Moscow', Russian Section, São Paolo Biennale

2001 'Painting for London', Vilma Gold, London
'How Are You, Ladies and Gentlemen?', Claudio Poleschi, Lucca

2000 'Inspiration', XL Gallery, Moscow

1997 'Erntedankfest', Atelier-Ester Freund, Vienna

1995 'Picture for the Reichstag', Higelman Gallery, Berlin

The Peacock
2003
Gouache on paper
58×82cm
Courtesy doggerfisher

Selected Bibliography

2003 *Real*, Kunstenernes, Oslo

2000–01 *Höstutstillingen*,
Kunstenernes, Oslo

2000 *Life School*, Glasgow School of
Art
A Day like Any Other, Francis
McKee, Stavanger kulturhus; CCA,
Glasgow

Selected Exhibitions

2003 'Zenomap', Gagosian
Gallery, London
Prague Biennale
'Zenomap', Venice Biennale

2003 Isabella Brancolini Arte
Contemporanea, Florence

2003 'Soft Sun Down',
doggerfisher, Edinburgh

2002 'A hundred flowers,
a hundred birds, a hundred children
in late spring and early summer',
CCA, Glasgow
'Back to the Future', Stavanger
kulturhus

2001 'Bat in mouth', site-specific
project, Bergen Museum for
Natural History

2000 'A Day like Any Other',
Stavanger kulturhus; CCA,
Glasgow

Hanneline **Visnes**

Born 1972
Lives Glasgow

A malevolent presence haunts the peacocks,
tigers and exotic flora and fauna that dwell within
Hanneline Visnes' paintings. These beautiful
creatures are accompanied by other objects – candles,
skulls and threatening dark matter – conjuring up the
spectre of death from these small, awkwardly shaped
works. Visnes' paintings trawl sources ranging from
traditional folk art to Renaissance Dutch painting.
The seductive formal register of her heraldic-like
work is undermined by the unsettling language
in which these memento mori speak. (DF)

Represented by doggerfisher C21

Portrait Ute M.
1968
Oil on canvas
116×110cm
Courtesy BQ

Reinhard **Voigt**

Born 1940
Lives New York

Long before the birth of the pixel Reinhard Voigt started to break images down into their basic cellular structure. In the early 1970s he began filtering the flotsam and jetsam of quotidian visual culture, rendering – or rather synthesizing – anything from found images to portraits in the form of clusters of small rectangles of colour. Voigt's earlier works have recently been rediscovered. The deadpan humour with which they embrace and transform the beautiful banalities of visual culture constitutes a historic approach to Pop art that makes some of the experimental graphics you see on MTV these days seem pale by comparison. (JV)

Represented by BQ B6

Selected Bibliography

2003 *Reinhard Voigt – Arbeiten von 1968–1974* (Works Between 1968–1974), BQ, Cologne

1991 *Reinhard Voigt: A Survey*, Angles Gallery, Santa Monica

1979 *Reinhard Voigt – Bilder und Zeichnungen* (Paintings and drawings), Studienstiftung des Deutschen Volkes, Bonn

1972 *Reinhard Voigt*, Kunstverein Unna

Selected Exhibitions

2003 BQ, Cologne

1998 'The Table', Sprengel Museum, Hanover

1991 'Reinhard Voigt: A Survey', Angles Gallery, Santa Monica

1986 'Die 60er Jahre, Kölns Weg zur Kunstmetropole' (The Sixties, Cologne's way to an art metropolis), Kunstverein, Cologne

1983 Willhelm-Hack-Museum, Ludwigshafen

1976 Kunstverein, Hanover

1972 Kunstverein, Unna

1971 Galerie M.E. Thelen, Cologne

1970 '14×14', Kunsthalle, Baden-Baden
Galerie Rudolf Zwirner, Cologne

Frontier
2003
Oil on canvas
198×273cm
Courtesy MW projects

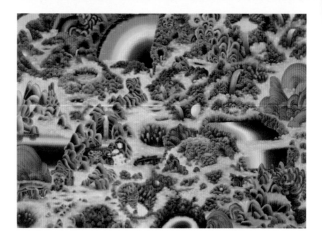

Christian **Ward**

Born 1977
Lives London

Despite their atmosphere of imminent apocalypse, Christian Ward's landscape paintings look like they're having fun. These are toxic destinations, as confused as a dream; time is a slippery, Technicolor place that changes its mood and mind every minute. Imagine a ride at Disneyland that projects you into the 19th century before hurtling into a high-keyed prehistory that confusingly exists somewhere in the future and you're getting close. Grottoes and bones so bright you blink; vivid, creepy, labyrinths and valleys; these are bulbous landscapes of fictional destinations accurately rendered. (JH)

Represented by MW projects C1

Selected Exhibitions

2003 'Inside the Island', MW projects, London
'Inaugural Exhibition', Saatchi Gallery, London
'Summer Exhibition', Royal Academy of Arts, London
'Rockwell', London
'Good Bad Taste', Keith Talent Gallery, London
'Friction', London Print Studio

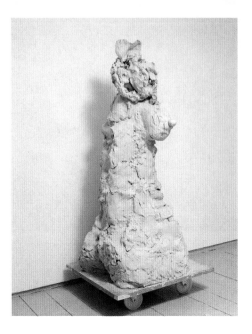

Deutsche Bank
2002
Unfired clay, MDF and wheels
166×74×74cm
Courtesy Maureen Paley Interim Art

Rebecca **Warren**

Born 1965
Lives London

Rebecca Warren makes eclectic, rough-hewn, energetic sculptures – think early Lucio Fontana remade with the occasional startled penis, labia, hand, breast or thigh emerging from the chaos. Despite the weight of history on their sturdy shoulders, these sculptures play gently with precedence. *Helmut Crumb* (1998), for example, is a giant-legged, high-arsed, high-heeled figure of a woman inspired by Robert Crumb and Helmut Newton. It's a sculpture that strides forth like a victor, headless yet uncowed. Warren has said, 'I think my approach to making art is a making sense of the madness of things.' This she does with humour, imagination and instinct in equal measure. (JH)

Represented by Maureen Paley Interim Art C11

Selected Bibliography

2003 'Under the Influence' Jennifer Higgie, *frieze*, 72, January–February

2002 *The Galleries Show*, Royal Academy of Arts, London
Summer Exhibition 2002, Royal Academy of Arts, London

2001 *New Labour*, Saatchi Gallery, London

Selected Exhibitions

2003 Donald Young Gallery, Chicago
'SHE', Maureen Paley Interim Art, London
'Rachel Harrison, Hirsch Perlman, Dieter Roth, Jack Smith, Rebecca Warren', Matthew Marks Gallery, New York
'4 Old Works', 56a Clerkenwell Road, London

2002 'The Galleries Show', Royal Academy of Arts, London
'Summer Exhibition 2002', Royal Academy of Arts, London
'Fleischvater', Modern Art, London

2001 'New Labour', Saatchi Gallery, London

2000 'The Agony and the Ecstasy', Maureen Paley Interim Art, London

1995 'Manliness without ostentation ...', The Agency, London

Broad Street
2001
DVD for 5-screen projection
40 minutes
Courtesy Maureen Paley Interim Art

Selected Bibliography

2002 *Mass Observation*, Museum of Contemporary Art, Chicago

2001 *Gillian Wearing 'Sous influence'*, Musée d'Art Moderne de la Ville de Paris

2000 *Gillian Wearing*, Serpentine Gallery, London

1999 *Gillian Wearing*, Phaidon, London

1997 *Signs that say what you want them to say and not Signs that say what someone else wants you to say*, Maureen Paley Interim Art, London

Selected Exhibitions

2003 'Mass Observation', Museum of Contemporary Art, Chicago and touring

2002 Maureen Paley Interim Art, London
'Trilogy', Vancouver Art Gallery Kunsthaus, Glarus

2001 Museo do Chiado, Lisbon
'Sous influence', Musée d'Art Moderne de la Ville de Paris
Fundacio la Caixa, Madrid

2000 Regen Projects, Los Angeles
Serpentine Gallery, London

1997 Turner Prize, Tate Gallery, London

Gillian **Wearing**

Born 1963
Lives London

Gillian Wearing's 1994 video *My Favourite Track* is excruciating to watch, but perhaps that's the point; other people's impulses aren't always dignified. Filmed in a shopping arcade in Peckham, Wearing dances wildly to music she is listening to on a Walkman. Described by Adrian Searle in *frieze* as a 'one-woman Mass Observation team', Wearing has, over the past decade or so, prised open the lid of personality with empathic and often humorous incursions into the human heart. She has variously persuaded members of the public to disguise themselves and 'confess all on video'; filmed the complicated relationship between a mother and daughter; asked pedestrians to write their slogan of choice on a blank placard; and questioned men in pubs about what they regret buying. (JH)

Represented by Maureen Paley Interim Art C11

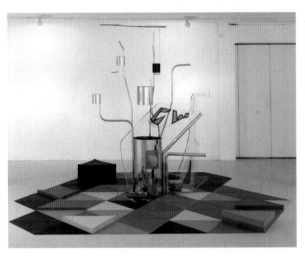

Adam or Gary
2003
Stainless steel, brass, Perspex, glass, rubber, paper, mini-disc player and speaker
270×350×450cm
Courtesy The Approach

Gary **Webb**

Born 1973
Lives London

At first glance Gary Webb's works look almost like proper abstract sculptures, but peer closer and their addled capriciousness makes itself known. Fabricated from a clashing overabundance of materials, sprigged with found elements (toys, syringes, mannequin heads), occasionally emitting sounds, they hint at both the work of 1960s New Generation and a bizarre semi-usefulness. This is sculpture looked at through the wrong end of a wilting telescope, an art that dangles a bunch of hermeneutic carrots – functional, narrative, purely formal – but is too contrary to make a single reading viable. Like unpredictable, tongue-tied teenagers, Webb's works purposefully combine audacity, clunkiness and flashes of pure brilliance. (TM)

Represented by The Approach D8

Selected Bibliography

2002 'Better than BritArt', Richard Dorment, Daily Telegraph, 17 July 2002
'Flim flam man', Alex Farquharson, *frieze*, 67, May
Early One Morning, Whitechapel Art Gallery, London

2001 'Virile Logic', Michael Archer, *Untitled*, Autumn/Winter
Casino 2001, Jeanne Greenberg Rohatyn, Lars Bang Larsen, Libby Lumpkin, Midori Matsui, Saul Anton and Andrea Scott, SMAK, Ghent

Selected Exhibitions

2003 'The Moderns', Castello di Rivoli, Museo d'Arte Contemporanea, Turin

2002 'Early One Morning', Whitechapel Art Gallery, London

2001 'Casino 2001' SMAK, Ghent
'Dedaelic Convention: du und ich' Kunstverein, Salzburg
'Brown', The Approach, London, Curated by Gary Webb
'Abstract Art', Delfina, London

2000 'Nouveau Riche', The Approach, London

1999 'Heart & Soul', 60 Long Lane, London

1998 'Gary Webb plays Gary Webb', The Approach, London
'Die Young Stay Pretty', ICA, London

Untitled
2003
Oil on canvas
160×160cm
Courtesy Wilkinson Gallery

Selected Bibliography

2003 *Catalogue*, Allianz-Building, Berlin
Willkommen in Leipzig (Welcome to Leipzig), Peter Guth, Museum für Bildende Kunst, Leipzig,

2002 *Räumen* (Vacation), Katharina Lökenhoff and Anja Hilgert, Kunsthaus Essen
Convoi, Anja Hilgert Metallgalerie, Frankfurt

2001 *Matthias Weischer, Susan Schmidt, Malerei*, galerieKleindienst, Leipzig

Selected Exhibitions

2003 'New Paintings', Wilkinson Gallery, London
Prague Biennale
'Willkommen in Leipzig' (Welcome to Leipzig), Museum für Bildende Kunst, Leipzig
Galerie Nicolai Wallner, Copenhagen
'Painting Show', Anthony Wilkinson Gallery, London
'Drei Zimmer, Diele, Bad' (Three rooms, hallway, bedroom), Galerie LIGA, Berlin

2002 'Arbeiten auf Papier', Galerie Frank Schlag, Essen
'Räumen' (Vacation), Kunsthaus Essen
Galerie EIGEN + ART, Leipzig

2001 'Malerei' (Painting), Galerie Kleindienst, Leipzig
'Szenenwechsel XX' (Change of scenes XX), Museum für Moderne Kunst, Frankfurt

Matthias **Weischer**

Born 1973
Lives Leipzig

Matthias Weischer's paintings of domestic interiors emphasize their oddness with great compositional care. Cheap products sit on swanky designer furniture, rendered in styles seemingly pulled from different dimensions. Lifestyle aspiration interlocks with the mundane truths of daily reality and indistinct memories of uneasy situations. Sickly images of imagined domestic bliss are collaged into empty rooms, seemingly put together by an interior designer on the verge of a nervous breakdown. (DF)

Represented by Wilkinson Gallery E1

Eric **Wesley**

Born 1973
Lives Los Angeles

Eric Wesley's sculpture *Kicking Ass* (2000) is the perfect punning embodiment of its title: a realistic full-size bucking donkey knocks a hole clear through the pristine gallery wall. It's an apt model for the way Wesley works: ripping past surfaces, looking behind the scenes, finding alternate methods of entry. He is a prankster of institutional critique, creating elaborate simulated environments that transform art galleries into Mexican fast-food restaurants or terrorist workshops or bootleg cigarette factories. These pirate operations mirror and mock the often shady networks of manufacture and distribution supporting the contemporary art world. (SS)

Represented by China Art Objects Galleries G6, Meyer Riegger Galerie B7, Galleria Franco Noero G13

Selected Bibliography

2002 'Just for Kicks', Julian Myers, *frieze*, 72, January–February

2001 'Eric Wesley to the Bone', Malik Gaines, *Artext*, 75, November–January

2001 'Breaking Away: A Flowering of Young African American Artists', Peter Schjeldahl, *New Yorker*, 11 June 2001

'Post-Black: Radical Intelligence at the Studio Museum in Harlem', Jerry Saltz, *Village Voice*, 22 May 2001

2000 'Too Autopoeitic to Drive' in *Drive*, Giovanni Intra, Govett Brewster Art Gallery, New Zealand,

Selected Exhibitions

2003 'Adios Pendejos', Officina para Proyectos de Arte, Guadalajara

2002 Metro Pictures, New York
Meyer Reigger Galerie, Karlsruhe
Galleria Franco Noero, Turin

2001 'Two Story Clocktower', CalTech, Pasadena
'Freestyle', Studio Museum, Harlem, New York and Santa Monica Museum of Art
'Snapshot: New Art From Los Angeles', UCLA Hammer Museum of Art, Los Angeles,
Museum of Contemporary Art, Miami

2000 'Kicking Ass,' China Art Objects Galleries, Los Angeles

1998 Brent Petersen Gallery, Los Angeles

Flowers in the Forest
2003
Glass and cable
Dimensions variable
Courtesy 1301PE

Selected Bibliography

2002 'Luxe, calme et volupté', Jennifer Higgie, *frieze*, 66, April
'Pae White', *Women Artists*, Taschen, Cologne

2000-01 *frieze*, 50-61, full page adverts for neugerriemschneider

Selected Exhibitions

2003–5 'Watershed, The Hudson Valley Art Project', Bear Mountain, New York

2002 'A Grotto, Some Nightfish and a Second City', Contemporary Art Gallery, Vancouver

2001 'the americans. new art', Barbican Art Gallery, London
'Extra Art: A Survey of Artist's Ephemera 1960-1999', California College of Arts and Crafts, San Francisco

2000 'Circles °3', Zentrum für Kunst und Medientechnologie, Karlsruhe
'Made in California, 1900-2001', Los Angeles County Museum of Art
'What if', Moderna Museet, Stockholm
'Against Design', Institute of Contemporary Art, Philadelphia

1997 'Enterprise', Institute of Contemporary Art, Boston

1994 'Pure Beauty', The American Center, Paris; Museum of Contemporary Art, Los Angeles
'Watt', Witte de With, Rotterdam and Kunsthal, Rotterdam

Pae **White**

Born 1963
Lives Los Angeles

Influenced as much by the weather as by design, and as much by the infinite shapes of the moon as by art history, Pae White not only exhibits in galleries, but designs magazine advertisements, shopping bags, catalogues, books and invitations. She considers her design work an integral component of her art practice, but whereas her exhibitions often embrace the ephemeral (cobwebs, birds, water and mobiles are recurring motifs), her 'commercial' work teasingly spins variations on themes of communication and ownership. Interdependence is central to White's work. Imagine, she seems to be saying, what art would be like without design, or design without art, or people who kept their imaginations to themselves. The world would be a very different place, and not a better one. (JH)

Represented by 1301PE B11, Galerie Daniel Buchholz A2, galleria francesca kaufmann H3, greengrassi A3, neugerriemschneider C6

Monument
2001
Resin and granite
9×5.1×2.4m
Courtesy Luhring Augustine

Rachel **Whiteread**

Born 1963
Lives London

Rachel Whiteread's *House* (1993) cast in concrete
the interior of a condemned Victorian terraced house
in east London. Subsequently bulldozed by the local
council, this work epitomized Whiteread's practice
of evoking lived experience by casting spaces in
negative. Applied to subjects including the undersides
of floorboards and chairs, baths, fire escapes and
water towers, and using materials from plaster to
translucent resin, her technique generates quasi-
Minimalist masses that seem literally and movingly
suffused with historical content. In recent years her
work has ranged from a vast imaginary library
produced as a Holocaust memorial in Vienna's
Judenplatz, and her own home in a former East
End synagogue. (MH)

Represented by Luhring Augustine D10

Selected Bibliography

2002 *To Be Looked At. Painting and
Sculpture from The Museum of Modern
Art, New York*

2000 *Judenplatz, Place of
Remembrance*, Museum Judenplatz,
Vienna

1999 *Looking Up: Rachel Whiteread's
Water Tower*, ed Louise Neri, Public
Art Fund, New York; Scalo, Zurich,
Berlin, New York

1997 *Sensation. Young British Artists
from the Saatchi Collection*, Brooks
Adams et al. Royal Academy of
Arts, Thames & Hudson, London

1995 *Rachel Whiteread House*, ed
James Lingwood, Phaidon, London

Selected Exhibitions

2003 Luhring Augustine, New
York
'Days Like These. Tate Triennial
2003', Tate Britain, London

2002 'Rachel Whiteread: Transient
Spaces', Guggenheim Museum,
New York

2001 Serpentine Gallery, London
'Trafalgar Square Plinth', London

2000 'Judenplatz: Place of
Remembrance', Vienna

1998 'Water Tower Project', Public
Art Fund, New York

1997 Tate Gallery, London
British Pavilion, Venice Biennale

1995 Institute of Contemporary
Art, Philadelphia

1994 Kunsthalle, Basel

The Hallway, Antmel
2002
C-type print on aluminium
183×183cm
Courtesy 303 Gallery

Selected Bibliography

2002 *Outer & Inner Space: Pipilotti Rist, Shirin Neshat, Jane & Louise Wilson and the History of Video Art*, Laura Cottingham, Eleanor Heartney and Jonathan Knight Crary, Virginia Museum of Fine Arts, Richmond

2000 *The British Art Show 4*, Hayward Gallery, London, Cornerhouse Publications
Jane and Louise Wilson: Las Vegas, Graveyard Time, Suzanne Weaver, Dallas Museum of Art
'Jane & Louise Wilson in the Light of the Gothic Tradition', Gilda Williams, *Parkett*, 58

1999 *Young British Art, The Saatchi Decade*, Booth Clibborn Editions, London

1997 *Jane and Louise Wilson: Stasi City*, Kunstverein, Hanover

Selected Exhibitions

2003 Lisson Gallery, London

2002 Kunst-Werke, Berlin

2001 'Public Offerings', Museum of Contemporary Art, Los Angeles

2000 'Las Vegas, Graveyard Time', Dallas Museum of Art

1999 Serpentine Gallery, London

1997 'Stasi City', Kunstverein, Hanover; Kunstraum, Munich; Museum of Contemporary Art, Geneva; Kunst-Werke, Berlin

1995 'Normapaths', Chisenhale Gallery, London; Gymnasium Gallery, Berwick upon Tweed; 'The British Art Show 4', Edinburgh and touring

1993–4 'BT New Contemporaries', Cornerhouse, Manchester and touring

1993 'Barclays Young Artists', Serpentine Gallery, London

Jane & Louise **Wilson**

Born 1967
Live London

The tagline to Ridley Scott's film *Alien* was 'In space, no one can hear you scream.' It could also be an apt description of the work of the Wilson twins. The relationship between architecture and power is at the heart of their video installations and photographic works. Shot through with a particularly unsettling paranoia, the Wilsons' split-screen video projections track slowly through decaying sites of power, from empty Las Vegas casinos to deserted East German secret police headquarters and, most recently, the crumbling Apollo Pavilion, a Modernist edifice in the north of England designed by the artist Victor Pasmore. From these silent walls and corridors they conjure the ghosts of buildings once shrouded in the cloak of secrecy. (DF)

Represented by 303 Gallery C12, Lisson Gallery B4

Paul **Winstanley**

Born 1954
Lives London

Paul Winstanley's paintings put a spin on the concept of corporate lobby art. Well-appointed conference rooms, institutional hallways and stern Bauhaus architecture are rendered in a chilly light all too familiar to office drones – perhaps the best example of fluorescent glare yet captured on canvas. Occasional references to painting's greats punctuate the dreariness: *Veiled Lobby* (2001) is almost Surrealist with its floor-to-ceiling drapes and protuberant red escalator; *Untitled (Woman at a Window)* (2000) somehow conjures Vermeer in a bare-bones setting. Winstanley zeroes in on the curtains, screens and other devices meant to insulate places of business from nature, which promote efficiency without managing to stifle longing. (KR)

Represented by 1301PE B11, Kerlin Gallery F16, Galerie Nathalie Obadia F2, Maureen Paley Interim Art C11

Selected Bibliography

2000 'Duncan McLaren and Paul Winstanley', *Independent on Sunday*, 10 December 2000
Paul Winstanley Archive: Complete Paintings 1989–2000, Maureen Paley Interim Art, London and 1301PE, Los Angeles

1998 *Postcards on Photography*, Cambridge Darkroom Gallery

1994 'Paul Winstanley', *frieze*, 18, September–October

Selected Exhibitions

2002 Kerlin Gallery, Dublin
Renaissance Society, University of Chicago
'Landscape', British Council touring exhibition, Casa Andrade Muricy, Curitiba

1999 1301PE, Los Angeles
'Go Away: Artists and Travel', Royal College of Art, London

1997–8 'Art Now 12', Tate Gallery, London

1996 Maureen Paley, Interim Art, London

1992–3 'Paintings 1991–92', Kettle's Yard, Cambridge; Lancaster Gallery, Coventry

Leere und Gewalt
(Emptiness and Force)
1978–2003
Installation view, Sprengel Museum,
Hanover
Courtesy Galeria Gisela Capitain

Selected Bibliography

2003 *Johannes Wohnseifer – Self-destroying History*, Fine Arts Unternehmen, Zug

2001 *Ars Viva 01/02*, Kulturkreis im BDI, Berlin
Black Helicopters Book, artist's publication, Cologne

1999 *Museum*, Projektraum, Museum Ludwig, Cologne

Selected Exhibitions

2003 'Leere & Gewalt' (Emptiness and Force), Sprengel Museum, Hanover
Ludwig Forum, Aachen
Neuer Aachener Kunstverein, Aachen

2002 'No Return', Positionen aus der Sammlung Haubrok Museum Abteiberg (Statements from the Haubrok Collection in the Abteibergmuseum), Mönchengladbach
'Prophets of Boom', Sammlung Schürmann, Kunsthalle, Baden-Baden
Galerie Johann König, Berlin

2001 'Ars Viva 01/02: Kunst und Design Bless, Pro qm' (Art and design, bless, per sqm), Johannes Wohnseifer, Museum für Angewandte Kunst, Cologne
'Break Down Lounge', Art Cologne
Yokohama Triennale 2001

2000 'This Night Worldwide', Galerie Gisela Capitain, Cologne

Johannes **Wohnseifer**

Born 1967
Lives Cologne

Art can be like the daily papers. Only better. Sigmar Polke and Martin Kippenberger knew it and Johannes Wohnseifer knows it too. In his paintings and installations he gives poignant commentaries on current political issues, often mixing fact and fiction, precise references and arcane allusions, irony and analysis – with a healthy bit of conspiracy theory thrown in for good measure. After all, it is from thrillers that we learn how the world really works: Mies van der Rohe invented the MacDonald's franchise restaurant, the Stealth bomber is what we love best about the States, while the Baader–Meinhof group are the only significant pop stars Germany ever produced. Arguably. (JV)

Represented by Galerie Gisela Capitain D11, Johann König B15

Christopher **Wool**

Born 1955
Lives New York

Using text, paint, various printmaking techniques and handmade marks, Christopher Wool makes paintings about painting, paintings about printmaking, and paintings about slogans and advertising and aggression and nonsense and disillusion (these are the funniest). He also makes paintings about design, repetition and provocation – and about how unsettling decoration can be. Developing and enlarging on details from previous works, Wool's messy exercises in repetition and renewal look good – in a ravaged, restless, movie star way – and, like so many movie stars, they too enjoy the act of obliteration: removing, reworking or re-energizing earlier aspects of themselves that no longer seem as necessary as they once were. (JH)

Represented by Galerie Gisela Capitain D11, Luhring Augustine D10, Sprüth Magers Lee B3, Galerie Micheline Szwajcer E5

Selected Bibliography

2002 *Painting on the Move*, Kunstmuseum, Museum für Gegenwartskunst, and Kunsthalle, Basel

2001 *ChristopherWool*, Secession, Vienna

1998 *ChristopherWool*, Thomas Crow, Ann Goldstein, Madeleine Grynsztejn, Gary Indiana and Jim Lewis, Museum of Contemporary Art and Scalo, Los Angeles

1997 *Birth of the Cool:American Painting from Georgia O'Keeffe to ChristopherWool*, Bice Curiger, Zdenek Felix, Jeff Perrone, Carter Ratcliff, Allan Schwartzman and Beat Wyss, Kunsthaus, Zurich

1993 *Absent without Leave*, DAAD, Berlin

1989 *Black Book*, Galerie Gisela Capitain and Thea Westreich, Cologne and New York

Selected Exhibitions

2002 Le Consortium, Dijon
Dundee Contemporary Arts
Galerie Max Hetzler, Berlin

2001 Secession, Vienna
Luhring Augustine, New York

2000 'Mixing Memory and Desire', New Museum of Art, Lucerne
'Art at MoMA since 1980', Museum of Modern Art, New York

1999 'The Passion and the Waves', Istanbul Biennial
Centre d'Art Contemporain, Geneva

1998 Museum of Contemporary Art, Los Angeles, touring to Carnegie Museum of Art, Pittsburgh; Kunsthalle Basel

1991 Museum Boijmans van Beuningen, Rotterdam and touring

Instructions on how to be politically incorrect: Two ways of carrying a bomb
2003
C-type print
126×184cm
Courtesy Galerie Krinzinger

Selected Bibliography

2002 *Fat Survival. Handlungs-formen der Skulptur* (Fat Survival. Forms of actions in sculpture), Neue Galerie am Landesmuseum Joanneum, Graz; Hatje Cantz Verlag, Ostfildern-Ruit
Sculptures with Embarrassment, Kiasma Museum of Contemporary Art, Helsinki

2000 *Erwin Wurm*, The Photographers' Gallery, London

1999 *One Minute Sculptures*, Hatje Cantz Verlag, Ostfildern-Ruit

1996 'Der Flipperspieler, Anmerkungen zu Erwin Wurms Skulpturbegriff' (The Pinball Player, annotations to Erwin Wurm's Concept of Sculpture), Roland Wäspe, *Parkett*, 46

Selected Exhibitions

2003 'Erwin Wurm', ZKM, Center for Art and Media, Karlsruhe
'European Dream', Museo de Arte Carrillo Gil, Col San Angel, Mexico City

2002 'Fat Survival – Handlungsformen der Skulptur', Neue Galerie Graz am Landesmuseum Joanneum, Graz
'Erwin Wurm', Centre National de la Photographie, Paris
'Erwin Wurm: Fat Car', Palais de Tokyo, Paris
'Sculptures with embarrassment', Kiasma Museum of Contemporary Art, Helsinki
'Tempo', Museum of Modern Art, New York
'Erwin Wurm', Galleria d'Arte Moderna, Bologna

2001 'Fat Car', Musée d'Art Moderne et Contemporain, Geneva

2000 'Erwin Wurm', The Photographers' Gallery, London, England

Erwin **Wurm**

Born 1954
Lives Vienna

A man balancing five long rods between his fingertips and the wall; a man standing motionless with an asparagus spear in each of his nostrils; a woman with her legs in the air, balancing a teacup on each of her feet – these are some of Erwin Wurm's 'one minute sculptures'. Based on drawings that work like instruction manuals, they are usually performed by a single person. A video documents the failed attempts and then, for an instant, the 'completed' sculpture. Photographs isolate these short-term victories from the process that led to them, turning the traditional idea that sculpture is made for eternity into freeze-framed slapstick. Wurm embraces the fundamental embarrassment of artistic production, throwing the relation between bodies and things into gravity-defying turmoil. (JöH)

Represented by Jack Hanley Gallery G4, Galerie Krinzinger E9, Galerie Aurel Scheibler D13

Picture of a Horse Stable
2001
Oil on canvas
74×175cm
Courtesy Mizuma Art Gallery

Akira **Yamaguchi**

Born 1969
Lives Tokyo

Akira Yamaguchi's paintings originate in a simple hypothetical scenario: if a Yamato-e painter from the Edo period were working in today's schizophrenic Japan, what would he paint? Rigorously trained in the ancient technique, Yamaguchi answers the question with images of huge, intricately choreographed battles between samurai and robots, salarymen and soldiers; idyllic landscapes in which clouds sourced from traditional paintings come to look like toxic smog; and wooden stables whose centaur-like horses have transmuted into rickshaws and four-legged androids. A chilly, time-collapsing cornucopia, Yamaguchi's art reflects his avowal that 'there's nothing wrong with imitating a past style as long as you innovate.' (MH)

Represented by Mizuma Art Gallery C13

Selected Bibliography

2002 *New Edition! Japanese Art: Other Inheritors of Japanese Tradition*, Yamanashi Prefectural Museum of Art

2000 *Department Store of Contemporary Art*, Yamanashi Prefectural Museum of Art

1999 *A Window (Inside and Outside)*, Kwangu City Art Museum

Selected Exhibitions

2003 Mizuma Art Gallery, Tokyo

2002 'Caricature of Sino-Japanese War & Russo-Japanese War', NADIFF, Tokyo
'New Edition! Japanese Art: Other Inheritors of Japanese Tradition', Yamanashi Prefectural Museum of Art
'Japan in Blekinge', Blekinge

2001 'The Joy of Painting', Mizuma Art Gallery, Tokyo
'The 4th Exhibition of the Taro Okamoto Memorial Award for Contemporary Art', Taro Okamoto Museum of Art Kawasaki

2000 'Department Store of Contemporary Art', Yamanashi Prefectural Museum of Art
'Five Continents and One City', Museum of Mexico City

1999 'Shakkei (Borrowing backdrops)', Mizuma Art Gallery, Tokyo
'A Window (Inside and Outside)', Kwangju City Art Museum

...Where everything was painstakingly ordered and in its place
2002
Two sets of free-standing rack modules
230cm high
Courtesy Galerie Barbara Wien

Selected Bibliography

2002 *Kunst und Technik*, Anja Casser, Dielmann Verlag, Frankfurt
Luft und Wasser (Air and Water), Isabel Podeschwa, Dresdner Bank, Frankfurt
Blink, Sungwon Kim, Artsonje Center, Seoul

2001 *Sonderfarben, Katalog 1998–2001* (Special Colours, Catalogue 1998–2000), Meike Behm, Martin Pesch, Jochen Volz and Peter Lütje, Wiens Verlag, Berlin

2000 *Grid Block*, cover design: Achim Reichert

Selected Exhibitions

2003 'Core Area', De Appel, Amsterdam,
Public, Paris
'From Dust to Dusk', Charlottenborg Exhibition Hall, Copenhagen
'Forget Igret Regret', Akiyoshidai International Artist Village, Yamaguchi

2002 'Luft und Wasser' (Air and Water), Dresdner Bank, Frankfurt
Manifesta, Frankfurt
Blink, Artsonje Centre, Seoul

2001 'Sonderfarben' (Special Colours), Kommunale Galerie, Darmstadt
Tirana Biennale
Frankfurter Kreuz', Schirn Kunsthalle, Frankfurt

2000 'Lacker Painting', Wiens Laden und Verlag, Berlin

Haegue **Yang**

Born 1971
Lives Frankfurt/Seoul

Haegue Yang stacks plastic drinks cases on a slightly inclined ramp so they are on the verge of toppling over, like drunks on their way home (*Tilting on a Plane*, 2002). Alternatively, the Frankfurt- and Seoul-based artist borrows grey metal rack modules and an Eiermann sofa for the duration of an exhibition, turning the ensemble of *What I'd Love to Have at Home* (2001) into less, and more, than 'just' a ready-made: less, because the objects are temporarily borrowed; more, because the title reveals them as being 'privately' desired beyond contextual artistic concerns. Yang inserts into what had seemed an unambiguous situation that one simple but decisive twist that makes it look awry, like the Queen in Shakespeare's Richard II. (JöH)

Represented by Galerie Barbara Wien G2

The long, harsh odyssey of a Chinese illegal smuggled from Fujian province to New Jersey

By TERRY McCARTHY FUZHOU AND NEW JERSEY

CAMOUFLAGE – LOOK like them
– TALK like them
2002–3
Video still
Courtesy Galerie Martin Janda

Jun **Yang**

Born 1975
Lives Vienna

Within everyday life cultural differences are reflected in bizarre imaginings and telling misapprehensions. Born in China and raised in Austria, Jun Yang has involuntarily become an expert in these everyday slippages. Many of his works are based on revealing anecdotes, which he recounts with the detached humour of a novelist. In the video *Jun Yang & Soldier Woods* (2002) he reflects on the frequent misspellings of his name, which routinely result in gender misattribution. The video *Coming Home – Daily Structures of Life* (2000) is a compilation of footage from Hollywood films showing Chinese restaurants. In the commentary Yang describes how recent immigrants, irrespective of their former jobs, inevitably end up opening restaurants as this is the role allocated for them in Western culture. (JV)

Represented by Galerie Martin Janda F14

Selected Bibliography

2003 'Man of the World', Bert Rebhandl, *frieze*, 73, March
'Look like them – talk like them', Sabine B. Vogel, *Kunstbulletin*

2002 *Manifesta*, Frankfurt

2001 *Encounter*, Tokyo Opera City Cultural Foundation

1999 *ExtraetOrdinaire, le printemps de cahors*, Christine Macel, Actes Sud, Paris

Selected Exhibitions

2003 Galerie Martin Janda, Vienna
PS1, New York

2002 Musée d'Art Contemporain, Marseille
Manifesta, Frankfurt
Index, Stockholm

2001 'Coming Home. Daily Structures of Life – Version D00', Galerie für Zeitgenössische Kunst, Leipzig
Art Statements, Art Basel
Museum für Angewandte Kunst, Vienna

2000 'Emerging artists', Kunst der Gegenwart, Sammlung Essl, Klosterneuburg

1999 Raum Aktueller Kunst
Martin Janda, Vienna

LOOK/I AM/BLIND/LOOK
1998–9
Spray varnish, auto lacquer on
aluminium
70×78×3cm
Courtesy Mai 36 Galerie

Selected Bibliography

2001 *Architecture by Herzog & De
Meuron, Wallpainting by Rémy Zaugg, a
Work for Roche Basel*, Rémy Zaugg,
Birkhäuser, Basel, Boston, Berlin

2000 *Reflexionen von und über Rémy
Zaugg*, Bernhard Fibicher and Rémy
Zaugg, Kunsthalle Bern, Dr Karl
Schmidt, Nuremberg

1999 *Rémy Zaugg*. Rémy Zaugg
and Hans Rudolf Reust, Kunsthalle
Basel, Schwabe & Co., Basel

1998 *Das Kunstmuseum, Das ich mir
erträume oder Der Ort des Werkes und des
Menschen* (The Art Museum, I have
been dreaming of or the Locus of
Works and People), ed Institut für
moderne Kunst, Nuremberg, Dr
Karl Schmidt, Nuremberg

1992 *Ein Blatt Papier II/A Sheet of
Paper II*, Rémy Zaugg, Rudi Fuchs,
Jean-Christophe Ammann, Erich
Franz, Christoph Schenker, Luk
Lambrecht, Michael Tarantino,
Art & Art, les Presses du Réel, Paris,
Dijon, Bruxelles

Selected Exhibitions

2003 'Works 1963–2003', Mai 36
Galerie, Zurich
'De la Cécité', Galerie Nordenhake,
Stockholm

2001 Mai 36 Galerie, Zurich

2000 'Über den Tod (On death)',
Kunsthalle, Bern
Galerie Nordenhake, Berlin
Kunsthalle, Basel

1998 'Schau, Ich Bin Blind, Schau
(Look, I am Blind, Look)', Galerie
Nordenhake, Stockholm

1997 Mai 36 Galerie, Zurich
'Retrospektive, ein Fragment',
Kunsthalle Nuremberg

1996 'Carnegie International',
Carnegie Museum of Art, Pittsburgh

Rémy **Zaugg**

Born 1943
Lives Pfastatt

Rémy Zaugg combines Ad Reinhardt's rigorously teleological understanding of the history of painting with a subtle sense for language and typography reminiscent of Lawrence Weiner and Christopher Wool. The Swiss artist denies the viewer instant visual gratification, offering a textual inquiry into the conditions of vision instead. *JE FERME/LES YEUX/ET JE SUIS/INVISIBLE* (1998) – reads the sentence distributed evenly and pristinely, in white on grey, across the picture plane. Other pieces from recent years, also silk-screened on to aluminium, work with strong colour contrasts – intense blue shimmering against equally intense red, for example. Feigning to be mere concepts, these paintings test the relation between eye and tongue in more than one way. (JöH)

Represented by Mai 36 Galerie D12,
Galerie Nordenhake D12

La Salsa
1998
Video installation
9 minutes 30 seconds
Courtesy Johann König

David **Zink Yi**

Born 1973
Lives Berlin

Are gestures expressions of individual body
languages or a coded form of cultural
communication? In his videos David Zink Yi
explores both possibilities. He focuses on stylized
movements of the body, with a phenomenological
interest in unique details and with an analytical eye
for their cultural meaning. 'De adentro y afuera'
(From within and without, 2003) is a series of three
videos about performing salsa. One shows a close-up
of the swiftly moving legs of a salsa dancer, the
second shows the hands of someone playing the
claves, while the third shows the mouth of the singer.
Salsa is thus identified as an easily recognizable style,
a commodity of the music industry, and as an
intricate performance practised differently by
different bodies. (JV)

Represented by Johann König B15

Selected Bibliography

2003 *Nation*, Kunstverein,
Frankfurt

Selected Exhibitions

2004 Kunstverein, Ulm

2003 'De adentro y afuera' (From
outside and inside), Johann König,
Berlin
Sammlung Harald Falckenberg,
Hamburg
'Nation', Kunstverein, Frankfurt

2002 'Kino der Kälte' (Cinema of
cold), Medienkunstarchiv, Vienna

Contributors

(DF) **Dan Fox** is assistant editor of *frieze*. He is also a writer and musician.

(JöH) **Jörg Heiser** is a writer based in Berlin. He is associate editor of *frieze*.

(MH) **Martin Herbert** is a writer and editor based in Whitstable, UK. In recent years he has written numerous catalogue essays and contributed to magazines including *frieze*, *Art Monthly* and *Artforum*.

(JH) **Jennifer Higgie** is reviews editor of *frieze* and a writer.

(TM) **Tom Morton** is a writer, curator and curios editor of *frieze*. His comic book, *Anyway*, will be published by Alberta Press in October 2003.

(KR) **Karen Rosenberg** is a writer based in New York. She contributes to *frieze*, *Art Monthly*, *ARTnews* and *The Village Voice*.

(SS) **Steven Stern** is a writer in New York.

(JT) **James Trainor** is a writer and a frequent contributor to *frieze*. He is also a contributing editor for *Tema Celeste* magazine and lives and works in New York.

(JV) **Jan Verwoert** lives in Hamburg and writes for, among others, *frieze*, *Afterall*, *Springerin* and *Camera Austria*. He is a visiting professor for contemporary art and theory at the Academy of Umeå and a Sputnik (member of the advisory board) of the Kunstverein Munich.

JACQUES ADNET J. DEN DRIJVER FRANCIS JOURDAIN GIO PONTI LOUIS SOGNOT
FONTANA ARTE CHARLES DUDOUYT JULES LELEU ALAN RICHARD ANDRE SORNAY
JACQUES BINY RENÉ GABRIEL CARLO MOLLINO LUCIEN ROLLIN MICHEL ROUX SPITZ
OSVALDO BORSANI MARCEL GASCOIN MAXIME OLD JEAN ROYÈRE GUGLIELMO ULRICH
DOMINIQUE JACQUES HITIER ICO PARISI J.E. RUHLMANN JULES WABBES

Frank Rogin

ANDRE SORNAY
SIDE TABLE
C. 1930
MAHOGANY AND ROSEWOOD
26 INCHES HIGH

European Furniture + Lighting 1900 - 1960

21 MERCER STREET NEW YORK NY 10013
TEL 212.431.6545 FAX 212.431.6632
INFO@ROGIN.COM - WWW.ROGIN.COM

ɘan prouvé
harlotte perriand
ɘ corbusier
ndré borderie
ierre guariche
eorges jouve
athieu matégot
ɘan royère
ierre jeanneret
ɘrge mouille
lexandre noll

galerie de beyrie

french modernism
jacques adnet
rené herbst
le corbusier
georges jouve
serge mouille
alexandre noll
jean prouvé
charlotte perriand
jean royère

jean royère
relax set, 1947

393 west broadway, new york, ny 10012
tel: 212 219-9565 fax: 212 965-1348
email: info@galeriedebeyrie.com
www.galeriedebeyrie.com
gallery hours: weekdays 1-6 p.m.

wright

1140 west fulton
chicago 60607
t: 312.563.0020
f: 312.563.0040
www.wright20.com

ICONS OF MODERNIST DESIGN

LOUISA GUINNESS GALLERY

Furniture and functional objects by artists

Ron Arad – Studio works 1981-2003

Currently showing
until 22nd November
Limited edition and unique pieces

Donald Judd Furniture

In association with the Judd Foundation
Works permanently on show and available

Jewellery by 20th Century Artists

Exhibition runs from 27th November until 20th December
Including works by: Alexander Calder, Lucio Fontana, Yves Klein,
Robert Mapplethorpe, Cesar, Arman,
Anish Kapoor, Antony Gormley, Mimmo Paladino
Sam Taylor Wood, Gavin Turk, Ettore Sottsass

Works, which include rugs, coffee tables, wallpaper, lighting,
tableware are also available by the following artists:

Tom Sachs
Chuck Close
Roy Lichtenstein
Richard Tuttle
Rachel Whiteread

Kiki Smith
Hiroshimo Sugimoto
James Turrell
Isamu Noguchi
Sol LeWitt

Tel: 020 7581 7047

Hours during the fair: 11am – 7 pm or by appointment

19 Elden House, 90 Sloane Avenue, London SW3 3EA. Tel: +44 (0)20 7581 7047 Fax: +44 (0)20 7589 8068
louisaguinness@louisaguinnessgallery.com Website: www.louisaguinnessgallery.com

Cristina Grajales Inc.

10 Greene Street New York NY 10013
tel 212.219.9941 fax 212.966.2620
info@cristinagrajalesinc.com

Pierre Jeanneret, Black Pickeled Oak Cabinet, c. 1950, 97 x 32 x 16 inches

HEMISPHERE

Ceramic Sculpture by Georges Jouve, French, 1955

173 FULHAM ROAD, LONDON SW3 6JW TEL. 020 7581 9800 FAX. 020 7581 988

ΛRIQUEZ BOCOBO CONSTRUCTS *Modern living with functional designs*

East 19th Street New York, NY 10003 tel 212.420.0161 www.enriquezbocobo.com

ORANGE GROUP POSTWAR FRENCH ARCHITECT AND MODERNIS
FURNITURE 515 BROADWAY NEW YORK NY 10012 TEL 212 96
8617 FAX 212 334 4703 EMAIL INFO@ORANGEGROUP.CO

NRIQUEZ BOCOBO CONSTRUCTS

Neptune Chair with Ottoman

East 19th Street New York, NY 10003 tel 212.420.0161 www.enriquezbocobo.com

habitat

Directions to the latest contemporary art gallery.

Your home.

This exciting innovation lets you visit our online gallery to buy the art you want, the way you want it, then have it delivered direct to your home – it's that easy.

Visit now to see work from established and emerging artists, including: Gary Hume, Martin Maloney, Neil Rumming and Rosie Snell.

Art on Demand at www.habitat.net

Bonhams 1793

NEW BOND STREET

Modern and Contemporary Art
Wednesday 22 October 2003

Bridget Riley, Nineteen Greys A-D, 1968, signed in pencil,
colour screenprints on card, artist's proofs, *76.2 x 76.2cm (30 x 30in).*

Enquiries:

Howard Rutkowski, +44 (0) 207 468 8232, howard.rutkowski@bonhams.com

Emma Simpson, +44 (0) 207 468 8366, emma.simpson@bonhams.com

Robert Kennan, +44 (0) 207 468 8212, robert.kennan@bonhams.com

Bonhams, 101 New Bond Street, London W1S 1SR
www.bonhams.com

Bonhams 1793

NEW BOND STREET

Modern and Contemporary Art

Wednesday 22 October 2003

Enquiries:
Howard Rutkowski
+44 (0) 207 468 8232
howard.rutkowski@bonhams.com

Emma Simpson
+44 (0) 207 468 8366
emma.simpson@bonhams.com

Robert Kennan
+44 (0) 207 468 8212
robert.kennan@bonhams.com

Andy Warhol
Hammer and Sickle, 1976
graphite and watercolour
on paper.
103 x 71cm (40 1/2 x 28in)

Bonhams, 101 New Bond Street, London W1S 1SR
www.bonhams.com

Bonhams 1793
NEW BOND STREET

Modern and Contemporary Art
Wednesday 22 October 2003

Enquiries:

Howard Rutkowski
+44 (0) 207 468 8232
howard.rutkowski@bonhams.c

Emma Simpson
+44 (0) 207 468 8366
emma.simpson@bonhams.com

Robert Kennan
+44 (0) 207 468 8212
robert.kennan@bonhams.com

Andy Warhol
$, 1982
synthetic polymer paint with
silkscreen ink on canvas
229 x 178cm (90 1/8 x 70 1/8in).

Bonhams, 101 New Bond Street, London W1S 1SR
www.bonhams.com

"...contemporary art is becoming the driving market force."

ART & AUCTION, SUMMER 2003

CHRISTIE'S

MIQUEL BARCELÓ (b. 1957)
Pinassi
mixed media on canvas
signed, titled and dated 'PINASSI Barcelo VII.91' (on the reverse)
78⅛ x 117¾ in. (198.5 X 299 cm.)
Executed in 1991
Estimate: UK£500,000–900,000 (EUR700,000–1,270,000)

Post-War & Contemporary Art

Auction
22 October 2003

Viewing
18-22 October

Enquiries
Anthony McNerney
amcnerney@christies.com
+44 (0)20 7389 2946

Catalogues
+44 (0)20 7389 2820

London
8 King Street, St. James's
London SW1Y 6QT

View catalogues
and leave bids online at
christies.com

Hayward Gallery
on the South Bank·London

Open every day from 23 October 2003
www.hayward.org.uk

Artangel

CAMERON JAMIE
SPOOK HOUSE
BB
KRANKY KLAUS

THREE FILMS BY CAMERON JAMIE WITH
SOUNDTRACKS PERFORMED LIVE BY THE MELVINS

An Artangel Commission
UK Tour November 2003

For further details see
www.artangel.org.uk
or call **020 7713 1400**

Artangel is supported by Arts Council
England and the private patronage
of the Company of Angels.

platform art

presents

David Shrigley
11 September 2003 –
19 January 2004

Mark Titchner
22 January – 9 April 2004

Gloucester Road
Underground station
District and Circle Line platforms
London SW7

Janette Parris
29 September 2003 –
2 February 2004

Piccadilly Circus
Underground station
Ticket hall Subway 2
London W1

Liam Gillick
26 September 2003 –
9 January 2004

in collaboration
with Frieze Art Fair

FRIEZE
ART
FAIR

Great Portland Street
Underground station
London W1

Platform for art is the public art programme for London Underground
More information: plat4art@tube.tfl.gov.uk www.tfl.gov.uk/tube

MAYOR OF LONDON **Transport for London**

Don't let the grass grow under your feet.

AOL Broadband* brings you faster downloads, exclusive
music content, film trailers, cartoons, and a free helpline.
Call 0800 376 4406 or visit www.aol.co.uk/broadband

*BT line or living in a ntl broadband enabled area required. Minimum 12 months contract. Conditions apply

 The beer
that inspired
everything

BEWARE
OF
FORGERIES.

Pilsner Urquell, invented 1842.
The original source of Pilsner with a taste never bettered.

The Groucho Club
SOHO-LONDON

TALENT REQUIRED?

As the leading global concierge service we provide the
best of everything - from the sublime to the ridiculous.

QUINTESSENTIALLY

WORLD +44 870 850 8585 USA 1 800 850 8002 www.quintessentially.com

the art of indulgence

it's a matter of taste
City Café Westminster, 30 John Islip Street, London
tel 020 7932 4600 www.cityinn.com

for your creative pallete

experience the mix
Millbank Lounge, 30 John Islip Street, London
tel 020 7932 4700 www.millbanklounge.co.uk

millbank
lounge

Simmons & Simmons

Challenging
expectations

Simmons & Simmons is more than just a world class law firm with offices throughout Europe, Asia, the Middle East and the US. At the heart of our business is a culture of supporting others, embracing creativity and challenging expectations. Reflecting this, the firm has been collecting art for more than 15 years and our commitment continues. Like the firm, the collection has grown increasingly international. Nonetheless, it remains true to its original objective of supporting young artists, early in their careers, by acquiring significant work.

To find out more about the firm and view our art collection online, visit www.simmonscontemporary.com

Trevor Appleson, 2003. From the beaches series of studio portraits shot on location in and around Cape Town

44,000 sq ft pre-let to Mother Advertising

Moving into Tea:
Hales Gallery
Andrew Mummery Gallery

Gallery spaces for rent
from 1,200 sq ft up to
6,000 sq ft

Pilcher Hershman
020 7399 8600

Stirling Ackroyd
020 7729 7763

Derwent Valley sponsoring
Frieze Art Fair 2003

Tea Building Shoreditch E1
Architects: Allford Hall Monaghan Morris

Projects Art Consultancy
26 Binney Street
London W1K 5BH
Tel +44 (0)20 7355 3222
Fax +44 (0)20 7355 3444
Email: info@projectsartconsultancy.com
www.projectsartconsultancy.com

Purchasing and commissioning art
for private and corporate clients

Over 90 years of purchasing work by contemporary artists

Augustus John Francis Bacon Henry Moore Stanley Spencer
Ben Nicholson Peter Blake David Hockney Anthony Caro
Gilbert & George Bridget Riley Richard Long Tony Cragg
Anish Kapoor Damien Hirst Douglas Gordon Simon Patterson
Liam Gillick Tacita Dean Fiona Banner Isaac Julien Mike Nelson
Martin Creed Mark Wallinger Rachel Whiteread Alison Wilding
Gavin Turk Keith Tyson Wolfgang Tillmans

Over 90 museum collections receive our gifts of contemporary art

from Belfast to Bristol, Norwich to Newcastle, Paisley to
Plymouth, Liverpool to London

Over 90 years of members' participation in the contemporary art world

at international biennales, artists' studios, new museums, major
exhibitions, private collections, artists' dinners, art fairs, lectures,
monthly bus tours and more

An independent organisation shaping contemporary art collections throughout the country

Be part of the future of contemporary art
Be part of the Contemporary Art Society
Bloomsbury House 74-77 Great Russell Street London WC1B 3DA
+44 (0)20 7612 0730 cas@contempart.org.uk www.contempart.org.uk

Momart is a dynamic company, often seen scaling walls and crushing ice ● We swim with sharks and chill blood ● Occasionally we tread water for days in a row ● We cross borders ● Our papers are good, our documents always in order ● We know the form ● We are professional ● Our lips are sealed ● We know how ● We know what's what and who's who ● We are experts in our field, veterans in love and outlaws in Perscipsi ● We are abstract strategists, concrete analysts and ruthless bookies ● Critics worldwide swoon over our original line ● We don't perspire ● Children trust us ● We know the exact location of every item in the hardware store ● We sleep once a week and when we do sleep we sleep in a chair ● The laws of physics do not apply to us ● We lift, we shift, we balance, we weave, we dodge, we frolic ● Our bills are all paid ● We are Momart ●

Bilderrahmen Landwehr

Handvergoldete Rahmen Wechselrahmen aus Holz und Alu Säurefreie Passepartouts
Rahmenrestaurierung Keilrahmen in verschiedenen Stärken Transportkisten

Meisterbetrieb Naunynstr. 38 10999 Berlin Telefon 030-615 64 64 Telefax 614 86 25
Montag-Freitag 9-18 Uhr Do. 9-20 Sa. 10-14 Uhr www.Bilderrahmen-Landwehr.de

ati kunsttransporte gmbh

→ consolidated fine art transport europe wide
→ air freight world wide
→ wrapping and crating
→ storage of art works
→ customs formalities
→ insurance
→ climate protecting packing
→ art express service
→ installation/ hanging service

lehderstraße 86-88
D-13086 berlin

☎ +49 (0)30-446 39 88
📄 +49 (0)30-446 39 91

www.kunsttransporte.de
info@kunsttransporte.de

http://artfacts.net/index.php/pageType/artistInfo/artist/21962

ARTFACTS.NET

PO BOX 02 55 92 10129 Berlin Germany
tel: +49-(0)700 278 32 287 info@artfacts.net www.artfacts.net

Take a different look at Art.

THE INDEPENDENT
YOU *are* WHAT YOU THINK

What Londoners take when they go out.

Time Out
London

EVERY WEEK

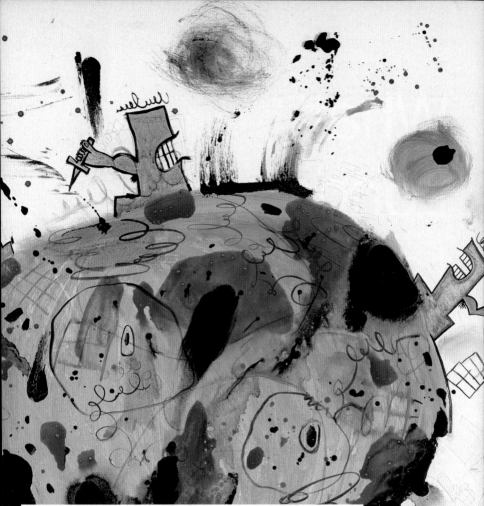

Art
+Auction

ELLE
DECORATION

THE MOST BEAUTIFUL
MOST INSPIRATIONAL
MODERN HOMES
MAGAZINE

TATE

ARTS AND CULTURE

**AVAILABLE AT
GOOD BOOKSHOPS,
NEWSAGENTS AND
VIA MEMBERSHIP**

WWW.TATE.ORG.UK/MAGAZINE

Cover image by Warren du Preez
and Nick Thornton-Jones from
artist project by Naoki Takizawa for
TATE magazine, September 2003

Foto: Dimitri Danilo

style

MAGAZINE FOR FASHION MUSIC CULTURE
MONTHLY style@spread.de

&TheFAMILYTUNES

ARTUPDATE.COM

international contemporary art

listings

maps

membership

BLUEPRINT

The magazine of architecture, design and visual culture

FRIEZE ART FAIR

Gallery Index

Gallery Index

† Artist exhibiting at the Frieze Art Fair.
‡ Artist exhibiting at the Fair and also featured in the Yearbook.

1301PE

Stand B11
Tel +1 310 989 0755

6150 Wilshire Blvd.#8
Los Angeles CA 90048
USA
Tel +1 323 938 5822
Fax +1 323 938 6106
m1301pe@aol.com
www.artnet.com

Contact
Brian D. Butler

Gallery artists
John Baldessari†
Fiona Banner‡
Andrea Bowers
AA Bronson
Angela Bulloch‡
Meg Cranston
Kate Ericson and Mel Ziegler
General Idea
Jack Goldstein†
Ann Veronica Janssens†
Mike Kelley‡
Rachel Khedoori†
Estate of Martin Kippenberger‡
Judy Ledgerwood†
Paul McCarthy‡
Liliana Moro†
Jorge Pardo‡
Jason Rhoades‡
Katy Schimert†
Diana Thater‡
Rirkrit Tiravanija†
Pae White‡
Paul Winstanley‡

303 Gallery

Stand C12
Tel +1 917 660 7332

525 West 22nd Street
New York NY 10011
USA
Tel +1 212 255 1121
Fax +1 212 255 0024
info@303gallery.com
www.303gallery.com

Contact
Lisa Spellman
Mari Spirito
Simone Montemurno

Gallery artists
Doug Aitken‡
Laylah Ali†
Anne Chu†
Thomas Demand‡
Inka Essenhigh†
Hans-Peter Feldmann‡
Maureen Gallace†
Tim Gardner†
Rodney Graham‡
Karen Kilimnik†
Liz Larner†
Kristin Oppenheim†
Collier Schorr†
Stephen Shore‡
Sue Williams†
Jane & Louise Wilson‡

ACME.

Stand C16

6150 Wilshire Blvd, #1
Los Angeles CA 90048
USA
Tel +1 323 857 5942
Fax +1 323 857 5864
info@acmelosangeles.com
www.acmelosangeles.com

Contact
Randy Sommer
Robert Gunderman
Ross McLain

Gallery artists
Uta Barth
Miles Coolidge
Tony Feher
Chris Finley
Katie Grinnan
Kevin Hanley‡
Kurt Kauper
Martin Kersels
Joyce Lightbody
Carlos Mollura
Aaron Morse
Michael Norton
Laura Owens‡
Monique Prieto†
Stephanie Pryor
Dario Robleto
John Sonsini
Jennifer Steinkamp

Work Available By
Darcy Huebler
Daniel Wiener

Air de Paris

Stand B16
Tel +33 6 62 50 20 84

32, rue Louise Weiss
Paris 75013
France
Tel +33 1 44 23 02 77
Fax +33 1 53 61 22 84
anything@airdeparis.com
www.airdeparis.com

Contact
Florence Bonnefous
Edouard Merino
Hélène Retailleau

Gallery artists
Annlee
Olaf Breuning
François Curlet
Stéphane Dafflon
Plamen Dejanoff
Plamen Dejanov &
Swetlana Heger
Brice Dellsperger
Trisha Donnelly
Jean-Luc Erna
Liam Gillick‡
Joseph Grigely†
Annika von Hausswolff
Swetlana Heger
Carsten Höller‡
Pierre Joseph
Inez van Lamsweerde &
Vinoodh Matadin
Paul McCarthy‡
Sarah Morris†
Petra Mrzyk & Jean-François
Moriceau†
Philippe Parreno‡
Rob Pruitt†
Navin Rawanchaikul
Torbjorn Rodland
Bruno Serralongue
Shimabuku†
Lily van der Stokker‡

The Approach

Stand D8
Tel +44 7930 484656

1st Floor
47 Approach Road
London E2 9LY
UK
Tel +44 20 8983 3878
Fax +44 20 8983 3919
theapproach@btconnect.com
www.theapproachgallery.co.uk

Contact
Jake Miller
Emma Robertson
Mike Allen

Gallery artists
Phillip Allen†
Dan Coombs†
Evan Holloway‡
Inventory†
Emma Kay†
Rezi van Lankveld
Dave Muller†
Jacques Nimki†
Michael Raedecker‡
Tim Stoner†
Mari Sunna‡
Gary Webb‡
Martin Westwood†
Shizuka Yokomizo†

Art:Concept

Stand G7

16, rue Duchefdelaville
Paris 75013
France
Tel +33 1 53 60 90 30/
+33 1 53 60 11 76
Fax +33 1 53 60 90 31
antoliv@galerieartconcept.com
www.galerieartconcept.com

Contact
Olivier Antoine
Béatrice Campillo
Caroline Maestrali

Gallery artists
Martine Aballéa
Francis Baudevin
Madeleine Berkhemer†
Jean Luc Blanc
Michel Blazy‡
Martin Boyce‡
Jeremy Deller‡
Richard Fauguet‡
Lothar Hempel
Jacques Lizène
Emmanuelle Mafille
Muntean/Rosenblum‡
Philippe Perrot
Daniel Schlier‡
Roman Signer†
Niek van de Steeg
Janaina Tschäpe‡
Uri Tzaig

asprey-jacques

Stand D14

4 Clifford Street
London W1X 1RB
UK
Tel +44 20 7287 7675
Fax +44 20 7287 7674
info@aspreyjacques.com
www.aspreyjacques.com

Contact
Alison Jacques
Charles Asprey
Alison Abrams
Walter Cassidy

Gallery artists
Candice Breitz‡
Delia Brown
John Chilver
Christian Flamm†
Thilo Heinzmann
Ian Kiaer‡
Tania Kovats
Graham Little‡
Antje Majewski†
Estate of Robert Mapplethorpe†
Paul Morrison‡
Nader Ahriman‡
Jonathan Pylypchuk†
Alessandro Raho†
Catherine Yass†

Blum & Poe

Stand D9
Tel +1 310 866 0090

2754 S. La Cienega Blvd.
Los Angeles CA 90034
USA
Tel +1 310 836 2062
Fax +1 310 836 2104
blumpoe@earthlink.net
www.blumandpoe.com

Contact
Tim Blum

Jeff Poe
Gabriel Ritter

Gallery artists
Chiho Aoshima‡
Tatsurou Bashi
Jennifer Bornstein†
Slater Bradley†
Nigel Cooke‡
Björn Dahlem†
Sam Durant†
Anya Gallaccio†
Mark Grotjahn‡
Shane Hassett†
Julian Hoeber†
Friedrich Kunath
Sharon Lockhart†
Florian Maier-Aichen‡
Daniel Marlos†
Dave Muller†
Takashi Murakami†
Yoshitomo Nara‡
Hirsch Perlman†
Dirk Skreber†
Chris Vasell†
Bruce Yonemoto†

Tanya **Bonakdar** Gallery

Stand E7
Tel +1 917 783 5849

521 West 21st Street
New York NY 10011
USA
Tel +1 212 414 4144
Fax +1 212 414 1535
mail@tanyabonakdargallery.com
www.tanyabonakdargallery.com

Contact
Tanya Bonakdar
Ethan Sklar

Gallery artists
Uta Barth
Sandra Cinto
Mat Collishaw†
Mark Dion†
Olafur Eliasson‡
Michael Elmgreen & Ingar
Dragset‡
Siobhán Hapaska‡
Sabine Hornig‡
Teresa Hubbard/Alexander

Birchler†
Ian Kiaer‡
Carla Klein
Atelier van Lieshout†
Charles Long
Robin Lowe†
Jason Meadows‡
Ernesto Neto‡
Peggy Preheim
Thomas Scheibitz‡
Paul Seawright†

BQ

Stand B6

Jülicher Strasse 14
Cologne 50674
Germany
Tel +49 221 285 8862
Fax +49 221 285 8864
yvonne.quirmbach@t-online.de

Contact
Jörn Bötnagel
Yvonne Quirmbach

Gallery artists
Dirk Bell‡
Matti Braun†
Friedrich Kunath
Bojan Sarcevic‡
Reinhard Voigt‡
Richard Wright†

The **Breeder** Projects

Stand H11
Tel +30 6977 442712

6 Evmorfopoulou Street
Athens 10553
Greece
Tel +30 2103 31 75 27
Fax +30 2103 31 75 28
system@thebreedersystem.com
www.thebreedersystem.com

Contact
Stathis Panagoulis
George Vamvakidis

Gallery artists
Andreas Angelidakis‡
Mark Bijl
Carol Bove

Brian Griffiths‡
Henrik Håkansson‡
Jim Lambie‡
Jenny Marketou
Ilias Papailiakis
Daniel Sinsel
Eli Sudbrack
Mark Titchner‡

Galerie Daniel **Buchholz**

Stand A2
Tel +49 170 430 0153

Neven-DuMont-Str. 17
Cologne 50667
Germany
Tel +49 221 257 4946
Fax +49 221 253 351
post@galeriebuchholz.de
www.galeriebuchholz.de

Contact
Daniel Buchholz
Christopher Müller

Gallery artists
Tomma Abts†
Kai Althoff†
Lukas Duwenhögger†
Thomas Eggerer†
Cerith Wyn Evans†
Morgan Fisher†
Isa Genzken‡
Jack Goldstein†
Julian Göthe†
Richard Hawkins†
Jochen Klein†
Jutta Koether†
Mark Leckey‡
Lucy McKenzie‡
Henrik Olesen†
Silke Otto-Knapp†
Jeroen de Rijke/Willem de Rooij‡
Frances Stark†
Stefan Thater†
Wolfgang Tillmans‡
James Welling†
Pae White‡
T.J. Wilcox†

Cabinet

Stand C9
Tel +44 7950 920126/
+44 7711 066935

20a Northburgh Street
London EC1V 0EA
UK
Tel +44 20 7253 5377
Fax +44 20 7608 2414
art@cabinetltd.demon.co.uk

Contact
Martin McGeown
Andrew Wheatley

Gallery artists
Tariq Alvi†
Gillian Carnegie†
Marc Chaimowicz
Enrico David†
donAtelier
Cosey Fanni Tutti
Mark Leckey‡
Lucy McKenzie‡
Paulina Olowska†
James Pyman†
Lily van der Stokker‡

Luis Campaña Galerie

Stand E3
Tel +49 173 539 3838

An der Schanz 1a
Cologne 50735
Germany
Tel +49 221 256 712
Fax +49 221 256 213
info@luis-campana.de
www.luiscampana.com

Contact
Luis Campaña
Annette Völker

Gallery artists
Kati Barath‡
Tatsurou Bashi
Ralf Berger†
Jan de Cock
Björn Dahlem†
Kendell Geers‡
Lisa Milroy‡

Wilhelm Mundt†
Gregor Schneider†
Qui Shi-hua
Dirk Skreber†
Jörg Wagner†

Galerie Gisela Capitain

Stand D11
Tel +44 20 7486 8539

Aachener Strasse 5
Cologne 50674
Germany
Tel +49 221 256 676
Fax +49 221 256 593
info@galeriecapitain.de
www.galeriecapitain.de

Contact
Gisela Capitain
Anke Kempkes
Nina Kretzschmar

Gallery artists
Maria Brunner†
Günther Förg†
Georg Herold†
Charline von Heyl†
Rachel Khedoori†
Estate of Martin Kippenberger‡
Zoe Leonard‡
Albert Oehlen†
Jorge Pardo‡
Stephen Prina†
Sam Samore†
Franz West†
Christopher Williams†
Johannes Wohnseifer‡
Christopher Wool‡

carlier | gebauer

Stand H9
Tel +49 171 857 1158

Holzmarktstrasse 15–18
S-Bahn-Bogen 51/52
Berlin 10179
Germany
Tel +49 30 280 8110

Fax +49 30 280 8109
office@carliergebauer.com
www.carliergebauer.com

Contact
Marie Blanche Carlier
Ulrich Gebauer
Elsa de Seynes

Gallery artists
A K Dolven‡
Cecilia Edefalk†
Michel François
Meschac Gaba
Hans Hemmert†
Jonathan Hernández
Thomas Huber
Marko Lehanka
Julie Mehretu‡
Aernout Mik
Santu Mofokeng‡
Sebastian Diaz Morales
Jean-Luc Moulène
Paul Pfeiffer†
Peter Pommerer†
Bojan Sarcevic‡
Eric Schmidt
Christian Schumann†
Thomas Schütte†
Fred Tomaselli†
Sophie Tottie
Janaina Tschäpe‡
Luc Tuymans†
Mark Wallinger†

China Art Objects Galleries

Stand G6

933 Chung King Rd
Los Angeles CA90012
USA
Tel +1 213 613 0384
Fax +1 213 613 0363
shansonuk@hotmail.com
www.chinaartobjects.com

Contact
Steve Hanson
Amra Brooks

Gallery artists
Andy Alexander
Mason Cooley
Kim Fisher
Morgan Fisher†

David Korty†
JP Munro‡
Jonathan Pylypchuk†
Eric Wesley‡

Sadie **Coles** HQ

Stand B8
Tel +44 7768 878 460

35 Heddon Street
London W1B 4BP
UK
Tel +44 20 7434 2227
Fax +44 20 7434 2228
sadie@sadiecoles.com
www.sadiecoles.com

Contact
Sadie Coles
Pauline Daly

Gallery artists
Carl Andre†
John Bock‡
Don Brown†
Jeff Burton†
Liz Craft†
John Currin†
Angus Fairhurst†
Urs Fischer‡
Jonathan Horowitz‡
David Korty†
Jim Lambie‡
Sarah Lucas‡
Hellen van Meene†
Victoria Morton†
JP Munro‡
Laura Owens‡
Simon Periton‡
Raymond Pettibon†
Elizabeth Peyton‡
Richard Prince†
Ugo Rondinone‡
Wilhelm Sasnal†
Gregor Schneider†
Daniel Sinsel†
Andreas Slominski‡
Nicola Tyson†
T.J. Wilcox†
Andrea Zittel†

Contemporary Fine Arts

Stand D4

Sophienstrasse 21
Berlin 10178
Germany
Tel +49 30 288 7870
Fax +49 30 288 78726
gallery@cfa-berlin.de
www.cfa-berlin.com

Contact
Nicole Hackert
Bruno Brunnet
Philipp Haverkampf

Gallery artists
Cecily Brown‡
Peter Doig‡
Angus Fairhurst†
Urs Fischer‡
Jörg Immendorff†
Robert Lucander†
Sarah Lucas‡
Jonathan Meese‡
Chris Ofili†
Raymond Pettibon†
Tal R†
Daniel Richter‡
Thomas Ruff‡
Juergen Teller†
Gavin Turk†

Corvi-Mora

Stand F10

22 Warren Street
London W1T 5LU
UK
Tel +44 20 7383 2419
Fax +44 20 7383 2429
info@corvi-mora.com
www.corvi-mora.com

Contact
Tommaso Corvi-Mora
Tabitha Langton-Lockton

Gallery artists
Brian Calvin‡
Pierpaolo Campanini†
Andy Collins†
Rachel Feinstein‡
Dee Ferris‡
Liam Gillick‡

Richard Hawkins†
Roger Hiorns‡
Jim Isermann†
Aisha Khalid†
Eva Marisaldi†
Jason Meadows‡
Monique Prieto†
Imran Qureshi†
Andrea Salvino†
Glenn Sorensen†
Tomoaki Suzuki†

Counter

Stand B13

44a Charlotte Road
London EC2A 3PD
UK
Tel +44 20 7684 8888
Fax +44 20 7684 8889
info@countergallery.com
www.countergallery.com

Contact
Carl Freedman

Gallery artists
Michael Fullerton†
Simon Martin‡
Peter Peri†
Lucy Skaer†
Fergal Stapleton‡

Editions available by
Jeff Burton†
Jake & Dinos Chapman‡
Mat Collishaw†
Nigel Cooke‡
Peter Doig‡
Tracey Emin†
Roni Horn†
Gary Hume†
Michael Landy‡
Sarah Lucas‡
Chris Ofili†
Laura Owens‡
Elizabeth Peyton‡
Tobias Rehberger‡
Collier Schorr†
Sam Taylor-Wood†
Juergen Teller†
Gavin Turk†
Gillian Wearing‡
Rachel Whiteread‡
Christopher Wool‡

CRG Gallery

Stand F8

535 West 22nd Street, 3rd Floor
New York NY 10011
USA
Tel +1 212 229 2766
Fax +1 212 229 2788
mail@crggallery.com
www.crggallery.com

Contact
Carla Chammas
Richard Desroche
Glenn McMillan

Gallery artists
Lyle Ashton Harris‡
Robert Beck†
Rhona Bitner
Russell Crotty‡
Sally Elesby
Robert Feintuch
Christie Frields
Pia Fries†
Ori Gersht†
Tim Hailand
Jim Hodges‡
Siobhan Liddell
Melissa McGill
Sam Reveles
Jeffrey Saldinger
Lisa Sanditz†
Sandra Scolnik†
Frances Stark†
Bernard Voïta

Galerie Chantal Crousel

Stand C17
Tel +33 6 80 65 24 42

40, rue Quincampoix
Paris 75004
France
Tel +33 1 42 77 38 87
Fax +33 1 42 77 59 00
galerie@crousel.com
www.crousel.com

Contact
Chantal Crousel
Joana Neves
Niklas Svennung

Gallery artists
Absalon
Darren Almond†
Tony Cragg†
Graham Gussin†
Fabrice Gygi†
Mona Hatoum†
Thomas Hirschhorn‡
Hassan Khan†
Wolfgang Laib
Moshe Ninio
Melik Ohanian†
Gabriel Orozco‡
Sigmar Polke
Anri Sala‡
Jose Maria Sicilia†
Sean Snyder†
Rirkrit Tiravanja†

doggerfisher

Stand C21
Tel +44 7779 085750

11 Gayfield Square
Edinburgh EH1 3NT
UK
Tel +44 131 558 7110
Fax +44 131 558 7110
mail@doggerfisher.com
www.doggerfisher.com

Contact
Susanna Beaumont
Ruth Beale

Gallery artists
Charles Avery†
Claire Barclay‡
David Connearn
Graham Fagen
Keith Farquhar‡
Moyna Flannigan‡
Fransizka Furter†
Ilana Halperin
Louise Hopkins†
Janice McNab
Sally Osborn†
Jonathan Owen†
Lucy Skaer†
Hanneline Visnes‡

Galerie EIGEN + ART Leipzig/ Berlin

Stand F12
Tel +44 20 7935 9072

Auguststrasse 26
Berlin 10117
Germany
Tel +49 30 280 6605
Fax +49 30 280 6616
berlin@eigen-art.com

Ferdinand-Rhode-Strasse 14
Leipzig 04107
Germany
Tel +49 341 960 78 86
Fax +49 341 225 42 14
leipzig@eigen-art.com
www.eigen-art.com

Contact
Gerd Harry Lybke
Kerstin Wahala
Birte Kleemann

Gallery artists
Akos Birkas†
Birgit Brenner†
Martin Eder†
Tim Eitel†
Nina Fischer & Maroan el Sani†
Jörg Herold†
Christine Hill†
Stephan Jung‡
Uwe Kowski†
Rémy Markowitsch†
Maix Mayer†
Carsten Nicolai‡
Olaf Nicolai‡
Neo Rauch‡
Yehudit Sasportas‡
Annelies Strba†

Entwistle

Stand E2

6 Cork Street
London W1S 3EE

UK
Tel +44 207 734 6440
Fax +44 207 734 7966
info@entwistlegallery.com
www.entwistlegallery.com

Contact
Lance Entwistle
Roberta Entwistle
Darren Flook

Gallery artists
Jason Brooks†
Patty Chang
Sarah Dobai‡
Dan Hays†
Dan Holdsworth†
Rosa Loy‡
Alan Michael†
Tatsuo Miyajima†
Conrad Shawcross‡
Gerhard Stromberg
Michael Stubbs†
Yoshihiro Suda

Foksal
Gallery
Foundation

Stand B2
Tel +48 504 270 905

ul. Górskiego 1A
Warsaw 00-033
Poland
Tel +48 22 826 5081
Fax +48 22 826 5081
mail@fgf.com.pl
www.fgf.com.pl

Contact
Joanna Mytkowska
Andrzej Przywara

Gallery artists
Pawel Althamer†
Cezary Bodzianowski
Katarzyana Józefowicz
Edward Krasiński
Anna Niesterowicz
Wilhelm Sasnal†
Monika Sosnowska
Artur Żmijewski

Galeria
Fortes
Vilaça

Stand F9
Tel +44 20 7935 9612

Rua Fradique Coutinho, 1500
São Paulo 05416-001
Brazil
Tel +55 11 30 32 70 66
Fax +55 11 30 97 03 84
galeria@fortesvilaca.com.br
www.fortesvilaca.com.br

Contact
Alessandra Vilaça
Márcia Fortes
Alexandre Gabriel

Gallery artists
Franz Ackermann‡
Efrain Almeida†
Lia Menna Barreto†
Los Carpinteros†
Leda Catunda†
Saint Clair Cemin‡
Gil Heitor Cortesão†
Tiago Carneiro da Cunha†
José Damasceno†
Mauricio Dias & Walter Riedweg†
Iran do Espírito Santo†
Chelpa Ferro†
José Antonio Hernandez -Diez †
Alejandra Icaza†
Fabian Marcaccio†
Beatriz Milhazes†
Vik Muniz‡
Ernesto Neto‡
Rivane Neuenschwander†
Hélio Oiticica†
Mauro Piva†
Nuno Ramos†
Rosângela Rennó‡
Julie Roberts†
Julião Sarmento†
Courtney Smith†
Valeska Soares†
Janaina Tschäpe‡
Meyer Vaisman†
Adriana Varejão†
Luiz Zerbini†

Marc **Foxx**

Stand G12

6150 Wilshire Boulevard
Los Angeles CA 90048
USA
Tel +1 323 857 5571
Fax +1 323 857 5573
gallery@marcfoxx.com
www.marcfoxx.com

Contact
Marc Foxx
Rodney Hill

Gallery artists
Tomma Abts†
Brian Calvin‡
Anne Collier†
Andy Collins†
Martin Creed†
Olafur Eliasson‡
Vincent Fecteau†
Sophie von Hellermann‡
Jim Hodges‡
Evan Holloway‡
Udomsak Krisanamis†
Luisa Lambri†
Michael Lazarus
Marcin Maciejowski‡
Jason Meadows‡
Hellen van Meene†
Richard Rezac
Matthew Ronay†
Dana Schutz†
Frances Stark†
Hiroshi Sugito†
Karlheinz Weinberger†

Stephen
Friedman
Gallery

Stand E6
Tel +44 20 7486 4562

25–28 Old Burlington Street
London W1S 3AN
UK
Tel +44 20 7494 1434
Fax +44 20 7494 1431
info@stephenfriedman.com
www.stephenfriedman.com

Contact

Stephen Friedman
Patricia Kohl
David Hubbard

Gallery artists

Mamma Andersson†
Stephan Balkenhol‡
Tom Friedman†
Kendell Geers‡
Dryden Goodwin‡
Thomas Hirschhorn‡
Jim Hodges‡
Corey McCorkle†
Beatriz Milhazes†
Helen Mirra‡
Donald Moffett†
Yoshitomo Nara‡
Rivane Neuenschwander†
Catherine Opie†
Vong Phaophanit†
Alexander Ross†
Michal Rovner†
Yinka Shonibare†
David Shrigley†
Kerry Stewart†
Rudolf Stingel†

Frith Street Gallery

Stand C4

59–60 Frith Street
London W1D 3JJ
UK
Tel +44 20 7494 1550
Fax +44 207 287 3733
info@frithstreetgallery.com
www.frithstreetgallery.com

Contact

Jane Hamlyn
Kirsten Dunne
Karon Hepburn

Gallery artists

Chantal Akerman†
Fiona Banner‡
Dorothy Cross†
Tacita Dean‡
Marlene Dumas†
Bernard Frize‡
Craigie Horsfield†
Callum Innes†
Jaki Irvine†
Cornelia Parker‡
Giuseppe Penone†

John Riddy†
Thomas Schütte†
Dayanita Singh†
Bridget Smith†
Annelies Strba†
Fiona Tan†

Gagosian Gallery

Stand F7
Tel +44 20 7935 0857

980 Madison Avenue
New York NY 10011
USA
Tel +1 212 744 2313

555 West 24th Street
New York NY 10011
Tel +1 212 741 1111

456 Camden Drive
Beverly Hills CA 90210
USA
Tel +1 310 271 9400

8 Heddon Street
London W1B 4BU
UK
Tel +44 20 7292 8222
info@gagosian.com
www.gagosian.com

Contact

Stefania Bortolami
Mollie Brocklehurst
Stefan Ratibor

Gallery artists

Ghada Amer‡
Richard Artschwager
Georg Baselitz†
Alighiero e Boetti†
Cecily Brown‡
Chris Burden†
Fransesco Clemente
Michael Craig-Martin
Dexter Dalwood
Peter Davies
Eric Fischl
Ellen Gallagher†
Frank Gehry
Gilbert & George‡
Douglas Gordon†
Arshile Gorky
Damien Hirst‡

Howard Hodgkin†
Anselm Kiefer†
Jeff Koons‡
Vera Lutter
Walter de Maria
Tim Noble & Sue Webster‡
Ed Ruscha‡
Jenny Saville
Richard Serra
Elisa Sighicelli
David Smith
Philip Taaffe‡
Mark Tansey
Robert Therrien
Cy Twombly
Andy Warhol†
Franz West†
Richard Wright†
Elyn Zimmerman

GBE (Modern)

Stand D5

620 Greenwich Street
New York NY 10014
USA
Tel +1 212 627 5258
Fax +1 212 627 5261
gallery@gavinbrown.biz

Contact

Gavin Brown
Corinna Durland

Gallery artists

Franz Ackermann‡
James Angus†
Dirk Bell‡
Martin Creed†
Verne Dawson†
Peter Doig‡
Urs Fischer‡
Mark Handforth†
Udomsak Krisanamis†
Mark Leckey‡
Aleksandra Mir‡
Victoria Morton†
Chris Ofili†
Laura Owens†
Elizabeth Peyton‡
Steven Pippin†
Rob Pruitt†
Nick Relph & Oliver Payne‡
Anselm Reyle‡
Katja Strunz‡

Spencer Sweeney†
Rirkrit Tiravanija†
Piotr Uklanski‡

Galerie
Gebr.
Lehmann

Stand C18
Tel +49 173 371 9710

Görlitzer Strasse 16
Dresden 01099
Germany
Tel +49 351 801 1783
Fax +49 351 801 49 08
info@galerie-gebr-lehmann.de
www.galerie-gebr-lehmann.de

Contact
Ralf Lehmann
Frank Lehmann
Grit Dora von Zeschau

Gallery artists
Domingo Molina Cortés
Markus Draper‡
Eberhard Havekost‡
Dirk Heerklotz
Hirschvogel
Martin Honert‡
Thoralf Knobloch
Frank Nitsche‡

Gimpel Fils

Stand D1
Tel +44 7970 073902

30 Davies Street
London W1K 4NB
UK
Tel +44 20 7493 2488
Fax +44 20 7629 5732
info@gimpelfils.com
www.gimpelfils.com

Contact
Rene Gimpel
Jackie Haliday
Victoria Long

Gallery artists
Estate of Robert Adams†
Louis Le Brocquy
Estate of Reg Butler

Alan Davie
Corinne Day‡
Estate of Andrea Fisher
Pamela Golden†
Albert Irvin
Estate of Ray Johnson
Peter Kennard
Estate of Peter Lanyon
Antoni Malinowski†
Hannah Maybank†
Bernard Meadows
Callum Morton‡
Niki de Saint Phalle
Andres Serrano‡
Christopher Stewart†
Jenny Watson
Edwin Zwakman†

Marian
Goodman
Gallery

Stand C8
Tel +44 20 7935 7385

24 West 57th Street
New York NY 10019
USA
Tel +1 212 977 7160
Fax +1 212 581 5187

79, rue du Temple
Paris 75003
France
Tel +33 1 48 04 70 52
Fax +33 1 40 27 81 37
rose@mariangoodman.com
www.mariangoodman.com

Contact
Marian Goodman
Robin Vousden
Rose Lord

Gallery artists
Eija-Liisa Ahtila‡
Giovanni Anselmo†
John Baldessari†
Lothar Baumgarten†
Christian Boltanski†
Marcel Broodthaers†
Daniel Buren†
Maurizio Cattelan‡
James Coleman†
Thierry de Cordier†
Tony Cragg†

Richard Deacon†
Tacita Dean‡
Rineke Dijkstra†
Kendell Geers‡
David Goldblatt†
Dan Graham‡
Pierre Huyghe†
Cristina Iglesias†
William Kentridge‡
Steve McQueen†
Marisa Merz†
Annette Messager†
Juan Muñoz†
Maria Nordman†
Gabriel Orozco‡
Giulio Paolini†
Giuseppe Penone†
Gerhard Richter‡
Thomas Schütte†
Thomas Struth†
Niele Toroni†
Jeff Wall†
Lawrence Weiner†
Francesca Woodman†

Greene
Naftali

Stand C10

526 West 26th Street
8th Floor
New York NY 10001
USA
Tel +1 212 463 7770
Fax +1 212 463 0890
info@greenenaftaligallery.com
www.greenenaftaligallery.com

Contact
Carol Greene
Molly Melver
Kathleen Eagan

Gallery artists
Julie Becker†
Lucy Gunning†
Rachel Harrison‡
Jonathan Horowitz‡
Jacqueline Humphries
David Korty†
Michael Krebber†
Mark Manders†
Daniel Pflumm†
Blake Rayne
Daniela Rossell‡
Amelie von Wulffen†

greengrassi

Stand A3

39c Fitzroy Street
London W1T 6DY
UK
Tel +44 20 7387 8747
Fax +44 20 7388 3555
info@greengrassi.com
www.greengrassi.com

Contact
Cornelia Grassi
Holly Walsh
Giovanna Paschetto

Gallery artists
Tomma Abts†
Stefano Arienti
Matthew Arnatt
Jennifer Bornstein†
Roe Ethridge‡
Vincent Fecteau†
Samuel Fosso
Giuseppe Gabellone
Joanne Greenbaum
Sean Landers‡
Simon Ling
Margherita Manzelli‡
Aleksandra Mir‡
David Musgrave
Kristin Oppenheim†
Alessandro Pessoli
Lari Pittman
Charles Ray
Karin Ruggaber‡
Allen Ruppersberg
Anne Ryan†
Cindy Sherman‡
Frances Stark†
Jennifer Steinkamp
Pae White‡
Lisa Yuskavage†

Galerie Karin **Guenther**

Stand G10
Tel +49 170 556 6994

Admiralitätstrasse 71
Hamburg 20459
Germany
Tel +49 40 3750 3450
Fax +49 40 3750 3451
k.guenther.galerie@gmx.de

Contact
Karin Guenther

Gallery artists
Markus Amm†
Friederike Clever†
Jeanne Faust‡
Michael Hakimi‡
Kerstin Kartscher‡
Stefan Kern
Nina Koennemann
Anita Leisz
Silke Otto-Knapp†
Gunter Reski
Stefan Thater†

Hales Gallery

Stand A8

70 Deptford High Street
London SE8 4RT
UK
Tel +44 20 8694 1194
Fax +44 20 8692 0471
info@halesgallery.com
www.halesgallery.com

Contact
Paul Hedge
Paul Maslin
Ella Whitmarsh

Gallery artists
Hans op de Beeck‡
Sarah Beddington
Zadok Ben-David
Andrew Bick†
Diana Cooper†
Richard Galpin
Jane Harris
Hew Locke‡
Paul McDevitt‡
Jaime Pitarch
Ben Ravenscroft
Danny Rolph
Michael Smith†
Myra Stimson
Tomoko Takahashi†
Spencer Tunick
Jane Wilbraham

Galerie **Hammelehle** und Ahrens

Stand E13

An der Schanz 1a
Cologne 50735
Germany
Tel +49 221 287 0800
Fax +49 221 287 0801
mail@haah.de
www.haah.de

Contact
Bernd Hammelehle
Sven O. Ahrens

Gallery artists
André Butzer‡
Stephan Jung†
Isabel Kerkermeier
Markus Oehlen†
Andreas Rüthi†
Jan Scharrelmann†
Matthias Schaufler‡
Markus Selg†
Vincent Tavenne†
Ina Weber
Daniela Wolfer†

Jack **Hanley** Gallery

Stand G4
Tel +1 415 470 1623

395 Valencia Street
San Francisco CA 94103
USA
Tel +1 415 522 1623
Fax +1 415 522 1631
JackHanley@aol.com
www.jackhanley.com

Contact
Jack Hanley
Meredith Goldsmith

Gallery artists
Simon Evans‡
Joseph Grigely†
Dean Hughes
Chris Johanson‡
Jim Lambie‡

Euan Macdonald
Alicia McCarthy
Keegan McHargue
Mathieu Mercier
Jonathan Monk‡
Shaun O'Dell‡
Bill Owens
Torbjørn Rødland
Will Rogan†
Hayley Tompkins†
Chris Ware†
Erwin Wurm‡

Haunch
of Venison

Stand G14

6 Haunch of Venison Yard
off Brook Street
London W1K 5ES
UK
Tel +44 20 7495 5050
Fax +44 20 7495 4050
info@haunchofvenison.com
www.haunchofvenison.com

Contact
Rory Blain
Harry Blain
Charlie Phillips
Graham Southern

Gallery artists
Mark Alexander
Thomas Joshua Cooper
Richard Long‡
Jorge Pardo‡
Diana Thater‡
Keith Tyson†
Bill Viola
Wim Wenders

Galerie
Hauser &
Wirth

Stand B5

Limmatstrasse 270
Zurich 8031
Switzerland
Tel +41 1 446 80 50
Fax +41 1 446 80 55

info@ghw.ch
www.ghw.ch

196a Piccadilly
London W1J 9DY
UK
Tel + 44 20 7287 2300
Fax+ 44 20 7287 6600
www.hauserwirth.com

Contact
Curt Marcus
Iwan Wirth
Marc Payot

Gallery artists
Louise Bourgeois†
David Claerbout†
Dan Graham‡
Rodney Graham‡
David Hammons
Mary Heilmann†
Estate of Eva Hesse†
Richard Jackson
On Kawara†
Rachel Khedoori†
Guillermo Kuitca†
Paul McCarthy‡
John McCracken†
Raymond Pettibon†
Jason Rhoades‡
Pipilotti Rist†
Anri Sala‡
Wilhelm Sasnal†
Christoph Schlingensief
Roman Signer†
Tony Smith
Diana Thater‡
Estate of André Thomkins†

Galerie
Ghislaine
Hussenot

Stand F15
Tel +33 6 16 29 44 62

5 bis, rue des Haudriettes
Paris 75003
France
Tel +33 1 48 87 60 81
Fax +33 1 48 87 05 01
ghislaine.hussenot@wanadoo.fr

Contact
Ghislaine Hussenot
Sonia Tricot

Gallery artists
Jeremy Blake‡
Andy Collins†
Peter Doig‡
Carroll Dunham†
Andreas Gursky†
Sophie von Hellerman‡
Mike Kelley‡
David Korty†
Michael Lin
Tony Oursler
Jorge Pardo‡
Tobias Rehberger‡
Daniel Richter‡
Cindy Sherman†
Diana Thater‡
Juan Usle
Franz West†

Taka **Ishii**
Gallery

Stand G9

1-31-6-1F shinkawa
Chuo-Ku
Tokyo 104-0033
Japan
Tel +81 3 5542 3615
Fax +81 3 3552 3363
tig@takaishiigallery.com
www.takaishiigallery.com

Contact
Takayuki Ishii
Nahoko Yamaguchi
Jeffrey Ian Rosen
Yuka Sasahara

Gallery artists
Amy Adler
Doug Aitken‡
Nobuyoshi Araki†
Thomas Demand‡
Jason Dodge
Michael Elmgreen & Ingar
Dragset‡
Naoya Hatakeyama‡
Naoto Kawahara†
Yuki Kimura‡
Sean Landers‡
Daido Moriyama†
Kyoko Murase‡
Jorge Pardo‡
Erik Parker
Jack Pierson†
Dean Sameshima†
Kara Walker

Jablonka Galerie Linn Lühn

Stand G11
Tel +49 178 4975 888

Brüsseler Strasse 4
Cologne 50674
Germany
Tel +49 221 397 6900
Fax +49 221 397 6907
ll@jablonkagalerie.com
www.jablonkagalerie.com/
linnluehn

Contact
Linn Lühn
Rafael Jablonka
Ralph Gleis

Gallery artists
Will Cotton
Sophie von Hellermann‡
Alexej Koschkarow‡
Christoph Schellberg‡
Andreas Slominski‡
Danyela Steinfeld
Kevin Zucker

Galerie Martin Janda

Stand F14

Eschenbachgasse 11
Vienna 1010
Austria
Tel +43 1 585 7371
Fax +43 1 585 7372
office@raumaktuellerkunst.at
www.raumaktuellerkunst.at

Contact
Martin Janda
Andreas Huber
Liliane Wolff

Gallery artists
Manon de Boer
Jean-Marc Bustamante†
Adriana Czernin‡
Werner Feiersinger‡
Giuseppe Gabellone

Asta Gröting†
Hodel, Schumacher &
Clavadetscher
Christine & Irene
Hohenbüchler†
Carsten Höller‡
Raoul de Keyser†
Jakob Kolding‡
Raimund Märzinger
Rupprecht Matthies
Peter Pommerer†
Allen Ruppersberg
Anri Sala‡
Joe Scanlan‡
Lara Schnitger
ManfreDu Schu
Andreas Schulze
Roman Signer†
Xavier Veilhan
Corinne Wasmuht†
Lois Weinberger†
Jun Yang‡
Gregor Zivic†

Galerie Rodolphe Janssen

Stand D2
Tel +32 475 471402

35, rue de Livourne
Brussels 1050
Belgium
Tel +32 2 538 08 18
Fax +32 2 538 56 60
rodolphejanssen@skynet.be
www.artnet.com

Contact
Rodolphe Janssen
Frederic Collier
Sébastien Janssen

Gallery artists
Lawrence Beck
Balthasar Burkhard
Lynne Cohen
George Condo†
Tim Davis†
Philip-Lorca diCorcia†
Peter Downsbrough
Pia Fries†
Justine Kurland†
David Levinthal†
Eskö Männikkö‡

Hellen van Meene†
Jean-Luc Moerman
Mrzyk & Moriceau‡
Yan Pei-Ming‡
Sam Samore†
Lisa Sanditz†
Stephen Shore‡
Robert Suermondt
Hiroshi Sugimoto†
Bernard Vöita
Olav Westphalen†

Annely Juda Fine Art

Stand F3

23 Dering Street
London W1S 1AW
UK
Tel +44 20 7629 7578
Fax +44 20 7491 2139
ajfa@annelyjudafineart.co.uk
www.annelyjudafineart.co.uk

Contact
Annely Juda
David Juda
Laura Henderson

Gallery artists
Roger Ackling
Anthony Caro†
Alan Charlton†
Eduardo Chillida
Christo
Prunella Clough
Nathan Cohen
Gloria Friedmann
Katsura Funakoshi
Alan Green
Nigel Hall
Werner Haypeter
David Hockney‡
Peter Kalkhof
Tadashi Kawamata†
Leon Kossoff
Darren Lago‡
Edwina Leapman
Estate of Kenneth & Mary
Martin
Michael Michaeledes
David Nash†
Alan Reynolds
Yuko Shiraishi‡
Graham Williams

Georg **Kargl**

Stand E11
Tel +43 676 624 5490

Schleifmühlgasse 5
Vienna 1040
Austria
Tel +43 1 585 41 99
Fax +43 1 585 41 999
georg.kargl@sil.at

Contact
Georg Kargl
Karina Simbürger
Evelyn Appinger

Gallery artists
Richard Artschwager
Mark Dion†
Cerith Wyn Evans†
Peter Fend
Vera Frenkel
Renée Green
Herbert Hinteregger†
Chris Johanson‡
Elke Krystufek‡
Thomas Locher†
Inés Lombardi†
Christian Philipp Müller†
Matt Mullican†
Muntean/Rosenblum‡
Raymond Pettibon†
Paul de Reus
Gerwald Rockenschaub‡
Lisa Ruyter†
Julia Scher
Markus Schinwald†
Rudolf Stingel†
Gabi Trinkaus
Rosemarie Trockel†
John Waters†

galleria francesca **kaufmann**

Stand H3
Tel +39 33 56 27 13 73

Via dell'Orso 16
Milan 20121
Italy
Tel +39 02 72 09 43 31
Fax +39 02 72 09 68 73
info@galleriafrancescakaufmann.com

Contact
Francesca Kaufmann
Alessio delli Castelli

Gallery artists
Lina Bertucci
Candice Breitz‡
Pierpaolo Campanini†
Gianni Caravaggio†
Maggie Cardelus
Susan Cianciolo
Naomi Fisher
Brad Kahlhamer†
Helen Mirra‡
Kori Newkirk
Kelly Nipper†
Tam Ochiai‡
Yoshua Okon†
Adrian Paci‡
Eva Rothschild†
Lily van der Stokker‡
Pae White‡

Kerlin Gallery

Stand F16
Tel +353 86 8233544

Anne's Lane
South Anne Street
Dublin D2
Ireland
Fax +353 1 670 90 93
Tel +353 1 670 90 96
gallery@kerlin.ie
www.kerlin.ie

Contact
David Fitzgerald
Darragh Hogan
John Kennedy

Gallery artists
Fionnuala Ní Chiosáin
Phil Collins‡
Barrie Cooke
Dorothy Cross†
Willie Doherty†
Felim Egan
Mark Francis†
Maureen Gallace†
David Godbold†
Richard Gorman
Siobhán Hapaska‡
Callum Innes†
Merlin James†
Elizabeth Magill‡
Brian Maguire
Stephen McKenna
William McKeown
Kathy Prendergast†
Sean Scully
Paul Seawright†
Seán Shanahan
Hiroshi Sugimoto†
Paul Winstanley‡

Klosterfelde

Stand B9
Tel +49 163 283 5305

Zimmerstrasse 90/91
Berlin 10117
Germany
Tel +49 30 283 5305
Fax +49 30 283 5306
office@klosterfelde.de
www.klosterfelde.de

Contact
Martin Klosterfelde
Lena Kiessler
Bettina Klein

Gallery artists
Matthew Antezzo†
John Bock‡
Michael Elmgreen & Ingar Dragset‡
Stefan Hirsig
Christian Jankowksi‡
Ulrike Kuschel
Peter Land‡
Nader Ahriman‡
Henrik Olesen†
Dan Peterman
Kirsten Pieroth‡
Steven Pippin†
Vibeke Tandberg†

Leo **Koenig**, Inc

Stand G16
249 Centre Street
New York NY 10013
USA
Tel +1 212 334 9255

Fax +1 212 334 9304
leokoenig@hotmail.com
www.leokoenig.com

Contact
Leo Koenig
Elizabeth Balogh

Gallery artists
Aidas Bareikis
Nicole Eisenman
Jeff Elrod
gelatin‡
Torben Giehler
Brandon Lattu
Tony Matelli
Jonathan Meese‡
Frank Nitsche‡
Erik Parker
Les Rogers
Tomoaki Suzuki†

Michael
Kohn
Gallery

Stand E12

8071 Beverly Boulevard
Los Angeles CA 90048
USA
Tel +1 323 658 8088
Fax +1 323 658 8068
info@kohngallery.com
www.kohngallery.com

Contact
Michael Kohn
Lisa Wells

Gallery artists
Matthew Brown
Bruce Cohen
Bruce Conner‡
Reed Danziger
Walton Ford
Mark Francis†
Maureen Gallace†
April Gornik
Katy Grannan‡
Stephen Hannock
Mark Innerst
Guy Limone
Dan McCleary
Michael Minelli
James Nares
Joan Nelson

Katherine Sherwood
Mark Tansey
Mitja Tusek
Darren Waterston
Xiaoze Xie

Johann
König

Stand B15
Tel +49 173 3807032

Weydinger Str. 10
Berlin 10178
Germany
Tel +49 30 3088 2688
Fax +49 30 3088 2690
info@johannkoenig.de
www.johannkoenig.de

Contact
Johann König
Kirsa Geiser

Gallery artists
Tue Greenfort‡
Jeppe Hein†
Michaela Meise†
Natascha Sadr Haghighian‡
Johannes Wohnseifer‡
David Zink Yi‡
Andreas Zybach

Tomio
Koyama
Gallery

Stand C5

Shinkawa 1-31-6-1F
Chuo-Ku
Tokyo 104-0033
Japan
Tel +81 3 6222 1006
Fax +81 3 3551 2615
tkoyama@tke.att.ne.jp
www.tomiokoyamagallery.com
www.artnet.com

Contact
Tomio Koyama

Gallery artists
Dan Asher
Gianni Caravaggio†

Jeremy Dickinson
Jeanne Dunning
Sam Durant†
Tom Friedman†
Atsushi Fukui‡
Rieko Hidaka
Satoshi Hirose
Tamami Hitsuda‡
Dennis Hollingsworth†
Mika Kato
Hideaki Kawashima
Joachim Koester†
Makiko Kudo
Masahiko Kuwahara
Paul McCarthy‡
Shintaro Miyake
Mr.
Takashi Murakami†
Yoshitomo Nara‡
Tam Ochiai‡
Tom Sachs†
Yoshie Sakai
Hiroshi Sugito†
Atsuko Tanaka†
Vibeke Tandberg†
Mamoru Tsukada
Richard Tuttle
John Wesley
Bruce Yonemoto†

Andrew
Kreps
Gallery

Stand B10
Tel +1 917 660 0601

516A West 20th Street
New York NY 10011
USA
Tel +1 212 741 8849
Fax +1 212 741 8163
andrewkreps@rcn.com

Contact
Andrew Kreps
Dean Daderko

Gallery artists
Ricci Albenda‡
Daniel Bozhkov
Juan Céspedes
Peter Coffin
Meredith Danluck
Liz Deschenes
Roe Ethridge‡

Jonah Freeman
Cary Leibowitz
Robert Melee
Ruth Root
Lawrence Seward
Hiroshi Sunairi
Cheyney Thompson‡
Hayley Tompkins†
Klaus Weber

Galerie
Krinzinger

Stand E9
Tel +43 676 324 8379

Seilerstätte 16
Vienna 1010
Austria
Tel +43 1 513 30 06
Fax +43 1 513 30 06 33
galeriekrinzinger@chello.at
www.galerie-krinzinger.at

Contact
Ursula Krinzinger
Eva Ebersberger

Gallery artists
Siegfried Anzinger
Günther Brus†
Chris Burden†
Angela de la Cruz†
Angelika Krinzinger
Oleg Kulik
Natacha Lesueur
Ulrike Lienbacher†
Atelier van Lieshout†
Erik van Lieshout†
Jonathan Meese‡
Bjarne Melgaard‡
Hermann Nitsch
Meret Oppenheim
Arnulf Rainer†
Eva Schlegel†
Hubert Schmalix†
Rudolf Schwarzkogler†
Frank Thiel‡
Gavin Turk†
Keith Tyson†
Vinogradov & Dubossarsky‡
Franz West†
Erwin Wurm‡

kurimanzutto

Stand B2
Tel +52 55 21 28 76 31

mazatlán 5 depto. t-6
col. condesa 06140
Mexico City D.F. 06140
Mexico
Tel +52 5256 2408/
+52 5553 0665
Fax +52 5256 2408
info@kurimanzutto.com
www.kurimanzutto.com

Contact
Monica Manzutto
Jose Kuri

Gallery artists
Eduardo Abaroa†
Abraham Cruzvillegas‡
Minerva Cuevas†
Daniel Guzman†
Jonathan Hernández†
Gabriel Kuri‡
Dr. Lakra†
Enrique Metinides‡
Gabriel Orozco‡
Damian Ortega‡
Fernando Ortega†
Luis Felipe Ortega†
Sofia Taboas†
Rirkrit Tiravanija†

Galerie Yvon
Lambert

Stand D16

108, rue Vieille du Temple
Paris 75003
France
Tel +33 1 42 71 09 33
Fax +33 1 42 71 87 47

564 West 25th Street
New York NY 10001
USA
olivierbelot@yahoo.fr
www.yvon_lambert.com

Contact
Yvon Lambert
Martine Aboucaya
Olivier Belot

Gallery artists
Francis Alÿs‡

Carlos Amorales‡
Carl Andre†
Alice Anderson
Robert Barry
Christian Boltanski†
Slater Bradley†
Mircea Cantor†
Spencer Finch
Anna Gaskell
Nan Goldin‡
Douglas Gordon†
Jenny Holzer‡
Roni Horn†
Jonathan Horowitz‡
Marine Hugonnier‡
Koo Jeong-A†
Isaac Julien†
On Kawara†
Anselm Kiefer†
Barbara Kruger†
Thierry Kuntzel
Bertrand Lavier
Louise Lawler
Claude Lévêque
Sol Lewitt
Jonathan Monk‡
Ernesto Neto‡
Guilio Paolini†
Liisa Roberts
Bojan Sarcevic‡
Andres Serrano‡
David Shrigley†
Ross Sinclair
Michael Snow†
Vibeke Tandberg†
Niele Toroni†
Richard Tuttle
Cy Twombly
Salla Tykkä†
Lawrence Weiner†

Lisson
Gallery

Stand B4
Tel +44 20 79355612

52–54 Bell Street
London NW1 5DA
UK
Tel +44 20 7724 2739
Fax +44 20 7724 7124
contact@lisson.co.uk
www.lisson.co.uk

Contact
Nicholas Logsdail

Jill Silverman van Coenegrachts
Pilar Corrias
Michelle D'Souza
Elly Ketsea

Gallery artists
Francis Alÿs‡
Carl Andre†
Art & Language
John Baldessari†
Pierre Bismuth‡
Christine Borland†
Roderick Buchanan‡
James Casebere
Tony Cragg†
Grenville Davey
Richard Deacon†
Ceal Floyer†
Douglas Gordon†
Dan Graham‡
Rodney Graham‡
Mark Hosking
Shirazeh Houshiary
Peter Joseph
Donald Judd†
Anish Kapoor‡
On Kawara†
Igor & Svetlana Kopystiansky
John Latham
Sol Lewitt
Robert Mangold
Jason Martin†
John McCracken†
Jonathan Monk‡
Juan Muñoz†
John Murphy
Max Neuhaus
Avis Newman
Julian Opie‡
Tony Oursler
Giulio Paolini†
Simon Patterson
Julião Sarmento†
Santiago Sierra†
Jemima Stehli
Lee Ufan
Jan Vercruysse
Marijke van Warmerdam
Richard Wentworth
Jane & Louise Wilson‡
Sharon Ya'ari

Luhring
Augustine

Stand D10

531 West 24th Street
New York NY 10011
USA
Tel +1 212 206 91 00
Fax +1 212 206 90 55
info@luhringaugustine.com
www.luhringaugustine.com

Contact
Roland Augustine
Lawrence Luhring
Claudia Altman-Siegel
Natalia Mager

Gallery artists
Janine Antoni‡
Zarina Bhimji†
Janet Cardiff†
Larry Clark†
George Condo†
Gregory Crewdson†
Günther Förg†
Jenny Gage†
Paul McCarthy‡
Yasumasa Morimura†
Reinhard Mucha†
Albert Oehlen†
Pipilotti Rist†
Joel Sternfeld†
Tunga†
Rachel Whiteread‡
Steve Wolfe†
Christoper Wool‡

maccarone
inc.

Stand H2

45 Canal Street
New York NY 10002
USA
Tel +1 212 431 4977
Fax +1 212 431 4977
kitchen@maccarone.net
www.maccarone.net

Contact
Michele Maccarone
Angela Kotinkaduwa

Gallery artists
Matthew Antezzo†
Mike Bouchet†
Christoph Büchel‡
Anthony Burdin†
Chivas Clem†
Phil Collins‡
Christian Jankowski‡

Corey McCorkle†
Claudia & Julia Müller‡
Daniel Roth‡
Olav Westphalen†

Kate
MacGarry

Stand C19

95–97 Redchurch Street
London E2 7DJ
UK
Tel +44 20 7613 3909
Fax +44 20 7613 5405
mail@katemacgarry.com
www.katemacgarry.com

Contact
Kate MacGarry
Effie Shinas

Gallery artists
Matt Bryans‡
Stuart Cumberland‡
Des Hughes†
Stefan Saffer†
Francis Upritchard‡

Magnani

Stand F11
Tel +44 7950 519255

82 Commercial Street
London E1 6LY
UK
Tel +44 20 7375 3002
Fax +44 20 7375 3006
anybody@magnani.co.uk

Contact
Gregorio Magnani
Marina Bassano
Annett Kottek

Gallery artists
Angela Bulloch‡
Vidya Gastaldon†
Isa Genzken‡
Dominique Gonzalez-Foerster†
Lothar Hempel
Candida Höfer†
Scott King‡
Christina Mackie
Donald Urquhart‡
Jean-Michel Wicker

Mai 36
Galerie

Stand D12
Tel +41 76 322 5024

Rämistrasse 37
Zurich 8001
Switzerland
Tel +41 1 261 68 80
Fax +41 1 261 68 81
mai36@artgalleries.ch
www.artgalleries.ch/mai36

Contact
Victor Gisler
Luigi Kurmann
Gabriela Walther

Gallery artists
Franz Ackermann‡
Ian Anüll
John Baldessari†
Stephan Balkenhol‡
Matthew Benedict
Troy Brauntuch
Anke Doberauer
Pia Fries†
Andreas Gursky†
Rita McBride‡
Harald F. Müller
Matt Mullican
Manfred Pernice†
Magnus von Plessen
Thomas Ruff‡
Christoph Rütimann
Jörg Sasse
Paul Thek
Lawrence Weiner†
R émy Zaugg‡

Giò
Marconi

Stand C14
Tel +39 3 55 24 58 05

via Tadino 15
Milan 20124
Italy
Tel +39 02 29 40 43 73
Fax +39 02 29 40 55 73
info@giomarconi.com
www.giomarconi.com

Contact
Giò Marconi

Gallery artists
Franz Ackermann‡
John Bock‡
Christian Jankowski‡
Atelier van Lieshout†
Jorge Pardo‡
Paul Pfeiffer†
Tobias Rehberger‡
Elisa Sighicelli
Vibeke Tandberg†
Grazia Toderi‡
Francesco Vezzoli‡

Matthew
Marks
Gallery

Stand C7
Tel +44 20 7486 4385

523 West 24th Street
New York NY 10011
USA

522 West 22nd Street New York
529 West 21st Street New York
Tel +1 212 243 0200
Fax +1 212 243 0047
info@matthewmarks.com
www.matthewmarks.com

Contact
Stephanie Dorsey
Jeffrey Peabody
Jill Sussman
Adrian Turner

Gallery artists
Estate of Robert Adams†
Darren Almond†
David Armstrong†
Nayland Blake†
Jean-Marc Bustamante†
Peter Cain
Peter Fischli/David Weiss‡
Lucian Freud†
Katharina Fritsch†
Robert Gober‡
Nan Goldin‡
Andreas Gursky†
Jonathan Hammer
Martin Honert‡
Roni Horn†
Peter Hujar†
Gary Hume†

Ellsworth Kelly†
Willem de Kooning
Inez van Lamsweerde†
Brice Marden†
Hellen van Meene†
Tracey Moffatt†
Ken Price†
Ugo Rondinone‡
Tony Smith
Sam Taylor-Wood†
Weegee†
Terry Winters†

Galerie
Meyer
Kainer

Stand F1
Tel +43 664 111 5747

Eschenbachgasse 9
Vienna 1010
Austria
Tel +43 1 585 7277
Fax +43 1 585 7539
contact@meyerkainer.at
www.meyerkainer.com

Contact
Renate Kainer
Christian Meyer

Gallery artists
Vanessa Beecroft
John Bock‡
Olaf Breuning
Plamen Dejanoff
gelatin‡
Liam Gillick‡
Dan Graham‡
Swetlana Heger
Mary Heilmann†
Christian Jankowski‡
Michael Krebber‡
Marcin Maciejowski‡
Sarah Morris†
Walter Niedermayr
Walter Obholzer
Jorge Pardo‡
Raymond Pettibon†
Mathias Poledna‡
Beat Streuli‡
Wolfgang Tillmans‡
Franz West†
T. J. Wilcox†
Heimo Zobernig

Meyer Riegger Galerie

Stand B7

Klauprechtstrasse 22
Karlsruhe 76137
Germany
Tel +49 721 821 292
Fax +49 721 982 2141
info@meyer-riegger.de
www.meyer-riegger.de

Contact
Jochen Meyer
Thomas Riegger
Iris Kadel

Gallery artists
Franz Ackermann‡
Heike Aumüller
Sebastian Hammwöhner†
Isabel Heimerdinger
Uwe Henneken†
Richard Hoeck
Dani Jakob†
Korpys/Löffler
Kalin Lindena
John Miller‡
Helen Mirra‡
Jonathan Monk‡
Peter Pommerer†
Daniel Roth‡
Silke Schatz†
Gabriel Vormstein
Silke Wagner
Corinne Wasmuht†

Milton Keynes Gallery

Stand H8

900 Midsummer Boulevard
Milton Keynes MK9 3QA
UK
Tel +44 1908 676 900
Fax +44 1908 558 308
info@mk-g.org
www.mk-g.org

Publicly funded exhibition space

Contact
Stephen Snoddy
Katharine Sorensen
Emma Dean

Gallery artists
Georgie Hopton‡
Colin Lowe & Roddy Thomson‡
Sarah Staton‡

Victoria Miro Gallery

Stand F4

16 Wharf Road
London N1 7RW
UK
Tel +44 20 7336 8109
Fax +44 2 07251 5596
info@victoria-miro.com
www.victoria-miro.com

Contact
Victoria Miro
Glenn Scott Wright
Andrew Silewicz

Gallery artists
Doug Aitken‡
Anne Chu†
Verne Dawson†
Thomas Demand‡
Peter Doig‡
Inka Essenhigh†
Ian Hamilton Finlay†
Andreas Gursky†
Alex Hartley†
Chantal Joffe†
Isaac Julien‡
Udomsak Krisanamis†
Yayoi Kusama†
Abigail Lane†
Robin Lowe†
Dawn Mellor†
Tracey Moffatt†
Hiroko Nakao†
Chris Ofili†
Grayson Perry‡
Tal R†
Adriana Varejão†
Stephen Willats†
Francesca Woodman†

Mizuma Art Gallery

Stand C13
Tel +81 90 6009 8183

2 F Fujiya Bldg.
1-3-9 Kamimeguro Meguro-Ku
Tokyo 153 0051
Japan
Tel +81 3 3793 7931
Fax +81 3 3793 7887
gallery@mizuma-art.co.jp
www.mizuma-art.co.jp

Contact
Sueo Mitsuma
Hideki Aoyama
Rika Fujiki

Gallery artists
Mario .A†
Makoto Aida‡
Satoru Aoyama
O Jun
Tomoko Konoike
Hiroyuki Matsukage†
Kaoru Motomiya
Ujino Muneteru
Jun Nguyen-Hatsushiba‡
Minh Thanh Nguyen
Quong Huy Nguyen
Van Cuong Nguyen
Hiroko Okada
Jeanne Susplugas†
Fujiwara Takahiro
Koji Tanada
Koki Tanaka†
Hisashi Tenmyouya†
Patrick Tosani
Shinsuke Tsutsui
Akira Yamaguchi‡

Works also available by
Inci Eviner
Catherine Lee
Tim Steel
Suzanne Treister
David Tremlett
Catherine Yass†

Modern Art

Stand A1
Tel +44 7887 556818

10 Vyner Street
London E2 9DG

UK
Tel +44 20 8980 7742
Tel +44 20 8980 7743
info@modernartinc.com
www.modernartinc.com

Contact
Stuart Shave
Detmar Blow

Gallery artists
Mat Collishaw†
Nigel Cooke‡
Ian Dawson†
David Falconer
Tim Gardner†
Brad Kahlhamer†
Martin Kersels
Barry McGee‡
Jonathan Meese‡
Tim Noble & Sue Webster‡
Erik Parker
Eva Rothschild†
Collier Schorr†
DJ Simpson
Ricky Swallow
Juergen Teller†
Clare Woods†
Richard Woods†

The **Modern** Institute

Stand G8
Tel +44 7803 082180

Suite 6
73 Robertson Street
Glasgow G2 8QD
UK
Tel +44 141 248 3711
Fax +44 141 248 3280
mail@themoderninstitute.com
www.themoderninstitute.com

Contact
Toby Webster
Claire Jackson

Gallery artists
Dirk Bell‡
Martin Boyce‡
Jeremy Deller‡
Urs Fischer‡
Luke Fowler†
Henrik Håkansson‡

Andrew Kerr†
Jim Lambie‡
Victoria Morton†
Scott Myles‡
Toby Paterson‡
Simon Periton‡
Mary Redmond†
Eva Rothschild†
Simon Starling†
Katja Strunz‡
Joanne Tatham & Tom O'Sullivan†
Hayley Tompkins†
Sue Tompkins†
Cathy Wilkes†
Michael Wilkinson†
Richard Wright†

Andrew **Mummery** Gallery

Stand H12
Tel +44 7710 062 967

Studio 1.4 – The Tea Building
5–11 Bethnal Green Road
London E1
UK
Tel/Fax +44 20 7251 6265
info@andrewmummery.com
www.andrewmummery.com

Contact
Andrew Mummery
Nick Chaffe
Thom Driver

Gallery artists
Philip Akkerman
Maria Chevska
Michael Fullerton†
Ori Gersht†
John Goto
Alexis Harding
Tim Hemington
Louise Hopkins†
Merlin James†
Peter Lynch
Wendy McMurdo
Ingo Meller
Alex Pollard†
Carol Rhodes†
Christopher Stevens
Graeme Todd
Richard Walker†

MW projects

Stand C1

43b Mitchell Street
London EC1V 3QD
UK
Tel +44 20 7251 3194
Fax +44 20 7689 3194
info@mwprojects.net
www.mwprojects.net

Contact
Max Wigram
Michael Briggs
Soraya Rodriguez

Gallery artists
Anna Bjerger†
Slater Bradley†
Paul Cunningham†
Toby Glanville†
James Hopkins†
David Hughes†
Marine Hugonnier‡
Xiomara de Oliver†
Julian Rosefeldt†
Nigel Shafran‡
David Spero†
Christian Ward‡
Richard Wathen†

Galerie Christian **Nagel**

Stand E4
Tel +49 172 740 0745

Richard-Wagner-Strasse 28
Cologne 50674
Germany
Tel +49 221 257 0591
Fax +49 221 257 0592

Weydinger Str. 2/4
10178 Berlin
Germany
cn.berlin@galerie-nagel.de
Tel +49 30 400 42 641
Fax +49 30 400 42 642
cn.koeln@galerie-nagel.de
www.galerie-nagel.de

Contact
Christian Nagel
Susanne Prinz (Berlin)

Anja Dorn (Cologne)

Gallery artists
Kai Althoff†
Cosima von Bonin
Merlin Carpenter‡
Clegg & Guttmann
Stephen Dillemuth
Mark Dion†
Andrea Fraser
Ingeborg Gabriel
Renée Green
Kiron Khosla‡
Michael Krebber†
Kalin Lindena
Hans-Jörg Mayer
John Miller‡
Christian Philipp Müller†
Stefan Müller
Nils Norman†
Josephine Pryde‡
Martha Rosler
Sarah Staton‡
Catherine Sullivan
Stephanie Taylor
Jan Timme
Joseph Zehrer
Heimo Zobernig

Galerie Michael **Neff**

Stand C20
Tel +49 177 392 0304

Hanauer Landstrasse 52
Frankfurt 60314
Germany
Tel +49 69 9043 1467
Fax +49 69 4908 4345
galerieneff@t-online.de
www.galerieneff.com

Contact
Michael Neff

Gallery artists
Michael Beutler‡
John Bock‡
Sunah Choi
Thilo Heinzmann
Sara Kane
Stefan Kern
Thoralf Knobloch
Gerhard Merz
Emanuel Ocampo

Paola Pivi
Josephine Pryde‡
Jackie Saccocio
Katharina Sieverding
Rachel Urkowitz
Olav Westphalen†
Stefan Wieland
Phillip Zaiser

Galerie **Neu**

Stand E10

Philippstrasse 13
Berlin 10115
Germany
Tel +49 30 285 7550
Fax +49 30 281 0085
galerie.neu@snafu.de
www.galerieneu.com

Contact
Thilo Wermke
Alexander Schröder
Marianna von Palombini
Lara Brekenfeld

Gallery artists
Kai Althoff†
Tom Burr†
Cerith Wyn Evans†
Keith Farquhar†
Christian Flamm†
Ull Hohn
Sergej Jensen‡
Thomas Kiesewetter
Birgit Megerle‡
Manfred Pernice†
Daniel Pflumm†
Josephine Pryde‡
Andreas Slominski‡
Sean Snyder†
Francesco Vezzoli‡
Katharina Wulff†

neugerriem -schneider

Stand C6
Tel +49 172 3000 970

Linienstrasse 155
Berlin 10115
Germany
Tel +49 30 28 87 7277
Fax +49 30 28 87 7278

mail@neugerriemschneider.com

Contact
Tim Neuger
Burkhard Riemschneider

Gallery artists
Franz Ackermann‡
Pawel Althamer‡
Keith Edmier
Olafur Eliasson‡
Isa Genzken‡
Sharon Lockhart†
Michel Majerus*
Antje Majewski†
Jorge Pardo‡
Elizabeth Peyton‡
Tobias Rehberger‡
Simon Starling†
Thaddeus Strode†
Rirkrit Tiravanija†
Pae White‡

Galleria Franco **Noero**

Stand G13

Via Giolitti 52A
Turin 10123
Italy
Tel +39 011 88 22 08
Fax +39 011 88 22 08
info@franconoero.com
www.franconoero.com

Contact
Franco Noero
Luisa Salvi del Pero
Isabella Bortolozzi

Gallery artists
Tom Burr†
Jeff Burton†
Adam Chodzko
Lara Favaretto‡
Henrik Håkansson‡
Mark Handforth
Jonathan Horowitz‡
Andrew Kerr
Jim Lambie‡
Paul Morrison‡
Muntean/Rosenblum‡
Henrik Olesen†
Rob Pruitt†
Steven Shearer

Simon Starling†
Costa Vece†
Francesco Vezzoli‡
Eric Wesley‡

Galerie
Nordenhake

Stand D12
Tel +49 179 679 2195

Zimmerstrasse 88–91
Berlin 10117
Germany
Tel +49 30 206 1483
Fax +49 30 206 14848
berlin@nordenhake.com

Nybrogatan 25A
Stockholm S-114 39
Sweden
www.nordenhake.com

Contact
Claes Nordenhake
Sofia Bertilsson
Ettina Pehrsson

Gallery artists
Miroslaw Balka‡
Stephan Baumkötter
John Coplans
Jonas Dahlberg
Jimmie Durham†
Ann Edholm
Anthony Gormley†
David Hammons
Mona Hatoum†
Eskö Männikkö‡
John McCracken†
Ingo Meller
Meuser
Walter Niedermayr
Margetica Potrc
Håkan Rehnberg
Ulf Rollof
Ulrich Rückriem
Ann-Sofi Sidén
Serge Spitzer
Leon Tarasewicz
Günter Umberg
Magnus Wallin
Robert Wilson
Rémy Zaugg‡

Galerie Giti
Nourbakhsch

Stand H6
Tel +49 170 555 4460

Rosenthaler Strasse 72
Berlin 10119
Germany
Tel +49 30 44 04 67 81
Fax +49 30 44 04 67 82
nourbakhsch@t-online.de
www.nourbakhsch.de

Contact
Giti Nourbakhsch
Sandra Bürgel

Gallery artists
Tomma Abts†
Susanne Bürner
Berta Fischer†
Uwe Henneken†
Kerstin Kartscher‡
Bernd Krauß
Zoe Leonard‡
Ryan McGinley
Anselm Reyle‡
Katja Strunz‡
Vincent Tavenne†
Hayley Tompkins†
Cathy Wilkes†

Galerie
Nathalie
Obadia

Stand F2
Tel +33 6 09 05 81 92

3 rue du Cloître St Merri
Paris 75004
France
Tel +33 1 42 74 67 68
Fax +33 1 42 74 68 66
info@galerie-obadia.com
www.galerie-obadia.com

Contact
Nathalie Obadia
Florence Simoni
Céline Cléron

Gallery artists
Carole Benzaken‡
Jean-Marc Bustamante†

Liz Craft†
Wim Delvoye†
Valérie Favre
Anne Ferrer
Ana Mendieta†
Beatriz Milhazes†
Frank Nitsche‡
Manuel Ocampo
Albert Oehlen†
Pascal Pinaud
Fiona Rae‡
James Rielly
Eliezer Sonnenschein‡
Jessica Stockholder
Nicola Tyson†
Paul Winstanley‡

Patrick
Painter, Inc

Stand B1
Tel +44 20 7935 1951/
+1 604 716 1333

2525 Michigan Avenue, B2
Santa Monica CA 90404
USA
Tel +1 310 264 5988
Fax +1 310 264 5998
info@patrickpainter.com
www.patrickpainter.com

Contact
Wendy Chang
Mayo Thompson
Sachiyo Yoshimoto

Gallery artists
Estate of Bas Jan Ader
Glenn Brown‡
Valie Export
Bernard Frize‡
Larry Johnson
Won Ju Lim‡
Mike Kelley‡
Paul McCarthy‡
Ivan Morley‡
Albert Oehlen†
Ed Ruscha (works available)‡
Jim Shaw‡
Meyer Vaisman†

Maureen **Paley** Interim Art

Stand C11

21 Herald Street
London E2 6JT
UK
Tel +44 20 7729 4112
Fax +44 20 7729 4113
info@interimart.net

Contact
Maureen Paley
James Lavender
Joel Yoss

Gallery artists
Ross Bleckner†
Kaye Donachie†
Mark Francis†
Maureen Gallace†
Ewan Gibbs†
Sarah Jones†
Karen Knorr†
Michael Krebber†
Malerie Marder†
Muntean/Rosenblum‡
Paul Noble‡
David Rayson†
Paul Seawright†
Hannah Starkey†
David Thorpe‡
Wolfgang Tillmans‡
Rebecca Warren‡
Gillian Wearing‡
James Welling†
Paul Winstanley‡

The **Paragon** Press

Stand A5
Tel +44 7957 421743

92 Harwood Road
London SW6 4QH
UK
Tel +44 20 7736 4024
Fax +44 20 7371 7229
charles.boothclibborn@paragon
press.co.uk
www.paragonpress.co.uk

Contact
Charles Booth-Clibborn

Gallery artists
Gillian Carnegie†
Jake & Dinos Chapman‡
Alan Davie
Richard Deacon†
Peter Doig‡
Terry Frost†
Hamish Fulton
Damien Hirst‡
Gary Hume†
Anish Kapoor‡
Michael Landy‡
Christopher Le Brun
Sarah Morris†
Paul Morrison‡
Marc Quinn†
Bill Woodrow†

Parkett Editions

Stand H5
Tel +44 20 7486 6790

Quellenstrasse 27
Zurich 8031
Switzerland

Tel +41 1 271 81 40
Fax +41 1 272 43 01

155 Avenue of the Americas,
2nd Floor
New York NY 10013
USA
Tel +1 212 673 2660
Fax +1 212 271 0704
info@parkettart.com
www.parkettart.com

Contact
Beatrice Fässler
Dieter von Graffenried
Ali Subotnick

Editions available by
Franz Ackermann‡
Eija-Liisa Ahtila‡
Doug Aitken‡
John Bock‡
Alighiero e Boetti†
Angela Bulloch‡
Daniel Buren†
Tacita Dean‡
Peter Doig‡
Tracey Emin†
Eric Fischl
Günther Förg†
Katharina Fritsch†
Dan Graham‡
Roni Horn†
Pierre Huyghe†
Karen Kilimnik†
Jeff Koons‡
Yayoi Kusama†
Malcolm Morley†
Sarah Morris†
Juan Muñoz†
Laura Owens‡
Jorge Pardo‡
Michael Raedecker‡
Jason Rhoades‡
Bridget Riley†
Matthew Ritchie†
Ugo Rondinone‡
James Rosenquist†
Thomas Schütte†
Roman Signer†
Diana Thater‡
Rirkrit Tiravanija†
Fred Tomaselli†
Luc Tuymans†
Lawrence Weiner†
John Wesley†
Franz West†
Robert Wilson†

Galerie Francesca **Pia**

Stand C3
Tel +41 79 247 57 52

Münstergasse 6
Bern 3011
Switzerland
Tel +41 31 311 73 02
Fax +41 31 311 73 02
fpiagal@yahoo.com

Contact
Francesca Pia

Gallery artists
Thomas Bayrle†
Lisa Beck
Valentin Carron‡
Hans-Peter Feldmann‡
Joseph Grigely†

Amy O'Neill
Mai-Thu Perret‡
David Shrigley†
Glenn Sorensen†
Hans Stalder
John Tremblay†
Amy Vogel

Galerie
Praz-
Delavallade

Stand B18
Tel +33 6 62 22 57 98

28, rue Louise Weiss
Paris 75013
France
Tel +33 1 45 86 20 00
Fax +33 1 45 86 20 10
gallery@praz-delavallade.com
www.praz-delavallade.com

Contact
Bruno Delavallade
René-Julien Praz
Nathalie Vitcoq

Gallery artists
Roderick Buchanan ‡
David Burrows†
Marc Couturier
Maria Hahnenkamp
Richard Hawkins†
Matthias Herrmann
Jim Isermann†
Nataçha Lesueur
Lovett & Codagnone
John Miller‡
Dario Robleto
Yvan Salomone
Fraser Sharp
Jim Shaw‡
Bob & Roberta Smith†
Jeffrey Vallance
Marnie Weber

Galerie Eva
Presenhuber

Stand D7
Tel +41 79 4476319

Limmatstrasse 270

Zurich 8031
Switzerland
Tel +41 1 446 80 60
Fax +41 1 446 80 65
info@ghwp.ch
www.ghwp.ch

Contact
Eva Presenhuber
René Lahn
Markus Rischgasser

Gallery artists
Doug Aitken‡
Emmanuelle Antille‡
Martin Boyce‡
Angela Bulloch‡
Verne Dawson†
Maria Eichhorn†
Urs Fischer‡
Peter Fischli/David Weiss‡
Sylvie Fleury†
Liam Gillick‡
Candida Höfer†
Roni Horn†
Karen Kilimnik†
Gerwald Rockenschaub‡
Ugo Rondinone‡
Dieter Roth†
Jean-Frédéric Schnyder†
Beat Streuli†
Franz West†
Sue Williams†

The **Project**

Stand H4

37 West 57th Street
Third Floor
New York NY 10019
USA
Tel +1 212 662 8610
Fax +1 212 662 2800

962-B East 4th Street
Los Angeles CA 90013
USA
Tel +1 213 620 0692
Fax +1 213 620 0743
mail@elproyecto.com
www.elproyecto.com

Contact
Christian Haye
Jenny Liu

Gallery artists
José Damasceno†
Maria Elena González
Nic Hess

Glenn Kaino‡
Kimsooja
Daniel Joseph Martinez
Julie Mehretu‡
Aernout Mik
Kori Newkirk†
Yoshua Okon†
Paul Pfeiffer†
William Pope.L
Jessica Rankin
Tracey Rose
Peter Rostovsky†
Jason Salavon†
Stephen Vitiello
Martin Weber

Galerie
Almine
Rech

Stand H7

127, rue du Chevaleret
Paris 75013
France
Tel +33 1 45 83 71 90
Fax +33 1 45 70 91 30
a.rech@galeriealminerech.com
www.galeriealminerech.com

Contact
Almine Rech
Frederic Fournier
Thomas Dryll

Gallery artists
Rita Ackermann
Nobuyoshi Araki†
Henry Bond‡
Rebecca Bournigault
Tom Burr†
Serge Comte†
Adam Dant
Philip-Lorca diCorcia†
Anders Edström
Wayne Gonzales
Johannes Kahrs‡
Ange Leccia‡
John McCracken†
Sven P ahlson
Tobias Putrih
Ugo Rondinone‡
Bruno Rousseaud†
Annelies Strba†
Vincent Szarek‡
Gavin Turk†

James Turrell
Stephen Vitiello
Miwa Yanagi†

Anthony **Reynolds** Gallery

Stand D3
Tel +44 7798 606343

60 Great Marlborough Street
London W1F 7BG
UK
Tel +44 20 7439 2201
Fax +44 20 7439 1869
info@anthonyreynolds.com

Contact
Anthony Reynolds
Jane Bhoyroo
Tristram Pye

Gallery artists
Eija-Liisa Ahtila‡
The Atlas Group/Walid Raad‡
David Austen†
Richard Billingham†
Ian Breakwell†
Erik Dietman
Keith Farquhar‡
Rudolf Fila
Leon Golub†
Paul Graham†
Lucy Harvey†
Georg Herold†
Thomas Lawson
Andrew Mansfield†
Alain Miller†
Lucia Nogueira
Nancy Spero†
Jon Thompson†
Amikam Toren†
Nobuko Tsuchiya‡
Mark Wallinger†
John Wilkins

Ridinghouse

Stand G15
Tel +44 20 7935 5282

38 Powis Square
London W11 2AY
UK

Tel +44 20 7229 6063
Fax +44 20 7792 2430
simon@thomasdane.com

Contact
Thomas Dane
Francois Chantala
Simon Preston

Editions available by
Peter Doig‡
Julie Mehretu‡
Enrique Metinides‡

Galerie Thaddaeus **Ropac**

Stand B14
Tel +43 664 1252125

Mirabellplatz 2
A-5020 Salzburg
Austria
Tel +43 662 881 393
Fax +43 662 881 3939

7, rue Debelleyme
Paris 75003
France
Tel +33 1 42 72 99 00
Fax +33 1 42 72 61 66
office@ropac.net
www.ropac.net

Contact
Thaddaeus Ropac
Nikolaus Ruzicska

Gallery artists
Donald Baechler
Stephan Balkenhol‡
Georg Baselitz†
Jean-Marc Bustamante†
Philippe Bradshaw
Maggie Cardelus
Dexter Dalwood
Christian Eckart
Manfred Erjautz
Elger Esser
Dominique Figarella
Sylvie Fleury †
Judy Fox
Gilbert & George‡
Claus Goedicke
Antony Gormley†
Peter Halley‡
Lori Hersberger†

Ilya Kabakov†
Alex Katz†
Anselm Kiefer†
Imi Knoebel‡
Peter Kogler
Wolfgang Laib
Jonathan Lasker
Estate of Robert Mapplethorpe†
Fabian Marcaccio†
Bernhard Martin
Jason Martin†
Yasumasa Morimura†
Not Vital†
Walter Obholzer
Mimmo Paladino†
George Perkins†
Jack Pierson†
Rona Pondick
Alessandro Raho†
Gerwald Rockenschaub‡
Lisa Ruyter†
Tom Sachs†
David Salle†
Hubert Scheibl
Elaine Sturtevant
Philip Taaffe‡
Andy Warhol†

Galleria Sonia **Rosso**

Stand C2
Tel +39 33 56 14 20 71

via Giulia di Barolo 11/H
Turin 10124
Italy
Tel +39 01 18 17 24 78
Fax +39 01 18 17 24 78
info@soniarosso.com
www.soniarosso.com

Contact
Sonia Rosso

Gallery artists
Knut Asdam
Charles Avery†
Pierre Bismuth‡
Christian Frosi†
Scott King‡
Jim Lambie‡
Peter Land‡
Jonathan Monk‡
Scott Myles‡
Annika Ström†

Salon 94

Stand D6
Tel +44 20 7935 4751

12 East 94th Street
New York NY 10128
USA
Tel +1 646 672 9212
Fax +1 646 672 9217
salon94@aol.com

Contact
Jeanne Greenberg Rohatyn
Augusto Arbizo
Carmen Hammons

Gallery artists
Jessica Craig-Martin
Benjamin Edward
Kendell Geers‡
Paul Graham†
Katy Grannan‡
Paula Hayes
Malerie Marder
Carlo Mollino‡
Aïda Ruilova
Laurie Simmons‡

Galerie Aurel Scheibler

Stand D13
Tel +44 20 7486 2210

St.-Apern-Strasse 20–26
Cologne 50667
Germany
Tel +49 221 31 1011
Fax + 49 221 331 9615
office@aurelscheibler.com
www.aurelscheibler.com

Contact
Aurel Scheibler
Brigitte Schlüter
Kirsten Pahlke

Gallery artists
Sam Crabtree
Öyvind Fahlström†
Anthony Goicolea‡
Barclay Hughes
Kalaman
Barbara Kruttke
Dan McCarthy

Ernst Wilhelm Nay
Jack Pierson†
Bridget Riley†
Peter Saul‡
Claudia Schink
Boy & Erik Stappaerts
Peter Stauss‡
Billy Sullivan
Hideo Togawa
Alessandro Twombly†
Christoph Wedding
Erwin Wurm‡
Joe Zucker

Schipper & Krome

Stand E8

Linienstrasse 85
Berlin 10119
Germany
Tel +49 30 2839 0139
Fax +49 30 2839 0140
office@schipper-krome.com
www.schipper-krome.com
Contact
Esther Schipper
Michael Krome

Gallery artists
Matti Braun†
Angela Bulloch‡
Nathan Carter†
Thomas Demand‡
Liam Gillick‡
Dominique Gonzalez-Foerster†
Grönlund&Nisunen†
Carsten Höller‡
Pierre Huyghe†
Ann Veronica Janssens†
Christoph Keller
Atelier van Lieshout†
Philippe Parreno‡
Ugo Rondinone‡
Julia Scher
Roth Stauffenberg

Gallery Side 2

Stand H10
Tel +81 90 1549 7703

2-18-3 Mitsuba Bldg. IF
Akasaka, Minato-ku
Tokyo 107 0052
Japan
Tel +81 3 6229 3669
Fax +81 3 6229 3668
info@galleryside2.net
www.galleryside2.net

Contact
Junko Shimada
Rieko Hasegawa
Takeo Hanazawa

Gallery artists
Doug Aitken‡
Brian Calvin†
Anne Daems
Sylvie Fleury†
Jun Fujita‡
Maureen Gallace†
Karen Kilimnik†
Udomsak Krisanamis†
Elke Krystufek‡
Yuko Murata
Chris Ofili†
Elizabeth Peyton‡
Steven Pippin†
Shinako Sato‡
Kiyomichi Shibuya
Taro Shinoda
Rirkrit Tiravanija†
Sue Williams†

Brent Sikkema

Stand G1
Tel +1 917 518 8989

530 West 22nd St
New York NY 10011
USA
Tel +1 212 929 2262
Fax +1 212 929 2340
gallery@brentsikkema.com
www.brentsikkema.com

Contact
Brent Sikkema
Michael Jenkins
Meg Malloy

Gallery artists
Burt Barr
Valerie Belin
Rachel Berwick
Tim Davis†
Mitch Epstein

Frank Egloff
Jeff Gauntt
Jan Henle
Arturo Herrera
David Humphrey
James Hyde
Merlin James†
Jac Leirner
Josiah McElheny
Vik Muniz‡
Carol Rhodes†
Shahzia Sikander‡
Amy Sillman
Janaina Tschäpe‡
Kara Walker

Sommer
Contemporary
Art

Stand C15
Tel +972 53 316 828

64 Rothschild Blvd
Tel Aviv 65785
Israel
Tel +972 3 560 0630
Fax +972 3 566 5501
iritms@netvision.net.il
www.sommergallery.com

Contact
Irit Mayer-Sommer

Gallery artists
Darren Almond†
Yoav Ben-David
Rineke Dijkstra†
Alona Harpaz
Michal Helfman†
Itzik Livne
Muntean/Rosenblum‡
Ugo Rondinone ‡
Wilhelm Sasnal†
Yehudit Sasportas‡
Ahlam Shibli‡
Efrat Shvily
Doron Solomons†
Eliezer Sonnenschein‡
Wolfgang Tillmans‡
Uri Tzaig
Sharon Ya'ari
Rona Yefman
Shai Zurim

Sprovieri

Stand D15

27 Heddon Street
London W1B 4BJ
UK
Tel +44 20 7734 2066
Fax +44 20 7734 2067
info@sprovieri.net

Contact
Niccolò Sprovieri
Birgitte Bjorholm
Allegra Marmont

Gallery artists
Keren Amiran
Alighiero e Boetti†
Alberto Burri
Maurizio Cannavacciuolo‡
Greg Colson
Mario Dellavedova†
Lucio Fontana†
Graham Gillmore
Ilya Kabakov†
Jannis Kounellis†
Piero Manzoni†
Randy Moore
Pino Pascali
Pavel Pepperstein
Cristiano Pintaldi‡
Daniele Puppi‡
Daniel Silver†

Sprüth
Magers Lee

Stand B3
Tel +44 7717 57269

12 Berkeley Street
London W1J 8DT
UK
Tel +44 20 7491 0100
Fax +44 20 7491 0200
info@spruethmagerslee.com
www.spruethmagerslee.com

Contact
Simon Lee
Monika Sprüth
Philomene Magers

Gallery artists
Bernd and Hilla Becher
Alighiero e Boetti†
George Condo†

Peter Fischli/David Weiss‡
Andreas Gursky†
Jenny Holzer‡
Donald Judd†
Barbara Kruger†
Louise Lawler†
Cindy Sherman‡
Stephen Shore‡
Rosemarie Trockel†
Christopher Wool‡

Paul
Stolper

Stand H13
Tel +44 7973 601059

78 Luke Street
London EC2A 4PY
UK
Tel +44 20 7739 6504
info@paulstolper.com
www.paulstolper.com

Contact
Paul Stolper
Anna Stolper
Louise Foster
Cary Littlefield

Gallery artists
Richard Cuerden
Susie Hamilton‡
Susan Hamston
Simon Hitchens
Linder
Peter Liversidge‡
Jim Medway†
Vinca Petersen
Peter Saville‡

Works also available by:
Peter Blake‡
Brass Art
Nick Crowe
Dean Hughes
Roger Kelly
Colin Lowe‡
Graham Parker
Simon Periton‡
Rob Pruitt†
Ian Rawlinson
Milly Thompson
Roddy Thomson‡
Gavin Turk†
Martin Vincent

Galerie Micheline Szwajcer

Stand E5

Verlatstraat 14
Antwerp 2000
Belgium
Tel +32 3 237 11 27
Fax +32 3 238 98 19
info@gms.bewww.gms.be

Contact
Micheline Szwajcer
Isabelle Grynberg

Gallery artists
Giovanni Anselmo†
Stanley Brouwn
Angela Bulloch‡
David Claerbout†
James Coleman†
Anne Daems
Wim Delvoye†
Jean-Paul Deridder
Jimmie Durham†
Luciano Fabro
Alicia Framis‡
Lee Friedlander
Bernard Frize‡
Liam Gillick ‡
Daan van Golden
Douglas Gordon†
Dan Graham‡
Rodney Graham‡
Ann Veronica Janssens†
On Kawara†
Mark Luyten
Guy Mees
Maria Nordman†
Richard Prince†
Tobias Rehberger‡
Allen Ruppersberg
Joe Scanlan‡
Robert Therrien
Rirkrit Tiravanija†
Niele Toroni
Uri Tzaig
Marijke van Warmerdam
Lawrence Weiner†
Marthe Wery
Christopher Wool‡

Timothy **Taylor** Gallery

Stand F13
Tel +44 20 7486 8342

24 Dering Street
London W1S 1TT
UK
Tel +44 20 7409 3344
Fax +44 20 7409 1316
mail@timothytaylorgallery.com
www.timothytaylorgallery.com

Contact
Tim Taylor
Terry Danziger-Miles
Charmine Farmanfarma
Faye Fleming
Joanna Thornberry

Gallery artists
Craigie Aitchison†
Michael Andrews
Miquel Barceló
Jean-Marc Bustamante†
Marcel Dzama†
Lucian Freud†
Philip Guston
Roni Horn†
Alex Katz†
Willem de Kooning
Guillermo Kuitca†
Jonathan Lasker
Matthias Müller†
Richard Patterson‡
Fiona Rae‡
James Rielly†
Sean Scully†
Joel Shapiro
Tony Smith
Mario Testino‡

Galerie Barbara **Thumm**

Stand A4

Dircksenstrasse 41
Berlin 10178
Germany
Tel +49 30 2839 0347
Fax +49 30 2839 0457
info@bthumm.de
www.bthumm.de

Contact
Barbara Thumm
Ute Pröllochs
Gonzalo Alarcón

Gallery artists
Bettina Allamoda†
Fiona Banner‡
Bigert & Bergström†
Daniela Brahm†
Sebastiaan Bremer
Fernando Bryce†
Martin Dammann‡
(e.) Twin Gabriel†
Sabine Hornig‡
Teresa Hubbard/
Alexander Birchler†
Alex Katz†
AnneMie van Kerckhoven†
Mariele Neudecker‡
Julian Opie‡
Mike Silva†
Bridget Smith†
Heidi Specker†

Transmission Gallery

Stand B17
Tel +44 7985 044932

28 King Street
Trongate
Glasgow G1 5QP
UK
Tel +44 141 552 4813
Fax +44 141 552 1577
info@transmissiongallery.org
www.transmissiongallery.org

Contact
revolving committee of six artists

Gallery artists
Membership of 300 gallery artists
including
Peter Donaldson‡
Laurence Elliott‡
Joanne Tatham and Tom
O'Sullivan†
Sue Tompkins†

Emily **Tsingou** Gallery

Stand A6

10 Charles II Street
London SW1Y 4AA
UK
Tel +44 20 7839 5320
Fax +44 20 7839 5321
info@emilytsingougallery.com
www.emilytsingougallery.com

Contact
Emily Tsingou
Iben la Cour

Gallery artists
Michael Ashkin†
Henry Bond‡
Kate Bright†
Lukas Duwenhögger†
Karen Kilimnik†
Justine Kurland‡
Dietmar Lutz‡
Daniel Pflumm†
Sophy Rickett†
Jim Shaw‡
Georgina Starr‡

Two Palms Press

Stand A7
Tel +1 917 733 9797

476 Broadway, 3rd Floor
New York NY 10013
USA
Tel +1 212 965 8598
Fax +1 212 965 8067
evelyn@twopalmspress.com
www.twopalmspress.com

Contact
David Lasry
Evelyn Day Lasry

Editions available by
Mel Bochner
Cecily Brown‡
Chuck Close†
Carroll Dunham†
Ellen Gallagher†
Sol Lewitt

Elizabeth Peyton‡
Matthew Ritchie†
Kiki Smith
Jessica Stockholder
Terry Winters†

Vilma Gold

Stand G5
Tel +44 79611 26968

66 Rivington Street
London EC2A 3AY
UK
Tel +207 613 1609
Fax +207 256 1242
mail@vilmagold.com
www.vilmagold.com

Contact
Steve Pippet
Rachel Williams

Gallery artists
Shahin Afrassiabi‡
Jemima & Dolly Brown†
Brian Griffiths‡
Daniel Guzman†
Sophie von Hellermann‡
hobbypopMuseum†
Ben Judd†
Andrew Mania†
Ilias Papailiakis
Michael Stevenson
Mark Titchner‡
Markus Vater†
Vinogradov & Dubossarsky‡

Waddington Galleries

Stand G3
Tel +44 20 7486 5428/
+44 20 7486 2102

11 Cork Street
London W1S 3LT
UK
Tel +44 20 7851 2200
Fax +44 20 7734 4146
mail@waddington-galleries.com
www.waddington-galleries.com

Contact
Benjamin Brown
Thomas Lighton

Leslie Waddington

Gallery artists
Craigie Aitchison†
Joseph Albers†
Milton Avery†
Peter Blake‡
Patrick Caulfield†
John Chamberlain†
Sandro Chia†
Giorgio de Chirico†
Ian Davenport†
Edgar Degas
Jean Dubuffet†
Barry Flanagan‡
Dan Flavin
Lucio Fontana†
Sam Francis†
Peter Halley‡
Barbara Hepworth†
Patrick Heron
David Hockney‡
Howard Hodgkin†
Gary Hume†
Axel Hütte†
Donald Judd†
Fernand Léger†
René Magritte†
Henri Matisse†
Joan Miró†
Henry Moore†
Giorgio Morandi†
Ben Nicholson†
Mimmo Paladino†
Francis Picabia
Pablo Picasso†
Robert Rauschenberg†
Larry Rivers†
Susan Rothenberg†
David Salle†
Lucas Samaras†
Julian Schnabel†
Frank Stella†
Thomas Struth†
Antoni Tàpies†
William Turnbull†
Andy Warhol†
Tom Wesselmann†

Galleri Nicolai **Wallner**

Stand B12

Njalsgade 21
Building 15

Copenhagen 2300
Denmark
Tel +45 32 57 09 70
Fax +45 32 57 09 71
nw@nicolaiwallner.com
www.nicolaiwallner.com

Contact
Nicolai Wallner
Claus Robenhagen

Gallery artists
Mari Eastman†
Michael Elmgreen &
Ingar Dragset‡
Douglas Gordon†
Jens Haaning†
Henrik Plenge Jakobsen†
Joachim Koester†
Jakob Kolding‡
Peter Land‡
Jonathan Monk‡
Christian Schmidt-Rasmussen†
David Shrigley†
Glenn Sorensen†
Gitte Villesen†

Galerie Barbara **Weiss**

Stand F14
Tel +49 171 211 9460

Zimmerstasse 88–91
Berlin 10117
Germany
Tel +49 30 262 4284
Fax +49 30 265 1652
mail@galeriebarbaraweiss.de
www.galeriebarbaraweiss.de

Contact
Barbara Weiss
Barbara Buchmaier

Gallery artists
Monika Baer‡
Heike Baranowsky†
Thomas Bayrle†
Janet Cardiff & George
Bures Miller
Maria Eichhorn†
Ayse Erkmen†
Friederike Feldmann
Adib Fricke
Christine & Irene
Hohenbüchler†

Laura Horelli†
Raoul De Keyser†
Boris Mikhailov‡
John Miller‡
Christa Näher
Jean-Frédéric Schnyder‡
Andreas Siekmann‡
Roman Signer†
Erik Steinbrecher
Niele Toroni†
Marijke van Warmerdam

White Cube

Stand F6
Tel +44 20 7486 4102

48 Hoxton Square
London N1 6PB
UK
Tel +44 20 7930 5373
Fax + 44 20 7749 7480
enquiries@whitecube.com
www.whitecube.com

Contact
Jay Jopling
Daniela Gareh
Alexandra Mollof

Gallery artists
Franz Ackermann‡
Darren Almond†
Nobuyoshi Araki†
Miroslaw Balka‡
Ashley Bickerton†
Koen van den Broek†
Sophie Calle†
Jake & Dinos Chapman‡
Chuck Close†
Gregory Crewdson†
Carroll Dunham†
Tracey Emin†
Cerith Wyn Evans†
Katharina Fritsch†
Anna Gaskell
Gilbert & George‡
Nan Goldin‡
Steven Gontarski†
Antony Gormley†
Marcus Harvey†
Mona Hatoum†
Eberhard Havekost‡
Damien Hirst‡
Gary Hume†
Tom Hunter†
Runa Islam†
Ellsworth Kelly†
Clay Ketter†

Raoul de Keyser†
Damian Loeb†
Eskö Männikkö‡
Julie Mehretu‡
Ryan Mendoza†
Harland Miller†
Sarah Morris†
Frank Nitsche‡
Richard Phillips†
Marc Quinn†
Clare Richardson†
Matthew Ritchie†
Doris Salcedo†
Christian Schumann†
Hiroshi Sugimoto†
Neal Tait‡
Sam Taylor-Wood†
Fred Tomaselli†
Gavin Turk†
Luc Tuymans†
Jeff Wall†
Terry Winters†

Galerie Barbara **Wien**

Stand G2
Tel +49 173 615 6996

Linienstrasse 158
Berlin 10115
Germany
Tel +49 30 2838 5352
Fax +49 30 2838 5350
info@barbarawien.de
www.barbarawien.de

Contact
Barbara Wien

Gallery artists
Michael Beutler‡
Ernst Caramelle†
Antje Dorn†
Jimmie Durham†
Hans-Peter Feldmann‡
Peter Fischli/David Weiss‡
Dorothy Iannone
Arthur Köpcke†
Isa Melsheimer‡
Nanne Meyer
Peter Piller†
Eva von Platen†
Dieter Roth†
Tomas Schmit†

Michael Snow†
Haegue Yang‡

Wilkinson
Gallery

Stand E1

242 Cambridge Heath Road
London E2 9DA
UK
Tel +44 20 8980 2662
Fax +44 20 8980 0028
info@wilkinsongallery.com
www.wilkinsongallery.com

Contact
Anthony Wilkinson
Amanda Wilkinson

Gallery artists
David Batchelor†
Tilo Baumgärtel†
Christopher Bucklow†
Brian Conley†
Angela de la Cruz†
AK Dolven‡
Geraint Evans†
Julie Henry†
Matthew Higgs†
Nicky Hirst†
Paul Housley†
Olav Christopher Jenssen†
Martin Kobe†
Elizabeth Magill‡
Silke Schatz†
George Shaw‡
Shimabuku†
Mike Silva†
Bob & Roberta Smith†
Johnny Spencer†
Matthias Weischer‡

The **Wrong**
Gallery

Stand H1

516A 1/2 West 20th Street
New York NY 10011
USA
thewronggallery@aol.com

Contact
Maurizio Cattelan
Massimiliano Gioni

Ali Subotnick

Gallery artists
Tomma Abts†
Christoph Büchel‡
Phil Collins‡
Martin Creed†
Sam Durant†
Jacob Fabricius
Sonja Feldmeier
Isa Genzken‡
Cameron Jamie
Paul McCarthy‡
Adam McEwen‡
Aleksandra Mir‡
Elizabeth Peyton‡
Paola Pivi
Jason Rhoades‡
Tino Sehgal‡

David
Zwirner

Stand F5

525 West 19th Street
New York NY 10011
USA
Tel +1 212 727 2070
Fax +1 212 727 2072
info@davidzwirner.com
www.davidzwirner.com

Contact
Angela Choon
Bellatrix Hubert
Hanna Schouwink

Gallery artists
Michaël Borremans†
Stan Douglas‡
Marcel Dzama†
On Kawara†
Raoul de Keyser†
Rachel Khedoori†
Toba Khedoori†
Estate of Gordon Matta-Clark†
John McCracken†
Jockum Nordström†
Raymond Pettibon†
Neo Rauch‡
Jason Rhoades‡
Thomas Ruff‡
Katy Schimert†
Yutaka Sone‡
Diana Thater‡
Luc Tuymans†
Christopher Williams†

Magazine Index

Afterall

M1

Central St Martins College of Art
and Design
107–109 Charing Cross Road
London WC2H ODU
UK
Tel +44 20 7514 7212
Fax +44 20 7514 7166
afterall@linst.ac.uk
www.afteralljournal.org

Art & Auction

M2

11 East 36th Street
New York NY 10016
USA
Tel +1 212 447 9555
Fax +1 212 532 7321
edit@artandauction.com
www.artandauction.com

Art in America

M3

Brant Publications Inc
575 Broadway, 5th floor
New York NY 10012
USA
Tel +1 212 941 2800
Fax +1 212 941 2885

Art Monthly

M4

4th floor
28 Charing Cross Road
London WC2H ODB
UK
Tel +44 20 7240 0389
Fax +44 20 7497 0726

info@artmonthly.co.uk
www.artmonthly.co.uk/

The Art Newspaper

M5

70 South Lambeth Road
London SW8 1RL
UK
Tel +44 20 7735 3331
Fax +44 20 7735 3332
contact@theartnewspaper.com
www.artnewspaper.com

Art Nexus

M6

12955 Biscayne Boulevard
suite 410
North Miami FL 33181
USA
Tel +1 305 891 7270
Fax +1 305 891 6408
info@artnexus.com
www.artnexus.com

Art Press

M7

8, rue François Villon
Paris 75015
France
Tel +33 1 53 68 65 65
Fax +33 1 53 68 65 68
contact@artpress.com
www.artpress.com

Artforum

M8

350 Seventh Avenue
New York NY 10001
USA
Tel +1 212 475 4000
Fax +1 212 529 1257
generalinfo@artforum.com
www.artforum.com

Flash Art

M9

Via Carlo Farini 68
Milan 20159
Italy
Tel +39 02 68 87 341
Fax +39 02 66 80 12 90
info@flashartonline.com
www.flashartonline.com

Springerin

M10

Museumplatz 1
Vienna 1070
Austria
Tel +43 1 522 91 24
Fax +43 1 522 91 25
info@springerin.at
www.springerin.at

Tate

M11

Millbank
London SW1P 4RG
UK
Tel +44 20 7887 8008
www.tate.org.uk

Tema Celeste

M12

Piazza Borromeo 10
Milan 20123
Italy
Tel +39 02 80 65 171
Fax +39 02 80 65 17 43
info@gabrius.com
www.temaceleste.com

Texte zur Kunst

M13

Torstrasse 141
Berlin 10119
Germany
Tel +49 30 2804 7910
Fax +49 30 2804 7912
verlag@textezurkunst.de
www.textezurkunst.de

Trans>arts. culture. media

M14

109 West 17th Street
3rd floor
New York NY 10011
USA
Tel +1 646 486 0252
Fax +1 646 486 0241
trans@transmag.org
www.transmag.org

FRIEZE ART FAIR

Artist Index

Artists Index